C000130064

WHY BRITAIN ROCKED:
How Rock Became Roll and Took Over the World

Elizabeth Sharkey

Academica Press
Washington~London

Library of Congress Cataloging-in-Publication Data

Names: Sharkey, Elizabeth (author)
Title: Why britain rocked : how rock became roll and took over the world |
Elizabeth Sharkey
Description: Washington : Academica Press, 2023. | Includes references.
Identifiers: LCCN 2022944868 | ISBN 9781680534450 (hardcover) |
9781680534474 (paperback) | 9781680534467 (e-book)

WHY BRITAIN ROCKED:
How Rock Became Roll and Took Over the World

Elizabeth Sharkey

To Tracy

Thank you for coming!

Elizabeth Sharkey

For my family,
my guiding light and inspiration

Contents

Foreword

"Why Britain Rocked: How Rock Became Roll and Took Over the World": an important challenge to the accepted narrative that only the American sexual charge and revolutionary spirit could have created the world-straddling beast we call Rock'n'Roll.

Elizabeth Sharkey's book is expansively and generously written, with a warmth and love for the musics of the people through the ages, throughout. These things, these indefinable impulses that humans have to dance, love, drink, murder and sing about it all - from our ancestors to the local teenager with the electric guitar in their parents' garage - those things infuse this alternative story of us.

This book will lovingly hold your hand as it takes you through the sociological history of our islands and their music, accompanied by an absolutely banging playlist that accompanies the end of every chapter: suggested songs and recordings that perfectly illustrate and illuminate the author's point.

You can perceive the love and respect with every sentence, the sense of wonder, at ancient culture that demonstrably peeks through to modern pop and rock through the author's history and family, and the histories and families of some of Britain and Ireland's finest modern songwriters.

I won't tell you what questions to ask as you read this, but I can tell you what came up around our kitchen table in greatly enjoyable, heated discussions.

Are folklorists and modernisers mutually exclusive - two different breeds of person? It's always been my perception that the modernisers and folk enthusiasts of the 1950s had to be folklorists as well as performers, as there were, of course, no internet sources to access and, in the case of my beloved venerable institution the EFDSS, were often unwilling to allow "no better than they ought to be" presumptuous youngsters into the hallowed rooms of the Vaughan Williams Memorial Library.

There are plenty of accepted narratives about the Victorian collectors, the movement of the Irish and the Ulster Scots; Elizabeth has researched and retold all of these thoroughly and faithfully. I love that this book, all about the birth of Rock, should go back so far - aren't all musics and human people connected in this golden threaded way, through the transmission of our physical bodies and families across time and continents, and our musical stories with it?

So we find the Lennon and McCartney families living in "Squalid Liverpool" in 1851, just a few streets away from where the Cavern Club would be situated. We find Kate Bush growing up in Kent with Irish and English parentage, in the garden of England with her mother's Celtic heart, and the golden thread is there, too.

There are some holes, though, some different understandings of the timeline of traditional music and practise in England, post 50s, that this writer can see. Elizabeth has been characteristically very generous in allowing me to write this foreword knowing that there are some points on which we disagree. My family is also Irish and Scots in origin, as well as Traveller and English, and many of the other strains that make up who resides on the England bit of our islands. I think there is plenty of evidence for a polytheistic, wild traditional music in England - and most of all for a Revival that occurred at exactly the same time as the Irish and Scots Revivals did, in part due to the huge explosion of English folk clubs where everyone could play, exchange information and begin to earn. I am from the East of England, and I see equivalent traditions of "ceilidh" culture in towns like Hull, as well as ballad storytelling filled with high tragedy.

Hull, as a port, was also a place where singing raucously was a multi-generational domestic delight - but though the Irish and Scots were there, so were the English, the Scandinavians, the Vikings, the Anglo-Saxons.

I maintain that we all, as close neighbours, rediscovered our roots when confronted by Lonnie Donegan, Joan Baez and the like. From Johnny Moynahan to Hamish Henderson, from Christy Moore thanking Mike Waterson for returning Lakes of Pontchartrain to the Irish, the fifties and sixties saw a "coming together" and a Renaissance that the romantic English and warlike Celts could all appreciate as brothers, we sowed stages together. And this, building on the first fusion or "world" music of them all - shanty singing - reaped incredibly fertile ground.

So, this is Elizabeth's book, and is, as first stated, an important revision of what makes up the "sexy" music. I believe there is further to go to allow the ordinary English more agency in a story which saw bands like Clannad looking to Pentangle and the Watersons for inspiration and the English looking lovingly back; I look forward to what is said next in response to this work. Do enjoy this excellent addition to the conversation.

Eliza Carthy.

Introduction

I understood I had an unusual infatuation with music around the age of nine. Some school friends were over to play one afternoon in the summer holidays. At the time I was obsessed with the *Grease* soundtrack album and all I wanted to do was put it on the record player and everyone have a dance in the living room. But they were only vaguely interested; a couple thought it was 'rubbish' but I persisted. I hit them with 'Greased Lightnin'' and asked them to listen, listen properly, couldn't they hear it? How marvelous it was? I started to dance like a furious pixie but when I came out of a particular intense appreciation of the saxophone bit I looked up and I was alone in the room. They had all fled the house and gone outside to play in the much more exciting haystacks in the barn.

Music is personal. Someone's all-time anthem can be someone else's three minutes and fifty-nine seconds of intolerable tedium. For some people, music is not personal at all, it's merely entertainment. They buy it because they're told to by advertising campaigns or because it's the latest thing and all their friends are listening to it. Growing up, music was everything to me: my home, my thrill, my escape and my understanding of the world. If you're like me and you love certain songs or pieces of music to the core of your very soul – in fact, if those songs or pieces of music are little maps of the landscape of your soul - then you might, as I was, be curious to look a little deeper into just why, how, such magic came to be.

We all know the history that led to America's musical dominance. There have been countless books and films tracing the story of early twentieth century blues, gospel and jazz that birthed rock and roll and so on. Britain's pop history, in contrast, rarely starts before 1950. I've always loved music documentaries on the hows and whys of British music - the story of the Beatles and the developments of punk, ska, post punk, gothic, new romantic, house, Britpop and drum n bass – but in recent years I've found them increasingly lacking. I've become more interested in the wider question; the big story still waiting to be told as to why Britain has produced some of the greatest pop

music in the world. Many have wondered the same, but to my mind no answers have ever truly got to the bottom of it.

The story goes that Britain suddenly started making spectacularly great music in the 1960s under the influence of American blues and rock and roll, like some clever, quick learning cultural satellite. It seems there was not much to say about British music before then, other than British dance bands and jazz musicians who created fabulous interpretations of the American style. With a quick glance, it's hard to disagree with that starting point. But if we stop, step back and look further into British history, we will discover why, of all American music crazes in Britain it was rock and roll and the blues, via skiffle, that British artists took to another level. You see, Britain's mid twentieth-century pop music explosion didn't happen from a standing start; far from it. For something so profound, dazzling and multifaceted the reasons for its sudden appearance lie deeper than those legendary deliveries of blues records into Liverpool and the legacy of music hall. To look at it another way, Britain is a country roughly the size of the state of Minnesota but has been as prolific in its creative output as a country forty times its size. Doesn't it make you wonder? Of course, the UK's compact size has been an advantage, allowing the speedy communication of trends and developments, but that's just logistics. In researching *Why Britain Rocked* I've examined the fertile soil that allowed the seedling plant of British pop to prosper and flower under the heat of 1960s' libertarian change. Further, I'll reveal how Britain and America have, in fact, been musically linked and a spur to each other's creativity for hundreds of years.

Whenever I've fallen in love with a newly discovered band or artist my first thought would be to ask, 'where are they from'? Although, I'm not sure why. Maybe it's because I've always found the best music has a sense of place; an essence of the artist's home and history. Or it's possibly due to something in the timbre of their voice or the melody and phrasing, along with the shifts of tempo and chord changes which have, in my imagination, led to a voyage of discovery in both time and place. Of course, it's almost now a cliché to mention the Beatles when talking about British pop, but my love for them is unfathomably deep. It goes beyond merely loving their music. When I hear a Beatles' song, I experience an almost parental connection of warmth and trust, along with the strange nostalgia one has for the years just before you were born. When I was a young teenager, I used to listen to my brother's *The Beatles Ballads* album and I was mesmerized by the sound of their voices

coming through my big headphones. I used to get a little thrill turning down the volume on one side to hear the isolated guitar track on 'All My Loving' and then the other side to hear John and Paul's naked harmonies; in my mind I was right there in the recording studio with them. 'Til There Was You,' 'Here Comes the Sun' and 'And I Love Her' made me dream of sixties Britain, tinged with a bit of sun dappled, student Americana. How I yearned to have been there just for one day.

I grew up on a farm in north Lincolnshire, under its big skies, surrounded by fields and woodland, then we later moved to one of its market towns further south. However, I got hold of my brother's copy of Joy Division's *Unknown Pleasures* when I was around fourteen and initially thought, what the hell is this? I couldn't work it out for ages. But in my mind's eye I saw lift shafts, broken glass and epic, angular darkness that I later learned was an imprint of Manchester's decaying industrial landscape. Similarly, while listening to Blondie's *Parallel Lines*, I became obsessed with the louche drive of New York. One of my all-time favourite songs is 'Native New Yorker' by Odyssey. God, I love that song. It's a high-flying, big picture anthem that captures the elegant shimmer and pulse of the city at its most glamorous and creative, against the backdrop of one of its more delinquent periods.

All of which brings me back to the fundamental question, which was the main preoccupation of all my childhood thoughts and dreams. What gives music that sense of place and time, with all its myriad differences? Because there lies the beauty of the greatest music. The intoxication of pressing play and plunging into the fleeting humanity of a moment, as I do when I listen to the Bee Gee's 'Nights on Broadway;' a song that takes you from its mean streets opening to the sweetest heartbroken serenade to the glorious confusion of Manhattan nightlife in 1975. Others are elemental. I drift into a childhood vision of summer when I hear 'Wichita Lineman;' the languid opening bass drops you into the shimmering mid-July heat with the occasional low breeze, and I can see fields of ripened wheat and the long, long line of a dusty, empty road disappearing into a distant horizon. Music can conjure a sparkling clean river rushing over mossy stones; the rain and wind up on the hills; a crying hawk climbing high into the blue; or the expansive joy of hitting the open road while almost being able to taste the essence from where it came.

Throughout *Why Britain Rocked* I'll refer to 'British pop' in its old, twentieth century sense, i.e., any music borne of the folk-gospel-jazz-blues family tree. Now, I know this is going to be an irritating confusion to younger

readers but for the sake of simplicity and to avoid having to use the cumbersome 'British contemporary music,' I'm going to stick with British pop. It might make you think of Kylie, or the Spice Girls or Dua Lipa, but to millions of Britons it's a term that was seared into memory by the epoch of the glorious, religiously watched, television highlight of the week - *Top of the Pops*. The forty-minute show, (first broadcast from a former Methodist chapel in Rusholme, Manchester), went out every Thursday evening at 7.20pm after the science programme *Tomorrow's World;* the BBC's couplet hour of educational discipline and its reward. We used to watch *Top of the Pops* with the quiet excitement of wonderings – who might be on this week? Might they show that song you love that's new in at number 15? And there was even the rogue possibility they might perform it…live! With real singing and everything! They rarely did, but it didn't matter. In a time before the overflowing riches of YouTube, *Top of the Pops* was a beginners guide to delayed gratification; of sitting through the acts you were bored by, to finally catch sight of the ones you adored.

The lasting wonder of the show, looking back, was that it reflected a time when the British charts were so fabulously bonkers and varied you could find The Rolling Stones, The Sex Pistols and The Smurfs simultaneously in the top ten; or were just so damned full of classics like the glorious November of 1978 when Barbara Streisand and Donna Summer's 'No More Tears' was knocking around with The Jam's 'Eton Rifles,' The Commodores, 'Still' and Madness' 'One Step Beyond;' or counting down the top five of November 1981, for example, we had Orchestral Manoeuvers in the Dark with 'Maid of Orleans,' Haircut One Hundred's 'Favourite Shirt,' Julio Inglesias' cover of 'Begin the Beguine,' The Police with 'Every little thing she does is magic' and in the number one spot, it's Queen and David Bowie with 'Under Pressure.' Then there was always a comedy song inexplicably tearing up the charts, like Benny Hill's 'Ernie (The Fastest Milkman in the West)' that kept T Rex's 'Jeepster' from reaching number one in December 1971. A bit of well-crafted daftness, you might think; but it was, in fact, upholding one of our most ancient gothic ballad traditions. Call me overly sentimental and dramatic but for the scope, humour and imagination the British charts once showcased, it makes me weep for what we took for granted.

Reverie over. So, in the face of ever more infinitesimal genre categorisations (which are not helpful, just reductive; music just is, let it be whatever you hear in it) I tend to use the Louis Armstrong approach, that

being, 'There is two kinds of music, good music and bad music.' So, if it's any good, it will be popular, and that's what made it pop music.

Sometimes, I think there is no greater truth than music, one that transcends language. I began thinking about *Why Britain Rocked* in 2006 when my friend Alex and I went on a pilgrimage to see the Arctic Monkeys at the FM4 Frequency Festival in Salzburg. They were due on at 4pm. We presumed it wouldn't be busy and we would be free to stand at the front without worrying about the usual life-threatening crush. Well, we got that wrong. When the band came on, I almost immediately had to be rescued by a security guard, suffering the indignity of being hauled over the barriers as hundreds of young Austrians surged to the front. It was packed. From the safety of the side-line, I looked around and saw all these kids, some dressed as mods, going nuts for this band from Sheffield. We tried chatting to some of them but none spoke English and Alex and I had no German. Still, all of the headline bands were British – Muse, Franz Ferdinand, Morrissey, the Kaiser Chiefs, The Prodigy, Belle and Sebastian and the Editors.

Moving forward to Twickenham Stadium, 8th July 2007 where the newly reformed Genesis were playing to 54,000 ecstatic fans. I was in the front row (courtesy of some freebie tickets – thank you, Piers), standing next to three young men who were in floods of tears. They were passionately singing along to every word, hugging each other, and they punched the air to cries of 'Phil, we love you!' These were not local lads. For Jesus, Alejandro and Angelo, I discovered after talking to them, this was a pilgrimage to see the band that had been their obsession since childhood, one that had taken months of planning and began 6,000 miles away in Los Alamos, Brazil. It was touching to witness and something I've never forgotten. The oft-quoted advantage of Britain's ports, entrepreneurial nous and the English language, while all are important, are simply part of the delivery system; merely the facilitator, rather than what is at the heart of why the songs are so great. It's the spirit. It's the feeling. It's the attitude. And above all, it's the music.

There can be no absolute answer as to *Why Britain Rocked*. For one thing, we can never know how great musicians come up with their wealth of melody. Take Jerome Kern's composition for 'The Way You Look Tonight,' for example (my absolute all time favourite version is from a scene in *Peter's Friends*). Have you ever heard an arrangement of notes more touching than these? Well, maybe Isham Jones's melody for 'I'll See You in my Dreams' comes a very close second. I've tried composing a few lines of melody. It's

hard. Even creating a mediocre tune is difficult, never mind one so exquisite it gives you the shivers or immediately moves you to tears. Or Simon and Garfunkel's 'The Sound of Silence,' Marvin Gaye's 'What's Goin' On,' Love's 'Alone Again Or,' Don McClean's 'Vincent,' Nick Drake's 'River Man,' Neil Sadaka's 'Laughter in the Rain,' ELO's 'Telephone Line,' Stevie Wonder's 'Lately,' The Pretenders' 'Kid,' or Prefab Sprout's 'When Love Breaks Down.' These songs are the tangible proof of magic that has been summoned from some other plain; they hypnotise me within the first few seconds and I'm gone – don't talk to me, because I can't hear you. There is enchantment at the core, something we can never explain. Lyrics are easier for the listener to divine or for the composer to explain, but so unreachable it is for most mortals to write a capturing melody that to fully understand the phenomenon we would have to examine the soul of each and every great songwriter.

But having said that, there is a phenomenon known as musical intelligence; a kind of generational hand on of musicality that has delivered the gift of melody to many of the finest composers of pop music. With this in mind, we will discover how Britain's pop explosion that surprised the world, really shouldn't have been a surprise at all. We've heard the story of what was happening at the time of British pop culture's upsurge in the 1960s, what it meant and the path it followed from there. This book digs deeper. It's a contribution towards understanding how conditions evolved that encouraged it *to be*, in all its glorious, crazy, luminous, joyous, profound, melancholic, ferocious, anarchic, witty, smart and wonderful ways.

1
Written on the Wind

In the biography, *Blue Monday*, the author Rick Coleman considers Fats Domino to be the creator of rock and roll. There are, of course, many claims to that title. But, for our purposes, it is irrelevant, for Coleman defines the creation of rock and roll thus: 'Domino himself was at the crossroads of black and white worlds, as he led the way in the crucial fusion of popular music with the West African tradition of polyrhythms, which moved the body, and emotive story telling, that moved the soul.' Coleman is precise about the origins of polyrhythms; they did indeed come from West Africa. But he gives no mention of the Northern European roots of that emotive story telling. Which is where we come in. For our story, that of examining just why Britain had an extraordinary talent for producing some of the most creative pop music on the planet, we need to start by looking at the centuries-old ballad culture of the northernmost part of Europe and, strangely enough, with the peoples in and around ancient Britain.

In *Wayfaring Strangers: The Musical Voyage from Scotland and Ulster to Appalachia*, Fiona Ritchie and Doug Orr point to a good place to start our musical journey. They tell us how, in 2012, the archaeologist, Dr Graeme Lawson, made a remarkable discovery that provided an insight into the music making of our ancient ancestors. On the Isle of Skye, in a Bronze Age subterranean shelter and burial ground known as High Pasture Cave, was found an unmistakable piece of what proved to be Europe's oldest stringed instrument. It was a 'bridge,' a little bit of wood that was once part of a lyre, and is approximately 2,300 years old. Dr Lawson announced to the press that the bridge 'pushes the history of complex music back more than a thousand years.' The historian and composer Dr John Purser also studied the fragment, and for him it confirmed, 'the continuity of a love of music amongst the Western Celts.'

Long before this startling discovery, Ewan MacColl, [1915-1989] the highly revered figurehead of the folk music revival in Britain, made it quite

clear that he didn't believe in such a thing as Celtic music. In one of his last interviews, he questioned, 'Who the hell can study music we do not know ever existed?' 'We do not even know if the Celts were musicians! There is nothing to suggest that they were!' He believed that without any physical evidence to prove the Celts were musical, there was a danger of building up a romantic notion of an ancient life about which we knew very little; although, if MacColl were alive today, that lyre bridge might possibly cause him to change his mind.

In one sense, MacColl was right. There is no one Celtic music genre, nor one homogenous grouping. We might think of the term 'Celtic' as a fairly modern superficial invention used for sentimental or political reasons, but its relatively recent coinage belies the fact that there have been active, cohesive Celtic cultures in Britain for thousands of years. A proto-Celtic language developed in Britain as early as 3,000 BC. Moreover, the maritime trading links of Cornwall, Wales and Ireland, together with the north west of England and Scotland, piece together evidence of a region of Atlantic facing territories bound by ideas, technologies and common belief systems that date as far back as the Bronze Age. As much as there remains a Roman Britain today – the roads, the ports and centres of commerce – there remains a Celtic Britain that was isolated and impregnable; where Roman de-tribalising couldn't reach. The boundary of Hadrian's Wall from Bowness-on-Solway to where now sits Newcastle upon Tyne was not only a Roman border checkpoint for taxing trade but it was also helpful to future invaders, marking out how far north to go when they arrived. It draws the line as to where the Romans gave up expending their troops trying to take the rough terrain and its Caledonian inhabitants into their administration. Through the migrations and colonising of the Angles, Jutes and Saxons, the Celtic peoples preserved their identifying characteristics. By the end of the ninth century most of the Brittonic speaking Britons residing in the Anglo-Saxon kingdoms of the south and east were united under the name of 'England;' but to the west and north, beyond the settlements of Northumbria, Mercia, East Anglia, Wessex, Sussex and Kent, they kept their languages and their cultures.

In the eighth century, Norsemen sailed across from Norway to carry out coastal raids of Scotland's furthest reaches, adding a genetic intensification to the Celtic pool. Norse blood merged with Gaelic as they settled in the mountain wilderness of the Shetland Isles, Orkney, Sutherland, Argyll and the Western Isles. The Norsemen came from a harsh climate with a scarcity of

workable land. These clansmen were fishermen and herdsmen, and kindred cousins to the Gaels of *Dal Riata*. They were both quick to battle; both mighty warriors who held a reverence for their weaponry as living entities, celebrating them with 'sword and shield' songs, and they liked a drink. But there is another legacy of Scotland's historic connection with Norway; one concentrated down the east coast between Aberdeen and the port cities of Stavanger and Bergen. Isolated by surrounding forests and mountains, Aberdeen was once a town with an almost exclusively North Sea-facing, international outlook, and practised more trade with the Scandinavian peninsular than the rest of Britain. Trade routes between Scotland and Scandinavia were well mapped by the twelfth century, by which time Aberdeen was known to Norwegians as the trading capital of the north of Scotland, the distance between Aberdeen and the fjordic ports equating to just two nights at sea. Exchanging food, music and storytelling, the cultures shared a mutual preoccupation with mournful, supernatural ballads; the kinds of ballads, 'Where fairy-folk, ghostly creatures of the sea, and the dead, share field and woodland, moor and bracken, house and churchyard with men and women of the workaday world.'

One hundred and thirty miles south of Aberdeen we come to Grangemouth, another major seaport town and oil refinery with shipping links to Stavanger. Grangemouth is notable for producing the Cocteau Twins - Elizabeth Fraser, Robin Guthrie and the original bassist Will Heggie were all born and raised there. Fraser's voice had a seismic effect on my imagination in a way, no doubt, along with all her other fans, I'll never fully comprehend and I've often wondered of where, or of what their unparalleled post-punk sound was borne. We could start with a sense of place. Their first album, *Garlands* especially captures the strange dreamland dystopia of Grangemouth's industrial landscape, yet, in Fraser's singing, there's something of the Scandi-Scots' ballad legacy of the known and ghostly unknown; of the vigour of the material world and the ache of what we shall never know, not until death comes to claim us. Similarly, the sound of Annie Lennox's voice in the Eurythmics' catalogue has a blissful reassurance of a beneficent other-world. Born and raised in Aberdeen, Lennox recognises a tendency towards what she described as 'Celtic melancholy' often present in Scottish folk songs, bagpipe tunes and in some of the greatest pop music. It's a quality that she and Dave Stewart used to extraordinary effect. Stewart pinpoints it when he says, 'There is something very moving about certain

inversions of chord changes, and the way they play against the timbre of someone's voice.' Lennox's voice has a soulful, haunting, grieving timbre powered by its silken strength and Stewart connects these qualities to the fact she comes from Aberdeen, whose 'musical heritage is littered with haunting airs.' These airs took their inspiration from the hard living of the east coast's fishing communities shaped over time by a wild, menacing sea and the daily expectation that husbands, sons and brothers, setting out to their fishing boats at the witching hour of three o'clock in the morning, might never return home.

The power of these songs is something Dave Stewart says he cannot quantify. 'It's hard to explain how such sadness and beauty can come from the melodies and chord changes in Scottish or Irish airs. You just have to listen to them and feel it.' It's what drew Stewart and Lennox together. 'It's something instinctive to Annie, and coming from the northeast of England myself, I easily relate. We both grew up where the sky was filled with varying shades of grey and where a freezing north wind blew. I think these elements added to the dynamic between us when we wrote ballads. We both knew when something had the chill factor.'

For a millennium, Aberdeen has been called the 'Cradle of Scottish Balladry.' But it is one rocked by a westward wind coming from across the North Sea. The Aberdonian folklorist David Buchan believed Scandinavian folk song is 'undeniably the British tradition's nearest sibling,' and regionally, the northeast of Scotland has the tightest similarities. Spanning hundreds of years and bringing us right up to the twentieth century, these ties have never lessened. Prior to ABBA going stratospheric, they knew they had to make it in Britain before they could achieve global success. By then of course, the United Kingdom was a feverish factory of pop music and the place to be to become recognised as a successful act. As Björn Ulvaeus told a British reporter after winning the Eurovision Song Contest with 'Waterloo,' 'It's always been our ambition to top the charts in Britain. It means more than a number one in the States to us. You see, for years Britain has been at the top – the headquarters of pop music.' But the beauty of Ulvaeus' statement is that he had touched upon an ancient connection. When ABBA delivered their immaculate songs to the British people, they were continuing an exchange in song-craft that had been in existence since the thirteenth century, and most likely long before then.

On returning to contemplate Ewan MacColl's belief that there is no such thing as Celtic music, we immediately face a problem. Because, by definition, any music that comes from these regions, and is rooted in what remains of their old Celtic culture - together with their place names, food, dialects and the extraordinary survival of their languages - is demonstrably 'Celtic.' It is the Celtic peoples' cultural inheritance that gave voice to the songs that mark the start of our journey. The musicality of Scotland, northern England and Ireland forms the bedrock of British pop, for it was their folk culture that travelled and prospered in the new American colonies, triggered a musical revolution, and brings our story full circle back to Britain.

Millions of Americans hold dear their Scottish roots. It was, perhaps, with this in mind that in 1860, the Bostonian folklorist and mathematician, Francis Child published a collection of folk songs entitled *English and Scottish Ballads*. The collection was vast; it ran to eight volumes. Still, his definitive collection *English and Scottish Popular Ballads* was published just over twenty years later to include every version of the 305 ballads he had collected. Almost two-thirds of the Child catalogue is connected, in some shape or form, to Aberdeenshire and the inland north east of Scotland. With its lochs and rivers, ancient forests, and fertile pastures the areas of Allanaquoich and Braemar in particular were once described as a lyrical arcadia, a 'sequestered, romantic pastoral country,' where 'the nurses and old women sing…peculiar airs and lilts of chivalry & love,' as well as ballads of 'ghosts and superstition' that floated over from Scandinavia. To give an example of the Scots-Scandi symbiosis in balladry, the first stanza in Child ballad number two, 'The Elfin Knight' features a reference to Norway:

My plaid awa, my plaid awa,
And ore the hill and far awa,
And far awa to Norrowa,
My plaid shall not be blown awa.

Accordingly, references to Scotland appear in the romantic Scandinavian ballad, 'Sir Stig and the King of the Scots' daughter,' which tells the story of Sir Stig who falls in love with the king's daughter after he sails to Scotland and spies her on her way to church; she happily reciprocates and they sail back

to Norway together. The Child ballad number four, 'Lady Isobel and the Elf Knight' follows a similar narrative to the Norwegian ballad '*Rullemann og Hilleborg;*' ballad number six, 'Willie's Lady' collected by Mrs. Brown of Falkland in 1783 has numerous Danish and Swedish variants. In fact, the similarities between the old Scottish and Scandinavian ballads are so marked, that there has been considerable confusion over provenance. Take the murder ballad 'The Twa Sisters' otherwise known as 'The Cruel Sister.' There are twenty-seven versions in the Child collection, two specifically from Aberdeen, multiple Scottish adaptations, and Icelandic, Norwegian, Danish and Swedish variants (although evidence leans towards it having entered Britain from Norway or the Faroes). It's also a perfect example of just how far a folk song can travel. It was first published as a broadside in 1656, but simply by word of mouth, or the oral tradition as it is known in folklore, it reached the Appalachians to be known there as 'The Wind and the Rain.' The song's endurance is proof of a musical natural selection, guided by its themes that will always draw us in: true love, murderous jealousy and a ghostly return (for a modern interpretation, see the aforementioned 'Ernie').

Lowland Scotland had its own impetus for creativity. The Lowlands once had an atmosphere unlike anywhere else in the British Isles, as described here by the folklorist Albert Lloyd, 'The bare rolling stretch of country from the North Tyne and Cheviots to the Scottish southern uplands, was for a long time the territory of men who spoke English but had the outlook of Afghan tribesmen;' but these were lyrical tribesmen for they 'prized a poem almost as much as plunder.' The ballad collector John Housman had a theory that a ballad culture often arises from social and political tensions. The borderland between England and Scotland takes the crown for having once been the most lawless region in Britain, which is why border ballads are often about fighting. From the late Middle Ages through to the rise of the Tudors this 'Debatable Land' covering approximately 1,800 square miles suffered incessant raids, racketeering and bloody conflict between the kings of Scotland and England over the precise ownership of various landholdings or castles. The chaos and violence endured by the people living within this territory was anonymously expressed in *The Complaynt of Scotland*, printed in Paris in 1548. It is a cultural manifesto for Scotland's independence and offers the earliest reference to the local ballads for which the region is famous. Mentioned in *The Complaynt* is a tune devoted to perhaps the first 'Johnnie' of popular song. He was the border raider, folk hero and Clan Chieftain Johnnie Armstrong of

Gilnockie who ruled like a Mafioso an area that covered the Scottish border down to Newcastle; that is, until he was ambushed and executed by James V's army at Caerlanrig. There's also a reference to the fairy ballad 'Tam Lin' and the Northumbrian epic, 'Ballad of Chevy Chase' that tells the story of warfare in the Cheviots between Earl Percy of England and Earl Douglas of Scotland, and effectively turned their local rivalry into epic folklore on both sides of the border.

There is a lasting legacy from exalted Scots society, too. Mary, Queen of Scots surrounded herself with fine musicians and singers in her bedchamber, but none were so dear to her as the tragic figure of David Rizzio or 'David le Chantre' as he was known by his fellow courtiers at Holyrood. Rizzio was from Turin, close to the Piedmont borders of France and Switzerland and within the boundary of old Occitania, the twelfth century origin place of the Troubadour and the romantic *chanson*. He was university educated, excelled at music and singing (his father taught music), and he was fluent in Italian, Latin and French. Having been employed in the court of the Duke of Savoy he not only had a thorough understanding of the nuances of palace life, he was a 'merry fellow' with great charm and personal appeal. Rizzio's fate was sealed when we he was selected to be one of a number in a diplomatic party sent on a quest to Edinburgh to secure an agreement from Mary that she would be represented at a Catholic conference on reformation; a more subtle, secondary part of the mission was to persuade the queen to accept a Spanish duke as her next husband. The mission failed on both counts, but the twenty-eight-year-old Rizzio stayed on in the chilly, northern city to see what opportunity might come his way. Chance came when he was chosen to fill a vacancy as fourth bass in the Cathedral choir. Mary spotted him singing in a requiem mass in December 1561 and by January he was employed in her household staff, one of the two hundred and forty courtiers mainly recruited from France and Italy.

The nineteen-year-old queen had 'a charming, soft singing voice,' played the lute well with her 'long white fingers' and had a romantic passion for music and poetry. When Rizzio sang, he had a 'deep, attractive voice' but his unique selling point was that he knew the troubadour *chansons* of old and he sang to Mary love songs that pulled at her heartstrings in the old Occitan way, reminding her of her childhood in France. Rizzio composed many ballads too; just one fragment of a composition remains, originally sung in

Italian. Here is the English translation - it has a very modern tone, and is typically troubadour:

> What is the power that the world calls love?
> Bitter if known, worse when he is thine own
> When you are in his power, he will prove
> Child or tyrant, you are before him prone,
> Is not this felt by those his talents rue,
> I tell you, and my words are true,
> If you should live a thousand years or so,
> Love's born of leisure, and desire,
> Feeds on sweet thoughts, and fair words won,
> Is made a god, by those who feed his fires,
> Some die for him, others he keeps in
> Shackled locks and chains.

In his essay on poetry and music published in 1778, the poet and philosopher Dr James Beattie refutes what was at the time, common opinion that Rizzio was the composer of a body of songs inspired by the Lowlands, 'the Arcadia of Scotland.' Songs which took their names from 'the rivulets, villages and hills, adjoining to the Tweed near Melrose…all these songs are sweetly and powerfully expressive of love and tenderness and other emotions suited to the tranquility of pastoral life.' But Beattie believed, 'The style of Scotch music was fixed before his time' and that, as a foreigner, and 'a man of business' Rizzio could not have 'acquired or invented a style of music composition so different in every respect from that to which he had been accustomed in his own country. *Melody* is so much the characteristic of the Scotch tunes,' whereas, '*Harmony* was the fashionable study of the Italian composers' during Rizzio's time, and 'too closely attached to counterpoint.' Beattie attributes the rise of idyllic pastoral song as coming from 'the men who were real shepherds' but he goes on to admit that 'Rizzio may have been one of the first who, perhaps, made collections of these songs; or he may have played them with more delicate touches than the Scotch musicians of that time; or perhaps corrected the extravagance of certain passages; for one is struck by the regularity of some, as well as amused with the wildness of others – and in all or any of those cases it might be said in truth that the Scotch music is under obligation to him.'

During Rizzio's first summer and autumn in Scotland, Mary made a progress from Holyrood Palace to Stirling Castle, up to Perth, and to Aberdeen, staying at Glamis Castle and the now ruined Edzell and Dunnoter castles along the way. After resting at Aberdeen, they continued west to Lord Atholl's home at Balvenie and on to Elgin and Inverness. All in all, the royal suite was on the road from the 10th August to the 21st November. The following summer the Queen toured the west of Scotland, from Holyrood to Glasgow, Paisley, all the way up to Inveraray and down to the lowlands of Dumfriesshire. According to David Tweedie, author of *David Rizzio and Mary, Queen of Scots: Murder at Holyrood* as one of the party in Mary's progresses Rizzio 'came to know the great clan chiefs' and grew to love 'the hills, moors and peaty smells of his mistress's country.' What could be more conducive to the harmony of new friendship than sharing a song? In this way, perhaps Rizzio's expertise in Italian polyphonic harmonies entered the musical waterways of Scotland, as Dr. Beattie suggested, and helped to develop what has become known as traditional Gaelic harmony; which makes a wild connection between David Rizzio and the Carter family across time and space.

With the Union of Scotland and England, the golden age of Scottish ballads came to an end. Where it had once been acceptable for the Scottish middle-class ladies to learn traditional ballads from rural peasant women, there was now a new English social awareness in accordance with their station in life. But just as class-consciousness invaded Scotland, so the Scottish spirit invaded England. With the 1745 Jacobite rebellion fading into history and a political need for a unified national consciousness, Scottish melodies were suddenly all the rage. With song books such as *The New British Songster* first published in Falkirk in 1785, there was a concerted effort to patronise 'British' art forms, both to create a coherent 'British' culture and to safeguard the aristocracy from Gallic infection and, later, from the dangerous ideas of revolution taking place just across the English Channel. In London especially, old Scottish melodies were heard in 'private homes, pleasure gardens, and even concert halls' as part of a national campaign to bring Scotland into the fold. Particular emphasis was placed on the importance of love, family and a respect for nature that the music conveyed and how British national identity would do well to draw on the strength and continuity expressed in the stirring purity of its pretty airs and the sound of the bagpipes. It also filled a vacancy for a nation that seemed to have no music of its own. England had, in fact, a

great catalogue of its own regional folk songs that represented the lives of ordinary working people. Not only were they of little interest, they were, frankly, unacceptable in middle and upper-class drawing rooms. Scottish ballads, by contrast, were found to be *charming*. To English ears, Scottish folk music was slightly removed and exotic, and possessed a more beguiling melody and harmony.

A good example of this melody and harmony could once have been found in the old textile communities of the Outer Hebrides. Here, centuries-old working methods of coordination and synchronisation remained intact and secure against any attempts at modernisation until well into the twentieth century. For the women who gathered, spun and wove the wool grown on the Isle of Eriskay, their ritual of song was not just a tradition passed down from mother to daughter, but was the oil in the engine of their industry. Some footage exists of the ladies at work on the isle in 1934 and a narrator describes the scene, 'Music is in the soul of these people and it is as natural as talk; there are songs of weaving, songs of spinning, songs for carding, songs for the crottle gathering, traditional and melodious as only such a people could make, living as they do in a land where the errant voices of the wind forever whisper.'

Playlist:

Lads of Alnwick – traditional, Kathryn Tickell
Ae Fond Kiss – Robert Burns
Jennifer – Eurythmics
Ivo – Cocteau Twins
Lady Eleanor – Lindisfarne

2
The Unstoppable Spirit

When you think of a typical Presbyterian, the image of a harsh ascetic, disciplinarian seems at odds with Celtic largesse and love of song. But it was within the Celtic population that Presbyterianism developed, launched in Scotland by the Calvinist John Knox [1502-1572] in protest against the profiteering Catholic Church. By the late sixteenth century Scotland had been 'saved' by Calvinism. Knox was a zealous new broom who swept away Roman Catholic complacency, nepotism and greed. He had an especially powerful influence on the Scots of the southwest where Presbyterianism took hold, persuading them to connect with their individualism, to embrace education and to trust in Jesus, not their priest.

Truly a revolutionary, Knox empowered the people to do something previously unthinkable - to sing their direct praises to God. It began with John Calvin's notion that it should not just be the clergy who may chant their worship but that the entire congregation should be permitted to make vocal contact with the Holy Spirit; not just through prayer, but by singing psalms, too. The Lowland Scots congregations were generally illiterate, so Knox advocated using a simple, repeatable melody with a precentor (meaning 'one who sings beforehand') singing out the lines of a psalm and the congregation then repeating the line *a cappella*. 'Lining out,' as it became known, was devised by the Kirk to create the purest form of word-based worship. But it also gave the precentor the freedom to improvise a melody, and for ordinary individuals to sing with feeling to express a divine connection with God. I'm trying to imagine how that first collective voice must have felt for the people of the Kirk in the 1560s. Group singing gives us goosebumps with its power, and the first time worshippers heard themselves sing, in spite of, no doubt, the initial cacophony of trying to stay in tune, must have been extraordinary. That they sang in their native Gaelic rather than in Latin gave their singing a lilting beauty that informed the melody in turn, and became a communal sound of relief, protection and comfort.

Under Catholicism, pastoral care of this 'hard-faced, thick-palmed' farming community had been neglected. The Presbytery, otherwise known as the council of Elders, set to lead by example and saw that it was not just the Kirk that need reformation, but also the people themselves. In the hands of the new ministers, morality was run like a tight ship, and those who had indulged in 'swearing, breaking the Sabbath' or in 'fornication, drunkenness' and 'uncomely gestures' were put before the Session of the local Kirk to atone for their sins. The omnipotence of the new moral tone had such an effect, that the English traveller William Lithgow noted when touring the Lowlands in 1628, 'Galloway is become more civil of late.' But religious dogma cannot completely override hundreds of years of genetic impulse and cultural conditioning. After centuries of border raids and intermarriage, the Lowlander bloodline was a mix of Anglo Saxon, Norse and Norman, together with a smattering of Flemish; yet they retained a Celtic identity, defined by the ability to scrape a living from the poorest of soil and by their lack of loyalty to national institutions. These people were tough, tight and handled hardship with a practical stoicism.

In 1899 Henry Grey Graham published *The Social Life of Scotland in the Eighteenth Century* in which he gives a pretty harsh account of what life was like in the west Lowlands in the early 1700s. Dumfriesshire and Galloway he describes as a treeless landscape of 'bleak and bare solitude' and barren hills of boggy ground and heather where cultivation amounted to 'dirty patches of crops.' Of its inhabitants, he paints a grim portrait. Their speech was 'uncouth;' they lived in hovels and were dressed in rags. The Lowlands were remote and all but road-less and its harsh conditions created a strong sense of community. As a result, the Kirk were unable to fully suppress the few pleasures the people indulged in to forget their lives of poverty and squalor. Their high days and holidays 'were accompanied by roistering and drinking' Grey Graham tells us, 'at a christening there was much, at a funeral there was more.' On Fastern's E'en (Shrove Tuesday), Hallowe'en, All Saints Day and fair days, 'they had their gatherings in the evening…with music, singing and dancing.' But it was on monthly 'moonlight nights they held their favourite meetings in barn or cottage, called 'Rockings,' when young women brought their "rocks and reels," or distaff and spindles to where young men assembled, and to the accompaniment of the spinning of the wool and flax, the song and merriment went round till the company dispersed, and girls went home

escorted by their swains, who carried gallantly their rocks over corn-rigs and moor.'

As time passed ''rocks' were no more used, and spinning wheels had taken their place, still by their familiar name of 'rockings' were these merry social meetings called.' Of course, the Kirk had an eye on any men and women caught in the act of dirty dancing. But Graham explains that 'However the Kirk might threaten and punish, the people danced defiantly: for to dance 'promisky,' as they called it, was their one great delight.'

Playlist:

Good Rockin' Tonight – Roy Brown
Rocks – Primal Scream
Tennessee Rock n Roll – The Shakin' Pyramids

3
Sing me a story

Throughout much of the sixteenth century, the Gaelic clans of the northern territories of Ireland had been a fluctuating threat to the stability of England's Protestant monarchy. The city of Dublin had risen out of the most fertile lands on the east coast and had been in the control of the Anglo Normans since the twelfth century, but the north was still fervently Irish and Catholic. As such, it was vulnerable to co-option by the Spanish kings as a staging post to invade England. For nine years the English armies skirmished with the Gaelic Lords of Ulster and with their defeat and their eventual flight to the Continent in 1607 they left a power vacuum in the Ulster province; or rather, to the advisors of King James VI and I, a fertile void.

A new plan was presented to the king, proposing how the northern territories and its key ports might be properly secured and taken into the Union's control. It was a move of political expansionism led by the Ayrshire estate owner Hugh Montgomery and the laird James Hamilton. They envisioned a new Ulster, one safely populated by compliant but hardy and adaptable Protestants drafted in from Lowland Scotland and the border regions of England. The newly acquired province would offer them enticingly cheap rents for land that, having lain fallow, was enriched and ready for cultivation; plus, it was neither too far to travel, nor too daunting a journey to cross the channel of the Irish Sea. Reassuringly, the new immigrants were to be allowed to come not just family-by-family but in groups of families to form ready-made clachans of cottages in the scattered sections of farmland marked for their arrival.

The exodus of Lowland Scots to Ireland marks the first, physical movement towards the development of British pop, for they took with them their folk songs, border ballads, their festivals and their superstitions. But with their leaving Scotland, they added a new tradition – the goodbye song, charged by a romantic sense of place that is so common in Scots and Irish poetry. The Lowlanders were leaving a landscape that made for harsh living conditions

but Scotland was their home. Saying goodbye to the land that shaped who they were set in their hearts a dreamy ideal and they carried their lyrical longings for the hills and streams of Galloway, Lanarkshire, Ayrshire, Inverness and Aberdeenshire into a culture that had an accord with its own.

For the Irish Catholics of Northern Ireland, there was a feeling of loss too, but for rather more bitter reasons; their lives having been upended by the imperialist power that Britain was to become. By order of King James, the land of Ulster was divided into Protestant and Presbyterian estates handed over to the London Guilds, the military and government officials, the Church of Ireland, and the English and Scots 'undertakers' who were expected to settle no less than ten families on their 1,000-acre estates. All those living in the six counties had to abide by English laws and customs and although in 1624 it was decided that Irish Catholics would be permitted to remain on 'a full fourth of the undertaken lands' it was only 'on condition of living in villages, going to church, wearing English clothes' and 'ploughing in English fashion;' otherwise, they drifted into the boggy, mountainous territories no one else wanted. The Plantation's ultimate quest was to remove the Irish Catholics from the Northern Provinces, but the reality on the ground was very different. The Scots and English landowners needed Irish hands to help work the land, and although the Irish Catholic and Scots Presbyterian tenants were communities at odds, in fact, they had much in common. They were poor, their farming techniques were similar by their lack of invention, and they were both looked down upon by the resident English.

Another mutual accord was a rare element that simplified life - the siren call of the folk tradition. Music transcends division; it is the sound of a spiritual vibration. People naturally gravitate to where music is and if someone is playing a fiddle, people will dance; in more modern times, if someone is playing a piano, people will gather round and invariably someone will start to sing. That's what music does. Distracted by an expression of beauty, joy or sadness, all is forgotten, even if it's just for a moment. Above all, those who are present are united. To express it in the words of the virtuoso Kentucky banjo player, Roscoe Holcomb, 'you pull the strings on some kind of instrument – a fiddle or a banjo, or something or other like that...and it draws the attention of the whole human race.' The Ulster Scots and Irish both kept the tradition of the *ceilidh*, or a session, as it's known in Ireland. In fact, they had been sharing the tradition for hundreds of years since the Irish Gaels invaded the west coast of Scotland to manifest the kingdom of Dal Riata in

the fifth century. It's a Welsh tradition too, they call it *noson lawen* and for the Cornish it's called a *troyl*. Its root comes from the word *cele*, which is old Irish Gaelic for 'spouse.'

On endlessly dark winter nights family, friends and neighbours gathered in someone's house for some 'yarning' - to tell living lore and folk lore, recite poems and sing ballads to pass the hours whilst keeping snug by the fire. For the illiterate, as the majority of the poorest people were, singing songs and telling stories were the only way to pass down their concerns, traditions, ambitions, defining news events and aspects of their culture; stories were mini mind travel for people who barely journeyed beyond the parameters of their village. Itinerant musicians and storytellers were welcome, too; in fact, anyone who wished to entertain or join in could be part of the *ceilidh* in the days before hotels and B&Bs, when a stranger with coins in their pockets looking for a bit of food and a bed for the night could fetch up at a home of similar social rank and not be turned away. The dead silence cried out for the sound of a human voice or a musical instrument to pierce it; the *ceilidh* turned what would otherwise be a long cold evening into one that was diverting and surprising.

Which is why, by the seventeenth century, the fiddler was central to a *ceilidh*. The fiddle migrated from Italy and arrived in Scotland towards the end of the seventeenth century, quickly becoming the portable instrument of the folk with its ability to convey sounds of joyous abandon and melancholy equally well. In the old, pre-colonial kingdom of Ireland the harpist was the God-like musician of noble standing in their own right (according to the ancient pre-Christian Brehon Laws); but in fact, the harp had been the most important instrument in both Scotland and Ireland since the eighth century - the harp image is carved in stones identified as Pictish relics in the north east of Scotland, while in Irish mythology, the mighty god Dagda carried a magical harp made of oak and embellished with jewels. Scots kings, Irish nobles and clan chieftains had a long history of patronising harpists and pipers. But in Ireland, under the colonising hands of the English Crown and the protectorate of Oliver Cromwell, the playing of these instruments was forbidden in an attempt to crush the spirit of the locals and their means of native expression. As a result, Irish music has since been almost political in its zeal to persist and define its nationality; for to ensure the sins of the past were paid for in the future you had to remember. The works of the eighteenth-century legendary harpist, Turlough O'Carolan still endure hundreds of years after his death. His

music was passed down through fiddlers and harpists, and over two hundred of his melodies are still played as an act of remembrance for the old country traditions. No matter how much the English administration tried, the Celtic traditions could not be suppressed. It still is an act of defiance to sing old songs and the newer, political ballads (such as Tommy Makem's 'Four Green Fields') in the pubs of Northern Ireland to spiritually repel the English invasion.

As the seventeenth century progressed, Puritans and Quakers joined the Ulster settlement, augmenting the community of the Protestant awkward squad at odds with the Anglican regime. Within the realm of this uneasy mix of denominations, the Ulster Plantation produced another great narrative song scenario, one that appeared in countless ballads and songs of modern times: the tragedy of forbidden love. There are no marriage records of the Plantation from the first arrivals in 1610 through to the last exodus to America in 1775, but, in spite of the natural mistrust between the Catholics and Protestants, simply down to sexual impulse and propinquity it is unlikely that romances between the two faiths never happened. The ballad 'Johnny Doyle' has strong ties to Ulster. It was collected in Donegal for a song book entitled, *Songs of Uladh*, published in Belfast in 1904 and its opening stanza sets up the idea of love that transcends religious differences:

> There's wan thing between us now, I frankly confess
> That I go to Meeting, and my true-love goes to Mass
> But for to go to Mass with him I'd count it no great toil
> And the world's round I would wender with my Seaghan og o Dubhghaill

Told from the viewpoint of a Protestant girl (most likely a Quaker or Methodist, by the reference to 'Meeting') and her Catholic lover, their parents forbide them to marry. The ballad has various versions with different endings – either the suicide of the young girl or her acceptance of a loveless union with someone of her own faith. It's another classic story song that transplanted from Ulster to the Catskills, before travelling down the Appalachian Trail into the southern states of America to add to the steaming brew of its musical pottage. The narrative song gave birth to some of the greatest songs of all time. There's a connecting line running all the way from 'The Twa Sisters,' ' Johnny Doyle,' 'Barbara Allen,' and 'Black Velvet Band,' through to a cascade of familiar hits: 'House of the Rising Sun,' 'Delilah,' 'Eleanor Rigby,' 'Stairway to Heaven,' 'Patches,' 'Space Oddity,'

'Billy, Don't be a Hero,' 'Hurricane,' 'Ode to Billie Jo,' 'Copacabana,' 'Emma,' 'The Killing of Georgie (Part I & II),' 'Hotel California,' 'X Offender,' 'Come Dancing,' 'Come Live With Me,' 'Love Vigilantes,' 'Fast Car,' 'The Ballard of Dorothy Parker' and 'Sign o' the Times.' Then there are the episodics: story songs with smaller arcs and fewer, if any scene changes, but with just as much of a compelling narrative. Songs such as 'Jolene,' 'Airport,' 'Down in the Tube Station,' 'Say Hello, Wave Goodbye,' 'Common People' and any number of songs by Squeeze and the Arctic Monkeys. Most especially, the narrative song is the blueprint of Motown.

In an interview with the songwriting triumvirate, Holland-Dozier-Holland – who between them they created a cannon of some of the world's finest, most sublime pop songs - Lamont Dozier recognized the reliable structure of a truly great pop song lies in its story-telling. Because, as with all great stories designed to help us understand the temptations, triumphs and failings of life, the listener wants to hear them again and again. Advising songwriters of the present day, Dozier explained, 'They need to realize that a song is a mini-story - with a beginning, a middle and an end. It has to have a complete, meaningful story. The song's story and theme have to be universal, so that listeners can identify with it.' A great melody is a gift from some higher plain in the songwriter's consciousness; it's so unfathomably hard to create a beautiful, original melody, it just has to be. But universality? That's the easy part – just choose from love, loss, co-dependency, temptation, pain, joy, confusion, disappointment and death; make it personal, make it specific and make it honest. Also, make it clear. The greatest songs of all time have their message or imagery writ large and upfront for all to see: 'My Way,' 'Careless Whisper,' 'In My Life,' 'Crazy' (take your pick from 1961, 1991 or 2006), 'California Dreaming,' 'She's Leaving Home,' 'Purple Rain,' 'Waterloo Sunset,' 'Satisfaction,' 'It's My Turn,' 'Street Life,' 'I Will Survive.' Their titles suggest a big idea and from the first opening lines, wallop! They plunge you into a narrative and keep the story bold, front and centre.

Like the Motown classics, Ulster Scots and Irish ballads are bound together by their themes of separation and loneliness. The Ulster Scots retained their feelings for the Scotland they left behind in song to create a folk-memory wealth of remembrance for 'The Bonnie Banks of Loch Lomond,' 'The Dowie Dens of Yarrow,' and 'The Gallowa' Hills.' For the Irish, their feeling of loss was the result of seeing their homeland scarred by chaos and

violence, and the reality that they were third-class citizens in their own country.

After centuries of guerilla warfare with the English armies, the Irish could neither own arms nor land. Catholic churches were taken over by the Anglican Church of Ireland and Mass, now all but illegal, was conducted in secret and in fear of the deadly work of the Priest Hunters. Oliver Cromwell loathed the Irish Catholics and in pursuit of a quashing a royalist alliance made up of old English Catholics and Protestants horrified at the execution of Charles I and Cavaliers who had fled across the water, he set about Ireland's inhabitants as he saw fit. The Interregnum resulted in the perishing of 616,000 people 'by sword, famine and plague' in the name of Cromwell's 'pacification' of Ireland with thousands slaughtered without mercy during the sacking of the east coastal towns of Drogheda and Wexford. By 1660, two-thirds of Ireland's land was Protestant domain, and any Catholics who survived were driven to the wild rocky bogs and granite mountains of Leitrim, Sligo, Roscommon Mayo, and Galway; a fitting domain for savages, as Cromwell perceived them.

The restoration of Charles II brought neither Catholics nor Presbyterians a reprieve from persecution. By the time the deposed James II tried to regain the throne and bring the whole of Ireland and England back to Catholicism, the majority of Ireland was under his control except for the rebellious north. English Protestants and Scottish Presbyterians were forced to flee the villages of Ulster and take refuge in fortified towns, the most well defended of which was Londonderry, the setting for the most famous siege in Ulster's history. Protestants converged in the town swelling the population from its usual 2,000 to 30,000. There they endured more than three months under lockdown, trapped within the city walls and surrounded by James's Irish and French troops. They fought back, nearly starved to death and held out until the English army and cavalry, commanded by the Earl of Marlborough in the name of William III, finally arrived at the eleventh hour to defeat England's last Catholic king, ending his dream of a unified kingdom of England, Ireland and Scotland.

Fourteen years later, a state declaration made it clear the Ulster Scots' hard fought loyalty to the English crown was all for naught. In 1704 a new Test Act, given assent by the freshly crowned Queen Anne, confirmed that all Presbyterian and Catholic rites were, in effect, illegal, including marriage ceremonies, baptisms and burial rites. Couples who did not comply and

married under non-Anglican rites were perceived to be fornicators; any children conceived by the same union were bastards. Without the Ulster Scots iron will and military grit the English armies might have lost control of Ulster, and England would have been forced to accept James II as their Catholic monarch. To be paid back with the ingratitude of the Test Acts that denied them any kind of civic status was too much. It proved to be a shortsighted move on the part of the English government, a perfidy that would come back to haunt Britain in the shape of the American Revolution. There, the British army faced defeat by soldiers rebelling against another king of England, and they fought for their new homeland with the same instinct of a Celtic warrior. All that anger had to go somewhere.

Playlist:

Watch: Martin Hayes and Steve Cooney, Doolin Folk Festival, 2018, YouTube
Johnny B. Goode – Chuck Berry
Stories of Johnny – Marc Almond
Jezebel - Sade
Johnny Come Home – Fine Young Cannibals

4

The Emigrant's Farewell

As soon as it became clear there was somewhere else for them to go, they left in their thousands. From the first major wave of 1715 until the final phase in 1775 around a quarter of a million people left the British Isles for America. Through this period, one hundred and fifty thousand people boarded ships leaving from the ports of Belfast, Derry, Newry, Larne and Portrush, the majority of them Ulster Scots. Reflecting on their grandparents' story, as community they must have believed that if they could have survived in a new, unknown country they themselves could do it again in another. This time the British colonies in America offered much more. Pressed by religious persecution and poverty, a few Presbyterians from Donegal had left back in the 1680s and had sketched out an Ulster Scots presence in Virginia ahead of the arrival of the thousands who followed. From the peak of the Blue Ridge Mountains one can see a bountiful version of Scotland and Ireland that for those settlers, the seekers and the banished had a beautiful familiarity.

The irony of the Ulster Plantation was that in the hundred years since its establishment it had become so successful it was deemed a threat to England's economy. The rainy hills of Ireland are ideal for sheep farming and Irish wool was sold cheaply on the London market. English farmers had been petitioning their monarchs to levy import taxes on Irish wool from the time of Henry VIII and in 1699 Parliament sought to suppress it. With the intention of developing Irish linen and strangling its wool trade the new Wool Act stated that Irish wool yarn and cloth could be exported to England and Wales only, and it was to be levied with heavy import duty. The ancient flax plant had been growing in Ireland since 1000BC, identified by vast patchworks of lilac blue fields, 'the colour of a summer sky' come late May. With its wet and mild climate Ireland was suited to every stage of linen manufacture, but for three hundred years its domestic production had been only of the 'ordinary type.' By the intervention of William III Ireland's linen industry was given a boost.

Picardy, a northern region of France, is known for its cotton and linen industry; the fine, lightweight closely woven cambric and lawn fabrics take their name from Cambrai and Laon in the Hauts-de-France. After the Edict of Fontainebleau of 1685 declared that France was no longer a safe place for Protestants, thousands of Huguenots fled to the Netherlands, including the wealthy linen manufacturer, Louis Crommelin, who's estate had been seized by the crown and its workshops destroyed. Crommelin met William, then the Prince of Orange, in Amsterdam and with the double benefit of populating Ireland with tens of thousands of French Huguenots and upgrading Ireland's linen industry, the new king invited the exiled linen specialist and his artisans to settle in Lisburn in County Antrim. Under Crommelin's direction, local farmers were shown advanced cultivation and weaving methods, and with his financial support and encouragement Irish linen became the highly desirable, international brand that it still is to this day. In fact, it was so profitable that they had to import flax seed from America, namely from Philadelphia, after migrating Quaker colonists had introduced the crop to the intensely fertile east coast. The toing and froing of flax imports and linen exports established shipping links between Ireland and the Quaker colony, enfolding the Atlantic Ocean into the Celtic story once again.

The Wool Act (which wasn't repealed until 1867) ensured the slow death of the Irish wool trade that had been thriving since the thirteenth century. It also sent the message to Ulstermen and women that their livelihoods were vulnerable to change over which they had absolutely no control. Land was now scarcer than it had been and once a lease expired it was available to whoever could afford to take it on. With the native Irish desiring to reclaim their land, at whatever the cost, families clubbed together to buy back a lease. There was no consideration for an Ulster Scots family that had dedicated their lives to replacing a dry-stone hovel with a substantial house, or increasing the value of the land in the hope of handing it on to their offspring. The lease was up, the price was higher and if you cannot pay then off you go. By the early 1770s Ulster's rents had reach a historic peak. In the village of Hillsborough, County Down rents had tripled in a generation and there were riots in protest at the absentee landlords' quadrupling of annual leases in Down, Derry, Tyrone and Armagh. Added to the rent hikes was a series of natural disasters that dogged Ireland during the eighteenth century. Droughts, crop failures, the Great Frost of 1740 that froze solid the rivers Boyne, Liffey, Slaney, Lee and Foyle (such was the brief novelty, an open-air ball was held on the Boyne,

complete with a large band as reported in the Dublin Evening Post). The famine that followed the Great Frost led to widespread starvation that killed hundreds of thousands of people. Outbreaks of dysentery, typhus, smallpox and sheep disease put further strain on rural communities. To those who survived, the idea of emigrating to America shaped up to be a very attractive prospect; especially as Scotland, now part of the Union, was an unwelcoming, Anglican alternative.

The Ulster Scots migrators left not just to find spiritual freedom, but in the hope of a longer, better life. Yet, they must have felt a churning uncertainty as they boarded the ships that were to carry them across an unthinkably vast, wild and wind-swept ocean, away from everyone and everything they knew. The goodbye songs of their Lowland forebears of two or three generations before triggered an art that was now carried out on an epic scale. So many songs and poems were written on the theme of goodbye to Scotland and Ireland that these emigrants turned the farewell song into a métier, with titles such as, 'The Scottish Emigrant's Farewell,' 'My Last Farewell to Stirling,' 'Jamie Raeburn's Farewell,' 'The Emigrant's Farewell to Donside,' 'Campbell's Farewell to Ireland,' 'McKee's Farewell to Ireland,' 'The Shamrock Shore,' 'Fare Thee Well Enniskillen,' 'Farewell Ballymoney,' 'The Parting Glass,' and in answer to all of these – 'Will Ye No Come Back Again?' and 'So Good To Be Back Home Again.'

At my nephew's wedding in Tynemouth in 2021, one of the many memorable moments I will keep forever happened at the reception. A song came on that everyone in the marquee, young and old, sang their hearts out to. It was Olivia Newton-John's version of John Denver's 'Take Me Home, Country Roads' and there it was: a beautiful moment that proved the sing-along spirit of the Celtic-American longing for home has endured for centuries and raises the love in all of us, because what else is love but a feeling of home. The heart-twisting themes of leaving and hoped-for reunions are in thousands of modern pop songs and they were launched into the world by the Ulster émigrés as they looked back at the land they knew as home disappear from sight forever. But it wasn't only from the Ulster Plantation that migrations took place. During the same period up until the outbreak of the American Revolutionary War, seventy-five thousand people sailed directly to the new colonies from the ports of Clyde and Solway Firth; further down the west coast, more than fifty thousand people left from the shores of Cumbria down to the Mersey estuary. The reasons these folks left were the same as those of

the Ulster Scots: the rural poverty, the inequality of land ownership and landlord absenteeism, only made worse by land enclosures, evictions and exploitative rent racking.

This *en masse* emigration from the British Isles took on 'a mania...an undulant fever.' They must have been high on the possibility, the gamble, the promise, and the hope of a chance to find a new life. After surviving the six-week sail across the Atlantic Ocean, they were ferried through Philadelphia by agents offering the easy purchase of fertile land to make their homesteads in the wilderness beyond; but unbeknownst to them, the Cherokee and Shawnee tribes would show them a whole new world of a people aggrieved by incoming trespassers. In fact, it was the discontent of the Native Americans that had instigated the pamphlet and broadside campaign back in the Ulster Provinces, advertising the prospect of religious freedom and most especially, *land* in the British colonies of America. This task of migration encouragement had been given to the Armagh Quaker James Logan by no less than the head of all Quakers in America, William Penn. The founder of Pennsylvania had been awarded the land by Charles II in settlement of a debt the monarch owed to Penn's father, and he invited Logan to be Provincial Secretary for the state; or, in other words, to act as land agent, to make a killing on the new fur trade shipping pelts back to Britain and to keep good terms with the Native Americans. Penn, like the true Quaker he was, had cultivated peaceful and fair financial negotiations and treaties between the southern Leni-Lenape tribes of Delaware and the new Quaker settlement of Philadelphia. But as years passed the settlement felt increasingly unsafe. It was entirely against their ethos to raise an army against anyone; a central Quaker tenet was that violence was not inevitable. But some kind of protection was needed as English, Dutch and Germans of various Protestant sects whom on Penn's encouragement continued to flood in and expand ever more westwards into Native American territory. The answer came from Logan, who remembered the famous determination with which the Ulster Scots had held their ground in the Siege of Derry. They would be new farm settlers, yes, but primarily they would be a ready army on the frontier edge of the colony to do the 'Indian' fighting for them. His thinking was smart and not a little engineering. The matter was agreed by the Pennsylvania parliament and a large area of land in what is now Lancaster County in south Pennsylvania was allotted for their arrival.

On their disembarkation, the Ulster Scots immediately ruffled the feathers of the colonists already there. As the Quaker Jonathan Dickinson strolled the

streets of Philadelphia marveling at the new influx, he witnessed, 'a swarm of people...strangers to our Laws and Customs, even to our language.' In 1717, after a summer of the Delaware River being 'crowded with vessels' from London, Bristol, Liverpool, Belfast, Derry, Carrickfergus, Kirkcudbright, Wigtown, Whitehaven and Morecombe, followed an autumn where the streets were full of people of an unQuaker-like demeanor, 'the men were tall and lean with hard weather-beaten faces. They wore felt hats, loose sackcloth shirts close-belted at the waist, baggy trousers, thick yarn stockings and wooden shoes.' As for the women, well, they must have had everyone in a fluster as their style was, 'full bodices, tight waists, bare legs and skirts as scandalously short as an English undershift.' Stubbornly proud and feeling unwelcome in Quakerland, they did not hang around in the city, nor indeed in Pennsylvania itself. The price for land with an abundance of game and chopping wood was cheap, but the attitude of the less 'respectable' immigrants, whose principal reason for leaving Ulster was poverty, was why pay for land when you can use it for free? In 1729, when Logan refused to issue any more parcels of land to the Ulster Scots for their 'audacious and disorderly habits,' they simply practiced 'frontier-squatting' instead. They headed out to the country to find this land of which they had been told, to clear the woodland, build their homesteads, create their own private world and to fight the Native Americans.

Those who left directly from the Highlands migrated under different circumstances. They suffered the same perennial burden of poverty but the defeat of Bonnie Prince Charlie at the Battle of Culloden and the Highland and Island clearances dismantled a centuries old Clan ethos, as Jacobite soldiers were sent to the colonies as indentured labourers. Some loyal to the cause left under their own steam and took with them the now prohibited Highlander culture and illegal tartan. After the Union of 1707 the Scots were as free as Englishmen to take legal advantage of the new developments in the colonies; plus, the British government was glad to see the back of the Scots rebels and encouraged their leaving by setting up a royal colony in Cumberland County, North Carolina, with many of them settling around Cross Creek and Upper Cape Fear. But up in the Western Isles the singular most frequent reason for people leaving Scotland were rent increases or, according to ship records, 'High rents and Oppression.'

In the late summer of 1773, Samuel Johnson and the young Scots lawyer James Boswell undertook a three-month tour of the Highlands and the Western Isles that coincided with the closing phase of Scotland's exodus.

Starting their journey in Edinburgh they travelled, via the tiny island of Inch Keith to St Andrews, Dundee, Arbroath and Aberdeen, then west to Inverness, down over the Highlands on horseback to Fort Augustus, then along through the stunning Glen Shiel to Glenelg and across the water to the Isle of Skye where they stayed for a month. They attended a country-dance at Armadale, on the southern end of Skye's Sleat peninsular. Recalling the evening, Boswell wrote in his journal, 'We had again a good dinner, and in the evening a great dance…which I suppose the emigration from Skye has occasioned. They call it "America."' Johnson was curious about the music, 'I inquired the subjects of the songs, and was told of one, that it was a love song, and of another, that it was a farewell composed by one of the Islanders that was going, in this epidemical fury of emigration.'

There must have been an atmosphere of desertion by the time Johnson and Boswell arrived in the Western Isles. Just a month or two before they arrived, in one single June day, Boswell wrote, 'between 700 and 800 people were reported to have left the port of Stornoway in the Outer Hebrides' (eight years later Jim Morrison's four times great grandfather, Alexander Morrison departed from that same spot to settle in Maryland). Throughout the month of June, '800 emigrants on the Isle of Skye completed arrangements for their voyage to North Carolina,' and 'on September 1,425 more were observed leaving Maryburgh in the western Highlands…a month later, 775 more were known to have left Stromness in the Orkneys.'

Towards the end of 1773 and for much of 1774 there was a media obsession with the evacuation to the Thirteen Colonies. *The Weekly Magazine, or Edinburgh Amusement* printed various pieces on 'the spirit of emigration which seems epidemic through Great Britain and Ireland,' followed by a series of monthly stories from March to October. *The Edinburgh Magazine and Review* produced two in-depth analyses, and the *Scots Magazine* painted a vision of romantic desolation, proclaiming that the emptied west of Scotland would become 'the resort of owls and dragons.' The most extraordinary scene of gothic desertion was envisioned by *Lloyd's Evening Post* with its publication of 'a short futuristic drama' set in 1974, in which two visitors 'from the empire of America' tour the ruins of London. They find 'empty, rubble strewn streets, a single broken wall remaining of the Parliament buildings, Whitehall a turnip field, Westminster Abbey a stable, the Inns of Court a pile of stones "possessed by hawks and rooks."' It was an apocalyptic prediction that Britain's population losses could never, ever be rebalanced and

that 'America will, in less than half a century, form a state much more numerous and powerful than their mother-country' – it took a bit longer than half a century, but nevertheless that last concern did eventually come true.

What did not come true was Johnson's fear for Scotland's culture, 'for a nation scattered in the boundless regions of America resembles rays diverging from a focus. All rays remain, but the heat is gone. Their power consisted in their concentration: when they dispersed, they have no effect.' But the power of light is more acute in a narrower concentration, and the heat remained. They kept their culture, their spirituality, their morals, and many elements of their 'time sanctioned ways of life.' Altered yes, but in many ways intensified. It was a conclusion that Johnson himself reached, when he wrote of 'whole neighbourhoods' who's 'departure from their native country is no longer exile. He that goes thus accompanied...sits down in a better climate, surrounded by his kindred and his friends: they carry with them their language, their opinions, their popular songs and hereditary merriment: they change nothing but their place of abode.'

Logan sort of achieved his aim. The Ulster Scots were indeed, he concluded ten years after his experiment, 'hard neighbors to the Indians.' But they were not as pliable as he had hoped or presumed. To Logan they were troublesome, disorderly, and their numbers kept growing. It seemed his plan had worked a little too well. The Quakers' great fear was the Ulster Scots would overrun them and become 'proprietors of the province.' They saw an unimaginable expanse of land 'unclaimed' or abandoned by absent landlords, grabbed it, cultivated it and kept on expanding. And they had high fertility – a census taken of the Appalachian backcountry in 1800 proved their rates of reproduction were 40% higher than the Delaware Valley; between five or ten children was not unusual, Walton family style. The process of squatting, cultivating, growing their families and moving onwards and outwards was idiosyncratic to the Ulster Scots. As Edmund Burke wrote in his *Account of European Settlers in America* in 1757, 'The number of white people in Virginia is...growing every day more numerous by the migration of the Irish who, not succeeding so well in Pennsylvania as the more frugal and industrious Germans, sell their lands in that province to the latter, and take up new ground in the remote countries in Virginia, Maryland and South Carolina. These are chiefly Presbyterians from the northern part of Ireland, who in America are generally called the Scotch Irish.' The Philadelphia administrators tried to bring the Scots-Irish squatters to heal and obey the law.

They turned up with sheriffs and officials to intimidate them into complying by burning down their cabins and they rode off thinking 'job done.' But no sooner where they gone, the cabins were simply rebuilt and life continued.

According to the folklorist Cecil Sharp, the people of Cumbria, Westmoreland, Durham, Northumbria and east and west of the Pennines in Lancashire and Yorkshire shared a rich, musical heritage with the Lowland Scots. They had similar ballads, traditional songs, singing games, dances, fiddling tunes and, in Northumbria's case, the Celtic pipes, and they lived the same border culture that blended a legacy of music making with their own distinct dialects. The immigrants from Ulster, Lowland Scotland and the northern counties of England made up 90% of the settlers in Appalachia. Given this majority we can conclude that the folk music of America's backcountry was truly the folk music of the British Isles. It was not just their numbers that dominated, but their cultural hegemony and this may be because of the symmetry of danger between the British borderlands and American backcountry. The backcountry was all but lawless and fighting with the Cherokee, Creek, Choctaw and Chickasaw continued into the early 1800s. In this contested territory the Borderers were not comfortable as such, but they were familiar with living life on the edge, raising large families and warrior sons. With each wave of immigration, they moved onwards south and to the west of Appalachia, along the southern regions of Ohio, Indiana and Illinois and edging the northern regions of Georgia, Alabama, Mississippi and Louisiana. By the sheer force of the Scots-Irish culture and proliferation their way of life dominated and became the very essence of southern living. Swedish, Finnish, French, Swiss and German immigrants heading west saw this capability in action and copied it. The borderer way became the backcountry way, for the sake of everyone's survival.

Playlist:

Blow the Wind Southerly – Traditional
D'ye ken John Peel? - Traditional
Homeward Bound – Simon and Garfunkel
Go West - Southern Death Cult
Sailing – Rod Stewart

5

The Folk Elite of Appalachia

In 1827, the Scottish naval officer, Basil Hall was travelling through the Carolinas when he heard his carriage driver sing, 'Should auld acquaintance be forgot?' He presumed the driver to be a fellow Scot, but on enquiry, 'to my surprise…I found he had not been out of North Carolina, though his feelings appeared nearly as true to the land of his forefathers, as if they had never left it.'

The music of the British Isles permeated everywhere south of the Appalachians. The migration to America allowed only the survival of the fittest. Fortune favours the brave, as the saying goes, and it took guts to start a new life in a strange land far, far away from all they knew. The stakes were vertiginously high. Self-pity would not have crossed anyone's mind for there was no luxury of wallowing when you had to build a homestead, stay alert to new danger, when food needed to be found daily and when you had to think ahead for your very survival; the kind of self-reliance upon which America was built. For those first settlers in the Appalachians their 'old-time' music and song were not just an emotional outlet but precious souvenirs of their lost homeland. They were a reminder of who they were and from where they had come; to sing a favourite old song or play a fiddle tune lifted the spirits and gave them re-orientation, and helped them to establish new homes in empty hills and mountains that, after the displacement of the Native Americans, were a cultural void. Over many years and many hundreds of miles along the Celtic trail, the preservation of their music developed what Seamus Heaney called a 'country of the mind.' Those Ulster Scots' themes of leaving and goodbye doubled down, distilled and intensified into a mystical feeling of longing that became known as the classic country 'lonesome' motif.

It is a rich inheritance that was understood by the celebrated fiddler Jim Brock, from Aliceville, Alabama. Jim was born in 1934 and started playing professionally when he was seventeen years old, reaching the heights of recording and touring with the old-time innovator Bill Monroe. With thirty years' experience as a master bluegrass fiddler behind him, in 1981 he heard

some tapes of traditional Irish and Scots fiddle tunes and realised how much they sounded like the music he'd been taught by his father and uncles when he was a boy. As did the musician and self-taught instrument maker, Arlin Moon. His family had farmed in Cullman County, Alabama since the 1860s and he kept alive the tradition of felling a tree, sawing it, planing it and whittling it down into a fiddle, banjo, guitar or mandolin. He, too, recognised the same fiddle tunes as being almost identical to the ones his father had taught him. Old-time, or 'hillbilly' as it became known, is a line up entirely of stringed instruments. You can hear a souped up, stripped-down version of the classic hillbilly band in Elvis' first single, the cover of Arthur Crudup's, 'That's Alright, Mama' with the spare arrangement of Scotty Moore on the guitar and Bill Black on double bass. It was the sound of Appalachia - Virginia, the Carolinas, Kentucky, Georgia and Tennessee - but it was not exclusively white in its development.

It is a little-known fact that enslavement was present in the Appalachians. At odds with its association with the flatlands of the plantation every county in the 'Mountain South' was touched by slavery, and although almost half of the region's population were landless and poor, still 18% of Appalachian households (compared with 29% of all southern households) owned slaves for working small farms, tending livestock, and mining. Surprisingly again, even before the Civil War there were more free African Americans living in the south than in the north. The census of 1860 revealed there were 261,918 free African American southerners, and 85% of whom lived in the Upper South – Delaware, Maryland, Tennessee, Kentucky, North Carolina and Virginia. These were the states most keen on manumission during the Revolution just under one hundred years before, first to bolster the British army and later the Patriots,' promising freedom to those who signed up for service. Although life was still precarious for free African Americans, some of whom had escaped from the Lower South by the Underground Railroad, the Piedmont country provided the same benefits for Affrilachians, as their descendants are known today, as it did the Ulster Scots. Nestled within the wooded hills was land that no one else wanted and it offered them seclusion to live as they liked in isolated shacks and small communities, which, for an African American in Antebellum America meant the bliss of escaping a world dominated by whites.

The meeting of West African and North European folk came about by the collision of two transplanted worlds both for whom music and song were an inherent part of their daily lives. For more than a hundred years they co-

existed side by side, then, sometime around the mid nineteenth century, polyrhythm merged with melody to make advances in music not seen since the late Middle Ages. An advance aided not just by their musical differences, but by what their cultures had in common. West African and Scottish cultures both held the belief that music making was incantation. The fiddle was mistrusted by the Catholic and Protestant clergy but the reformed Scottish Kirk took an especially dim view coming from the top down. John Knox had a hatred of dancing, channeled in the direction of his young ideological enemy Mary, Queen of Scots who, by more measured accounts loved to dance 'gracefully and becomingly' as she had been taught in the French court. Yet, to Knox dancing was the indication of a wicked character and the Kirk at large was keen to denounce fiddling as the work of the devil disordering people's souls with its inexplicable enchantment inducing them to wild, erratic movement. So, too, for the pipes that had migrated from Africa via the Basque Country, Brittany to Ireland and Scotland. The kind of fever and frenzy these instruments whipped up looked too much like satanic abandon to the fiercer Presbyterian.

In West Africa, similar notions of conjuration were once associated with *griots*, a hereditary group of troubadours who emerged in the thirteenth century. Many West African music traditions are communal – collective dancing, choral singing and sometimes the orchestrated percussion of an entire village. But the *griots* were different. *Griots* or *jeli* in Mande, were of the Mandinka oral tradition and like the Celtic bards, their entire *raison d'etre* was to remember. They were narrators of daily life, and by the power of the word they kept alive the history of the Mandinka's westward migration from central Sahara - the villages left behind, military victories and family trees; they retained and recited epic stories and poems, and sang songs accompanying themselves with lute like instruments. They were also warriors, diplomats, and advisors to court. In modern times, anyone can practice the traditional music of the *griot*, but in the Middle Ages and the early modern period to be a *griot* you had to be a boy and one born into a *griot* family. They were trained as apprentices by their fathers and uncles to memorise their tribal history, word for word, as a sacred oral chronicle from which they must never deviate (on pain of a 'High Curse' on their family for generations). There are *griottes*, too but since the male was preeminent, the *griots* played an instrument, typically a *ngoni* or *xalam* (both similar to the *akonting*) and

recounted victorious histories in spoken word, whilst *griottes* sang praise to their leader.

In order to fix the tribal history in his audience's imagination the *griot* used call and response, often by inviting them to sing along with him, or by posing a question to which the audience answered back, or he cued them to repeat a particular phrase. *Griots* offered themselves for hire, too, for a day, a week or a month, to sing praise and publicly declare the virtues of whoever had money to pay them. But there was a strange dichotomy in how *griots* were once positioned in society. For all that they were valued for their singing, genealogy skill and entertainment, there was a received mistrust of the *griot* and they were kept on the outside of society. In fact, in spite of their almost celebrity status within the tribe, *griots* were once feared. Superstition surrounding *griots* has since fallen away but it used to be believed that in order to play their instruments well *griots* had to have consorted with the spirits. That *griots* were rumoured to be in conversation with 'their divell *Ho-re*' is documented in the diaries of the Jacobean English explorer Richard Jobson, during his 1620 expedition up the Gambia River looking for gold. As he spent time in 'Mandingo' society he realized, 'There is, without a doubt, no people on earth more naturally affected to the sound of musicke than these people' and that the *girots* were, 'a perfect resemblance to the Irish Rimer sitting in the same maner as they doe upon the ground, somewhat removed from the company.' He goes onto describe the instrument they played, 'made of a great gourd, and a neck thereunto fastened resembling, in some sort, our Bandora.' Jobson noticed how their singing resembled 'much the maner and countenance of those kinde of distressed people which are among us and are called Changelings.' By his ear, Jobson interpreted their vocals to be a sound that had links to the underworld.

Clara Smith iconized the fiendish with the blues when she released 'Done Sold My Soul to The Devil' in 1924. The folklorist Alan Lomax believed this superstitious link had an entirely European source, one rooted in an ascetic Presbyterian view of music and dancing, and by which every African American 'blues fiddler, banjo picker, harp blower, piano strummer and guitar framer' measured himself as 'a child of the devil.' Yet it was twin superstitions, one borne of the myth of the spirit teacher, the other of constraint, that coalesced in Christian America's psyche the idea that any music that was neither a glorification of God, nor considered 'high art' was indelibly marked as 'the devil's.'

Call and response is found in different cultures the world over. But in 2003, the jazz musician and Yale professor, Willie Ruff made a case for what he called 'A Co-joining of Ancient Song.' Ruff is not only an accomplished French horn and bass player – he had a long career opening for Duke Ellington, Louis Armstrong, Miles Davies, Sarah Vaughan and Dizzy Gillespie – he is equally passionate about the history of jazz, the people who made it and from whence it came. Now in his nineties, he once travelled the world telling audiences of the roots of jazz, yet Ruff always felt there was a 'void' at the heart of the story: the origin of the 'dirge-like and emotional' lining out psalms that were sung at his Baptist church when he was a child. It's a fascination that has stayed with him since he first heard the *a capella* song at his local church in Alabama that struck him as the most mysterious, soulful and dynamic sound he had ever heard sung by a congregation that only knew marginalisation and discrimination, as Ruff marveled, 'we're talking about truly the people on the bottom, here, and yet they sang like they had more power than the president of the United States.'

His curiosity intensified when he was told that the now extinct Baptist lining-out he remembered was, in fact, alive and well in a Black Presbyterian church near his home. Ruff had always remembered his old friend Dizzy Gillespie's claim that in a few hidden away churches in the south African Americans worshipped in Gaelic which now made him wonder, had white Presbyterian churches the same practice? He then started to trace the journey of Highlanders and Hebridians who settled in North Carolina in the 1700s, many of them Presbyterians who went on to become plantation owners. The African American enslaved were often compelled to become Christians and to make irregular visits to church. But these visits took on a whole new meaning when they found they were briefly reunited with beloved family members from another plantation, from whom they had been cruelly separated. Their prayerful moaning and singing of psalms were not just a release of the deep and heavy pain they carried but also an expression of joy at being physically reunited with loved ones and friends, forming powerful, aural bonds in these precious moments of unburdening. At high times of harvest, plantations helped out on each other's farms and Baptist enslaved were ordered to fall in with Presbyterian. Whilst working together in the field, the Baptists picked up the Presbyterians' psalms and chants sung to placate the overseers and to help themselves get through the hellish parts of day.

After consulting with his colleagues at the Yale Divinity Department,

Ruff learned that lining out had all but died out in Scotland, and in England to where it had spread, but that it could still be found in the furthest reaches of western Scotland. Ruff duly flew to the Outer Hebrides and visited its remote churches, and there it was – line singing in Gaelic and, by his musical intuition, the source of the spirituals that were the returning ghosts of his childhood fascination. In Ruff's own words, 'I was struck by the similarity, the pathos, the emotion, the cries of suffering and the deep, deep belief in a brighter, promising hereafter.'

<center>***</center>

Back in 1940, the composer, musicologist, folklorist and Fisk University lecturer John Wesley Work III acknowledged the similarities between Black and white spirituals, but he explained how the two forms diverged to create a new catalogue of African American religious song. It came about with the help of something Work calls 'Afro-American creative folk genius' and he gives an example of this adaptation in action, using the late nineteenth century hymn, 'Praise to the living God':

> Praise to the living God
> All praised be his name
> Who was, and is, and is to be
> For aye thro' the same
> The one Eternal God
> Ere aught that now appears
> The first, the last, beyond all thoughts
> His timeless years

The same hymn re-created by African American singers shows the words edited into phrases that became 'shortened and strengthened' by 're-assembling special words' or 'phrases of interest' into what Work calls 'a more satisfactory musical creation':

> God is a God
> God don't never change
> God is a God
> And he always will be God

As you can see, the elaborate phrasing of the first version is remodeled in

the second version to give a feeling and shape that gives precedent to the rhythm. For the source of this precedence, we could look to West African folk songs of the Yoruba people of southwest Nigeria, which can only be described as a punchy delight. In 1921, a *Daily Telegraph* critic reviewed a recital by the tenor Roland Hayes, highlighting his rendition of a Yoruba folk song, describing it as 'so concentrated as to be epigrammatic' compared with the 'verboseness of Western European ballad literature.' For anyone not familiar with the language, you can hear Yoruba at the opening and the end of another Lamont Dozier masterpiece, Odyssey's cover of 'Back to My Roots.' The rousing chant was a perfect fit for the song's finale while at the same time it revealed the line patterning, backing vocals and swing that created the blueprint of popular modern song. Africa's regional musical specialties formed the foundation of how the music making of the enslaved played out after their removal to America. To perpetuate the memory of their homeland it was necessary to encompass cultures with different songs, rituals and traditions, and their ways of making music merged and intermingled to create a new, united African American sound.

Old America's first established music held at its core an instrument of West African creation – the banjo. The precise origin of the banjo is unknown. By the fact that African peoples were taken by force from their homelands with nothing in their possession except their folk memory to live, to a large extent, undocumented lives in America, it probably will always remain so. But we can start by looking at Senegambia, a vast region that is home to people of Mandinka, Wolof, Fula, Serer, Lebu and Jola heritage, for it was they who were the first Africans to arrive in significant numbers in the colonies. Overall, Senegambians accounted for 24% of Africans who were removed to America, but during the early period of rapid expansion of the trade, from 1750 to 1775, as many as approximately half of the enslaved were from Senegambia, with their presence as high as 53% in Georgia on the eve of the American Revolution.

The history of the people of Senegambia communing with Arabian culture beyond the Sahara influenced its musical evolution, and its traditional music is played on myriad stringed instruments of Arabian origin. As such, a strong contender for the banjo's beginning is the *akonting* that might have travelled to America in the memories of the captured Jola people. It's around a metre long, with a dried-out gourd cavity covered with calf or goat leather, three gut strings tied to a bamboo mast and a floating bridge. In the right hands

it makes a beautiful low, warm, restful sound. In America, an *akonting*-fiddle mishmash was assembled using available resonators such as discarded biscuit tins, along with opossum hide and metal strings that produced that bright, banjo twang. A fingerboard was added, along with fiddle style tuning pegs and it was played with the classic thumb and middle finger 'clawhammer' style, derived from an old *akonting* technique. Yet, we could also look to the Wolof people for the source of the banjo. The *xalam* is an instrument specifically of, and central to, the Wolof tradition. It has up to five strings and the kind of music played on it resembles early American banjo music. It also has a musical structure that might offer another clue as to the origins of the blues. It's called a *fodet*, and it has a word pattern of AAB song text - make a statement, repeat that statement and resolve it on the third.

But then sightings of other possible contenders were made further down the west coast in Sierra Leone. The Irishman Nicholas Owen, who spent five years as a resident slave trader living close to the Sherbro river estuary wrote in his memoir of 1746-57 of an instrument called a 'bangelo.' Some decades later in 1791, an English woman named Anna Maria Falconbridge wrote in her diaries of spotting an instrument 'resembling our guitar' that was locally called a 'bangeon' in Granville Town, the first free settlement for previously enslaved Africans. It's all inconclusive. But one thing is for certain, as the Benin born Olaudah Equiano wrote of his fellow Africans, 'We are almost a nation of dancers, musicians, and poets.'

As you explore all the west coast's musical traditions, you can find not just the origins of the banjo, but the key building blocks of what became America's popular music. Hints of the blue note can be found in choral singing all the way down the west coast, from Senegambia to the Congo. But for the Akan-speaking people of Ghana, it has a special accentuation. Akan is a 'pitch tone language,' wherein a single word, or even just a syllable may have different meanings depending on its pitch - high, middle or low – with rising emotion expressed by falling intonation. In the Congo Angolan region, the choral singing of the Bantu people has highly complex polyphonic orchestration of great depth and warmth. As Robert Palmer explains in *Deep Blues: A Musical and Cultural History of the Mississippi Delta*, within the Bantu 'there are local traditions of exceptionally refined vocal polyphony; sometimes solos, duets and trios emerge from a dense choral backdrop that pits two sections of singers against each other' with 'sudden jumping into the falsetto range.'

In 1578, the Portuguese merchant Duarte Lopez discovered what is, to my mind, is at the heart of the magic. He sailed from Lisbon via Cape Verde to the Kingdom of Congo and after spending time within the King of Congo's royal court in the city of Mbanza Kongo he observed how, 'marriage and other feasts' were celebrated by 'singing love ballads and playing on lutes of curious fashion.' He goes on to say, 'The players touch the strings in good time, and very cleverly with the fingers…by means of this instrument they indicate all that other people would express by words of what is passing in their minds, and by merely touching the strings signify their thoughts.' There it is. The origin of the blues and onwards, all those guitar breaks that express the emotion of the singer beyond the power of words - or to put it another way, *while my guitar gently speaks*. West African musicality gave the power of talk to all manner of instruments, not just strings, but animal horns, drums, flutes and xylophones. It was a sensibility that was to make jazz one big, terrific conversation with a leading speech, asides, supporting elaborations and in traditional jazz pieces, a delightful general agreement of all the various voices at their close. It's why the best of jazz could sound as succinct as Harold Pinter, as eloquent as Oscar Wilde, or as moving as Arthur Miller.

The drum is fundamental to life in all regions of Africa for rituals and ceremonies, to celebrate life events, for music making, dancing, and military maneuvers. But in the British colonies the beat of a drum was the sound of retribution. It was remembered as a call to arms and a celebration of freedom during the Stono Slave Rebellion of South Carolina in 1739 and in the aftermath, the instrument was prohibited for more than a generation, both the possession of and the use of. Instead, the enslaved persisted and used a percussive instrument that they could not ban – their bodies. Hand clapping, body patting and feet stamping, all pre-cursors to tap dance, kept African polyrhythms alive and, it has been suggested, added a fresh attack to the syncopation of their fiddle playing. There was little by way of entertainment for the early plantation owners; dancing was the singular merriment for which the fiddle and the fife were essential instruments. By the time America declared its independence, enslaved African Americans accounted for more than half of the fiddlers in the upper southern states. String bands were in demand for parties, their repertoires a mix of reels and cotillions, and they improvised new music by blending fiddle tunes from the British Isles with African American lyrics, accents and syncopation. George Tucker described a typical dance in his 1825 novel *The Valley of Shenandoah* that captured rural

life in Virginia at the end of the eighteenth century: 'In the adjoining house, which had once been a tavern, was a long room, where the young people were exercising their limbs in dancing reels, consisting of four, five, and even six couples, in which no regard was made in suiting the figure to the tune, though it must be admitted they kept admiral time with their feet. Two fiddlers, and one fifer, all black, rent the air with their enlivening sounds; and when they first struck up a favourite Scotch air, they set the whole room capering.'

In their private time, the fiddler was a member of the folk elite and the king of the Saturday night frolics. On these precious nights off, they were orchestrators of diversion who provided for their fellow enslaved a reason to sing, dance and laugh. They would turn up like superstars dressed in attention grabbing outfits of 'bright-hued, long-tailed coats, accented with gilt buttons and fancy shirts' and take centre stage before an audience that was ready and waiting to dance and, for a few hours, try to forget their lives of captivity. With the whole night's entertainment depending on their energy and skill, they proved that their costume was merely the opening introduction to their ability to create a night to remember, safe in the knowledge they and the revelers would be left alone. On quieter days, they were the keepers of tradition, passing on fiddle tunes, dances and folklore to their children, as well as songs remembering past generations of relatives left behind in 'Africa – Dat Good Ole Land.'

African Americans played as much a part in preserving and perpetuating the oral tradition of English, Scots and Irish ballads as the European southerners. The old narrative ballads were repeatedly sung in the 'great house' and were picked up by the enslaved who sang them to their children, often creating their own variants. But they were just a small portion of songs created or adapted by the African American enslaved. By the beginning of the 1800s, work songs for the field, for flailing, grinding, spinning, weaving, loading and rowing provided rhythm for regulation or relieved the boredom of repetition, erroneously giving the impression they were happy in their work. In the cotton fields singing was frequently by order, as Frederick Douglass remembered, 'A silent slave was not liked, either by the masters or overseers.' Singing was 'a means of telling the overseer, in the distance, where they were and what they were about.' The cotton field teamsters sang at all times - by command, by natural impulse, from exhaustion and emotion, most usually in sorrow 'as an aching heart is relieved by its tears.' The strength of their collective sound helped the individual African American find their voice

again, to lift it up, charge it up and shoot it up into the sky in a rainbow formed of anguish and divinity, to claim the sonic space and root their voice in America. With Emancipation, that bewildering period of freedom with sanctions, the collective became personal, the subject matter earthly not heavenly, and the solitary African American, without the constant presence of their fellow field workers, found the response to their call in a guitar.

Playlist:

Strange Things Happening Everyday – Sister Rosetta Tharpe
Tighten Up – Archie Bell and the Drells
The Devil Went Down to Georgia – Charlie Daniels Band
Death Letter Blues – Son House
Na Rua, Na Chuva, Na Facenda – Hyldon
California Soul – Marlena Shaw
Night Shift – The Commodores

6

A Brethren of Oddities

That wherever else I may be a stranger, that in England I am at home
Frederick Douglass, Farewell speech, 30th March 1847

It's well-told, pop culture legend that Jimi Hendrix became a superstar simply by catching a plane to Britain. In 1966, in the four years since he had left the army his career in the music business had been patchy. When Linda Keith famously spotted him in the Cheetah Club in New York he was a frustrated, under-the-radar, jobbing guitarist. Keith later took Chas Chandler, ex-drummer of the Animals and by that time, a talent scout and manager, to see Hendrix play in Café Wha? in Greenwich Village and he intuited that Hendrix might be better appreciated in the London that London was in 1966 – the Beatles had just released Revolver, Cream and Led Zeppelin were materialising and an atmosphere prevailed where the virtuoso guitar player, particularly an African American virtuoso guitar player would not just be embraced, they would be cherished and revered.

Joe Boyd, the Boston born, Harvard educated tour manager, record producer and all round behind the scenes person of influence captures this London perfectly in *White Bicycles: Making Music in the 1960s*, a rivetingly clear-sighted account of events in the music world in England and America. The scene is the Hammersmith Odeon, June 1964. The concert is a caravan tour of the Animals and various American artists under Boyd's care, including Chuck Berry who is on stage doing his duck walk. This drives the audience wild and a mass of screaming teenage girls leave their seats and rush to the foot of the stage where Boyd had been observing the show and was now besieged by over excited fans. A split second later, he spots John Lee Hooker (who happened to be in the UK for a club tour) quietly watching in the wings and in an involuntary burst of excitement Boyd blurts out, 'Hey, that's John Lee Hooker.' The girls cast around yelling, 'John Lee? John Lee? Where? Where?' As soon as they spot him, they start chanting his name and 'half the

hall – hundreds of kids' join in. A slightly miffed Berry invites Hooker out of the shadows to join him on stage to acknowledge his fans. 'In that moment,' Boyd recalled, 'I decided I would live in England and produce music for this audience. America seemed a desert in comparison. These fans weren't the privileged elite, they were just kids, Animals fans. And they knew who John Lee Hooker was! No white person in America in 1964 – with the exception of me and my friends, of course – knew who John Lee Hooker was.'

The 1960s seemed like a musical turning point for the UK, as Black American artists routinely flew across the Atlantic to perform, filling Britain's concert halls with the evocative sound of Chicago and the southern states, and stimulated something reciprocal in young Britons. Their influence seemed brand-new and a shining landmark in Britain's cultural development. Yet, African American performers had been coming to Britain for more than a century before. Whilst they still encountered racism, colour bars in hotels, and trade union discontent along the way, the fact is, like most of northern Europe, the atmosphere in Britain was altogether more agreeable for African Americans to fulfil their career potential than it was at home. It was by the sheer courage of one Ira Aldridge and his unshakeable faith in his creative ability, and following on, by the ambitions of unfamiliar names such as Samuel Morgan Smith, James A. Bland, and The Bohee Brothers, to the legendary Paul Robeson and those bringers of the blues, Josh White, Big Bill Broonzy and Muddy Waters, that Britain became a natural choice for Black American performers; either to boost their income and their international reputation, to seek refuge, or even just to feel appreciated, all the while giving Britain the benefit of a fresh, invigorating musical influence.

Robeson first came to Britain in 1922 for a national tour of *Voodoo* after the play had transferred from Harlem. Reflecting in his autobiography *Here I Stand* on why he decided to remain in England to pursue an acting career, he explained, 'My reasons were quite the same as those which over the years have brought millions of Negroes out of the Deep South to settle in other parts of the country. It must be said, however, that for me London was infinitely better than Chicago has been for Negroes from Mississippi.' Contemplating that if someone should ask him why he was not at home where he belonged, he would have replied, 'Go *back* – well, what in heaven's name *for*?' He did return to America. He felt the call to fight for the civil rights of his fellow African Americans too strongly. But he acknowledged how his perception of the world had developed during his time in Britain and further, presented him

with a clearer vision of his purpose back home, for 'It was in Britain – among the English, Scottish, Welsh and Irish people of that land – that I learned that the essential character of a nation is determined not by the upper classes, but by the common people, and that the common people of all nations are truly brothers in the great family of mankind. If in Britain there were those who lived by plundering the colonial peoples, there were also the many millions who earned their bread by honest toil. And even as I grew to feel more Negro in spirit, or African as I put it then, I also came to feel a sense of oneness with the white working people whom I came to know and love.'

In among the endless compares and contrasts between the two nations, an advantage Britain's young musicians possessed over their American contemporaries was the liberty to absorb the exalted dexterity of African American expression and to mix it in with their own invention without fear of committing what would be in some parts of 1960s America, a social transgression. Keith Richards, Jimmy Page and Eric Clapton were free to pick up Black American music and translate it into their own British version because none of the record-buying public in Britain gave its colour or race association a second thought, it was just a thrilling new sound. Jonathan Gould goes so far as to say in his Beatles' biography *Can't Buy Me Love* that John Lennon's discovery of Little Richard in 1956, via an early Dutch pressing of 'Long Tall Sally,' 'gave him access to sources of musical energy that even Elvis couldn't tap.' Richard's energy dropped like a bomb in every performance and the Beatles were free to emulate it. It was one of the generators of 'Beatlemania' and it's why, on each and every listen, their early songs infect you with their addictive exuberance, high pitched oo's and all. Britain's new Caribbean community brought with them their calypso, ska and reggae that in a few years bubbled up to form new sounds in rhythm and brass in British pop, but so strong was the association of African Americanism with the gift of vocal supremacy that few black British artists had any success until the latter part of the 20th century; the music industry was fixated with the idea that if it wasn't a Black *American* sound, it wasn't real.

But let us return to the first person of colour to step onto the British stage, the one who made the same journey Jimi Hendrix was to make on the promise of career progress that was impossible for him to achieve at home. Ira Aldridge was the first African American, if not the first American full stop, to beat a path to Britain supported only by the knowledge that for the sake of the unquellable urge within him to be an actor, he had to go to where it would be

physically possible for him to do it. For Aldridge, that place was England.

Aldridge's ascent was guided in its timing by immaculate destiny. He arrived in London in an age of dramatic, ethical change propelled by a growing wave of national consensus for Abolition. It was a campaign that had been spearheaded by the Quakers almost forty years before. The Quakers were the most successful of all the Protestant non-conformist groups that emerged from the trauma and change of England's Civil War. Viewed as a brethren of oddities by everyone else, they dressed plainly, addressed each other in terms of 'thee' and 'thou' and refused to remove their hats upon greeting each other; all rituals that served as a daily affirmation of their belief in equality. But beyond these stubborn eccentricities, they became visionary progressives, the inventors of 'caring capitalism' and to whom we owe the establishment of all modern society's cherished ideals. Reflecting their belief in untapped female potential, they established the first girls' secondary school in York in 1785; driven by their compassion for the depressed and mentally disturbed they established the first mental health retreat in 1792, proposing the idea that proper food, calm, tranquility and exercise, as well as reading, writing and crafts in a peaceful country setting were better methods to heal melancholy and mania than being chained to a wall in a Godless cellar, a practice that continued in standard mental asylums for another thirty years. At the heart of what humanity is and the values we now hold in the highest regard - campaigns for equality, non-violence and personal freedom stem from pure Quakerism.

This eccentric English sect developed out of the mind of the Leicestershire born George Fox and his alternative vision for Christian living. Fox was the eldest son of a comfortably off weaver from a staunchly Puritan Leicestershire village now known as Fenny Drayton and he came of age on the outbreak of England's civil war. The national schism reflected his own inner crisis, for he was a serious-minded young man who rejected the ordinary pleasures of youth. Instead, he became absorbed in his struggle to find a spiritual connection, the spirit of Emmanuel, or 'God with us,' and he wandered alone in the country waiting for the quiet voice to come to him in the silence and give him direction. After years of contemplation, he reached what was at the time, a startling conclusion. Charles I was unseated for abusing the divine right to rule as God's representative on Earth, but Fox started to question any human being – a priest, bishop, king or a Cromwell coming between man and his communion with the Lord. God was not in

church, he bravely told anyone who would listen, their light was within, he told them, and it was all they needed. It was a notion that was immediately empowering and simplifying; no doctrines and no encumbering original sin. He presented to those with no wealth and little material comfort the idea that they could, at least, claim their spiritual autonomy and that they deserved respect as a fellow human.

In his attempt to spread this realisation around the towns and villages of England, Quakerism took root most strongly in its craggy highlands. The inhabitants of Lancashire, Yorkshire and Westmoreland were independently minded but mostly poor farm labourers who felt disregarded by the church and state and were ever oppressed by landowners' rent demands. Kendal, especially, became a Quaker seat of operations raising funds to send missionaries around the country and to help the families of those who had been imprisoned for their Quakerism under the accusation of blasphemy. Cromwell was especially keen on imprisoning Quakers. Their egalitarianism was a threat, particularly as they went about converting soldiers of the New Model Army who gave up their arms or were otherwise booted out of the army for their new spiritual outlook. The one hundred years that followed the onset of the Civil War was a high time for political and civil disruptors being shipped to the colonies and Quakers found themselves 'to Barbadoes,' along with thousands of Catholic Irish, Jacobites, vagrants, the poor and the general rejects of society. Using all kinds of bylaws and old vagrancy laws, any interruption to Sunday service or the failure to attend the Sunday service was made illegal. By definition a Quaker was vulnerable to arrest, 'The prisons were full of them,' wrote Voltaire, but 'persecutions hardly ever fail to make converts, and they came out of prison strengthened in their belief and followed by their gaolers who they had converted.' Otherwise, their meeting-houses were raided and they were pelted with 'stones, Dirt, rotten Eggs, human Dung and Urine' and word was slanderously put about that they were 'cannibals, satanists' to justify their prejudiced treatment, 'men were herded through the streets like cattle, crammed into stinking confinement, beaten, starved and roundly abused.'

For self-preservation, they organised their pockets of society with a discipline rigorous enough to strengthen their growing fellowship from outside attacks. Non-violence is a central belief of the Quaker faith but by keeping steadfastly to their principles they presented to ordinary Britons a united front of order, calm and constancy, and formidably so. In true Quaker

style, they kept an account of all the persecutions, and the kindnesses they received, though the persecutions far outstripped any empathy from the wider public. Viewed as potential anti-Monarchists for their refusal to swear oath to the King, the Restoration period was so blighted a time for the Quakers that in 1675 a 'Meeting for Sufferings' was called to document what amounted to 15,000 instances of mob violence, arbitrary fines, attacks on their livelihoods, and confiscation of their property. The meetings were held annually, and regionally every quarter, with a weekly meeting in London for strategic lobbying of parliament to improve their civic rights to worship as they wished without the threat of being fined or imprisoned. It was by this strategy for survival the Quakers developed a communication network, with honour and efficiency uppermost. In time, as they became more accepted and their persecution started to fade, they put their energy into profit rather than preservation, a formula that was the secret of their success. By their family connections, inter-marriage, and a trusted nationwide network of contacts, the Quakers helped to transform Britain – through business, through philanthropy and their indefatigable pursuit of equality.

Time and again, Quaker values filtered through all their interactions. Loans were made knowing that the debt would be repaid; recommendations and contacts in Britain, America and the colonies were taken up on the trust that they were part of a community, eliminating the inherent risk in international trade; business deals were struck with mutual advantage as the priority rather than personal gain. And commercial opportunity abounded in the eighteenth century, in textiles, tobacco, groceries, botany and apothecary, iron mining and ironmongery, bridge building, rail track laying, the banking system that made good use of the surplus profits of their rigorously sound business practice, and of course, chocolate. But for our story, it was by their communication network and mercantile success that the Quakers were ideally positioned to develop the first ever co-ordinated, national protest movement – no longer to improve their own lives, but the lives of people they would most likely never meet. In spite of their small number (at any one time they never reached more than 80,000 Friends) the Quakers went on to exert a disproportionately positive influence over the British people. Most likely for the simple reason that Quakerism and its most famous tenet, the campaign for human rights, developed domestically in England, and spread organically; plus, their argument was strengthened by grim, personal experience. By the very nature of their survival and success they were living proof of the power

of change and what it could achieve.

The eighteenth century saw Britain become the interconnected, quick trend spreading, print obsessed nation that has powered its cultural developments ever since. Rapid industrialization at the beginning of the 1700s had put a spotlight on the terrible state of Britain's roads. Impassable, often dangerous, tracks, even in the best of weather, were a liability when factory production relied upon the delivery of raw materials; particularly in the northern regions of England, where sticky clay soil and the unforgiving Pennines separated towns trying to do business with one another. But after significant mid-century investment, a map of England and Wales in 1770 shows the country riddled with new turnpike roads, from Portsmouth to Berwick on Tweed, Truro to Norwich, Dover to Carlisle and with an especially dense scribble through the West Midlands and up to Manchester and Sheffield.

A communication boom occurred at the same time. *Berrow's Worcester Journal* (1690) claims to be Britain's oldest newspaper, but after the expiration of the Licensing of the Press act, every county, if not every city and market town had its own *Mercury, Chronicle, Journal, Post* or *Gazette*. London first newspaper, *The Daily Courant*, went to print in 1702, and by the 1720s the city had a dozen different papers all supplying the latest news that was disseminated via coach and horses racing along the new super highways day and night to feed the regional press. By 1800, approximately 60% of men and 40% of women in Britain were literate. People were becoming more informed but still barely anyone in the country was allowed to vote. In the absence of any direct political influence, Britons used the only alternative people power available – petitioning.

Manchester, the once pastoral town that was on its way to becoming Britain's second city was especially in the ferment of change and progress. The abolitionist newspapers the *Manchester Chronicle* and the *Mercury* printed poems and articles praising 'the African' and imploring their fellow Mancunians to join the campaign. Stirred by the impassioned sermon delivered by the Quakers' Anglican representative, Thomas Clarkson in the Manchester Collegiate church in the autumn of 1787, the city's anti-slavery committee delivered to parliament the nation's first significant abolitionist petition and on it were 10,639 names, almost a quarter of the town's population. The activists of Manchester sought to marshal the rest of the country. They raised a substantial sum to advertise petitions in newspapers

and publications across Britain and helped to transform the campaign into a national movement until practically every British town and city had an anti-slavery committee. Their purpose was to raise funds to circulate the Quaker viewpoint, via clutches of articles sent to local newspaper editors, and with thousands of pamphlets and hundreds of petitions left in town halls, banks, coffeehouses, inns and taverns that were signed or marked by hundreds of thousands of Britons during the high years of campaigning. So strong was public feeling for the cessation of the slave trade the *Edinburgh Review* magazine had to conclude in 1807 (the year of Aldridge's birth), 'This is not, we apprehend, one of these cases where the wisdom of government has gone before the voice of the people...The sense of the nation has pressed abolition upon our rulers.'

The Abolitionists' method of persuasion is still the greatest tool used to fighting injustice in the world today - they brought the argument home. Being denied personal freedom was no theoretical, abstract scenario for many Britons. As an island nation with global interests, its primary defence was 'a good fleet at sea.' Britain became the greatest naval power in the world but it came at the grubby cost of the lives of the poor and vulnerable. Sanctioned by various acts of parliament, naval press gangs prowled coastal towns all through the eighteenth century; the port towns of the north of England especially, were prime locations for the forced 'recruiting' of hands to fight the almost constant naval wars in which Britain was engaged. By necessity press gang coercion and abduction rates ramped up and became a national terror. For example, between 1759-60, at Hull's press gang headquarters out of all the men who joined the navy 63% were impressed; during the American Revolution, of the 116,000 on the naval register impressment figures came in at 85% and 66% for Liverpool and Newcastle respectively.

This legalised kidnapping had rules: only seafaring men over the age of eighteen and under fifty-five were to be taken. But documentation was needed to prove your age, and artisans and general labourers were just as much a target as those with experience of the sea. The demands of the Imperial Navy always took precedence. If you worked the land for crops, or you were a fisherman you were a free man; likewise, if you were a gentleman, or at least had the good fortune to wear the right clothes to present as one. Otherwise, men needed their wits about them when armed gangs set up a *rendezvous*, usually at a nefarious alehouse to lure, drug and capture men for its various missions. Once aboard, the impressed were invariably at sea for several years,

living the brutal existence of an ordinary seaman with only the inhumane naval laws as protection.

For sailors and landlubbers alike, another threat hung over them. Since the 1600s, stories circulated by popular broadsheets, journals, by word of mouth, in diplomatic reports and depicted in Daniel Defoe's 1719 best-selling novel *Robinson Crusoe* told how British and Irish men, women and children were captured by Barbary pirates in their thousands and lived out their days in chains as a galley slave or doing hard labour in Morocco, or in harems in the Ottoman vassal states of Algiers, Tunis or Tripoli. *Rule Britannia* was written in 1740, an anthem proclaiming Britain's liberty, its return to naval power and an ever-expanding Empire. But many Britons *were* slaves, along with men, women and children from America, Iceland, Sweden, Ireland and Spain, having been seized by North African corsairs, the swift and able seamen who roamed the North Atlantic and the Mediterranean looking for ships carrying valuable cargo of gold, goods and humans, or they otherwise stormed and rampaged their way through coastal towns and villages. The working poor who were left behind were just as vulnerable to abuse of their liberties. Rural land enclosures added to the speed of change in the fast-growing towns across the north of England. Hundreds of thousands of new industrial workers with few, if any rights to decent hours and working conditions were most often living in poverty and under the tyranny of the Bloody Code; legislation that enthusiastically put property rights before human life, listing paltry crimes such as stealing a rabbit or cutting down a tree as a capital offence.

For all kinds of contemporary maltreatments and ones of the recent past, when the Quakers invoked the spirit of Exodus 23:9 in their Abolition speeches, 'Thou shalt not oppress a stranger: for ye know the heart of a stranger,' their words resonated with many, many people.

From the middle-class point of view, one most likely untouched by all of the above, the mid to late eighteenth century boom in popular novels in England had cultivated the idea of empathy in the, usually, female reader. By describing experiences they themselves most probably would never have, best sellers such as *Moll Flanders*, *Pamela; or, Virtue Rewarded*, *Clarissa*, *Tom Jones*, and Ann Radcliffe's Gothic masterpiece, *The Mysteries of Udolpho* opened up an understanding of personal motivation for a low born protagonist; the ways in which good may overcome evil, of mistakes and atonement, the damage done by audacious rakes who shrug off accountability, or the realities

faced by a pretty young peasant girl with little protection save for the only power her parents were able to bestow, her Christian morality. These new fictional worlds broadened minds and enlivened middle-class imaginations to consider the lives of those who had different starting points to theirs. An exponential growth in the reading public ran in parallel to the Quakers' compelling Britons to empathise with the suffering of another people in another country. They succeeded by making it personal, and by prioritising decency and humanity over policy and profit. In this way the Quakers developed all our modern campaigning methods - they went door-to-door, canvassing face-to-face, talking to people in their homes, imploring them to stop stirring slave grown sugar into their tea by loading it with guilt as well as calories, and to sign their petitions.

It was into this England that Ira Aldridge arrived in 1825. As an African American offering up his acting skills, the New Yorker was a gift to the London theatre world. When the seventeen-year-old son of a Presbyterian minister knocked on the stage door of the Royalty Theatre in Whitechapel in May of that year, he presented the owner with the opportunity for a theatrical coup. The East End theatre was in the middle of an unofficial or rather, unlicensed season of Shakespeare, (for without a royal licence no theatre was permitted to stage serious drama) but tucked away in unfashionable Whitechapel, they got away with it. In January they had performed *Richard III*, in May they put on *Macbeth* and on Aldridge entering their lives, it was announced in the *Public Ledger*: 'This evening, the 11th instant, will be performed the Tragedy of *Othello*, the Moor of Venice. Othello, Mr. Keene, a Gentleman of Colour from the New York Theatre; Desdemona, Mrs. Clifford.' For the first time in British theatrical history, the announcement told the public if they came to the Royalty Theatre that night, they would witness Othello played by a 'Gentleman of Colour.' Never before had there been a Black actor on the British stage, and a gentleman to boot.

Aldridge's debut was a sensation. The *Public Ledger* duly reported back two days later, 'The House was very full, and the whole performance went off with *éclat* – We hope to have another opportunity of seeing Mr. Keene, as there are many more characters of *Colour* which he might fill with great ability.' (Just to clear up the name confusion, for those starting out it was the fashion to evoke the name of an already successful actor, in this case Edmund Kean, plus Aldridge's mother's maiden name happened to be Keene.)

Aldridge's first review confirmed his courageous decision to come to England to be the right one. Even after having received a classical education at the African Free School, his options for finding acting work in 1820s New York were narrow to nil. Despite the North's reputation as a place of liberty, the status of African Americans was blurred and it was certainly a hostile environment for those trying to set up a theatre company. In spite of the heroic persistence of Aldridge's friend, William A Brown, a West Indian free man and ex ship steward who tried many times over to create a venue for Black Americans to enjoy and participate in theatre, he was routinely hounded out of business and forced to shut down his premises. The likelihood of an African American being cast in a white production was infinitesimally small.

In London, by contrast, not only was he accepted into a theatre company, he was given a lead role, and Aldridge stayed with the Royalty Theatre for several months before moving onto the Royal Coburg, now the Old Vic. Even better, just a few months after his arrival he met and married twenty-seven-year-old Margaret Gill, the daughter of a stocking-weaver from the market town of Northallerton in North Yorkshire. The woman who was to be his wife of forty years was described as 'an intelligent lady of fine accomplishments and great conversational talent,' but she was also pretty fierce and ready to deal with the 'rascals in the box office' who tried to diddle her husband out of his receipts. With Margaret by his side, he played London's unpatented theatres Southwark's Surrey Theatre and Sadler's Wells and exhaustively toured the towns and cities of Britain where his performance nights were often extended by popular demand; he was a box office draw first out of curiosity, then by reputation.

The nature of theatre in the nineteenth century was very different to how we experience it in modern times. In the absence of radio, television or cinema, it was customary to see a play perhaps three or four times a week. To keep audiences entertained theatres changed the playbill every few nights and for an actor to stay in work they needed to be able to hold in their memory a great range of roles so that they might fetch up at any town and fall in with whatever play had been chosen to stage. Through his early years in Britain, Aldridge was continually expanding his repertoire. His greatest triumph was 'Othello' but he took lead roles in the many anti-slavery plays that were enjoying a revival during the Abolition campaign. He played Caucasian parts too, applying whiteface to try out Iago, Macbeth, Shylock and the Scots outlaw, Rob Roy, and gained the kind of experience only regular repertory

theatre can give an actor to hone their skill, work up memory muscle, relax and learn to trust their instinct. He had a skill for comedy, too. A popular favourite throughout his career was a play called *The Padlock* in which Aldridge took the part of Mungo, the enslaved house servant of a rich West Indian planter who constantly punctures his boss's bombast and self-delusion, revealing a sort of *Steptoe and Son* dynamic British audiences adored.

He was especially well received in the Quaker heartland of the Midlands. He spent the beginning of 1828 oscillating between two theatres, one in Birmingham, the other Coventry where after just a few weeks and some excellent reviews, he was top of the bill. It so happened the Coventry Theatre was being badly managed by a Mr. Melmoth who had a habit of letting unprofessional behavior from his actors go by and had effectively run the theatre into the ground. Aldridge made capital of the opportunity to take over as Actor/Manager and set about forming a new company. He sacked most of the Melmoth stable and recruited trusted friends he had worked with at the Coburg and various theatres around the country. On their opening, the *Coventry Herald* appraised the enterprise as, 'better conducted than by the last manager, and the company, on the whole, is decidedly improved…Mr. Keene himself represented *Othello*, with considerable discrimination and effect.' Having brought the Coventry Theatre back to life, he returned to the simpler existence of performing. He went back on tour, often causing a sensation where his reputation preceded him, boosting interest for struggling theatres in the smaller towns. He performed in Aberdeen, Glasgow, Paisley, Dublin, Swansea, Bath, Lichfield, Leamington, Ledbury, Southampton, Worcester, Gloucester, Hereford, Norwich, King's Lynn, Lancaster, Scarborough, Manchester, Kendal and Hull. Hull became a kind of second home; as the birthplace and political seat of Wilberforce, the city had a natural ground swell of abolitionist support and he returned to it many times for long runs through the early 1830s.

As I mentioned before, the most celebrated lead actor of the age was Edmund Kean. Kean had been raised in the streets of Covent Garden and was a wild one. Like a nineteenth century Oliver Reed he was terrific company but he was moody, destructive and he drank too much. Alcoholism eventually destroyed his ability to memorise his lines but in his zenith his stage presence was spellbinding, arousing 'those emotions that are always felt at the presence of genius – that is, at the union of great powers with a fine sensibility.' Impulsive, intuitive with Plutonian intensity, 'his lips might be said less to

utter words, than to distil drops of blood gushing from his heart.' Again, by immaculate timing and at the still young age of twenty-six Aldridge was presented with the challenge of trying on the mantle of the nation's greatest tragedian.

Aldridge was performing 'Othello' in Glasgow when the *Caledonian Mercury* anointed him as the natural heir to Kean, 'when time may have deprived us of that great master, the African Roscius will not be an unworthy successor.' The writer of this piece had both supernatural foresight and a naiveté of the immovable London critics. The date of this article was the 20th March 1833. Just five days later, on the hallowed stage of Covent Garden's Theatre Royal, Kean was giving his Othello when he collapsed mid performance, his body finally giving up after years of alcohol abuse (he died just under two months later). Events moved quickly as the very next day, another Glasgow playbill announced with breathless excitement, 'Positively the last appearance but two of the African Roscius, the celebrated trans-Atlantic actor of colour…who is engaged by Mons. Laporte, Manager of the Theatre Royal, Covent Garden, to appear there in May next.' Aldridge had been publishing notice of his *fictional* imminent appearance at Covent Garden for months and now, it had finally manifested.

To appear at the Covent Garden Theatre Royal (now the Royal Opera House) was the greatest test for any actor. Founded in 1732 on the profits of London's first long-running hit, *The Beggar's Opera* it was just one of three theatres in London that held a royal patent (the other two being the Drury Lane and Haymarket) and was where an actor trying to build a reputation could acquire the 'London stamp.' To succeed meant pleasing the manager who had hired you, the audience that had paid to see you and not giving an inch for the London critics who circled like sharks sensing any weakness. Most especially endowed with razor teeth was *Figaro in London*, a vicious, satirical society weekly paper of a *Private Eye/Tatler* type with a pro-slavery editor who had a reputation for 'demolishing everybody.' Aldridge, too, had been circling Covent Garden in his mind's eye and here was the moment. After touring England, Ireland and Scotland for eight years he was now quite literally stepping into the shoes of one of Britain's greatest actors.

After his opening night, the critics filed their appraisals of Aldridge's performance to the press. Some denigrated the idea that not just an American, but an African American should consider playing 'Othello' and littered their pieces with racist insults; others praised his performance and attacked the

prejudices of their media competitors. The response that no doubt gave Aldridge the greatest comfort was that of his public. The *Globe* reported, 'Nature has been good to Mr. Aldridge in more than the identity of complexion which she has given him for the Moor et similes – that is, he possesses a good figure and a speaking, intelligent countenance.' He delivered his 'Othello' it went on 'with all the fire and spirit of a first-rate actor…and at the close of the tragedy he was called for by the unanimous voice of the house.' Like a gladiator in ancient Rome, Aldridge had taken on combat with the London critics in the city's greatest amphitheatre and survived, in as much he went on to become one of Britain's most esteemed actors of the nineteenth century. But that particular summer saw Britain abolish slavery in all of its colonies. The racist reviews by the snobbish gatekeepers of London's high arts scene and the media cronies of the pro-slavery lobby were a rather desperate attempt to knock Aldridge down just as his wave was cresting. Still, the ramping up of their lost cause had sufficiently put a question mark over Aldridge's standing as a London actor. After a month's run at the Surrey and a few other minor theatre engagements, and with *Figaro in London* pursuing him like a rabid dog, Aldridge went back to where he was comfortable, to the provinces of England and to Ireland, where he was warmly welcomed and toured for five years running with great success.

To succeed as a freelancer, you need many qualities: patience, humility, determination, an open, friendly character and resourcefulness. That Aldridge's good fortune continued was largely down to his resourcefulness. As the 1830s progressed, Britain's theatres, the Covent Garden included, went into a slump. The rise of singing rooms and makeshift 'saloon theatre' in pubs, and 'free and easies' where entry charge was a mug of beer led to respectable theatre's emptying auditoriums. To navigate the downturn, Aldridge put together his own show, entitled 'Grand Classical and Dramatic Entertainment' with an assembled cast that was a mix of old friends and new young talent, and by 1836, had made a comfortable profit; or as the Dublin newspaper, the *Warder*, put it, 'he is, as to cash, in full feather.' With his own carriage loaded with costumes and props he toured Ireland's inns, court-rooms, schools, assembly rooms and military barracks giving lectures on the virtues of drama, supported by a medley of scenes and songs, with Mrs. Aldridge taking care of ticket sales. In the midst of his Irish tour the *Galway Patriot* spoke of his 'strict sense of honour and gentlemenlike demeanor' that had earned him 'the friendship and esteem of numerous circles of acquaintance of the first rank, in

almost every part of this kingdom' whilst the *Tipperary Free Press* reported glowingly, 'the success of the African Roscius's tour over Ireland has been perfected unprecedented in the annals of the Provincial Theatres in this country…he has performed before crowded and fashionable audiences and been patronised by all the resident Nobility and Gentry.'

After eight years of bucking the economic trend in box office receipts, sustaining top billing in theatres all around the country, with houses 'crowded to excess' including the uber-fashionable Theatre Royal Bath where he succeeded in a 'blaze of triumph,' he returned to the London stage. Not to the West End but to 'the Surrey side' where he starred in *The Revenge, The Padlock* and *Othello.* He was now forty-one years old, the perfect age to play the Moor, and the *Theatrical Times* celebrated his return to the capital by putting an illustration of Aldridge in character as Othello on their front cover, with a feature article inside. The review of his London reprisal of the Moor spoke of his 'grandeur and sublimity' and his, 'thrilling tone, as cannot fail to reach the soul of every hearer, and invariably brings down a torrent of applause.' The *Telegraph* pronounced his performance as 'a treat of high order.'

Even the *Times*, which fifteen years earlier had witheringly concluded, 'We could not perceive any fitness which Mr. Aldridge possessed for the assumption of one of the finest parts that was ever imagined by Shakespeare' had either new personnel, a new outlook or perhaps reflected how much Aldridge had matured as an actor. On the 26th March 1848 they told their readers, 'His delineation of the proud, revengeful Moor was finely conceived and executed with great dramatic effect. In the soliloquies and those passages in which the reflective powers of the mind are at work, while the material action is suspended, he possesses the rare faculty of completely abstracting and separating himself from all external objects, or of only receiving impressions from those that harmonize with the state of his mind.'

It was a heartening return to the London stage, summed up by Aldridge himself. At the play's end he stepped out onto the stage to enthusiastic applause to make an address, as was his habit, and for the first time he publicly referred to the way he had been received in his earlier years. The *Satirist* reported he told the audience, '"the twenty years struggle" he had made, was amply repaid by the reception he had that night received, and hoped "the prejudice was fast dying away, when one man should be deprived of a hearing on the stage because his face was of another colour, seeing the black man and

the white were both the work of the same Creator," and which brought down the most deafening applause.'

But the prejudiced cliques of the capital's royal theatres hung on and after twenty-seven years touring Ireland and the British Isles, performing starring roles to great acclaim and artistically, reaching his full potential, a frustrated Aldridge was compelled to instead take his acting company to the finest theatres of Europe and Russia. In July 1852 he began a two-year Continental odyssey with the instinct of a seasoned producer. Venues were sold out to see his Othello, Shylock, Macbeth and for the first time, with encouragement from his friends in Pest, he performed King Lear at the Hungarian National Theatre and was critically acclaimed. The critics did not harrumph at Shakespeare being brought to them by an actor who was not British, they simply appreciated an actor of great talent. In Belgium, Holland, Prussia, Germany, Russia, Russian Poland, Hungary, Austria, and Sweden there awaited him adulation, celebration, glittering prizes, royal orders and in pre-Revolutionary Russia, where the serf possessed about as much liberty as the plantation enslaved, almost deification. So laden was he with honours bestowed by European nobility that a *Times* critic compared the list of Aldridge's Royal patrons to 'an index to the Gotha Almanac.'

In a letter to a friend in March 1863, the usually modest Aldridge wrote, 'A simple recital of all my successes abroad would fill a volume larger than your history of Yorkshire. Indeed, the furore seems to increase with each visit. When you come up to town you can inspect the presents, which they have heaped upon me. I will not express my feelings of pride but I might be excused for doing so, as they have conferred titles and Decorations in abundance.' He had experienced the exalted status of the actor abroad that no British actor could ever find at home (the first actor to be knighted was Sir Henry Irving in 1895). For he could see, 'the actor is looked upon as but a remove or two from what he was in reality in former days namely a Vagabond. No nothing would tempt me to act again in England.' He did, of course, return to England. It was his home. Ira Frederick Aldridge was born in New York City but Ira Aldridge 'the Celebrated Tragedian' was born in London. All the while Aldridge was touring abroad the leading theatrical journal *The Era*, had been publishing a running commentary of his movements, successes and riches earned, keeping British audiences and theatre managers up to date with quite how much the tragedian-in-self-imposed-exile was lauded in Europe. *The Era* coverage provided some handy publicity when he returned for lengthy provincial tours

in 1855 and 1859, and he received constant offers from theatre managers during the interims. Aldridge finally became a British citizen in November 1863 and he bought several properties on Hamlet Road in Upper Norwood, including Luranah Villa (named after his mother), that was Margaret's home towards the end of her life, and for his second wife, the Swedish born Amanda and their three surviving children.

For a snapshot of the change that occurred during Aldridge's lifetime brings us to the most encouraging scene of the love and appreciation from his fellow actors. In April 1864 just a month after Margaret had died 'The Actor's Shakespearean Supper' was held at the Freemason's Tavern on Great Queen Street to celebrate William Shakespeare's 400th birthday. Aldridge was in attendance along with the other 399 members representing the London theatre world, and throughout the evening there were speeches and toasts. *The Era* reported that the popular playwright Leicester Silk Buckingham proposed the health of Mr. Ira Aldridge, and after 'The toast having been most cordially received, MR ALDRIDGE said he felt utterly incompetent to make any suitable acknowledgment for the very high compliment that had been paid him. He was a humble exponent of the Shakespearian (sic) Drama, and he was proud to say that in Germany, in Holland, in Austria, in Prussia, and in Russia his efforts had been crowned with success. (Cheers) He did not attribute that success to his own humble talents, but to the love of that great Poet whom they now met to honour. It was known that he was no *impromptu* orator. What he said was from the pure feeling of his heart, and as such, he hoped it would be accepted. Having stated that he had recently been admitted to the rights of citizenship in this country, he concluded by proposing "The Health of their Presidents, Mr. Webster and Mr. Buckstone." The toast was drunk with enthusiastic cheering.'

Always relentless in his need to work, in spite of illnesses, he kept the show on the road and promised appearances in faraway cities when he shouldn't have been working at all. At the beginning of August in 1867 he arrived in the Polish town of Lodz and started preparations for debuting his Othello. But the people of Lodz never had the chance to see the African Tragedian. He died of a respiratory disease on the 7th August 1867, two weeks after his sixtieth birthday. Nevertheless, the people of Lodz gave him what was approaching a state funeral, a fitting end to the life of a man who proved how much theatre hasn't just reflected changes in society but has actively led them. An audience witnessing a group of actors on stage sees a tableau of

mutual trust and shared values; they see a group of people using every fibre of their being to tell a relatable and ultimately, universal story. An over-arching truth in theatre, as with music and in fact, all the arts, is that no one sees class or colour, just talent, should you possess it. And Ira Aldridge had it. He was a star of the stage. He was one of the less than half a percent of Britain's acting fraternity that achieved fame, adulation, riches and respect and satisfyingly, he eventually won out against the vicious first reactions of *Figaro in London* and its cohort. Aldridge was a beacon of bright illumination; he lit a path towards understanding and with his grace, intellect and comic timing, he proved the bigots wrong.

Playlist:

War – Edwin Starr
Sail Away to The Sea – Sandy and the Strawbs
Little Britain - Dreadzone

7

A Hand Across an Ocean

As America's civil war escalated in the cause of human rights, the British craze for its minstrel music reached its height. While the nation was awash with the sounds of the 'plantation south,' looming in the background was a powerhouse textile economy gorging on cotton cultivated and harvested by enslaved African Americans that was then cleaned, processed and woven into cloth by the ill-fed, ill-clad, terrorised English mill hands working twelve-hour days in hot, noisy, confined conditions, breathing in oily air heavy with fibre dust and inhumanity.

Since the 1840s, the American South had been almost the sole supplier of cotton to England's textile industry. True to their moral integrity, the Quakers, specifically, Quaker women made a valiant, but in the end, vain attempt at trying to persuade the British cotton industry to cease colluding in slave labour and instead buy 'Free Cotton,' that is, raw cotton grown by free workers (in truth, indentured workers) in India, the West Indies and West Africa. In May 1853, catching spring time enthusiasm, Eleanor Clark, wife of the shoe manufacturer James Clark, opened a depot selling 'free cotton' goods near the site of the company's headquarters in the village of Street in Somerset. The majority of the rolls of calico, gingham and muslin, and ready-made stockings and gloves were supplied by the Manchester Quaker, Josias Browne, Britain's foremost and trustworthy free cotton merchant. Browne not only understood the Quaker aesthetic of simplicity, but he was also scrupulous in his dedication to the free cotton trade, ensuring that the cotton used to make the goods he supplied was indeed grown by free workers.

Eleanor was testing out the market for the first 'ethical' line of goods for the customer who wanted to support anti-slavery by voting with their purses. With the availability of cheaper poplins, silks and satins, a consumer revolution had given the opportunity to women of a more modest income to define who they were by what they wore; but by purchasing cotton items from the 'Free Labour Cotton Depot' you could define what you thought by what

you wore. But the Free Cotton Movement was a false start. It never took off. It was an early form of conscious consumerism that finally reached Britain's high streets one hundred and fifty years later, but for nineteenth century Britons it was a 'virtue signal' too far. Given the Quaker's belief that pride in dress was sinful, the range of items on offer, exquisitely made as they were, were perhaps too plain for the general public who didn't feel the need to wear their principles. The movement was a reminder of the radicalism that lay at the heart of Quakerism, and the British majority saw it as a 'sincere effort of earnest people' but nevertheless, a 'crack brained scheme.' It was a fringe, mercantile operation in a period that saw Britain's hunger for slave grown cotton not abate but remain steady.

To the Confederate states, England was a crucial market. Britain's industrial power house was at its global peak in the mid nineteenth century and while the South exported raw cotton to France, Germany and Russia, more than half of its bales shipped to Britain, specifically, Lancashire, providing its cotton mills with 77% of 'white gold' that was converted into 90% of the nation's textiles and fabrics. So vital was cotton to their mutual economic well-being that an accord was struck under the concept that 'cotton is king,' or 'King Cotton,' a legend coined in 1855. The years preceding the Civil War were an especially fecund period. A cotton boom driven by bumper crops saw profits reach an extraordinary 30% return on the cotton traders' investment, but having learned nothing from the set piece of boom and bust, the factory owners' eagerness to satisfy the seemingly unstoppable demand for cotton goods in Europe and India caused an overshoot of production and brought a dramatic slowdown in 1861. Cotton imports to Britain fell by 50%, exports of England's stocks of surplus raw cotton remained steady, and in between, the mills and factories of Lancashire, Cheshire and Derbyshire started to slack off and operate on three-day weeks, if they operated at all.

But outside events transformed the plight of the redundant cotton workers, who were usually no more than flotsam and jetsam tossed about by market forces, into a heroic, international story. In an attempt to bait Britain into the Civil War on their behalf and provide military aid, the Confederates informally withheld their stock of cotton bales that sat unshipped in the ports of Houston, New Orleans, Charleston, Mobile and Savannah through the summer of 1861. The Union began encircling the Confederate ports with their own blockade that was to last until the war ended, and the Rebels were unaware that Lancashire's cotton industry was in a state of glut. The export

value of Britain's surplus bales more than doubled, whilst the government started to eye India and Egypt again for its future raw cotton needs, and Ireland for flax. The South's exports of cotton bales had totalled 3.8 million in 1860 but were reduced to almost nil by the end of 1861, save for some efforts by cotton smugglers. The failed embargo was called off.

Still, the British government refused to be drawn into America's war, nor to back the Confederates; giving their support would, at a stroke, recognise the legitimacy of slavery and undermine the progress made since it had been abolished in British territories and shatter the nation's image as a beacon of liberty. In spite of Parliament's position of neutrality, dock managers and shipping company owners in Liverpool, once the axis of the Atlantic slave trade and now, of the international cotton trade, came out on the Confederate side in May 1861 and stayed there. In Manchester, too, factory owners offered Confederate support in the shape of the Southern Independence Association, led by the MP and businessman Edward Hardcastle. But silently, hundreds of thousands of Lancashire workers were supporting the Republican stance on free labour. At the beginning of 1862, with the Union's blockade prolonging the depression, the cotton workers of England had not yet officially come out on the Union side, but their reticence spoke volumes. At a London workers' meeting in January, Karl Marx interpreted their silence: 'The working class is accordingly fully conscious that the government is only waiting for the intervention cry from below, the pressure from without, to put an end to the American blockade and English misery. Under these circumstances, the persistence with which the working class keeps silent, or breaks its silence only to raise its voice against intervention and for the United States, is admirable. This is a new, brilliant proof of the indestructible staunchness of the English popular masses, of that staunchness which is the secret of England's greatness.'

The cry from below never came. The 'King Cotton' accord, upon which the Confederates' economic, political and cultural strength relied was broken by England's cotton workers. Days after a decisive Union victory at the Battle of Antietam in September that year, Lincoln announced a Proclamation of Emancipation whereby he made a promise to free all slaves held in the Rebel states if the Confederates would not surrender. They did not. Suddenly, by this declaration, the war that had been raging for seventeen months was transformed into a noble crusade that fortified the mill workers for the hardships that were to come. In October, factory inspectors reported that just

11% of the operatives were working full time, 33% were on part time, 51% were unemployed. By Christmas, just under 285,000 souls were on poor relief as the workhouse hovered like spectre and the wider economy of the day-to-day businesses of artisans – tailors, shoemakers, bakers and beer houses, stagnated.

The people were suffering but they bore it with 'little murmuring.' The local writer and poet, Edwin Waugh observed how a 'great number' of Blackburn's 'tall chimneys were smokeless' rendering Lancashire's foremost weaving town unrecognisable by 'an unusual clearness of air.' To Waugh, the place had the 'look of a doleful holiday, an unnatural fast-day quietness about everything. There were few carts astir, and not so many people in the streets as usual, although so many are out of work there. Several, in the garb of factory operatives were leaning on the bridge, and others were trailing along in twos and threes, looking listless and cold; but nobody seemed in a hurry.' Destitute and desperate, the hungry unemployed had nothing to use but their voices, and they wandered the streets singing for spare change. Waugh observed, 'There is one feature of the distress in Lancashire which was seen strikingly upon the streets of our large towns during some months of 1862. I allude to the wandering minstrelsy of the unemployed. Swarms of strange, shy, sad-looking singers and instrumental performers, in the work-worn clothing of factory operatives, went about the busy city, pleading for help in touching wails of simple song – like so many wild birds driven by hard weather to the haunts of man.'

Waugh goes on to explain how much music underpinned the lives of these people, 'Any one well acquainted with Lancashire, will know how widespread the study of music is among its working population...I believe there is no part of England in which the practice of sacred music is so widely and lovingly pursued...{than} in the counties of Lancashire and Yorkshire.... The great works of Handel, Haydn, Beethoven, and Mozart have solaced the toil of thousands of the poorest working people of Lancashire. Anybody accustomed to wander among the moorlands of the country will remember how common it is to hear the people practising sacred music in their lonely cottages....{and} to meet working men wandering over the wild hills, "where whip and heather grow," with their musical instruments, to take part in some village oratorio many miles away.' But in the face of mass unemployment he laments, 'There is no part of England where, until lately, there have been so many poor men's pianos, which have been purchased by a long course of careful savings from

the workman's wages. These, of course, have mostly been sold during the hard times to keep life in the owner and his family.'

In spite of a *Manchester Guardian* article discouraging workers from taking the Union side, a meeting and a formal declaration marked the end of the year. Lancashire's people were perishing from hunger and lack of fuel to keep them warm, yet still, on the 30th December 1862, cotton workers, packers and porters, clerks, bookkeepers and warehousemen attended the Free Trade Hall in support of the Union's blockade, declaring that the end of slavery was a spiritual necessity. In the chair the Mayor of Manchester, Abel Heywood read the motion, 'that this meeting, recognising the common brotherhood of mankind and the sacred and inalienable right of every human being to personal freedom and equal protection, records its detestation of Negro slavery in America.' Collectively, a letter was drafted and sent to the President stating the same. Lincoln sent a letter of reply thanking the people of Manchester for their support and in early February of 1863, one of several ships docked in Liverpool bearing cargoes of provisions sent by the American International Relief Committee for the Suffering Operatives of Great Britain. The *George Griswold* contained '11,236 barrels of flour; 50 barrels of pork, 125 barrels and 375 boxes of bread, 200 boxes of bacon and 500 bushels of corn' and the mass of crates was offloaded by dockworkers and stevedores who refused to take payment, and was shunted by rail to their destinations without charge.

The working peoples' support of the union was by no means unanimous. Yet, only in Britain's port cities were 'workingmen divided - in London because never united, in Liverpool because of close touch with the South, in Glasgow because of the blockade runners.' When the American Abolitionist Henry Beecher Ward toured Britain in the same year, the French politician and historian Louis Blanc observed Beecher was 'all but spurned at Edinburgh, all but cursed at Glasgow' and in Liverpool, 'he would have died, if one could die of such things, under a shower of groans and hisses.' On the 10th March, to mark the marriage of Edward, the Prince of Wales and Princess Alexandra of Denmark at St George's Chapel, a meeting of operatives was held in Stevenson's Square and afterwards they were to march to Kersal Moor where a consignment of fifteen thousand loaves of bread were to be distributed. Two boats were to be dry drawn in procession: one flying the Union flag, the other, 'a black vessel destined to be burned on the moor' to represent the blockade runner, the *Alabama*. The meeting took place in the

square but the operatives wanted no part in the political statement and they took the bread and left.

Yet, for the majority of Britons the idea of free labour was more important than economic security. Added to this was a reluctance to intervene in an American civil war, for it would be making war with 'their friends and brethren across the Atlantic' as the Quaker MP John Bright observed, referring to the 2.3 million who had departed for the northern states of America from almost every street in every town in Britain since 1845. Taking the temperature of the national mood, Charles Gilpin, MP for Northampton assessed in January 1862, 'if there was one principle which had thoroughly permeated every class in this country, it was an unmitigated hatred for the trade in human flesh.' The cotton workers held not merely an opinion, but bore a physical sacrifice. Which was why the captain of the *George Griswold* was welcomed with a dinner given by the Manchester Central Relief Committee at the Free Trade Hall where the chairman announced, 'This public meeting desires to express its heartfelt gratitude to the noble donors in America who in the midst of a dire domestic struggle for freedom and nationality have so generously contributed to the succour of the operatives of Lancashire and the meeting declares its conviction that no amount of privation will induce the people of the cotton districts to sanction any recognition of a Confederacy based upon the doctrine that it is right for man to hold property in man.'

Playlist:

Ghost Town – The Specials
Shipbuilding – Robert Wyatt
The Story of the Blues – The Mighty Wah!

8
The Idols of the Halls

Meanwhile, Victorian Britain was crazy for the American minstrel show. For good and ill, Britain has made a habit of absorbing trends and influences from America ever since the bloody separation of the two nations in 1783, and there was no bigger US trend than the one that took like a bush fire in the summer of 1836. Thomas Dartmouth Rice was an apprentice cabinet-maker turned itinerant actor from the Black and Irish ghettos of lower Manhattan, and he had arrived in London armed with a particular novelty. The Surrey Theatre had booked him for a run of farces and it was there he first revealed his bigoted curio to British audiences. It was called, 'Jump Jim Crow,' a song and dance routine that was a sinister mix of jaunty old-time and Morris tunes paired with lyrics that parodied the everyday language of African Americans; to complete the look of this authority skewering, 'runaway' character, the pro-slavery Rice painted his face black and dressed in a costume of ragged clothes, broken shoes and a beaten-up hat. But the element that most thrilled audiences and had London's apprentices and chimney sweeps copying it in the streets was the dance - a combination of African ring steps and an Irish jig with moves that matched 'the velocity of a dancing master, with the quaint capers of a cleave-boy.'

After Rice introduced his song and dance routine, minstrel music steadily became mainstream entertainment in Victorian Britain; it was a crude, grimly stereotyped, first cycle of African-Celtic-American music's influence on British culture, sketching out the way for the second, spectacular cycle of the 20th century. For the first time, minstrel songs tested out the new mix of borrowings and blending's between two cultures with strong musical identities. They were a mix of African syncopation, fiddle music, and the Scotch snap rhythm that follows two-syllable English words – Bonnie, Johnny, rolling, city, running, jumping; it has a kind of upward end note or word emphasis that you hear in fiddle music, or in the cowboy songs of Rogers and Hammerstein, and much of modern pop. Minstrel song lyrics told stories

of episodes from real Black life but corrupted their meaning with exaggerated racial caricature that sent a message that African Americans and their art could be enjoyed but never taken seriously.

Ira Aldridge's career served as a kind of barometer for progress in Britain. When the 'Ethiopian Serenaders' first toured in 1846, audiences were disappointed to discover they were witnessing not genuine Black Americans but white men with their faces 'smeared in lampblack...giving rather feeble imitations' of African Americans 'in their gayest moods.' By then, music halls, minor theatres and seaside piers were teaming with an English knockabout version of minstrelsy that focused more on comedy with a cockneyfied spin. Wilton's music hall in Wellcose Square, then an East End docklands enclave of predominantly German and Irish immigrants, had a blackface comedy act on nearly every playbill for the first thirty years of its existence (it closed in 1888 but reopened in 1999 and is now a Grade II listed building; go visit one day, if you've not been, it is a magical place). Unhampered by the deep complexities of America's race issues, the British public was eager to see *actual* African American performers.

Times changed after the Civil War. Up until the 1860s only white performers were employed in the minstrel business but after the Confederates had been defeated, African American singers and dancers were free to try a career in show business and they began a natural takeover of the minstrel format that became more sophisticated and staged on a grander scale. When the Pennsylvanian promoter, Colonel 'Jack' Haverly debuted his all-African American, male and female 'Haverly's Genuine Colored Minstrels' at Her Majesty's Theatre in July 1881 they were an immediate sensation. Audiences had never seen anything like it. Haverly had developed a showstopping extravaganza with a grand finale that was a precursor to the Hollywood 'big number,' as 'line upon line' and 'rising in tiers nearly to the flies' the performers were 'introduced one by one by means of coloured lights and a series of transparencies...with the last revealing a big drummer in picturesque dress perched high at the back as the centrepiece of the whole display.'

The Haverly act, one of the first and most famous troupes, was packed with Black American talent, including the comedian and dancer Billy Kersands, the actor, dancer and banjo virtuoso Horace Weston, the Bohees Brothers and the handsome, gifted James A. Bland. These dusty old references mean next to nothing to us now, but certainly the last two names, the Bohees and Bland meant a lot to our music hall loving ancestors of the late nineteenth

century. They toured all over the British Isles singing plantation ballads, spirituals made popular by the Fisk Jubilee Singers and Bland's own songs such as 'Carry Me Back to Old Virginny,' 'In The Evening By The Moonlight' and 'Oh, Dem Golden Slippers' which became a standard. Hinting at the tendencies of Britain's future blues and jazz obsessives' love of rare presses and obscure 'B' sides, British critics were all about the *authenticity* of the music, and showed off their nerdy, expert knowledge of a minstrel tune or the origins of a 'plantation' song.

The music was what British audiences appreciated most, and none reached the top more so, than James A. Bland and the Bohees. The Queens born Bland was the first successful African American singer songwriter. He had been a musical prodigy and in his early youth he played the banjo obsessively and organised glee clubs in Washington, to where his middle-class family had moved. He went to every minstrel show he could, studied the melodies, and taught himself to write his own songs that put a sentimental spin on 'plantation culture' in the style of Stephen Foster a generation before him. After pursuing Colonel Jack when Haverly's Colored Minstrels were playing in Baltimore, he was taken on for a minor part, but what separated him from the others was his knack for writing a catchy, pretty melody with cosy homestead lyrics that shone with an American timbre that to British audiences, set them apart - with titles such as, 'The Old Homestead,' 'The Farmer's Daughter,' 'Father's Growing Old,' 'The Old-Fashioned Cottage' and 'Christmas Dinner.'

Yet, in spite of becoming the 'Idol of the Music Halls,' little is known of Bland's life, either in England or America, except from what is told in a misty-eyed and, most likely, embellished biography, *A Song In His Heart* published forty years after his death. Albeit he did spend a lot of time on the continent touring Paris, Berlin, Cologne and Hamburg, there are strangely few mentions of Bland in British newspapers considering he lived in London for twenty years (in Battersea Park, in what used to be called the Old Dog's House Section, according to the author John Jay Daly). But there are a few sightings we can draw on. The Haverly troupe appeared at Her Majesty' Theatre again in August 1881, with the *Daily Telegraph* telling its readers, 'a vast assemblage of persons…filled to repletion every corner of the spacious house;' of all the performers in the sixty strong cast, one third of whom were women, 'none more fairly won an encore than the pretty melody of "Golden Slippers" composed and sung by Mr. James. A. Bland.' In April 1882, the

Meath Herald and Cavan Advertiser reviewed the Haverly's at the Rotundo music hall in Dublin after they had been, 'drawing crowded houses nightly. A more talented and better lot of minstrels has never fallen to my lot to witness. The singing and the acting are both faultless. There are about forty performers, including men and women. In the opening scene the men and women are arranged in tiers, one above the other, and when they burst forth, in music and song, with the beautiful chorus, "Down in Georgia," the effect is sublime. Mr. Wallace King did full justice to the song "Scotch Lassie Jean" the words of which are full of beauty and pathos. The efficient chorus lent a charm to the rendering. Mr. James A. Bland sung, "Oh, Dem Golden Slippers" with great sweetness and judgment, the chorus joining in. The words are replete with simplicity;' and like a nineteenth century *Smash Hits*, the report follows on with the song's lyrics.

On the 4th August 1883 the *Manchester Times* reported the 'annual visit of Hague's Minstrels' for their Saturday night entertainment at the Free Trade Hall 'which was well filled in every part.' The best songs, the report continued, were 'undoubtedly "The Diver," by Mr. J. Dornan; "Hark, the clarion" by Mr. E. Stepan; and "The golden slippers" which was sung by its composer, Mr. James A. Bland.' After some "banjo eccentricities" and clog dancing 'by Mr. T. Ward, the champion clog dancer of the world,' Bland appears again at the end of the show with an '"absurdity" and the entertainment was brought to a close with a farce entitled, "Bounce," which created roars of laughter. Altogether, the entertainment was highly amusing.' He's mentioned again in May 1890 in the *Era's* 'Provincial Theatricals' listing, appearing at Blackburn in a show called 'London Day by Day.'

According to a biography, by the start of the 'gay 90's' the thirty-six-year-old Bland, 'had taken London over completely.' But his style of songwriting eventually faded from fashion and he is mentioned no more in the press. As is the way in life, he felt the call to return home to Washington to live out what was to be his final decade. His last move was to Philadelphia where he died of tuberculosis in 1911 in near poverty and obscurity. As the twentieth century progressed without him small signs that Bland's work might yet be remembered started to show. 'Carry Me Back to Old Virginny' was emblazoned in an advert for the film of the musical 'Maytime' in the Burnley Express in November 1937. The fact that one of Bland's songs was highlighted as a draw for British cinema goers (there's no mention of the song in the American adverts of the film), proved his impact still lingered. But

perhaps the film was the beginning of a revival as three years later 'Carry Me Back to Old Virginny' was made Virginia's state song, and with Ray Charles' cover version in 1960 it was placed in the annals of the greatest ballads on the subject of longing for home. In 1970, Bland was entered into the Songwriters' Hall of Fame.

The Canadian-Caribbean Bohee brothers formed their own spin off act. So delighted was the response to elder brother James' banjo playing that the Bohees' popularity reached every part of British society, from the street corner barrel organs cranking out his most famous tunes, all the way to their most elevated fan, 'Bertie' the Prince of Wales. The future King Edward VII had played the banjo since youth, and invited James to the palace to give lessons – or as the press put it, 'to tickle the banjo-strings a l'americaine.' In a double act with his brother George who was armed with a fine tenor voice, the renamed 'Royal Bohee Brothers' took London by storm. Dressed in 'silk costumes of gay colors, high silk hats and with banjos over their shoulders' the brothers were often seen in a carriage driving down Piccadilly, with a tandem of horses and 'an attendant in livery that would knock your eye out.' They were entertained by society hostesses, 'patronised by Earls and seduced by Countesses.' For a time, they took over The Gardenia, 'an elegant night haunt in Leicester Square.' One of Jim Bohee's favourite spots was the Criterion where he was known for ordering champagne in a cultivated English accent, supping the 'effervescent top,' letting 'the greater part of the wine remain in the glass.'

As with all royal interests and fashions playing the banjo became highly desirable, a craze in fact, and the authentic sounds of the American south were heard in drawing rooms all over London. Seventy years before Lonnie Donegan strummed the banjo to his skiffle hit, 'Have a Drink on Me,' upper class ladies were learning old Americana songs as part of their repertoire of accomplishments. His skill was so much in demand that James set up a banjo tutoring school. On the 31st March 1887, he announced in an advertisement the opening of 'The Great American Banjo Academy. By the Paganini of the Banjo.' The advert went on to detail, 'James Bohee has opened a first-class Academy, at 7A Coventry Street, opposite Prince's Theatre, where he will teach the five string Banjo to Ladies and Gentlemen. Mr. James Bohee, who has had twenty-five years' experience as a Solo Player, and who has brought the Banjo to the level it has now attained as a classical instrument, can be seen from Ten a.m. till Six p.m. The only Banjoist in London who has had the

honour of appearing by special command at Malboro' House before Their
Royal Highnesses, THE PRINCE AND PRINCESS OF WALES.' He also
had a line in selling banjos and their paraphernalia, as the advert went on in
smaller print, 'The Great American Banjo for Sale,' plus, the 'Finest
American Strings and Banjo Thimbles,' with the reminder that, 'The
Celebrated Bohee Brothers can be engaged for First Class Drawing Room
Entertainments' before signing off, 'The Public Humble Servant, James
Bohee.'

After a stellar London season of three hundred consecutive performances,
the 1890s saw the brothers take off for a national tour that kept them from the
West End for eight years, earning them 'hundreds of thousands of dollars' and
securing them as a British institution. Known variously as the 'Bohee Operatic
Minstrels' with a large cast, or 'The Royal Bohees' as a duo, they toured
provincial town halls and theatres with a repertoire of antislavery protest
songs, cakewalks, minstrel songs, the old favourite, 'Home Sweet Home' and
the more recent song 'A Boy's Best Friend is his Mother.' They headlined at
theatres in the Isle of Wight, Eastbourne, Brighton, Hastings (returning five
times), Jersey, Guernsey, Aldershot, St. Albans, Bury, Bristol, Derby, York,
Sunderland, Morpeth, Greenock, Glasgow, Cupar, Dundee, Edinburgh,
Belfast, Derry, Dublin, Louth, Waterford, Cork, Lisburn, Cardiff, Swansea,
Glamorgan, Abergavenny, Uxbridge and Bexleyheath. When they played to a
packed house at the Star of Erin in Dublin, their rich harmonies and mournful
playing were 'so moving that they actually cried and the Audience wept with
them.' On their return to the London Pavilion in March 1896 'the enthusiasm
of their reception was instantaneous.' James played, '"The Banjo March"' and
'was cheered to the echo, but after he played "Yankee Doodle," finishing with
"Rule Britannia" the great audience arose en masse, and made the Pavilion
ring with their plaudits.'

When James died of pneumonia whilst on tour in Wales in December the
following year it was the end of an era. The brothers had been a part of British
entertainment for seventeen years. George tried to continue with the 'Operatic
Minstrels' but without James the act was not the same. Instead, he tried
touring the Moss Empire Theatre circuit as 'The only George B. Bohee,
Banjoist and Vocalist (late Royal Bohee Bros.). One of the first to appear by
Royal Command before T.R.H. The Prince and Princess of Wales, now the
King and Queen of England.' He also made cylinder recordings with
England's first phonograph company, Edison Bell, in Liverpool in 1898 but

sadly they remain in catalogue reference only, the rolls themselves never survived. In the March census of 1901, we find him lodging alone at a house in Stockport, Lancashire; ten years later he is down as a 'visitor' at a boarding house in Grimsby, now married and accompanied by his wife Kathleen Bohee, born in Hull, aged 24, occupation - music hall artist. Curiously, *The Era* published a 'Notice' on the 19th August 1914 that read, 'If George B. Bohee, late of Bohee Brothers, will communicate with Mrs. George Bohee, care of General Post Office, New York City, U.S.A., he will hear of something to his advantage.' Whatever it was must have pulled George back home; that, or the outbreak of war in Europe, because in 1920 he was spotted in New York by an old acquaintance from the London years, leaning against the wall of a 'moving picture theater on Broadway,' white haired, debilitated, a ghost of his old self wistfully remembering 'the days of forgotten glory.'

Playlist:

Mr. Bojangles – Sammy Davies Jr
The Rainbow Connection – Kermit the Frog
Come On Eileen – Dexy's Midnight Runners and The Emerald Express

9

The People's Artist

*...in England, I learned that there truly is a kinship
among us all, a basis for mutual respect and brotherly love.*
Paul Robeson, Here I Stand, 1958

One hundred years after Ira Aldridge fled New York a Black American arts scene outside of the hugely popular minstrel format was finally starting to build in the city. In the upper west area of Manhattan, a property development boom of the 1880s that went bust in the 1890s opened up the rental market to African Americans as smart, newly built brownstone houses stood vacant. Thanks to the stealthy efforts of the real estate businessman Phil Payton Jnr and his alliance with Jewish landlords, the Owners' Protective Association of Harlem, established with the single aim of keeping their neighbourhood white, was outmaneuvered. Black New Yorkers finally had access to decent housing and were able to move out of the slums of Hell's Kitchen, and the area became a natural gravitational point for ambitious artists, politicians and intellectuals who manifested a phenomenon known as the Harlem Renaissance.

The Harlem Renaissance was a period of extraordinary cultural development for African Americans, built on the groundswell of the Great Migration and the shutdown of New Orleans' sporting houses. With its all-night clubs and drinking joints, the creative energy of the Renaissance was embodied by some of the greatest names of the 20th century, Louis Armstrong, Duke Ellington, Billie Holiday, Cab Calloway, Count Basie, Coleman Hawkins, Ethel Waters, Bessie Smith and Fats Waller. In the mix of the musical innovation were the Harlem intellectuals: the poets Claude McKay and Langston Hughes, the playwright Eugene O'Neill, the photographer and novelist Carl Van Vechten, the novelist and playwright Gertrude Stein, and Alain Locke, author of the 1925 publication, *The New Negro* that proclaimed the African American no longer held the 'status of beneficiary and ward' but who was now 'a conscious contributor...a collaborator and participant in

American civilization.' Black and white, the Harlem intellectuals were all united by a common feeling: that by the exploration of their art, African Americans would begin to be recognized for their valuable contributions to American society, or as Paul Robeson put it, 'it is through art we are going to come into our own.'

Robeson is barely mentioned in British entertainment history, which is surprising, because for many decades he was a huge star. As a man of great presence, humanity and global fame, the story of his life comes in two parts: before his cancellation by the FBI and after, with his later years seeing the steady erasure of all that he once was. His father had escaped a North Carolinian plantation at the age of fifteen and went on to become a Presbyterian minister in New Jersey, while his mother was of the notable Bustill family of Philadelphia, who were a mix of African, Native American and white Quaker heritage. In 1787, great, great grandfather Cyrus Bustill founded the Free African Society, had children and grandchildren who became teachers, artists, activists, writers and scholars and 'in the Quaker tradition' helped with the running of the Underground Railroad, the route by which a future Bustill son-in-law was to escape to the north. The impulse to think, act and lead was in Robeson's blood.

Robeson chanced upon his destiny when he moved from his home town of Princeton to Harlem in 1919 having graduated from Rutgers College as an all-round star student. He had moved to the district to study law at Columbia University but for kicks he joined a small company of Black American amateur players whose ambition was to produce 'plays of their race' and he caught the Harlem spirit and switched to pursuing an acting career. The Renaissance was a glorious time for African American artists, but there were few acting parts for actors with Robeson's ambition. The bandleader and composer Noble Sissle and pianist Eubie Blake created the first all African American hit musical *Shuffle Along* in 1921 staged at the Sixty-third Street Theatre with its most famous number 'I'm Just Wild About Harry,' and it became the longest running musical to be composed, produced, directed and performed by an entirely Black company. But in the realm of serious drama, opportunities for Black actors to work with whites were few and there was scant investment in developing plays specifically for Black actors and audiences. Hollywood was little better; film roles on offer were usually either servants or comedy cameos.

By the time Robeson made his London stage debut in 1925 he had

already reached a glass ceiling in the States. Harlem was a crucible of intellectual progressive ideas but it had yet to have much impact outside of Upper Manhattan and Greenwich Village. Still, even in the Village he'd had to contend with bullying threats from the Ku Klux Klan before he had even stepped on stage in May the previous year. Robeson was about to commit the sin of performing a chastely intimate role with a white actress in *All God's Chillun Got Wings*, Eugene O'Neill's fifth of the six plays he wrote exploring the Black American experience. During a brief Broadway run playing the lead in O'Neill's *Emperor Jones* Robeson was approached backstage by the English producer Sir Alfred Butt who was interested in transferring the play to England. Contracts were arranged and agreed and by the beginning of August, Paul and his wife Essie were on a steamer to England where, they had been told, 'there will be no prejudice,' to which Essie confided in her diary, 'Here's hoping.'

Emperor Jones opened at the Ambassadors Theatre in September and at the curtain call, Robeson, a man of towering height and charisma to match was called back a dozen times, encouraging him to finally say a few words after which the audience 'stood up and cheered and shouted.' The reviews were equally rapturous; from the *New Statesman*, he was 'magnificent,' the *Times*, 'superb,' the *Tatler*, 'singularly fine,' although the *Manchester Guardian* thought his performance 'too intellectual.' The play received a generally quizzical look by audiences who found O'Neill's writing too overwrought and morbid for English taste but Robeson's reputation spread among the glitterati. For Essie, England was a revelation. She found it 'warm and friendly and unprejudiced' and 'that here in London…as respectable human beings' they could 'dine at any public place' and sit in any train compartment, or take a seat in any part of the theatre, not just high in the gallery. Once the play closed the Robesons stayed on for two more weeks to enjoy the city. They went to the theatre and dined with composers, actors and actresses, but most significantly of all, they spent an afternoon with Ira Aldridge's daughter Amanda, by then almost sixty and an established opera singer, teacher and composer. She had written to Robeson to offer her congratulations for his performance and at their meeting, she presented Paul with a precious talisman from the collection of her father's belongings - she gave him the earrings worn by Aldridge when he performed Othello, in the hope, she said, that he would one day play the part.

All through this period, Robeson had been developing and arranging a

repertoire of African American spirituals and folk songs with the composer Lawrence Brown. He had met Brown in London back in 1922 when Robeson had his first taste of England whilst touring with *Voodoo*. Prior to the show's opening in Plymouth he'd stopped over in London to stay with a Harlem acquaintance, whose other houseguest happened to be Brown. Brown was already a veteran of London's recital circuit, and he and Robeson discovered a creative marriage of mutual delight - Paul at Larry's authentic arrangement of Black spirituals and Larry marveled at the beauty of Paul's voice. The happenstance of meeting Brown was the beginning of a musical discovery for Robeson. The composer helped him to see the value in the songs of his childhood passed onto him from his preacher father, 'the great poetic song-sermons' and the folk songs and blues he'd learned whilst working on a plantation in North Carolina and that they should form the body of work upon which he could develop his career as a singer.

The late 1920s saw London's entertainment world brimming with Black celebrities who had migrated from the hot house of Harlem to the open fields of northern Europe. It was a period highlighted by the first on the hoof, short notice charity concert given by a collective of musical stars. Christmas 1927 had seen a dump of heavy snowfall in the south and south west of England, then southerly winds brought a sudden thaw on New Year's Eve turning the snow to melt water, which, combined with a high tide and a storm surge in the Thames estuary and unusually heavy rainfall, caused the Thames to burst its banks in the early hours of Saturday morning on the 7th January. The subsequent flood put Southwark's, Lambeth's and Westminster's surrounding slum streets and grandest buildings under more than four feet of water, drowning fourteen people in their cellar dwellings and making thousands homeless.

Noble Sissle happened to be in London on the night of the disaster and through his network of friends and associates he pulled together a concert to raise funds for the flood victims. The show took place three weeks later at the London Pavilion Theatre in Piccadilly with the singer-songwriting team Layton and Johnstone top of the bill. The duo had been London residents for four years and were one of the country's most successful music acts. Like the Bohee Brothers, Layton and Johnstone appealed to all classes in Britain: from the crowds of the Hackney Empire to the crème de la crème of society at the newly opened Café de Paris. Joining them that afternoon were Leslie 'Hutch' Hutchinson, the Four Harmony Kings, and the jazz and blues singer Alberta

Hunter who flew in from Nice. Hunter had been working the chic clubs of Paris and the Cote d'Azur for several months but her real aim was to get a work visa to perform in London and her chance came when Sissle promised the visa problem would be dealt with by simply mentioning the Lord Mayor's name at the passport check point. Another last-minute surprise guest was Josephine Baker. Sissle had given Baker her big break when she was cast in *Shuffle Along* back in the States and he convinced her to fly in from her residency in Paris. Despite the fact she had been performing all through the night, Baker boarded a plane in the early morning to arrive just in time for the 3pm curtain up on Sunday 29th January for what was announced as 'the greatest all-star coloured show.' They raised an astonishing £1,000 for the Lord Mayor's Flood Relief Fund, and Sissle made the donation in honour of 'The Queen of Happiness,' Florence Mills. The Washington born cabaret star had died of tuberculosis at the age of thirty-one just three months before. The tender-hearted Mills had performed many times in London and 'at the height of her fame' she was known to go out 'to the Embankment night after night, distributing help to the derelicts.' It was a fitting salute.

Alberta Hunter's fixation on getting to London proved out and her support for the fundraising endeavor was returned to her tenfold; or perhaps, it was her now or never chutzpah to make the most of an opportunity. When she took to the stage that afternoon, in her own words, she 'tore up the place' and 'put my foot down and went to town,' singing 'Just Another Day Wasted Away' accompanied on the piano by 'Hutch.' It turned out it was one of those legendary moments on which the anything-can-happen-if-you're-in-the-right-place-at-the-right-time dream of show business success is built. Jerome Kern and Oscar Hammerstein were in the audience jotting down names of performers who impressed them, and just under three months later, the call came of an offer of the part of Queenie playing opposite Robeson in their London staging of *Show Boat* scheduled for a spring opening.

Robeson's rendition of the show's big hit, 'Ole Man River' with his magnificent bass-baritone voice marked his third return to the British stage and it confirmed him as the toast of London's theatrical world. He and Essie took a flat in St John's Wood with a view of Regent's Park as he received continual offers of concert work with Brown: a matinee performance of spirituals was given to a packed audience at the Theatre Royal and invitations for private recitals came in from the M.P. and owner of the *Daily Express*, Lord Beaverbrook, the society host Sir Philip Sassoon and Lord Curzon's

daughter, Lady Irene Ravensdale. In their private time, he and Essie went to
the opera at Covent Garden and to a ballet conducted by Stravinsky; they had
front row centre court seats at Wimbledon to witness Rene Lacoste beat Henri
Cochet, and watched Learie Constantine, the West Indian cricketer who was
destined to be Britain's first black peer, come to bat at the Oval. When an
admirer of Paul's, the Countess des Boullett, offered the Robesons the use of
her house on Carlton Hill in St John's Wood for a pepper corn rent (with a
cook, maid, gardener and best of all, central heating) they celebrated by
throwing a fabulous party coinciding with a visit from old friends from the
Harlem circle, Carl van Vetchen and his actress wife Fania. In a letter to
Gertrude Stein, Van Vetchen wrote 'There was a great deal of food and much
champagne…Everyone radiated happiness' and Paul sang to the crowd that
was a stellium of British and American talent and London's high society -
Fred and Adele Astaire, his *Voodoo* co-star Mrs. Patrick Campbell, the
American publisher Alfred Knopf, Layton and Johnstone, Alberta Hunter, the
actor John Payne, Hutch, Lady Ravensdale, Lord Beaverbrook, the actress
Constance Collier, Ivor Novello and the novelist, Hugh Walpole. Details of
the party made front-page news of America's first Black newspaper, the
Chicago *Defender*.

It was Paul's intention to stay in England and develop a serious film
career and indeed, British films companies continually offered him lead roles.
But they were characters that still played into the old colonial imagination. He
was offered the part of the African chief Bosambo in the Korda Brothers 1935
film *Sanders of the River*, and to Robeson it had initially shown great promise.
Zoltan Korda had footage of African music, speech, dancing and rituals he
had filmed during the five months he spent in Central Africa that so impressed
and delighted Robeson, especially of the music and dance, he imagined that,
'Americans will be amazed to find how many of their modern dance steps are
relics of an African heritage – a pure Charleston, for instance, danced in the
Heart of the Congo.' Re-creating a Congolese village in Shepperton, the
Kordas employed two hundred and fifty African and West Indian men and
women as extras drafted in from towns around Britain and they used authentic
African song for the soundtrack. It was all shaping up to be a production that
might finally honour African custom and culture without sensationalizing it.
But that was exactly what *Sanders of the River* did, signaled by the film's
trailer exclaiming, 'A million mad savages fighting for one beautiful
woman!...until three white comrades ALONE pitched into the fray and

quelled the bloody revolt!' The film did well at the box office but left Robeson disillusioned and embarrassed to have been in it; he was criticized by the Black press for having given his name and time to a movie that, ultimately, patronised Africans. He admitted he had 'committed a faux-pas' and stated conclusively, 'I hate the picture.'

The fledgling Hammer Films' third production *Song of Freedom* was one of just two films he made in England in which he took any real pride. He played the role of a British born dockworker called John Zinga, 'a man of charm and intelligence' who, by the ol' happenstance plot twist, is overheard singing in the street by an opera impresario who then helps Zinga go onto to have an international career as a concert singer. Further to that, by another twist, the carved icon that he has forever worn around his neck is, in fact, an ancient heirloom from the eighteenth century that declares him to be the rightful king of the African island of Casanga. The film ends with Zinga taking up his birthright bearing the wealth he has earned from singing and western medicine to help his people. The reviews were good all round and Robeson liked the final cut, for the film portrayed the straightforward, everyday life of a black British man for the first time. The Pittsburgh *Courier* concurred and wrote that *Song of Freedom* was indeed the 'finest story of colored folks yet brought to the screen...a story of triumph.'

The commonality Robeson felt with British working people first came to him through song, specifically Welsh song. Back in the winter of 1929 he had come across a procession of unemployed Welsh miners who had marched from the Rhondda valley to London to protest the closure of the mines and the lack of poor relief. He heard them before he saw them; the distinctive tones of Welsh harmonies, as the miners walked the street with their banners aloft singing for spare change. Robeson instinctively fell in, standing out somewhat dressed in a dinner jacket having just left a society event, and sang to them in return well-known ballads, spirituals and 'Ol' Man River.' There is never one moment in a person's life that leads to an epiphany; more a collection of moments. This was certainly a moment. One of the crucial freedoms Robeson took full benefit of during the years he lived in England was the liberty to express a political view. Robeson was as much an activist as he was an artist, and as his beliefs took shape, he developed a muscular commitment to expressing them.

From their London base, he and Essie travelled all over Europe, observing the sinister developments in Germany and Spain, and to Russia, delighting in

what seemed like a society that had achieved perfect equality with an absence of racism. Their first visit in December 1934 began Paul's love affair with the Soviet Union and of his coming to the conclusion that the practice of socialism was the way to achieve liberty and equality for his fellow Black Americans. He and Essie were received as V.I.P.s and treated to a fabulous two week stay experiencing the best of Russian society. They were given a suite at the National Hotel on Red Square and enjoyed 'Nights at the theatre and opera, long talks with Eisenstein, gala banquets, private screenings, trips to hospitals, children's centers, factories.' The Robesons were presented with a Soviet success story. It confirmed to them the federal union did indeed have the right balance of cultural egalitarianism and social responsibility, all supported by new, seemingly advanced economic models, and agrarian reform depicted in poster campaigns showing steady, strong-jawed men and bright-eyed, plump cheeked women standing triumphantly with a healthy cow or abundant bushels of corn in the foreground of an epic-scale, colourful wonderland of industry and plenty. Robeson visited Russia several times over the following years, embedding himself more and more into the Soviet mind-set and reorganising his time between moneymaking concert tours of Britain and his political activity.

On the afternoon of Monday, the 26th April 1937, Germany demonstrated its support of Franco by giving its new Luftwaffe fleet a test run. For three straight hours, the people of the pretty medieval town of Guernica in Basque were saturated with 1,000lb bombs, hand grenades and machine fire by Nazi mercenaries without mercy, an unprovoked civilian attack designed to terrorise the Republican government into surrender. Hundreds were killed, many more hundreds were wounded and the town burned for days. The British government was undecided how to respond. While it condemned the attack, Britain and France stopped short of taking action for fear of escalation; to act would break the 'non-intervention' treaty they had signed the year before, even though Germany and Italy had smashed it to pieces. Instead, the British people took up the task of getting Basque children out from the civilian territory that was now a war zone and ferrying them to England. Once there they were taken in by children's homes all over England with funds raised by the Salvation Army, churches and convents, trades unions, the Labour Party, co-operatives, youth groups, local benefactors and general tin rattling. The lack of decisive intervention from the British government to aid the Republican cause spoiled the love affair between Robeson and the

Establishment. Their indifference, Essie wrote in a letter to a friend, 'has soured us, and we despise them openly.' Robeson made a point of appearing at various fundraisers including the International Peace Campaign at the Royal Opera House and the Basque Children's Committee, and in January 1938, he flew into a ravaged Barcelona for a four-day morale boosting tour of the Republican-held east. From here he made a public statement to the world's press that he 'could not understand how the democracies of Britain, France and America can stand by inactive.' His London agent, Harold Holt, advised him to be less politically visible in fear of it harming his career. But neither did Robeson heed the advice, nor did it harm his career. That same month he made his second appearance at the Royal Albert Hall to yet another packed house that welcomed him such an extended round of applause that Brown had to play the introduction music twice through. Robeson was deaf to persuasion, for by his own admission, 'something inside' had 'turned.'

With his earnings remaining steady from his concerts with Brown, he could now afford to take acting work that satisfied his principles. The Unity Theatre was one such theatre group that aligned with all his beliefs. It was founded by the Rebel Players and Red Radio that evolved out of the Workers' Theatre Movement in Britain, itself under the influence of the Soviet arts scene. For Robeson the group's appeal lay in the fact it maintained itself as an amateur enterprise to avoid the censorship of the Lord Chamberlain, and provided him the chance to work on something other than a distributor sanctioned movie script. Their shows were held in a hall on Goldington Street, near King's Cross and in the summer of 1938, Robeson took the lead part in *Plant in the Sun*, a play that charts the ascent of union power in America. To add to the realism, the supporting cast was made up of working-class men and no-one was given star credit, in fact all the players were nameless. Almost twenty years before the social realism of the 'Angry Young Men,' the Unity Theatre put together a tight study of the working man's life and with Robeson in the play, not only was the run a four-week sell out, there was the added *frisson* of society theatre goers mixing in with the working-class audience, a sight not seen since the high days of music hall. With his easy smile and courtly manners, Robeson was one of the first big stars in Britain to balance a controversial political persona with one as a hugely popular entertainer. *The Star* and the *Motion Picture Herald* placed Paul in the top ten recording artists and a British film star popularity poll respectively, as audiences around the country flocked to see him. When Paul and Larry went back on tour for what

would be the final time in Britain, hundreds had to be turned away from the box office in Eastbourne; in Torquay, police were needed for crowd control, whilst the huge queue to see him in Glasgow confirmed Robeson's desire to be the 'people's artist' had been fulfilled.

During the almost ten years since he had spontaneously joined the miners' march, he had been drawn to the Welsh identity for all the qualities by which defined Robeson himself; for 'their ethnic insistence, their strength of character, their political radicalism' and of course, their love of harmony and song. It was fitting, then, that Robeson's final film in Britain was a story of the daily hardship and danger faced by Welsh miners. The script for *The Proud Valley* was developed from a story by the Polish sculptor Alfredda Brilliant and Herbert Marshall, who had directed Robeson in *Plant in the Sun*; it was co-written by a diversity of personalities: the novelist Louis Golding, the screenwriter and actor (and father of Dr. Who) Roland Pertwee, the Welsh miner, politician and trade union leader Jack Jones and the film's director, the young Chelsea born, Eton educated Penrose Tennyson. Tennyson, who was to tragically die in a plane crash a year after the film's release, told the press that the reason why Robeson agreed to the film was that his character, David Goliath was an ordinary working man. The film was shot on location in the Rhondda Valley with the supporting cast made up of local residents, and the weeks he spent there in the community made Robeson realize that, coming from a working-class background himself, he had 'found the hand of brotherhood here among these working people in Britain' and that there was 'a closer bond between us than the general struggle to preserve democracy from its fascist foes.' To Robeson and his new friends, class division was as much a battle of import as fighting the Nazis.

The Proud Valley came out to rather damning reviews, with Graham Greene leading the charge writing in the *Spectator* that Goliath was a, 'big, black Pollyanna' who raised everyone's spirits before nobly dying at the end. Its release was further hampered by Robeson's now ex-acquaintance, Lord Beaverbrook who had banned any mention of the film in his newspaper. Beaverbrook held a grudge for he could not swallow the fact Robeson had pinned the Molotov-Ribbentrop pact of 1939 on Britain's failure to support Russia in the face of Nazi aggression. The film flopped at the box office and rarely appeared on Sunday afternoons on British television in the decades following (it's now shown on the *Talking Pictures TV* channel quite frequently). But the fine and noble intentions of *The Proud Valley* remain,

depicting the values of working-class unity that Robeson stood for, that the screenwriters, Tennyson and Ealing Studios supported, and is a landmark in the history of British film for airing those values on the big screen.

With the onset of World War II and the growing urge to fight for civil rights in his own country, the Robesons returned to America. They settled back in their old neighbourhood of Harlem and just over two weeks after his return, with one single radio broadcast, Robeson became a superstar in the States. He had been asked to sing 'Ballad for Americans' for the half hour radio programme *Pursuit of Happiness* on CBS. It was a rousing, patriotic folk ballad of the old style with multiple verses, and lyrics that expressed the national state of mind. Its impact was swift and complete. After the broadcast CBS's switchboard was jammed with hundreds of listeners asking for it to be aired again. The song was broadcast once more on New Year's Day, after which Robeson recorded it for Victor Records and it became an unofficial national anthem. But the America Robeson was welcomed back to preferred to keep its social distance. He was nationally celebrated, yet he was still required to hide in hotel rooms to have dinner with visiting friends. Gently, he insisted on his natural rights. When he collected an honorary doctorate from Hamilton College in January 1940, he read out some of the lyrics of 'Ballad for Americans' to re-emphasise how 'wide in human terms is our civilization' and that he himself felt, 'so much a part of all America.'

In the same spirit, he took on the role of 'Othello' for the second time. The first had been a rather blighted production at the Savoy Theatre in London back in 1930, with odd direction and lighting so unhelpfully dim to set a gothic scene that neither the actors could barely see to cross the stage nor the audience divine what was going on. More than a decade had passed since, and after studying the role in the intervening years he had the urge to give it another, proper try. The American-English actress and director Margaret Webster had seen the Savoy run and agreed with Paul. Not only was he ready and in his prime, the time was absolutely now for a man of colour to play Othello on the American stage.

At first, he and Webster struggled to find a theatre that would agree to it; all the Broadway managers passed. Instead, they took their search into the country and two little theatres came forward that would - the Brattle Theatre in Cambridge Massachusetts and the McCarter Theatre in Robeson's home town of Princeton. The husband-and-wife team Uta Hagen and Jose Ferrer were cast as Desdemona and Iago, and the well-regarded Webster played

Emilia. They rehearsed ten hours a day for just two weeks; to increase the pressure of expectation, tickets for its opening at Brattle sold out within hours. But all their anxiety translated into a hot August first night blessed with success. Robeson's charismatic interpretation of the titular lead culminated in never-ending 'bravos' at the curtain call and an applause so 'thunderous' that a reporter feared that the theatre's walls might 'burst from noise and enthusiasm.' The reviews were near unanimous, the play was 'a great artistic achievement' and the ovation 'abundantly deserved.' A *Variety* critic put his praise in the simplest terms: that 'no white man…should ever dare presume to play Othello again.'

Broadway suddenly became a possibility. With Robeson's schedule of concerts there was a year delay, but it was worth the wait. The opening night on Tuesday the 19th October at the Shubert Theatre was announced by a *New York Times* theatre critic as a night that 'has all the earmarks of a rare occasion in the annals of the Broadway stage.' Webster herself was 'paralytic with fright' at the momentousness of the event. Perhaps, she was anticipating the significance of what was to follow, for by the evening's end, the curtain call and cries of bravo went on for twenty minutes, breaking the pin-drop silent tension of an audience that had been mesmerised by what they were witnessing. Webster described the moment in a letter to her mother, and how the audience 'yelled at us through a long succession of calls and fairly screamed at Paul and finally I had to make a speech to finish it up…Then they cheered the roof off again.'

The Black American press splashed Paul's triumph on their front pages, mentioned Ira Aldridge and how, like his nineteenth century predecessor, Robeson had fought back against intolerance in the most powerful way. But a Soviet reporter turned the opening night into legend, and wrote, 'many American writers and journalists…consider the 19th of October 1943' to have been the day that 'the doors of the American theatre opened for the Negro people.' 'Othello' broke all box office records for a Broadway production of Shakespeare; on the national tour and in Canada, the company visited forty-five cities coast to coast. In an interview during the Broadway run, Robeson explained the significance of this breakthrough in his understated way, 'Shakespeare, the genius that he was, seemed to foreshadow and understand many of the problems that have since arisen in our world, perhaps were present then…here is a part that has dignity for the Negro actor, often we don't get those opportunities.'

Robeson's popularity in the States reached its zenith during the 1940's. As soon as Germany tore up the Molotov-Ribbentrop pact there was an outbreak of pro-Russian sentiment in America, with the Soviet Union recast as a heroic ally. For a brief time, Robeson's communist leanings were free to be. But with the onset of the Cold War normal service resumed and the F.B.I. worked behind the scenes making preparations for what would be an orchestrated 'collision' of the image of Robeson the superstar and Robeson 'the Communist.' They were tapping his phone and bugging places they knew he would visit (aided, no doubt by the British Intelligence which had been monitoring Robeson since 1933). In late December 1948, he accepted an offer from England to do a concert tour of the British Isles and Scandinavia. The State Department agreed to Robeson travelling only on the condition that he remained apolitical. He confirmed that he would and in early February 1949, Paul set sail to England on the *Queen Mary* to start a four-month sold out concert tour of the British Isles with Larry. Ten years had passed since he had been in England, but in a letter to Essie, Larry wrote, 'the English public seem as fond if not fonder of Paul than ever.'

Indeed, on the 18th February, the *Manchester Guardian* printed, 'It is common enough for reporters to show a somewhat desultory interest in celebrities. But to-night's great man held a ring of people so closely around him that a waitress had almost to elbow her way in to offer drinks. It was Paul Robeson. He towered above us, spoke quietly in his rich voice, and by his manner alone, forbade any but serious questions. Mr. Robeson is to visit twenty towns between the end of this month and mid April...and give a programme of songs in French, German, Italian, Spanish, Russian, Yiddish, and Hebrew...and of course, English.' It was Paul's intention, he told the paper two months later, to give free concerts wherever he visited, or charge 'just a shilling or two.' He received a 'generous welcome' when he sang at the vast King's Hall in Belle Vue, an area in the eastern part of Manchester's city centre. 'He sang a great many folk songs and Negro spirituals and his choice of music ranged from "The Magic Flute" to "Showboat." He preferred to sing popular songs' the reporter considered, 'not because he is unable to sing opera well but because he makes a point of giving the public what it wants. Mr. Robeson takes his social responsibilities seriously, and the audience were not allowed to forget the woes of oppressed humanity during their evening's entertainment. But they forgave him when he altered the words of "Old Man River" to make a political point. When Mr. Robeson returns to

Manchester on May 10 he might well leave the moralising out of his music.'

But Paul was preternaturally unable to remain politically mute. The *Bradford Observer* reported in April that when Robeson performed in Stockholm and sang the Russian anthem 'some members of the audience whistled and cat called and others walked out...at one point it was virtually impossible to hear Robeson, who continued to sing in spite of the tumult, which included loud cheers from pro-Communists.' When he returned to King's Hall in May he was introduced as 'champion of human rights' to which he was given a 'rapturous reception' by the '5,000 or so who attended.' While 'the songs were from his familiar repertoire,' his speech addressed the plight of six African Americans who were under death sentence for the murder of a white storekeeper in Trenton, New Jersey. Referring to their confessions made under duress, Robeson said, 'My work...will be to impress upon Britain and other countries that it is impossible to keep their freedom while freedom is withheld from other peoples.' Russia, he told the crowd, where racial discrimination was punishable by law, was the first country he felt, 'complete dignity.'

But the event that triggered Robeson's downward spiral, that before and after moment of his life, was a deliberately misquoted speech he gave at the Soviet funded World Peace Congress in Paris. The press duly altered his call for the Black and white workers of America to fight for peace and to refuse to go to war against Russia into an accusation that the American government was behaving as Nazis, and that Robeson had finished with a cry of a determination that all workers should have a share of the nation's wealth. This twisted paraphrase was printed far and wide and condemned him not only to Congress but also to many of his fellow African Americans who were repelled by this seemingly anti-American/pro-Russian sentiment.

The press and public contempt for Robeson reached a grotesque peak in August 1949, when Robeson was to appear at a benefit concert for the Harlem chapter of the Civil Rights Congress at a park in Peekskill, a provincial city forty-four miles north of Manhattan. The *Peekskill Evening Star* ran a series of hostile news stories and editorials on Paul and by the time he arrived there on the 27th August the atmosphere had reached boiling point. A mass protest had been mobilized to ring the concert site, blocking the entrance with cries of 'Lynch Robeson!' as a burning effigy of Paul hung from a tree. When Paul arrived in a taxi and saw the terrible scene his instinct to refuse to give into intimidation and press on; but when he saw a cross burning on a nearby hill

he relented and left.

The F.B.I. now had a body of evidence contained in a fat file confirming him to be, in their belief, an enemy of the State. By September, the writing was on the wall. Congress passed the McCarran Internal Security Act, requiring communist organisations to register with the Justice Department, and authorising the exclusion or deportation of 'subversives.' In July, he had optimistically announced a plan to return to Europe in the autumn and finally, having monitored Robeson for eleven years, under the legality of the McCarran Act and on the orders of J. Edgar Hoover, the Internal Security Division confiscated his passport. They also issued a 'stop notice' to prevent him from crossing the border into Mexico and Canada or to enter any other country for which U.S. citizens didn't require a passport. He was grounded and he, his family, friends and associates were under intensive surveillance. All the many invitations to perform in Britain, including another production of *Othello* had to be declined.

Robeson became a non-person. The F.B.I. had successful managed to sabotage his last big U.S. tour in 1949 by coercing local agents into cancelling his concerts; Madison Square Gardens wouldn't consider an event if Robeson was on the programme and all the big venues followed suit. The conservative press had labeled Robeson 'a propagandist' and even the NAACP's official magazine, *The Crisis* published an article entitled, 'Paul Robeson – the Lost Shepherd' outlining his, 'spiritual alienation from his country and the bulk of his own people.' With so many professional avenues blocked off to him Paul's concert circuit was confined to Black churches, peace rallies, progressive cultural events and union halls, more than anything for his own safety. The strain of having his life controlled by the monolithic authority of the U.S. government took its toll. All applications to have his passport reinstated were rejected without further explanation. Robeson was effectively sealed off from the outside world and for one whose lifeblood was communication, fellowship and above all, singing, the psychological pressure was acute. His annual earnings dropped from $100,000 to $6,000 and they remained at this level for nearly ten years; he became depressed and suffered a mental decline from which he never truly recovered.

The idea of the special relationship between Britain and America is often derided as an illusory sham. But for Robeson it was never more meaningful than at this lowest point in his life. In March 1956, the president of the

Foundry Workers Union told a conference in Manchester '...we are
assembled in 1956 to ask that a little book be given to a gentleman with his
photo in it and the statement that he is American by birth. Here where the
Chartists met to map the first struggle for the free vote, we launch a struggle
for the right of all human beings to leave their country at any time and return
at any time. America must get back to the principles of the Mayflower
pilgrims, who sailed from this country seeking freedom, before its name stinks
all over the world.' Manchester held a special resonance for Paul as he wrote
in *Here I Stand*, 'I recall how a friend in Manchester deepened my
understanding of the oneness of mankind as he explained how closely together
the two of us were bound by the web of history and human suffering and
aspiration. He told me of the life of bitter hardship and toil which his father
and grandfather had known in the mills of that great textile center in England,
and of the cotton which his forefathers wove linked them with other toilers
whose sweat and toil produced that cotton in faraway America – the Negro
slaves, my own people, my own father.'

The Foundry Workers' announcement was the beginning of an unofficial
British campaign to appeal to the U.S. government to liberate Robeson, for
which he extended his heartfelt gratitude. He sent a message by return saying,
'It is deeply moving for me to know that you and so many others throughout
Britain are speaking out on behalf of my right to travel, my right to resume
my career as an international artist which I began some thirty years ago.
Though I must send these words from afar, I can say that never have I felt
closer to you than I do today. The warmth of your friendship reaches out
across the barriers which temporarily separate us and rekindles the memories
of the many happy years that I spent among you.' So outraged were his friends
and associates in the U.K. that a National Paul Robeson Committee was
formed. The sponsoring council included Benjamin Britten, Anthony
Wedgwood Benn, Hugh MacDiarmid and was chaired by the journalist,
politician, and Communist Party member Tom Driberg and on the 26th May
1957, they made live broadcast history. Cedric Belfrage, the British socialist
and former editor of the U.S. newspaper the *National Guardian* organsied a
concert at St. Pancras Hall, entitled 'Famous People Say...Let Robeson Sing'
with a host of artists and literati lending their support, including Kingsley
Amis, Augustus John and John Betjeman, and together they inaugurated the
first transatlantic live broadcast.

All day there had been a celebratory build up to the broadcast. The English actress Marie Burke shared stories of her time as a fellow cast member in *Show Boat*, speeches were given by Gerald Gardiner, Q.C., by the Welsh trade union leader and communist Arthur Horner and by David Pitt, the first Black Labour party parliamentary candidate. Letters were read out that had been signed by twenty-seven M.P.s and Equity members urging the U.S. government to give back Robeson's passport. On the empty stage, a huge photograph of Paul was hung in between the Union flag and the Stars and Stripes as an audience of over a thousand people waited to see whether the experiment would work. The comedy actor Alfie Bass, a friend of Robeson's from *Plant in the Sun*, was keeping everyone entertained, when, after a few false starts, a connection was made and Robeson's voice 'suddenly flooded the hall.' The reception was clear as a bell. The crowd could barely contain themselves as he sang six songs that left Robeson close to tears and his British friends on a spiritual high. There were small mentions of the event scattered in the British press, none in the American, but the *Manchester Guardian* published an article, concluding that the concert had made 'the United States Department of State look rather silly.'

Robeson's connection with his friends in Britain became almost sacred to him during his years of confinement, most especially with the Welsh miners. The South Wales Miners Union had invited him to perform at their Eisteddfod at Porthcawl in October. Again, by the magic of telephone, Robeson was united with the Treorchy Male Voice choir and its audience in Porthcawl, for whom he sang five songs and they sang for him in return. Down the line, Robeson responded, 'I can't tell you what it means to hear you like this – it seems as though I'm really standing there right with you…and I want you to know that it is a very moving occasion. My family is here in the studio and my little grandchildren – I have a grandson and granddaughter, David and Susan, and they also send you their love. David is a good Welsh name, as you know.' Will Paynter, the president of the South Wales Miners Union signed off saying, 'Thank you very much Paul; and our best wishes to you. You know that the fervor with which we sing is no greater than the fervor with which we struggle in the cause of freedom for all peoples. And now I'm going to ask the Male Voice Choir and all this great audience to sing a song and to dedicate it to you: "We'll Keep a Welcome in the Hillsides."' Robeson's son, then aged 30, was there that day and he remembered, 'As we were engulfed by the wave of affection surging from the voices of the choir, joined by those of thousands

of people from the mining valleys of South Wales, there wasn't a dry eye in the New York Studio.'

Playlist:

Your Feet's Too Big – Fats Waller
Scandalise My Name – Paul Robeson
If You Tolerate This Your Children Will Be Next – Manic Street Preachers

10
Coal Town Crossroads

Music is unifying; the marketing of music in the early twentieth century was not. With the birth of the music industry the Black string tradition began to fade. Like the population, the music became segregated. Jazz, blues and gospel of African American creation were sold as 'race' music and for the white folks, they had their 'hillbilly' banjo and fiddle tunes. The Okeh label recorded several sides of the Black hillbilly band the Mississippi Sheiks in the 1920s and 30s, and DeFord Bailey was a pioneering country artist released on both the 'race' and 'hillbilly' labels for RCA but, by and large, the market was simplified. Black string bands gave up and moved over to playing the blues for a chance to be recorded and the Black hillbilly scene faded into history. It was a neat division that erased the influence the enslaved, their sons and liberated grandsons who never did head north after emancipation had on the 'hillbilly' sound.

In 1820, a farmer named McClean found a lump of material that burned; he called it 'black rock,' so the local story goes, and by 1830 coal was being mined at McClean bank, near Paradise in Muhlenberg County, Kentucky. At the turn of the twentieth century, coal mining had expanded right across the Appalachians to supply the fuel for building the railroads of America. The coal companies needed manpower but they were wary of the new unionisation that was becoming 'a thing.' So, to counteract any cohesion that might form among the workers the coal companies brought in labour from as diverse regions as possible – from as far away as Italy, Poland and Hungary along with African Americans from the southern states, altering the demographic of Appalachia at a stroke.

The coal regions of Kentucky lie to the east and west of the state. Here, the coal companies quickly threw up clusters of coal towns close to the mines and along the established rail lines sometimes in just a few weeks; Van Lear, in East Kentucky and of 'Coal Miner's Daughter' fame was put up so fast by Consolidated Coal Co. a journalist coined it 'the overnight city.' These

makeshift communities of grey board houses, churches, schools, hospitals, shops, and even golf courses were not built to last and merely gave the impression of being a normal functioning society. Anyone employed by the 'company' was in hock to the 'company.' Instead of being paid in legal tender, the miners were paid in company credit, to pay their rent and to spend in the overpriced 'company store' as captive consumers destined to a lifetime of working in the mines. These strange, isolated settlements kept to the segregation laws to minimize racial violence that often flared up. But frequently, at the coal face white miners worked alongside Black and proved that beautiful developments arise from scenes of unity.

West Kentucky is famous for its 'Travis picking' - that is, the extraordinary picking technique that combines melody, rhythm and bass. It was named after Merle Travis, a bluegrass star from Muhlenberg County who made Kentucky famous for it across America in the 1940s. But in truth, the technique emerged from west Kentucky's coalfields after more than two decades of refining by multiple sets of fingers and thumbs. Which brings us to Arnold Shultz, a 'preternaturally talented' guitar player and part-time coal loader from Cromwell, Ohio County. He was born into an African American family in 1886, and to say that Arnold's kin were musical is an understatement. His parents, uncles and cousins all played at least one instrument, be it the fiddle, guitar, banjo, mandolin or piano. Uncle Jack Shultz had a homestead that was the place they all gathered 'about every Saturday night,' a friend of the family remembered and Jack, his sons Luther, Hardin, Rastus and his daughter Ella used to have big dances and barbeques for 'down at Uncle Jack Shultz's every *one* of 'em played; everyone in the family played…They had lots of house parties and of pullings. They'd have a big taffy pull, and then they'd get up with the old string instruments and so forth, and they'd start to makin' music and dancin,' and they'd have a *good* time.'

Arnold picked up music in the family home, a natural Shultz inheritance. He could play the fiddle, piano, mandolin and banjo, but the guitar was his main instrument. His half-brother, Ed, brought him one back as a present from his travels working on the steamboats and by his next return from a trip, the fifteen-year-old Arnold was as good as professional. A few years later, Shultz worked as a porter at a hotel in Beaver Dam, where the musician Paul Landrum showed him some new guitar chords, an encounter that pushed him on another step. But Shultz immersed himself in all the Black music traditions

– pulling at the strings blues-style, ragtime syncopation Amos Johnson transferred from the piano to the guitar, the open tune method, and fretting with a knife or bottleneck, a technique innovated by another little known African American guitarist, Levi Foster.

By 1918, Shultz was adept at what became known as 'Travis picking' and those who saw him play marveled at the new technique. Forrest 'Boots' Faught, another miner from Ohio County, was the drummer and bandleader of 'Faught's Entertainers.' Ignoring mutterings of local prejudice he hired Shultz as the lead fiddler - occasionally he'd get a complaint along the lines of 'you got a colored fiddler, we don't want that,' to which Faught responded, 'The reason I've got that man is because he's a good musician. The color doesn't mean anything. You don't hear color, you hear music.' When Shultz switched to playing his guitar, Faught recalled, 'People were amazed,' and he remembered saying to his friends, 'Looky there – that man's *leadin'* that music on the guitar and playin' his own accompaniment!' Faught recalled another occasion, 'Arnold Shultz showed a bunch of us one night – we were sittin' under a coal tipple – and we was playing 'I'll See You In My Dreams,' but we was usin' three chords – back then three chords was about all you heard a musician play; if he was playin' in C he'd be using F and G; they did not make these accidental chords – and Arnold Shultz says, "Throw that A in there!" And we'd start putting that A in, and he'd say, "See how much better it sounded?" That A *belonged* in there, that A chord.'

Whilst Kentucky upheld segregation laws for marriage, education, healthcare provision, streetcars and trains, out in the wilds of the coalmines, Black Americans were working alongside their white neighbours, playing together and inventing new sounds in music. As the Kentucky coalminer Mose Rager recalled, 'we've always got along, played music together, and, oh, have big gatherings.' 'The mines, back then during the Depression…sometimes, would get down to one day a week. And that's when we'd get together and get out and have parties. And have guitars and fiddles and mandolins…bass fiddles…five string banjos.' Rager goes on to describe a fantastically other worldly scene of wandering musicians colliding with each other along a coal-town track, 'You see, you could not get out of town; there weren't any roads…, had dirt roads just about everywhere…People would walk up the railroad – it was never muddy, you know, on the railroad…And me, and oh, several of the ol' guitar players…(would) get a guitar and go up to the railroad, you know, come up to a rail road crossin' and stop. And, boy,

I'm telling you: there'd be people going each way, you know, and the first thing you'd know you'd have a big crowd listenin' to you.'

When not working the mines of Rosine and Horton, Shultz was a traveler and a wanderer. He was often times encountered within the seventeen-mile radius of what has been called the Shultz-Travis region centered at Green River on the Muhlenberg-Ohio County line. He used to herald his arrival with the flourish of his guitar, and after he'd stayed for a while, he'd be picking still as he strolled off into the distance, the sound slowly fading, sometimes not to be seen again for years. He might have been found playing on the riverboats, those Dixieland 'floating dance-halls' that steamed up and down Green River or else he might have been spotted by his signature big black hat in the musical hubs of Cincinnati, Louisville, St Louis or when wintering in New Orleans. On his return, he drifted back along the railroads through the coal towns of Muhlenberg, McLean and Ohio, and played impromptu gigs. As with many of the under-the-radar Black musicians of the time, Shultz was never recorded, leaving no trace of his skill and craft. He was adept at the fiddle, he could play the blues or a waltz or a 'bouncy, cut time rhythm' for square dancers, and he could make a guitar sound like a ragtime piano better than anybody. But most of all, he was the embodiment of early twentieth century southern folk music. He synthesised the Black and white sounds of Kentucky to finesse a new style of finger picking magic that 'spread like wildfire' as it was taken up by his fellow coalminers as an absorbing distraction from the dangerous work and hardscrabble, colourless monotony of their lives. According to those who heard Shultz play, he was one of the greatest guitarists to have walked the earth.

He had an especial influence on another musical family from Muhlenberg. The Everlys had lived there since the early 1800s, working in the mines, playing music and they learned guitar techniques from Shultz. Ike Everly, 'Dad' in the famous family group of the 1950s, described Shultz as 'magnificent.' As a boy he used to follow him around and the story goes he and Mose used to crawl under Arnold's porch, listen to him pick of an evening, then go home and try to copy him. Phil and Don's grandfather, Melford, made the arrangement official and paid Shultz to teach his offspring; to Ike's sister Hattie he taught a complex guitar tune called 'The Drum Piece;' to Ike, Shultz taught the thigh-slappingly great Muhlenberg ragtime anthem, 'Cannonball Rag' that amply showcased the picking sound of the region and later became a hit in the hands of Travis.

Ike was a talented guitar player and he passed on his dedication to his sons, along with his great songbook. It was full of 'lyrics to hundreds and hundreds of songs, and he knew them all' Phil Everly remembered of his father in later years, 'and you know, we were never smart enough to ask him where he found them.' There was an unspoken assumption that the origins of the songs were Irish, Scottish or English, but when the brothers visited Ireland, they were disappointed to discover no Everly presence there, but 'everyone sort of assumed we were Irish anyway.' The Everly name, in fact, has its roots in north Yorkshire and Wiltshire, and a genealogist has traced the Everly/Eberly family tree back to Hesse in Germany; but regardless, Phil and Don, by their own admission, 'tried very hard to be Irish.' What does that mean? Well, using Phil's own words when he explained the feeling behind their songs in an interview for the 1984 Arena film, *Songs of Innocence and Experience*, it's simply expressing 'a basic truth.' 'Life is full of both happy and sad events, love and death, losing and winning.' Of Kentucky and its music, he goes on to say 'people are very honest about it. When you're happy you sing a happy song and when you're sad you sing it sad.' Phil's final thought on the subject was simply, 'you allow yourself to feel.'

Brownie, the Muhlenberg coal town where the Everly brothers were born has gone now. It served its purpose. The Peabody coal company stripped the land of its coal and moved on. But a lasting emanation of West Kentucky's ghost towns is the fellowship of the old-time musicians and the music they made. They presented an almost unique tableau of Black and white men innovating and playing together. That's the beauty of the musician's attitude, when nothing so narrow or tedious as prejudiced thinking can override their curiosity in what their contemporaries are up to.

Blurring the lines between Black and white sounds even more, Chuck Berry had his first hit in 1955 with 'Maybellene,' a reworking of the 1938 fiddle-led country song 'Ida Red' by Bob Willis and his Texas Playboys. Berry was a big fan of early country music; he knew all of Jimmie Rodgers records and a big chunk of Bill Monroe songs. The intermingling of these musical cultures happened easily and naturally. Paul Robeson spoke of his understanding of 'the riches of English, Welsh and Gaelic folk songs' and that, 'as I sang these lovely melodies, I felt that they, too, were close to my heart and expressed the same soulful quality that I knew in Negro music.' Frederick Douglass also spotted a kindredness, 'recalling the songs both "merry and sad"' sung by the enslaved on the farm where he spent his

childhood that made, 'the grand old woods for miles around reverberate with their wild and plaintive noises.' Douglass remembered, "Child as I was, these wild songs depressed my spirit. Nowhere outside of dear old Ireland, in the days of want and famine, have I heard sounds so mournful.' Almost a hundred years on, The Waterboys' Mike Scott looked at it slightly differently. 'Somewhere in the wilds of 1987,' Scott recalled, 'I saw the great Irish traditional musician Donnal Lunny playing with his big band. He was merging Irish fiddle jigs and African conga rhythms. This sounded so natural that I wondered if, at a deep level, all the indigenous musics of the world dovetail; if perhaps all are expressions of the same world soul, only with their different flavours and accents.'

Playlist:

Blue Smoke – Merle Travis
This Charming Man – The Smiths
Hit 'Em Up Style – The Carolina Chocolate Drops

11
Messages from the Mountains

In the classic Western film *My Darling Clementine*, Wyatt Earp, played by Peter Fonda, embarks on a quest to track down and kill the clan that murdered his brother. An early scene depicts the soon to be no more James Earp fondly admiring his beautiful silver Celtic Cross that he keeps wrapped in cloth. It's a talisman that brings him pride and keeps him comfort, until he is shot dead and the cross is stolen, to become incriminating evidence later in the film. Christianity tends not to be a feature of Western films, but the Celtic cross is the single, tangible image that connects early Christian Pictish sculpture with the roaming cowboys of the southern states. It represented the Clan faith, an icon of ancestral connection and of their way of life, then as now, from Moray to Ulster, to Virginia, Kentucky and westwards.

James Webb brings this journey to life in the story of his ancestors, *Born Fighting*. His five times great grandfather, Thomas Lackey was a descendant of the persecuted McGregor clan, and he and his family left Derry in 1748, settled for a while in Lancaster County, and then headed south to a quiet corner in the Blue Ridge Mountains. Many generations of Webb's family are buried in the same spot not far from Natural Bridge in Virginia, including Lackey. There's written evidence of his family's story too, as Webb goes on to describe his grandmother's eleven-page document of the family's later progress from Virginia to Tennessee, onto Mississippi and finally settling in Arkansas, with all the significant dates of births, deaths and marriages. It was with a sense of kinship and 'near-biblical storytelling' that Webb's family continued their rituals and traditions, and to remember the songs, those will-'o-the-wisps of family treasure kept alive to bring the past into the present and relive memories of loved ones long gone and the home they left behind.

As much as history is an account of change, the Texan historian Forrest MacDonald reminds us how much human nature prefers the avoidance of change and to keep constant the 'patterns of life's rhythms, rituals and belief structures.' Even after periods of outside interference these old patterns and

rituals reassert themselves, if a fraction altered. As an example, McDonald offers the make up of modern Spain and the still separate identities of the Basques, Catalonians, Murcians, Andalucians, and Castilians, despite the fact that Spain was unified all the way back in 1512. Their regional identities have survived through all manner of industrial, scientific and social advancement, leading to the conclusion that hundreds, if not thousands of years of cultural development cannot be undone by physical and mental invasions from without; it's something that remains within. Human nature loves a ritual, a long-kept tradition or special dates in the calendar, and they are re-enforced in the psyche with each new generation.

The Irish and Scottish borderers had been used to interruptions to their culture and traditions, but in America, conditions were primed for them to flourish in peace and develop a distinctly Appalachian cast. All the old living conventions were there in the new mountain communities - they were still tight, still self-sufficient, but now they had the benefit of a wide-angled, panoramic viewpoint. Buna Hicks was born on 11th November 1888 on Egg Knob, a summit in Watauga County in North Carolina and lived all her life just three miles down the road at Beech Creek. Towards the end of her life the folk song collectors Thomas Burton and Ambrose Manning led an exploration into Appalachian folk traditions for East Tennessee State University and they recorded an interview with Buna at her home in 1966. It was a project shared with Edinburgh University's School of Scottish Studies, and they were kind enough to allow me access to their archive. As I sat listening to the stories Buna told and the songs she sang, I glimpsed through a little window into the old ways of mountain living that persisted all through the twentieth century. For Buna, the mountains were her entire world; she was schooled there and went everywhere on foot, the family needing to keep the one horse they possessed for farm work. It was considered unladylike for women to play the banjo or the fiddle; instead, they were the keepers of the songs. Yet, for both the men and women, singing was not just for the evening's entertainment after supper but, like the wool gatherers of the Hebrides and the farm women of Allanaquoich, it was an inherent part of daily life – to make a mule plow if it refused to move unless it was sung to, or to signal to their children where they were, 'whether in the garden, woodshed, or in the kitchen.'

Buna learned songs from her father and then from her husband Roby, who had picked them up from his mother. She remembered, 'Sometimes we might get up pretty soon from supper; we gonna try to play a little music or

somethin' else we had to do. We'd sing and learn 'em that way more, and these stories that you hear told back in the old times. Roby's mother and all of 'em – they said after supper they sit around the fireplace and tell them tales. Now Roby he knew a lot of 'em.' From Roby she learned love songs, from her preacher father she learned spiritual songs. One song Roby taught her was Jobal Hunter ('Sir Lionel,' Child 18) a dark ballad that recalls the medieval romance of Nordic supernatural tales. A knight out hunting a wild boar encounters a 'witch wife' who claims the spotted pig he had in his sights belongs to her. He kills the boar and she retaliates by saying 'there are three things I would have of thee, your horse and your hound and your fair lady.' Understanding this was not a particularly fair deal, the knight instead 'split her head down to her chin.' To Buna, the idea of a witch loomed large in her childhood imagination, 'I've heard so many witch tales back when I was a kid a-growin' up till I really thought that there was witches. I really believed that and said that they go through keyholes, you know, and get in there and do big things.' The old ballads were lessons for living, fables of a kind, 'I guess sometimes it might help a body to watch out. Some of t'em that's sung might be a good warning to people sometimes…I think it would be a help to young folks and get the understandin' of them. It might be a little warning to a body to learn a little more about how to start out.' When asked why she sang these songs, she answered simply, 'Life's a long crawl…pretty lonesome up in that high mountain.' She sang the spiritual songs in her final years, the ones her father sang in his church services. These songs, she said, 'just give me a lift…Seems like they just make me feel real good singin' 'em, and get the understandin' of the words. It means a lot. I'm a tellin' you it does.'

The old songs were messages sent down through the ages, echoing an ancient northern European culture in and around hills and mountains that were previously void of music. In *Can't Be Satisfied: The Life and Times of Muddy Waters* Robert J. Gordon captures a musical alchemy that quietly occurred at the beginning of the twentieth century: 'Muddy Waters was raised on a musical cusp, coming of age at the time the blues was crystalizing as a genre. The catalyst was the Reconstruction period following the Civil War, when a large population of African Americans were unmoored, searching for their place, searching for their place in a society that had previously defined them as chattel. Like a kiln, this integration fired the mix of Anglo-Scottish ballad traditions and jigs (which had cascaded down the mountains and into the Delta like water into a basin) with the existing dominant form in Black music –

string bands, led by violins and banjos, with mandolins and guitars playing two-chord breakdowns. The blues, born of the frustration of freedom, began taking shape.'

No truer Mississippian was there than Jimmie Rodgers. Born in 1897, he is known and beloved mainly by country music fans and music aficionados, belonging to a shadowy age when contemporary music as we know it was flickering into life. He enjoyed just of few short years of national fame and success before his early death from tuberculosis at the age of 35. But his legacy is astonishing for a man many believed would be no more than a rambler and failure. Like Arnold Shultz, he lived a peripatetic life, taking to the railroad to find work wherever he could, hobo style, but always with his guitar and always strumming the possibility of a new song. Rodgers was another one of the early interpreters. He took the buttoned up old-time style, blended it with the new blues sensibility he learned from his railroading years, added his trademark yodel and the indefinable Rodgers charm. In his understated way, he injected what was, at the time, a new emotional clarity into his songs that was strikingly modern and he performed with a relaxed sweetness that paved the way for some of America's (and Britain's) greatest singers. It's why he's called 'the Father of Country Music.' But he's more than just the Father of Country Music. As Barry Mazor states in his biography *Meeting Jimmie Rodgers* he was the first successful artist, albeit with early twentieth century modesty by modern standards, to make a departure from straight-laced popular song that transmitted all that was nice and pleasant to become the inaugural 'pop roots music performer.'

He was born in Pine Springs, Mississippi around ten miles from the fast-developing town of Meridian, a major rail hub that was rebuilt after being razed to the ground by the Yankees. The new, thundering era of steel roads that branched like blood vessels across the USA by the end of the nineteenth century defined Rodgers' life. For aside his love of music, his other great love was working the railroad. He loved not just the life of optimistic adventure it gave him but the beauty of the trains themselves, 'powerful black monsters belching fire and smoke; smoke white, chiffon blue, blue-black; smoke shot through with crimson and gold.' He never stopped yearning for the escapism he found in that separate world with a brotherhood of workers whose camaraderie and understanding of the wayfaring life bound them together. When tuberculosis made him too weak to continue working, he presented himself as 'The Singing Brakeman;' when he became famous, he was known

as 'America's Blue Yodeler;' but privately, in his own mind, he was always a railroad man.

The development of the railroad aided America's industrial ascent but it also played an essential part in the story of the blues with its promise of mystery, romance, and possibility. It was soon after the turn of the twentieth century that first reports came in of people hearing 'strange and poignant' songs new to the ears of the young veterans of the minstrel show. For the popular bandleader, musician and composer W.C. Handy, his first hearing of a sound wrapped in desolation and spiritual mystification was, 'the weirdest music I had ever heard.' It was 1903 and the 30-year-old Handy was waiting for a train to take him home to Clarksdale after playing a tent show in the small town of Tutwiler in Tallahatchie County. In *Deep Blues* Palmer's imagining of Handy's long wait at the deserted Mississippi station gives you a visceral feeling of one of the earliest moments the sound of the blues was heard: 'in the middle of the night, the train depot, with closed up stores in forbidding lines on either side of it must have been a lonely place. Looking down the tracks, which ran straight off into the flat Delta countryside, Handy could probably hear the ghostly rustle of cypress and willow trees that were watered by nearby Hobson Bayou. The darkened stores, the trees bending and swaying over the track, a stray dog or two – it wasn't much to see.' And Handy had a long, long wait. The train was not due for nine hours and through the night, as he slept on a hard wooden bench, a man in worn out clothes appeared next to him. Handy awoke to the sound the man was making with his guitar, 'pressing a knife against the strings, to get a slurred, moaning, voice-like sound that closely followed his singing,' a sound drawn from the bleakness of its surroundings, from the atmosphere, the trees, the earth, and waiting for eternity.

The golden age of the railroad, from the end of the Civil War to the 1930s, coincided with the emergence of an African American working class. The blues was the expression of both liberation and up-rootedness that the railroad offered to the people of a vast rural country that was converting its dirt roads into 254,000 miles of track. It was also the next largest job market for African Americans after the cotton fields. But they were confined to positions as trackside labourers and porters; no African American was permitted to work as a conductor, nor could they be promoted to locomotive engineers. But at the very least, it offered African Americans a means of removing themselves from the Jim Crow south to the industrializing north, to New York, Detroit

and Philadelphia and most especially to Chicago, 'the railroad hub of the US.'
Black migration to the northern cities occurred in historic numbers after
America entered the First World War in 1917. European immigration had all
but halted and with unprecedented speed, the US military expanded its
personnel from 130,000 troops to 4 million. African Americans – and
Mexicans - were now actively encouraged to move north to man the factories,
lumberyards, steel mills and meatpacking houses. For these men, and the
young single women who were now allowed to do a man's job, live in
boarding houses, go out to night clubs and enjoy a flapper existence, 'those
factory whistles cried freedom.' Within five years, half a million African
Americans had fled segregation and the poverty of the sharecropper existence
to settle in the north, with 50,000 moving to Chicago's South Side.

The war hit New Orleans, or specifically, its entertainment district of
Storyville with a direct blow. It was customary for local barbershops, railway
stations and bars to display for sale a must-have information booklet for any
man visiting the city for a splendidly decadent time. This helpful publication,
yours for 25 cents, was called *The Blue Book: A Guide to Pleasure for Visitors
to the Gay City* and it detailed for perusal all the different 'sporting-houses'
in Storyville, their landladies and their girls. Storyville was unique. It was the
only district in all of the United States that legalised prostitution and the Blue
Book 'puts the stranger on the proper grade or path as to where to go to be
secure from hold ups, brace games and other illegal practices usually worked
on the unwise in the Red Light Districts.' Lula White's and Gypsy Schaeffer's
were two of the most scandalously high-class houses, decorated with fine
furniture, champagne on tap and mirrored parlours with hidden doors. Any
gentleman visiting these houses was entertained not only by the girls 'dressed
in their fine evening gowns,' but by the early jazz pianists of New Orleans
who were in constant employ of the Basin Street landladies, earning
handsomely in tips every evening, then working after hours in the multitude
of clubs and gambling houses.

New Orleans had a musical eco-system all of its own. It was a town built
on music with its funeral marches, dueling trumpeters, and street parades for
any life event. The New Orleans born Creole jazz pianist and composer
Ferdinand Morton, aka, Jelly Roll Morton recalled as he looked back to 1902,
the year, by his own opinion, he invented the musical style that came to be
known as jazz, 'New Orleans was the stomping ground for all the greatest
pianists in the country. We had Spanish, we had colored, we had white, we

had Frenchmens, we had Americans, we had them from all parts of the world, because there were more jobs for pianists than any other ten places in the world...it would not make any difference that you just came from Paris or any part of England, Europe, or any place – whatever your tunes were over there, we played them in New Orleans.' The end product of all this mixing and merging and reinterpretation was musical invention that off the scale, driven by the need to keep the public freshly entertained. Morton attributed his invention of jazz to the necessity for 'breaks...clean breaks and...beautiful ideas in the breaks.' He regarded his compositions, as something 'like a musical surprise...many of the most important things in jazz originated in some guy's crazy idea that we tried out for a laugh or just to surprise folks.' It was in the Storyville district that the early jazz musicians, like the Beatles in Hamburg, had their Gladwell tipping point; most especially Morton, who 'played piano all night and practiced all day' in a city where music was as free as oxygen.

America declared war with Germany in April of 1917, with US troops landing in France in June. By November, Storyville had been reclassified as a danger to the war effort. By order of the Secretary of the Navy, the district had its legal status revoked. The good time businesses were forced to close and jazzmen were out of a job. The experimental age of New Orleans was unnaturally ended and its players were forced up stream, some to join the hot jazz bands on the excursion steamers along the Mississippi, but for many, Chicago was 'the money town.' The railroad trumped the river and with a ready audience of African Americans new to the city with good money earned and feeling independence, the Southside dance halls were the ultimate destination for the New Orleans jazzmen.

The Chicago *Defender* was launched in 1905, and kept those who remained in southern states up to date with all the happenings in city, either by postal subscription or borrowing a copy from a friend. It was *the* newspaper for the African American people, publishing stories on civil liberties, sport and entertainment, and adverts for situations vacant. With the onset of the recording industry, by 1922 the paper was advertising new recordings of rural Black artists singing about rural Black concerns. Record companies were inundated with orders for the country blues and the Pullman porters were their distribution system. They'd land in Chicago, load up with presses bought at wholesale prices and run them down south selling to 'dealers and private persons,' pulsing sounds out of the city into Black neighbourhoods from

Texas to Florida where, with a nice bit of side money earned to bolster their meagre pay, the Pullman porters played their brand spanking, freshly released blues songs in their friends' living rooms on a Saturday night.

Railroading was in the blood of the Rodgers family. Jimmie's father, Aaron joined the Mobile and Ohio Railroad as a young teenager and he stayed with the company his entire working life; Mama Rodgers, Eliza, had dedicatedly followed her husband wherever his work took him, staying in the disease-ridden rail camps, which was most likely where she contracted tuberculosis that weakened her constitution. She died in 1903 when Jimmie, the youngest in the family, was around six years old. His elder brother Walter joined the New Orleans and North Eastern line and with no one to look after them at home, Jimmie and middle brother Tal were sent to live with various relatives around the borders of Mississippi and Alabama for a year or so. His father remarried and after a failed attempt at cotton farming, he returned to his old line and got a job as a section foreman, which meant extended periods away from their home base in Meridian. The fraught relationship between Tal and Jimmie and their stepmother Ida resulted in her joining Aaron in the peripatetic life of the rail camps and the young boys were sent away yet again, this time to live with their spinster aunt from their mother's side, Dora Bozeman at the family farm at Pine Springs. Jimmie's musical education came from both sides of his family. From the Rodgers side, Grandfather Zack played the fiddle and Tal played the banjo, his maternal uncle Samuel Bozeman played the fiddle. Dora was an educated, good-natured woman who had a brief spell as a music teacher, sang light opera, played the piano and bore life's disappointments with humour and grace. Jimmie's schooling was unstable and he had a tendency to bunk off, but Dora lovingly provided routine and regular meals, and by her presence instilled in him ideas of musical discipline and a light-hearted stoicism that would bare him well for the tough hand life was to deal him.

Once Jimmie was old enough to take care of himself, he returned home to live with his father and the nurture of country life was superseded by lessons of city life. Hoofing around Meridian to avoid being at home with Ida, he hung out with his uncle Tom Bozeman, who must have been cool Uncle Tom, for he was an entrepreneur who, among his many interests, opened the city's first smart white enamel tiled barber shop, that sanctified male institution where the rising stars of Meridian's elite would congregate. Jimmie ran errands for change and made chat with travelling businessmen, cops, politicians,

railroaders and baseball players, taking peaks in to the veiled adult world and flexing his youthful masculinity. He became mesmerised by the pizzazz of vaudeville and the tent shows that toured all around the southern states. At the age of twelve, Jimmie already had a 'wistful Irish charm and a cocky grin' and he entered himself into an amateur singing competition held at the Elite Theatre; with his rendition of 'Steamboat Bill' and 'Bill Bailey, Won't You Please Come Home,' he won. Bolstered by this success, he ran away with a medicine show that had stopped in town for a few days, having convinced the manager that he was indeed a professional. He made it all the way to Birmingham with the show before falling out with 'the Doctor,' by which time his father had written to him insisting he come home and find himself a proper job. Dutifully following his father's wishes, Jimmie made his way back to Meridian and signed up for the railroad, a working environment that would only enrich his desire to become a professional musician.

Rodgers was fourteen when he took his first job working as a water boy on the M&O, earning 50 cents a day carrying drinking water to the African American track workers. The routine was to break at midday for their 'noon dinner-rests' during which, as his widow Carrie wrote in the sentimental memoir of her husband's life, 'they taught him...moaning chants and crooning lullabies.' As the years passed and Rodgers worked up to the position of brakeman, he took a job on the NO&NE that stretched from New Orleans to Meridian, bedding down in the encampments that sprang up near stations where 'hoboes of all races slept, ate, talked – and traded blues verses.' Carrie was eighteen when she married Jimmie. Four years older than his new wife, he introduced her to the adult world of railroad living as a 'happy-go-lucky youngster, forever strumming and singing – when he wasn't "going high" on box cars; caring little whether he had a job or not – but loving the old smokies, silver rails and the hollow whistles from "that old smokestack."' He was a dreamer, and in love with the sound of the distant promise in those train whistles, as Carrie recalled, 'He'd jump up from the table leaving a delicious, nourishing meal to grow cold and tasteless – while he rushed outside so he could hear better, to – listen; just listen to some old smokie in the distance – "whoo-o-who-o-o-.'"

It's an unpalatable truth that war is good for business. When America entered into the First World War the railroads were nationalised and jobs with good wages were in abundance. After the war, the railroads were sold back into the prudent hands of private ownership and with the lack of freight

shipments and troops to be moved the industry contracted. The 1920s augured the lean years with wages reaching rock bottom in 1922. Laid off from the NO&NE, Rodgers took whatever job might be found pinned up on the board at the local depot and Carrie learned to keep a bag packed as she got used to boarding houses being a version of home. Other times, when Carrie was pregnant with their first daughter Anita, she remained in Meridian whilst Rodgers travelled to random towns to find railroad work or any job he could get: driving a truck for a dollar a day, working as a farmhand or washing dishes in a restaurant. He caught rides to Texas, New Mexico, Colorado, Utah, Arizona, 'going from callboard to callboard' to wherever there might be work through the first freezing, wet months of 1924, finally returning to Meridian with a cold and a brutal cough. He was back jobbing with the NO&NE when a hemorrhage he suffered in September that year finally confirmed a diagnosis of the tuberculosis bacteria that had damaged his lungs and caused internal bleeding. Throughout the rest of his life and most intensely during his final years of heady success was the backdrop of managing the advanced state of a serious illness. Intermittently he had pleurisy attacks, high fevers and orders to stay in bed for months to rest, advice he routinely ignored; not only was he pathologically incapable of taking it easy, he refused to give up doing what he loved, nor did he allow his life, whatever time might be left of it, to be defined by the disease.

The Rodgers spent so many years moving from place to place 'Wherever the night caught us,' Carrie recalled, 'that would be our home – the remainder of our lives, it seemed.' Even after success, fame and earning enough to buy their dream home, 'Blue Yodeler's Paradise' (they lived there just under two years), Jimmie's restlessness instinct for moving on never left him; perhaps a habit instilled in him as a child. When Jimmie's mother died, he was of an age when he was just starting to notice things and he knew only of being moved every few months to stay with various relatives; love and security was associated with travel, that he had to move to find it and receive it.

A different take comes from revelatory detail of the Rodgers ancestry from Jimmie's stepbrother Jake. Mike Paris and Chris Comber interviewed him in the 1970s and he confirmed the Rodgers family was Scots Irish and Dutch in origin. Another biographer, Nolan Porterfield connects the Rodgers' heritage to a related sense of 'restlessness, displacement, loneliness, and exile' and in Jimmie's case, the eternal belief that life would be better down the road. By the time he had reached the age of twenty-nine he had been married twice

(the first was a brief, youthful mistake), lost a baby daughter to illness, had failed to maintain a steady job, be taken seriously as a performer or find a life of constancy and security for his little family; 'about all he had was the clothes on his back, a warped-neck guitar, and that cough in his lungs.' What he did possess was a grasp of his own destiny, fearlessness in forcing the record companies to pay attention, and he hustled and faked it until they did.

In 1920 hillbilly music did not officially exist. The rising star genre for the decade was jazz. But when Columbia announced a new fiddle and guitar craze coming up from the south and that the new 'hillbilly' sound was there to be harvested, Victor Records, the largest and most successful record label at the time, departed from its usual output of popular tunes of the day by releasing a traditional fiddle tune. It was called 'Sallie Gooden' by Henry Gilliland and A.C. Robertson (with its hypnotic, extended high tension it brings to mind Underworld's 'Rez.' I can hear why it sold well). But there was snobbery around hillbilly music; it was not a genre Victor Records particularly wanted to cultivate. Nevertheless, witnessing the rise of this 'upstart new variety of musical entertainment' on smaller labels like Okeh, Columbia and Vocalion, Victor came to terms with it, held its nose and took the profits anyway.

Ralph Peer had been a highly successful and pioneering record producer with Okeh for six years, overseeing the release of two records that marked the twin starting points of America's modern music business, Mamie Smith's 'Crazy Blues' and Fiddlin' John Carson's 'The Little Log Cabin in the Lane.' In 1926, the thirty-four-year-old Peer approached Victor with a deal that was then an industry shaping idea and is now it's entire foundation. It also proved to be a win-win for the record company with all the money to be made from recording the new authentic sounds coming from the south, rather than the cleaned up, big-city interpretations of the vaudeville kind. Peer understood that the well-used business model of the publisher conning a songwriter out of their song (often by getting them drunk and agreeing a one-off sale of $20), taking it to a popular recording artist and pressing a record that makes everyone, except the composer, lots of money was not sustainable. Sooner or later songwriters would work out that they were being shafted, so it was bad for repeat business. He also recognised that what creates the asset or the commodity, what actually is the value of the music lies in its copyright. So, he created a new deal that would make everyone happy: contracts for new songwriters based on the price of a record. For every new release, he ensured

the recording artist was credited as the songwriter and that they would receive royalties rather than a paltry one-off payment, on the understanding that giving the artist a percentage of records sales was good for everyone's interests. He presented this business plan in a letter to Victor Records: he would work for them for free as long as he controlled the copyrights. Victor agreed the deal by return, clearly ready to take a punt on Peer finding interesting new artists in the 'hillbilly' field they were now keen to expand. The status of the singer songwriter was about to become established.

In early 1927, Peer headed south and took a new portable recording machine with him. Through February and March, he travelled to Atlanta, Memphis and New Orleans where he recorded gospel singers and the early 'hillbilly' pioneers the Georgia Yellow Hammers and the Carolina Tar Heels. But it was on his second expedition that year, a summer spent touring the Tennessee cities of Bristol, Charlotte and Savannah that Peer recorded what are now the finest classics of American song. Bristol happened to be the hometown of the band that Rodgers had been playing with, known variously as the 'Tenneva Ramblers' and under Rodgers' persuasion, the 'Jimmie Rodgers Entertainers.' They got wind of Peer's visit in late July, announced in the *Bristol Herald Courier* with a proud flourish, 'In no section of the South have the pre-war melodies and old mountaineer songs been better preserved than in the mountains of East Tennessee and Southwest Virginia, experts declare, and it was primarily for this reason that the Victor Company chose Bristol as its operating base.' Bristol had a reputation for being the epicentre of this fertile region of music. It's a twin city residing in both East Tennessee and Southwest Virginia with the state line running directly through it from east to west and sits in the foothills of the Blue Ridge and Smoky Mountains, just an hour's drive from Beech Creek where those songs had been kept alive for hundreds of years.

On the second floor of a hat company on the Tennessee side of State Street, Peer and two engineers set up his recording machine and taped a succession of locally known acts: the singer songwriter Ernest Stoneman, the old-time band Ernest Phipps and His Holiness Quartet, and The Carter Family from Maces Spring, Virginia. To drum up more local talent, Peer requested the editor of the *Bristol News Bulletin* print a re-emphasis of this opportunity for local talent, claiming that 'if you knew how to play C on the piano, you were going to become a millionaire.' He got a good response and at the end of the two-week session Rodgers was waiting in line with the Jimmie Rodgers

Entertainers who, after recurring disagreements between Jimmie and band member Jack Grant, were straining to become the Tenneva Ramblers once more. Personal issues aside, Peer's record executive objectivity spotted the combination of Jimmie's blues sensibility and the band's solidly old-time fiddle music were 'Oil and water... they do not mix' and either by his suggestion or a natural parting of the ways, the Ramblers cut some sides and Jimmie recorded alone, giving space, as Peer put it, to 'his own personal and peculiar style.'

Of all the tunes recorded at the Bristol Session, Peer evaluated Jimmie's melancholy waltz, 'The Soldier's Sweetheart' – a reworking of 'Where the River Shannon Flows' - was the safest first cut. It was released in October and sold well for a first record. But never one to let things happen by themselves, the second recording session was hustled by Rodgers the following month. As Carrie described, the 'shabby, lanky youngster with the pitiful cough and wistful smile' just happened to be in New York, he told Peer from a telephone in the lobby of the smart Hotel Manger on Seventh Avenue (whose bill, he had convinced the receptionist with shameless audacity, would be picked up by Victor Talking Machine Company). He went on to explain that since he *was* in town, and all, and had some free time he may as well give Victor another opportunity to record him. Rodgers had the charm to pull off this stunt that Peer, no doubt, saw through. Carrie imagined what Peer might have detected down the telephone line, something she herself often heard in her husband's gentle Mississippian voice, that 'underneath that painfully casual drawl, he must have sensed the repressed eagerness, wistful longing – even fear.' Peer had recognised in Jimmie a unique and individualistic talent and possessing, more likely, commerce nous than compassion Peer replied to Rodgers with what must have seemed magic words, '*Why, yes. I think we can use it now.*' His next record turned out to be 'T for Texas' and became one of his biggest selling hits. The following year of 1928 was a good one for the Rodgers family. From then on, life was never the same, that is, until his death five years later. In total, Jimmie Rodgers released forty-nine records on the Victor label, but he was never to know the magnitude of his reach. By the early 1950s his record sales of originals and reissues had totaled over ten million.

Rodgers became famous for his *Blue Yodel* songs, thirteen in all; number 9 with the unmistakable crisp, clean accompaniment of Louis Armstrong's trumpet piercing the air with the power of the undisputed champion of New

Orleans' 'carving' contests. To twenty-first century ears the Rodgers' yodel
is antiquated and very much of its time, but to audiences of the 1920s and 30s,
his particular kind of yodel - not the bracing, staccato holler of the mountain
goat herder but a tender, languid yowl at the moon - was so distinct that it
secured his fame. Another gift that marked him out was his simplicity,
something that struck me when I listened to the last song Jimmie recorded,
called 'Years Ago' that has a plaintive, boyish sweetness reminding me of
Paul McCartney. Porterfield sums up how unquantifiable are the qualities that
made Rodgers a music legend, for he, 'could not keep time, read a note, play
the "right" chords, or write lyrics that fit;' Carrie mentions at length that her
husband was 'no genius.' She puts it simply that he had '"just sort of
happened" on an unusual method of expressing the music that was in his Irish
heart,' and 'he was shrewd enough to gauge its potential value.'

Once I discovered his music, I became slightly obsessed with Rodgers.
But I could not truly put my finger on why he was so charismatic and likeable.
When you listen to him sing you can hear that his untrained voice is timeless
- straight, strong, yet clear and gentle, and carries with it a sense of ease in his
upbeat spirit; that's what his audiences fell for in the 1920s, and it's what I
fell for on hearing him for the first time in the 2016. His life was driven by
optimism and determination, and punctured by tragedy and hardship. After
years of uncertainty, insecurity and hunger, Rodgers' formula for success was
communicating truth of feeling as direct as an arrow, and with it he finally
achieved his greatest wish of all, that of 'touching the hearts of millions of
Americans, and lifting them up.'

He also gave them comfort. In 1931 Rodgers confronted reality and
recorded 'T.B. Blues.' He knew he was dying, and in true Jimmie Rodgers
style he made light of it in a song. *Tubercule baccilum* was identified in 1882
and once it was established that it was passed on not genetically but through
poor hygiene it became associated with poverty, the unclean and the wretched;
for those who contracted it, not only was it an intermittently painful and
prolonged death, it also carried the stigma of the outcast. In the first twenty-
five years of the twentieth century, it took 3.5 million lives in America. In the
year Jimmie was diagnosed 90,000 died of the disease whilst 180,000 people
were living with it. For Rodgers to sing of his 'T.B. Blues,' an 'indelicate'
subject to those not afflicted, was to declare the very thing he had been
denying to himself since the day he was told he had it. He had always been
determined that the disease would not get the better of his life, but he finally

accepted it and dealt with the hard fact the only way that eased his unconventional soul; not just for himself, but for the thousands of others who suffered, that brotherhood and sisterhood of 'lungers,' or for those who loved someone who was one.

Like Arnold Shultz, Rodgers stood right in the centre of Coleman's crossroads of Black and white worlds. But the contributions of the two musicians had very different outcomes. As Paul Robeson recognised, 'here in America there have been many who appreciated – and appropriated - Negro music while showing an utter disregard for its creators.' As a white performer Rodgers had the privilege of being free to create opportunities for himself and use ideas of African American imagination to reach a much wider audience than was possible for Black blues musicians at the time. But, in his own way, he furthered the dissemination of the blues by delivering them to the white - and, as it turned out, to the Black - listener, not by the surface appropriation of minstrelsy but with the feeling of the roots musician that he was. It was a feeling understood by Huddie Ledbetter, otherwise known as Lead Belly. But when Alan Lomax presented Ledbetter on northern lecture tours he advised him against using Huddie's 'favourite' but 'inappropriate' material of Rodgers' yodeling ballads about love and embellishments of nugatory truths; they did not fit the profile of a song catalogue gearing up to become the protest movement of the east coast intellectual left. Robert Johnson was also a fan. He would have been sixteen when 'T for Texas' was released and Johnny Shines, Johnson's partner on the road, recalled 'The country singer Jimmie Rodgers – me and Robert used to play a hell of a lot of his tunes, man, and I liked him. Robert played *all* that stuff.' The mighty Howlin' Wolf proclaimed in an interview in 1970, '*My* man that I dug, that I really *dug*, that I got my yodel from, was Jimmie Rodgers. See he yodeled, but I turned it into something more of a howl.'

I'll leave the last word on Rodgers to another blues legend and fellow Mississippian, B.B. King. He summed up the shared experience of living poor in the rural south, 'Mississippians, black and white weren't getting the best end of the stick, so we all kind of understood everybody's trouble. There was a lot of white people who felt like some of us do - and *some* of 'em weren't afraid to talk about it, or sing about it. Jimmie Rodgers was one of those people. *We* knew he was white, but that white person sounded good to me, singing the blues. Jimmie Rodgers, in my opinion, was one of the great, great

singers. He sang a lot of blues, a *lot* of blues, and he was very, very good at it.'

Playlist:

Mandolin Wind – Rod Stewart
Going to California – Led Zeppelin
The Wind Knows My Name – Fairground Attraction
Always Look on The Bright Side of Life – Monty Python
Tennessee Whiskey – Chris Stapleton

12
The Murder Ballad

*Yes, I travelled all over England – all over it, I think – but the North's
the best – Manchester, Liverpool, and them towns: but down
Bath and Cheltenham way I was nearly starved.*
Samuel Milnes, street balladeer, 1869

The reason classic blues songs were as compelling then as they are still, is that they take the listener deep into the intimate worlds of a little-known people. Suddenly, African Americans could be heard expressing their thoughts on love, rejection, infidelity, failed relationships, anxiety and loneliness. But the most iconic blues theme, one that infiltrated all kinds of pop hits, was murder. The empress of the southern tent shows, Bessie Smith recorded 'Sinful Blues' in 1924 that rang out with the declaration, 'gonna get me a gun long as my right arm, shoot that man because he done me wrong;' three years later Jimmie Rodgers' 'T for Texas' told how he fancied shooting Thelma 'just to see her jump and fall;' and in 1953 Johnny Cash sang of shooting a man in Reno in 'Folsom Prison Blues.' But none of them are as dark or unfold with as much sinister subtly as 'Pretty Polly.' It dates back to late eighteenth century England and is believed to be sourced from Gosport, a naval and munitions port that once had a reputation as a party town for sailors on shore leave, and for its wide selection of prostitutes. The song tells the creeping story of a rogue sailor who seduces the young Polly by saying they will marry. When she gets pregnant, he chooses the devil's way out and murders her before escaping to sea again. The song's menace is exposed with each verse as Polly slowly realises her fate and is stabbed in the woods by her lover who led her there, and she is left to rot in the shallow grave he had dug for her the night before, as the piteous last lines say:

"He threw a little dirt over her and turned to go home
Leaving no-one behind but the wild birds to mourn."

With its roots in Celtic-Nordic balladry, the development of the murder ballad is deeply British. George Orwell observed in his 'Decline of the English Murder' how stories in the Sunday newspapers of evil brought to justice held a morbid fascination for the British public, proved time and again by the success of Agatha Christie stories. This dark curiosity found a commercial purchase in Britain's early print media that offered blow-by-blow accounts of violence at a safe distance, and justice seen to be done. For its origin, we need to go back to late seventeenth century London, namely to Seven Dials and to its print shops. These one-room publishing houses sold newssheets and ballads on the subjects of love, royal and political scandals, satire and gossip. But it was the 'Horrible,' 'Dreadful,' 'Full Particulars' of a murder that always caught the public imagination and was milked for a broadside 'awful' in every Act: The Crime, The Capture and Arrest, The Confession, Repentance and Execution.

The marshlands of St Giles Fields had been developed by the MP Thomas Neale in the 1690s in the hope of replicating the residential grandeur of the recently built Covent Garden piazza. Seven Dials was designed with an ingenious star shaped layout of streets to maximise space and its famous centerpiece - one of the last commissions of the sculptor Edward Pierce - heralded it as an area of *Quality*. But the speculation did not draw as much investment as anticipated; as a consequence, the houses themselves were built comparatively on the cheap and quickly fell into disrepair. The area attracted not wealthy ladies and gentlemen of society but the cohort Neale had strained to prohibit, namely artists, writers, engravers, actors, prostitutes, wigmakers, watchmakers, broadside printers, book sellers, stationers, and unskilled labourers who could afford the rent for the substandard accommodation and its cellar dwellings. Huguenot craftsmen were the first immigrants to take up residence but by the 1840s, the majority of Seven Dials' inhabitants were Jewish and Irish, the former on what is now Monmouth Street with its old clothes and second hand boot shops; the latter living in the surrounding lanes and courts. That a popular sausage shop flourished at one end of Monmouth Street and a Roman Catholic bookseller at the other, Charles Knight, in his 1842 essay collection of *London*, put down to the Jewish community's 'practical tolerance.'

Over the centuries, artists and writers have been compelled to illustrate Seven Dials and its surrounding areas. Hogarth famously painted scenes of life in the back passages of St. Giles that were 'Gin Lane,' the half way stop-

off on the journey from Newgate to the Tyburn gallows for the condemned to have one last stiff drink. Dickens wrote of his love of the second-hand clothes shops on Monmouth Street and hailed, 'Seven Dials! the region of song and poetry – first effusions, and last dying speeches.' A faded gentility radiated through its shabbiness, and its chaotic, dung strewn streets were the setting for all that is beautiful and ugly in this world, as if the area was a symbol of what it is to reach for greatness and to fail, and in between lay pleasure, sensation and degradation that attracts the artistic mind to portray. As was once remarked of Seven Dials, 'The air of the footman or waiting maid can be recognized through the tatters' and it had always, 'worn its *dirt* with a difference.'

Seven Dials had a pub at the end of each of its seven passages, and there was always a ready market of idlers, drinkers and a raucous audience out to gawp at the local pillory and to whom the broadsides printers could sell their latest ballad sheet. The battle for broadside supremacy was duked out between the Catnachs of Monmouth Court (roughly where Shaftsbury Avenue now stands) and the Pitts of Great St Andrew's Street (Monmouth Street), with bitter competition and sniping false reports. The Catnachs and the Pitts were forerunners to the tabloid newspaper, publishing compressed, simplified, sensational news stories and ballads based on events as they unfolded, printed on a roughly A3 size piece of flimsy paper. The Northumbrian born Jemmy Catnach, likened Medici style as 'the Leo X of street publishers' revolutionised the broadside business. He replaced the 'execrable tea-paper, blotched with lamp black and oil' for 'tolerable white paper and real printer's ink' and he came up with the idea of selling songs by the yard.

The Catnachs hailed from Burntisland in Fifeshire and according to Jemmy, as he took another glass of his beloved whiskey, they were 'Catnach, King of the Picts. We descend in a straight line from the Picts. That's the sort of blood-of-blood that that flows in the veins of all the true-bred Catnachs.' The family business was in gunpowder mills but Jemmy's father John, born in 1769, set up a print shop in Berwick on Tweed after an apprenticeship at his uncle's printing house in Edinburgh. John Catnach published beautiful, expensively embellished volumes of ballads and natural history that would become future collector's items. But he was dogged by debt. After bankruptcy and a period in the Debtor's Gaol, the family fled to London to start afresh. Jemmy, the second born son, in youth had dreamed of a life in the Northumbrian country. He spent time as a shepherd boy and would disappear

for days and nights on the moors with his dog Venus and a notebook in hand to capture 'rhymes and chymes' on the romance of pastoral life. His move from Alnwick to London to rescue the family print business that again found itself in trouble happened in an epoch that bore plenty of newsy material to play with and newsy material was what sold. It was the end of 1813 and in a few months the Peninsula Wars were drawing to a close with victory for Britain and her allies, and a bitter defeat for Napoleon Bonaparte. But in the years following there was high unemployment, industrialization, the Peterloo Massacre, the Cato Street plot to assassinate the Prime Minister Lord Liverpool and his cabinet, a population increase and higher food prices exacerbated by the Corn Laws that kept the market value unnaturally high, all of which conspired to create a scene of political unrest and a rise in crime rates.

Like Georgian era Alan Lomaxes, the broadside printers sent their men out of London to gather ballads and folk songs from singers in country pubs to print up for their city customers. Another supply of songs came from a team of local writers - the 'Seven Bards of Seven Dials' as they were known, 'who's pens are kept in constant employment by the fires, rapes, robberies and murders which, from one year's end to the other, present them with a daily allowance of evil sufficient for their subsistence;' or if they'd spent the day in the pub and were not inclined to go chase a story, they chased verisimilitude instead and made one up. Seven Dials was always alive with music; songs were a penny a yard and in high times, a penny bought you two further yards: 'Songs! Songs! Songs! Beautiful songs! Love songs! Newest songs! Old songs! Popular songs! Songs, *Three Yards a Penny!*'

Catnach kept a fiddler in his print shop ready and waiting, along with ballad writers and singers; the fiddler to try out the merits of the latest ballad set to whichever popular tune he thought it might suit, and the singers to be quick as flash and take the new ballad out into the streets. There were two types of ballad singers, the chanter, 'who sings the songs through every city, town, village or hamlet in the kingdom' or the 'pinner up,' who hung ballads in their hundreds on lengths of string and nailed the ballad bunting to a wall or fence for passers-by to peruse. As Charles Hindley wrote in 1878, 'Time was when this was a thriving trade: and we are old enough to remember the day when a good half-mile of wall fluttered with minstrelsy of war and love under the guardianship of a scattered file of pinners-up, along the south side of Oxford Street alone.'

Events in the Royal family, then as now, kept the printers in good business

but for the most part, the bards wrote of everyday stories of love and tragedy, and murder: the arrest, the trial, the confession and the execution of the wicked protagonist. The story most often reported was one that we hear too frequently still, of violence committed against women. For example, 'The Scarborough Tragedy' is a ballad account of 'how Susan Forster, A Farmer's Daughter, near Scarborough, was seduced by Mr. Robert Sanders, a Naval Officer, under promise of Marriage. – How she became Pregnant, and the wicked hardened and cruel Wretch appointed her to meet him at a well-known, retired spot, which she unhappily did, and was basely Murdered by him, and buried under a Tree – and of the wonderful manner in which this base Murder was brought to light, and he committed to Gaol.'

Then there is 'The Life, Trial, Character, Confession, Behaviour and Execution of James Ward, Aged 25, who was hung in front of the Gaol, For the willful Murder he committed on the Body of his own Wife.' Under a wood cut illustration, in Daily Mail style it reads 'To which is added a Copy of Affectionate Verses which he composed in the Condemned Cell The night before his EXECUTION.' And at the end there is a 'Copy of Verses,' eight of them, giving the prisoner's confessional, the public a satisfaction, and for anyone with a similarly heinous plan in mind, reason to think twice:

> "Come all you feeling hearted Christians, wherever you many be,
> Attention give to these few lines, and listen unto me:
> Its of this cruel murder, to you I will unfold,
> The bare recital of the same will make your blood run cold.
>
> Confined within a lonely cell, with sorrow I am opprest,
> The very thought of what I've done, deprives me of rest;
> Within this dark and gloomy cell in the County Gaol I lie,
> For murder of my dear wife I am condemned to die.
>
> For four long years I'd married been, I always lov'd her well,
> Til at length I was overlooked, oh shame for me to tell;
> By Satan sure I was beguiled, he led me quite astray,
> Unto another I gave way on that sad unlucky day.
>
> I well deserve my wretched fate, no one can pity me,
> To think that I in cold blood could take the life away;
> I took a stake out of the hedge and hit on the head,
> My cruel blows I did repeat until she were dead.

I dragged the body from the stile to a ditch running by,
I quite forgot there's one above with an all-seeing eye,
Who always brings such deeds to light, as you so plainly see,
I questioned was about it and took immediately.

The body's found, the inquest held, to prison I was sent,
With shame I do confess my sin, with grief I do repent;
And when my trial did come on, I was condemned to die,
An awful death in public scorn, upon the gallows high.

While in my lonely cell I lie, the time draws on apace,
The dreadful deeds that I have done appear before my face;
While lying on my dreadful couch, those horrid visions rise,
The ghastly form of my dear wife appears before my eyes.

Oh, may my end a warning be now unto all mankind,
And think of my unhappy fate and bear me in your mind;
Whether you are rich or poor, young wives and children love,
So God will fill your fleeting days with blessings from above."

The 'Seven Bards of Seven Dials' were neither poets nor musicians, but jobbing hacks who kept to a successful formula to make money. The fact they kept to that formula was what aided the adaptation of these ballads from county to county in England, and onwards from state to state to America. They could be modified to a different town, with a different cast of characters but their beginning, middle and end remained the constant framework. For example, 'The Berkshire Tragedy,' 'The Oxford Girl,' 'The Wexford Girl' and its American version, 'Knoxville Girl,' are all sourced from a seventeenth century broadside called 'The Bloody Miller,' preserved in Samuel Pepys' collection of the 1,800 he gathered. With many verses and a baroque, Shakespearean elaboration they were widely distributed throughout the states and territories of America in the eighteenth and early nineteenth century. But by the time they invaded popular imagination they had transfigured from their hymnal parlance and convoluted shape into something altogether crisper, more direct and brutally to the point. For example, the finale of the forty-four versed 'The Berkshire Tragedy' was thus:

"Young men take warning by my fall:
All filthy lusts defy;

By giving way to wickedness,
Alas! This Day I die.
Lord, wash my hateful Sins away,
Which have been manifold,
Have mercy on me I thee pray,
And Christ receive my Soul."

The American 'Knoxville Girl' has just six verses, with its last verse:

"They carried me down to Knoxville and put me in a cell,
My friends all tried to get me out but none could go my bail,
I'm here to waste my life away down in this dirty old jail
Because I murdered that Knoxville girl, the girl I loved so well."

As you can see, 'The Berkshire Tragedy' is sober, melodramatic and all 'Alas!' and 'I thee pray,' whilst the American version is candid and to the point. 'The Gosport Tragedy' from which 'Pretty Polly' evolved has thirty-four verses but 'Pretty Polly' was whittled down to seven or so. Perhaps, by the influence of Wesley Work's 'Afro American creative folk genius' these ballads condensed from saga-like epics into snappier, sharper, briefer stories, all the better to entertain a bigger audience. The first murder ballad to reach no. 1 in the Billboard Hot 100 was Lloyd Price's super tight rendition of 'Stagger Lee.' There have been many versions of the song, from Champion Jack Dupree's to Nick Cave's, all based on the alleged true story of Lee Shelton who shot his friend after they had been drinking and arguing on Christmas Eve in St. Louis in 1895. Price's version is a murder ballad that makes you jump for joy; by contrast, Mississippian John Hurt's earlier 'Stack O'Lee Blues' has a shimmer of George Harrison's 'Here Comes the Sun' in the beautiful opening riff.

For upfront candidness try Pat Hare's dirty, languid 'I'm Gonna Murder My Baby;' or Jimi Hendrix' 'Hey Joe,' again a song devoid of wordiness but retains all the menace and misery. Then, of course, there's Tom Jones' 'Delilah' that gets the crowd singing along with a mariachi flourish to the cry of a hot-blooded murderer. As Ewan MacColl said, the best ballads are not just about the narrative but 'move right into the heart of the action immediately.' 'Delilah' lyricist Barry Mason takes us straight there with his opening line and by the end of the first verse we know it's not going to end well. But perhaps the greatest 'murder ballad' does something else

completely. This heroic, six-minute song has had many less literal interpretations, but all my life of hearing it I've understood the story of 'Bohemian Rhapsody' to be a magnificent elaboration of a confession in the hero's wild imagination as he sits alone and shivering in a dark, dripping underground prison cell.

<div align="center">***</div>

In 1938, Alan Lomax recorded Jelly Roll Morton as part of his field research. The eight hours of interviews and music captured in sessions in May, June and December at the Library of Congress document Creole folklore, life in early twentieth century New Orleans and the birth of jazz. Twenty years before, Morton had so finessed syncopation and harmony that his ragtime compositions subtly created new forms of jazz, and the 1920s and earlier 1930s had seen the height of his career as a composer and performer of what are now considered jazz masterpieces (listen to his 1926 arrangement of 'Someday Sweetheart' for something sublime and play it right to the end). But by the time he sat down with Lomax, Morton was managing a club in D.C., his career was behind him and he bore an injured body after being stabbed by a thuggish customer as he sat playing the piano at his club one night; he had just three more years to live.

All of these facts render the recording of what is an extraordinary, hypnotic song even more captivating. Lomax asked Morton to play one of the old songs from his first days as a professional pianist, aged just fifteen, in the sporting houses of Storyville in the early 1900s and Morton gave him 'The Murder Ballad' that took the genre back to its original epic status. It is a woman to woman saga that forms seven parts and comprises sixty verses written in the first person telling of the protagonist's emotional roller coaster journey with the most 'X' rated descriptions: from jealously and bloodlust at finding out another woman has slept with her man, to threatening murder of the other woman, then shooting her in the head and between the thighs, to trial in court and being sentenced to fifty years in prison at Baton Rouge and there, the thrilling discovery of masturbation and lesbianism. As with all good murder ballads, it ends with remorse, regret, a plea for prayers for forgiveness by the audience and finally, advice to others:

"Girls, if you get out of here, try to be a good girl

That's the only way you gonna wear your diamonds and pearls"

Playlist:

Maxwell's Silver Hammer – The Beatles
Denmark Street – The Kinks
Jenny Was a Friend of Mine – The Killers

13
The Hillbilly Cat

The northern shore of Cromarty Firth, roughly from Dingwall to Alness, was once known as 'Donald's Land.' This ten-mile stretch was named after the formidable clan chief Donald Munro who, as historic legend has it, came from Ireland in the eleventh century to help one of the Scots' most enduring kings, Malcolm II to fight the Danes. The Munro motto is 'Dread God' and their crest is a rather angry looking eagle, with its wings flapping and tongue extended. Famous for their inter clan warfare with the Mackintoshes, MacKenzies and MacDonalds, much is known of the Munro's battles, cattle raids, victories and losses, but what of their music?

Referring once again to Dr. James Beattie, the natural environment influenced the Highlander's story-telling, poetry and song. Beattie observed it is 'a melancholy country. Long, tracts of mountainous desert, covered with dark heath, and often obscured by misty weather…a lonely region, full of echoes, and rocks, and caverns.' The Highlander life was dangerous; accidental death was a common occurrence when hunting, fishing, or at war, and as such, 'horrors would often haunt their solitude, and a deeper gloom overshadow the imagination of even the hardiest native.' Not for them the musical strains of joy and tranquility that were the signature style of the folk songs of southern Scotland, with its 'smooth and lofty hills covered with verdure' through which 'clear streams' wound through their 'long and beautiful valleys.' No, the piper's lament reflected their experience of life, and their expression was 'warlike,' and encompassed 'the terrible.'

The Highlanders transplanted their songs to the bountiful mountains of North Carolina and the memory of clan-warring faded until all that remained was the melancholy. I came up against a later strain of this melancholy when I was around seven years old, and it stung me in a way I shall never forget. I'm in my bedroom with light blue walls and soft muslin curtains that veiled the view of the field beyond and I'm reading a nursery rhyme version of the mawkish old country weepy, 'Oh, My Darling Clementine' in a picture book.

I can't remember what the book was called but I remember wondering what 'a miner forty-niner' was, and the illustrations of a poor young girl walking by the river in shoes made of 'herring boxes.' The story goes that out on her daily ritual of driving 'ducklings to the water' she injured her foot, 'fell into the foaming brine' and drowned. The details of how this sweet girl died was too much for my little soul and I had to stop reading as it made me cry (I also felt a bit daft for getting so worked up). Bill Monroe is remembered for his fast, foot tapping, hoedown hits but he was also the master of the too-sad story song - his upbeat version of 'Put My Little Shoes Away' is a killer – that was a continuation of his ancestors' ancient vein of pathos delivered to twentieth century audiences. With his tenor falsetto 'lonesome' voice, rich harmonies, snappy tempo and his Blue Grass Boys all smartly presented in collar, tie and Stetson hat, Monroe was another of the great interpreters to use myriad musical elements and styles to blend a whole new sound - bluegrass.

Bill's ancestors started their stateside story in Virginia. John Monroe, 'the patriarch of the Ohio County Monroes,' was born in Westmoreland County in 1749, and after fighting in the Revolutionary War he, along with his fellow Virginia Line compatriots, were given land grants in Kentucky as a reward for their loyalty to the patriot cause. Here the Monroes prospered as 'proud, hardworking, honest, and law-abiding' landowners and timber merchants; well educated, industrious and meticulous in their bookkeeping. For release, they turned to music. Bill was raised on the music of his mother Malissa and her brother Pendleton, who were an archetypal American mix of European exiles – Irish and Dutch – although, to friends and neighbours the Monroes were just 'Scottish.' Malissa was accomplished at the fiddle, accordion and harmonica and she loved to sing the old ballads of her grandparents 'in a high, clear voice,' while Uncle Pen was *the* master fiddler for parties and family gatherings in and around their hometown of Rosine.

Bill had a childhood of solitude, roaming his father's 320-acre farm estate of woods and fields on the outskirts of Rosine. The youngest of eight children, he was born with impaired vision and an in-turning eye that wasn't corrected until his teens, and his siblings viewed him as too young and inconsequential to play with. For those who are used to solitude, music becomes a friend, or a place of mental refuge and escape and his sense of sound took on a greater power and meaning. When his mother took up her fiddle to play tunes like 'Old Joe Clark,' or polkas on her accordion or when she sang ballads from the British Isles, Bill was transported. Those nights of musical excitement for the

Monroe children were even more so when Uncle Pen came to visit. After supper they would gather around the fire and Uncle Pen played his fiddle. Bill was around six years old when he first heard him play and he recalled how 'he got a wonderful Scotch Irish sound out if it.'

Malissa died from an illness at the age of just 51 years old. To break the oppressive silence and to ensure that the music did not die with her, the three boys still living at home, Charlie, Birch and the reluctantly admitted Bill formed a little group of fiddle, guitar and Bill on a 'bug potato mandolin' that was cobbling around the house and he was left to quietly teach himself. But it just so happened Arnold Shultz was an occasional field hand on the Monroe's farm and he showed the young boy how to innovate his playing with African rhythms. After a few years' getting good Bill was offered the thrill of his first paid job, backing up Shultz on the guitar as he fiddled for a local square dance. As a trio, the Monroe Brothers played the old-time ballads of their childhood, but once Bill broke up the brother act and formed his own band, he needed to musically set himself apart. Old tunes like 'Chittlin' Cookin' Time in Cheatam County' gave way to Monroe's new compositions such as 'Tennessee Blues' and 'Kentucky Mandolin' that had 'fire and speed and sheer drive' turning Monroe's bluegrass into something that could only be described as *hot*.

Significant developments in music come from a switch and a change embodied by the musician's personal energy. Monroe took 'Mule Skinner Blues' with Rodgers' languorous delivery, jaunty rhythm and delicate upbeat accentuations and made it tighter and friskier. Rodgers' innovation had combined old-time melody with country blues and a touch of offbeat syncopation, whereas Monroe threw almost everything in there, and in the process officially created bluegrass. In an interview with the country star Bobby Bare in the 1980s, Monroe explained his formula, 'I wanted to have a music of my own, so I went to puttin' what I thought should be in the music and everything. The drivin' behind the music…so it taken a long time, a lot of music I had to keep out of it, you know. But I put some blues and a little bit of jazz and the ol' Scotch bagpipe and a bit of Irish music, you know, the ol' time fiddle music and a lot of gospel sings in bluegrass music like the Methodist, Baptist and Holiness, like that. But it's got a drive to it that no other music ever had and check back over and you'll see rock n' roll got its time from bluegrass music.'

What made Sam Phillips choose 'Blue Moon of Kentucky' as the B-side to 'That's Alright'? It was then, and still is the pinnacle of bluegrass standards. Elvis was so embedded in the bluegrass tradition that 'Blue moon of Kentucky' might equally have been his debut A-side rather than 'That's Alright Mama.' As it was, the A-side was a jumped-up version of Arthur Cudrup's blues song and the B side was a jumped-up version of the bluegrass waltz – the sounds of the south, both Black and white, united on vinyl. Sam Philips most likely promoted 'That's Alright' as it satisfied his own long held desire to fully combine the musical spirits of his homeland. In that one single song we hear the rhythms of the cotton fields, the swooning reach of evangelical gospel and the guitar picking of the hoedown, and with every play it desegregated the airwaves by the same ethos as his DJ pal Dewey Phillips; by Sam's own intention, 'That's Alright' 'knocked the shit out of the color line.'

Phillips' early childhood was spent living on the cotton farm his father rented out in the fields of Oakland, Mississippi until the Depression forced him out of business. As Sam and his siblings helped with the harvest, he noticed poor Black and white sharecroppers working in the fields alongside he and his family, and it was here he made the greatest observation of his young life: the power of the human voice to raise the vibration of body and spirit. Listening to the *a capella* singing of the African American workers as they toiled in the field 'picking four rows at a time, at 110 degrees,' he could see, 'the backs of these people aren't broken, they can find it in their souls to live a life that is not going to take the joy of living away.' The Phillips family were eight in all, father Charles, mother Madgie and six brothers and sisters, with Sam the youngest, bonded together by their parent's work ethic and the love and support they gave every single one of their children. Their generosity of heart extended out into the wider world, to anyone who needed food, a roof over their head, or a friend. They took in the fellow sharecropper from the Oakland farm, African American Silas Payne for he was blind from syphilis and too vulnerable to survive on his own. Payne became an important person in young Sam's life; he loved him for his 'invincible determination,' 'emotional freedom,' his kindness and generosity, for his songs, and his creativity that lit up Sam's world in his telling of mythical stories of the Africa of Payne's imagination, of 'battercake trees and a Molasses River.'

But the defining impact Silas had on Sam's psyche came one June day, when Sam was twelve years old and dangerously ill with double pneumonia

and pleurisy. He overheard his mother quietly telling a neighbour that she was worried her son might die and he panicked at the thought of it. As his body tried to fight the illness he confided in Silas of his fears and Silas grabbed his little shoulders and replied with a certainty that gave the boy hope, 'Samuel, you're going to grow up and be a great man someday.' Suddenly, Sam was instilled with fortitude and crucially, 'a belief in things that are unknown to you.' This was Mississippi 1935, segregation was ingrained and attitudes were complacent in their disregard of the African American people, but for Sam, 'there was something almost magical about Uncle Silas.' To put it in the words of Peter Guralnick, a friend of Sam Phillips for 25 years, these formative experiences 'became the lodestar for his life...he wanted to test the proposition that there was something very profound in the lives of ordinary people, black and white, irrespective of social acceptance.' It was the belief that drove Phillips to set up his first recording studio, 'Memphis Recording Service' and his independent label Sun Records. He was determined to offer a chance to the kind of artists who barely dared to believe they had a something to show the world and that the world might pay them attention, so 'un-tried, untested, unspoken-for people' that they were.

Phillips' own musical influence was the typical southern American Celtic tradition. His mother's family name was Lovelace, a derivation of the Welsh Gaelic Laighleis and the Lovelace extended family were known all around the neighbourhood for their musical talent. Every month they evoked that old *Noson Lawen* spirit at home or at a neighbour's house, when they cleared the furniture from the room and out came their fiddles, banjos, ukuleles, guitars and little Sam sat quietly in the corner watching all the adults - his parents, his elder brothers and sisters, and their neighbourhood friends dance and have a high old time. On nights with just the family at home, his mother would pick up the guitar and strum the old ballad 'Barbara Allen' or the Civil War song 'Aura Lea,' the melody of which was written by Wiltshire born George R. Poulton, and in time, was used to create one of Elvis' most famous love songs, 'Love Me Tender.' When Phillips was six, the family acquired their first gramophone player and the one record they possessed was Jimmie Rodgers' 'Waiting for a Train.' They played it over and over again, captivated by its almost cheerful declaration of displacement foretelling the Depression that in just a few months was about to bite.

Elvis, perhaps the ultimate interpreter, changed the music once again. He absorbed the relaxed sweetness of Rodgers' vocal delivery and blended it with

restless drive of Bill Monroe, slipped in the tones and phrasing of Roy Hamilton, the blues of Arthur Crudup, the cry of gospel, added the pelvic swivels of the Beale Street showmen and his own contradictory qualities of playfulness, naughtiness and sincerity to make his version of rock and roll, all telegraphed by the physiognomy of that beautiful face. Elvis was a mesmerising bundle of contrasts, but surely his greatest charm of all was his ready smile and on-stage humour that told you that he never took himself too seriously.

A hundred and one efforts have been made to draw up some kind of credible family tree for Elvis and great credit must be given to those who have put in the work to solidly verify it as far back as Dunnan Presley, Elvis's three times great grandfather born in South Carolina in 1780. Prior to that date, it's a picture of fragments and wishes. One family tree has been traced back to an Andrew Presley born in Lonmay up near the coast in Aberdeenshire in 1686; another genealogy camp believes they have established a dot-to-dot connection between Dunnan and a Johannes Valentine Bressler, a Palatinate German who migrated with his family to New York. A third story has emerged with a court document dated 1775 in Wicklow stating that a farmer named William Presley had been brutally attacked by a group of men and was in fear of his life. No evidence remains of the outcome of the case but attempts have been made to link William who, with Andrew Presley (either his brother or son) fled Ireland and settled in South Carolina. But all the suggested ancestral stories collide with the birth of Dunnan in 1780, who lived a rootless life in and around Tennessee.

Dunnan Presley junior inherited his father's peripatetic instinct, siring two daughters Rosalinda and Rosella with a Martha Jane Wesson in Mississippi before deserting them one Sunday when they were all at church. According to Elvis' great aunt, Mrs Robbie Stacy interviewed in 1977, Dunnan junior had returned to his other wife and child back in Tennessee. The instability of Rosella's childhood could possibly answer as to why in adulthood, she gave birth to ten children and raised them as a single mother free from the disruption of a potentially feckless patriarch. She was born in 1862 and lived in Itawamba County, M.S., just east of Richmond and she reached the age of 63 years having given her children the best life she could offer them. In the memory of her youngest son, Joseph Presley, 'She was a sharecropper. She was a very strict disciplinarian but she was a loving mother. Despite hardships she always managed to give each of us a little present at

Christmas – even if it was only a piece of candy or a pair of second-hand shoes.' Of her ten children, eight survived. Noah, the eldest son, became a popular mayor of East Tupelo whilst his brother JD and Elvis' grandfather had a more curdled temperament. JD was equipped with good looks in his youth but he liked a drink and, despite being comfortably off by previous Presley standards, he had a mean disposition, keeping the household whiskey supplies under lock and key, and policing the quantities of snacks his wife Minnie Mae might offer her friends who dropped by for coffee. Like the majority of the population of rural Mississippi, J.D. carried on the family tradition of cotton sharecropping and occasionally worked as a hand on a dairy farm belonging to Orville Bean, a character destined to have significant impact on the Presley story.

In *Gladys and Elvis*, Elaine Dundy states Elvis' mother's maternal line, the Mansells, were of Ulster Scots heritage. The Mansell name first appeared on a document in connection with the abbey of Kelso around 1180, originating partly from Norman French blood. The people of Le Mans, of the Norman controlled county of Maine in northwest France, migrated with William the Conqueror and scattered throughout England, Wales and Lowland Scotland. Their presence intensified in the Lowlands when King David I of Scotland married Maud, William's great niece and under her influence he adopted French manners, the Norman feudal system and invited Norman nobles and their entourage to take up estates in the south east. The Mansells merged culturally and biologically with the Lowland Scots who made the great migration to Ulster then on to America where they formed, by Dundy's belief, Elvis' maternal bloodline.

His Ulster Scots ancestors are not just the likely story of the birth of Elvis, but the bloody birth of the American South itself. South Carolinian Richard Mansell was first-generation Scots Irish and fought in the Revolution, and his son William was a soldier in the armies of Major General Andrew Jackson, the Scots Irish lawyer who became the seventh President of the United States and one of the founders of the Democratic Party. Jackson led the sweep of battles that slowly, through victories, treaties and broken treaties claimed the territories of the south from the Native Americans. William settled in Tennessee, on land once held by the Cherokees and married one of their daughters, Morning Dove White (the new Americans added White to the name of any Native American deemed to be peaceful), as the Cherokee nation was forced to cede more and more land to the American federal government

in North and South Carolina and areas west of Virginia. The union of William Mansell and Morning Dove White provides us perhaps with another clue to Elvis' lineage for it was common for Cherokees to convert to Christianity and intermarry with the Scots Irish, more so than any other tribe and any other immigrant group, creating a blend of living that made the best of both worlds amid the warfare of early nineteenth century America.

In the winter of 1820, the Jacksonian spirit of adventurism instilled William to up his family into the wagon and drive them south over the frozen-solid Tennessee River to the fertile lands of Alabama, as so many thousands had already done. An English geographer making notes on land conditions in the state, claimed he encountered what became known as 'Alabama Fever' when he witnessed, 'twelve thousand travellers within a single day.' They came not just from Tennessee but from the Shenandoah Valley, from the mountains of North and South Carolina and the forested wetlands of Georgia seeking yet more space, better quality soil and to their mind, the victory rights to the spoils of war; the majority of them were Scots Irish. The Mansells laid claim to their piece of land in Alabama and established a farm in Marion County, finding themselves in the company of many ex-comrades from the Jackson army. But his elder son John, Elvis' great, great grandfather, was more interested in bedding women than maintaining the family farm and by 1880 it was gone. Unable to watch their father self-destruct, John's third son, White Mansell and two of his brothers took themselves far away, heading to northeast Mississippi to raise a homestead near Saltillo. Neighbouring White's farm at Saltillo were the Tacketts - Abner and his wife Celia Ann, known as Nancy, of Jewish heritage, and their six children. Their daughter Martha married White on the 22nd January 1870 and they had four children, one of who, Octavia Luvenia, Lucy for short, was Elvis' grandma. Hard by were White's brothers, William and George and their families; in true Celtic habit, they defined that sense of kinship tightened over the centuries, if not millennia, building new lives in new states and counties and facing unknown hazards as a blood bound unit.

But this scene of homestead contentment had again been dismantled by the turn of the twentieth century; this time not by personal fecklessness, but by the Panic of 1893 that devastated the US economy, sent unemployment skyrocketing and put many farmers in the south out of business. The Mansells had to adjust to the lowlier position of sharecroppers and the entire clan moved wholesale to a farm twenty miles south near Richmond, owned by the Hussey

family. Their survival in the first decade of the new century was made even harder by the boll weevil that marched and munched its way from Central America to Mexico, into Texas and then on to decimate the cotton crops of the American south, by as much as 75% in Mississippi, all the way to the Atlantic coast. Life as a sharecropper was, even at the best of times, frequently a cycle of poverty for poor Blacks and whites alike. More often than not they were indebted to the landowner for the seed and farming tools, and they saw just a small share of the profits earned from the continual hard labour of raising cotton. Their living conditions were rough and limited. At the end of a long day, whole families retired to what was usually little more than a two-roomed, brown wood hut for food and sleep. But the two Hussey brothers were neither usury nor wealthy; with eighteen children between them they were just getting by themselves and their shared struggle cultivated an unspoken understanding and sense of community. In the summer months they had picnics, and square dances in all seasons, as every now and then, the children looked on as all the grown-ups gathered together in a room of one of the larger Hussey houses, removed all the furniture and had a good old sing song and a dance of 'Do-Si-Do' or 'Weaving the Basket' accompanied by a fiddle, a guitar and a drop or two of moonshine.

Lucy, nicknamed 'Doll' for her delicate prettiness, had the attention of many gentleman callers but she married her first cousin, Robert Lee Smith, then a normal, accepted custom in the southern states. Bob was a son of White's sister Ann who had followed her brothers to Richmond having tired of her next to useless husband, Obe Smith, another neighbour from the Saltillo days. Then the Mansell-Smith clan moved again, this time to White's own farm within the lush fields and pretty forests of Pontotoc County. But in 1917, the Smiths, by now a family of six with their four daughters Lillian, Levalle, Rhetha, Gladys and two young sons, Travis and Tracy abruptly splintered off, and moved back to Lee County to a barely visible community called Gilvo, just outside Tupelo.

The reason for this sudden, uncharacteristic move might be that in between scraping a living sharecropping or working long days as a labourer, Elvis' Grandpa Bob had a habit of disappearing to a place of seclusion in Mississippi's north eastern hills to practice the ancient and illegal art of moonshining. Moonshine has strong roots in Scotland and Ireland's history of covert distillation, carried out with the determination of an independently minded people. With the introduction of the Malt Tax Law in Scotland in 1725

the act of producing and smuggling whisky was viewed as the right and proper way for Scottish producers who resented the Union to get one over on the English government. By 1777, it was estimated that there were just eight licensed distilleries but four hundred illegal operations in Edinburgh alone.

The Irish method of distilling *poitín* is much older. It goes back to the sixth century and bears a closer resemblance to moonshine; both *poitín* and moonshine are a more vodka-like sip through their lack of aging in oak barrels. *Poitín* was once a reputed 'fever cure' so common in Ireland 'there wasn't a rivulet or a stream in place that hadn't a still-house beside it.' It's made from similar mashes to moonshine - potatoes or cornmeal and sugar, rather than whiskey's barley malt – and the two spirits are synonymous with rural hideaways (in nineteenth century Ireland the possession of a mere bottle got you six months in prison). The mystery, the canniness, the dark romance of the night-time operations and of course, the drink itself have given moonshine a special mention in the annals of the South's hillbilly history and Grandpa Bob was particularly good at brewing it. Elvis was destined never to meet his maternal grandparents, for they both died young, Bob of pneumonia at fifty-two and the tubercular Lucy at fifty, just a few months after Elvis was born. But Grandpa Bob had a reputation as 'the master.' He was no good at the family tradition of farming, he could not handle animals to get the best out of them, but he understood distillation, how to make the purest, smoothest un-aged moonshine that tasted as good as bourbon - it's all in the purifying.

The kind of poverty of Elvis Presley's childhood is the kind you picture when you think of the term 'hillbilly.' No-one knows exactly where the tag originated but perhaps it was in honour of the Wigtown Martyrs and their fellow Covenanters who hid from James II's Privy Council in the hills of the south west; or it might possibly be an improvisation of the term *Billy-Boys*, given, or perhaps was a proud self-title, after the Ulster Scots fought in the name of William of Orange to see off *Seamas an Chaca* in the Glorious Revolution's most decisive battles, the Battle of the Boyne; more simply, in the Scots language *billie* means a companion or comrade. It came into parlance as a pejorative at the turn of the 1900s when the *New York Journal* announced a person of this type as one who should be either held in contempt or best avoided, 'In short, a Hill-Billie is a free and untrammelled white citizen of Alabama, who lives in the hills, has no means to speak of, dresses as he can, talks as he pleases, drinks whiskey when he gets it, and fires off his

revolver as the fancy takes him.' But a year later, the *Buffalo Courier* more generously stated, 'that same "Hill Billie" will divide his last hot biscuit, corn pone or strip of bacon with you, if you ride up to his cabin tired and hungry, and be glad of the opportunity to serve you.' But beware of crossing a particular line, as a 1913 article on 'The Code of the Hill Billies' declared 'The worst crime in the code of the hill Billie is hog stealing.'

People referred to Elvis as a hillbilly, or The Hillbilly Cat, because his family were poor and his musical upbringing was mountain folk song and early country. But as much as the Presley family was vulnerable to the circular life of poverty, they were conscientious churchgoers, open hearted, generous and attempted to uphold all the values of living a decent, respectable life as they could manage. But instability was lodged in the family psyche; in the words of another poor farmer who knew the Smiths, 'They were like a mule train – they just kept on moving.' From the age of five years old to young adulthood Gladys moved house eight times around the rural environs of Tupelo, rarely staying in one place for more than two years, and 'each time with the hope that things would be better; that the soil would be better, the cotton crop better, the shack they lived in better, that they might be able to make ends meet at the end of the year.' Habitually the Smiths would up sticks, children, animals and all and load them onto a wagon sent to transfer them to the next sharecropping farm. It became the pattern of her adult life. Gladys left behind her childhood of summers picking cotton, but after she and Vernon married, they could never shake the habit of moving, for so frequently did they reach the point where they had to leave their current home; a complicity of outside forces and instinct, but still, it was a repetition of their ancestors' time worn impulse. There's a Celtic watermark that runs through the lives and stories of the Mansell and Presley families identified by strong kinship, the clan mentality, of safety with and loyalty from your family, making music and moving on.

By the time Elvis was eighteen he and his parents had moved twelve times. Their first home was carved, sanded and assembled by Vernon - one thing he was good at was carpentry - on Old Saltillo Road on the eastern outskirts of Tupelo. The land beneath the house was owned by a powerful landowner and politician in Lee County, the aforementioned Orville Bean. In fact, the Presley's entire lives were in the hands of Orville Bean for not only did Vernon work on his dairy farm, but he also borrowed from Bean the cash to buy materials to build his house (which still stands today as an Elvis shrine)

and he was expected to pay back the sum of $180 with interest. With this loan Vernon built a smallholding with potential, adding a barn and an outhouse, and kept chickens, a cow and a hog. The two room, tongue and board house had a front porch on which Vernon, Gladys, Vernon's cousin Sales and his wife Annie would every week pass an evening singing hymns, since 'That's about all there was to do in those days. Vernon and Gladys both had fine voices,' remembered Annie.

Within three years of Vernon creating this solid home for Gladys and a two-year-old Elvis their security crumbled. After a few years of economic growth and the Depression seemingly over, the US economy contracted and by late autumn of 1937 jobs were scarce. Vernon, indebted to Bean but unable to work off the repayment, took a considerable step. In desperation, he agreed to sell his hog to Bean and was delivered of a cheque for a mere $4. Indignant that he had been short changed for the sale of a valuable beast, Gladys's brother Travis and another man, Leather Gable cooked up a foolish plan to write a new cheque after Vernon gave them sight of Bean's signature; they defrauded Bean of $40 and gave Vernon a cut of $15. They were, of course, discovered and prior to the trial they were remanded in Tupelo prison. Gladys petitioned the county judge with the support of her church friends, their preacher, and Vernon's uncle Noah, one time Mayor of East Tupelo, grocery store owner and all-round good guy. But Bean would not relent and insisted on pressing the charge of fraud. The three of them were sentenced to three years in Parchman prison, a plantation penitentiary in Sunflower County. Here, from dawn until dark, the prisoners, most of whom were poor farm hands, laboured in the woods and fields, usually under the threat of the whip; sometimes the punishments were 'off the record' and they were assaulted with chains or even shot at.

A well-known contradiction embedded in rock n roll is it simultaneously being cast as the devil's music yet was borne of an agitation of the purely Christian evangelical kind. Gladys' music was the syncopated blue note hymns of the Holiness churches. In between the precious fortnightly Sunday visits when Gladys and Elvis took the ten-hour round journey on the Greyhound bus to see Vernon, she sought solace and comfort by going to services at the First Assembly of God Church 'every time the door was open.' Gladys cuddled her son close as they sat listening to the preaching and prayed for light and recovery in their lives. As he absorbed his mother's desperation and tried to give her comfort, little Elvis' mind was immersed in the sad,

happy, hopeful, yearning gospel singing that he would years later admit, 'puts your mind to rest. At least it does mine, since I was two.'

By a combination of his good behaviour inside, letters to the governor of Jackson from Gladys signed by many friends and acquaintances in Tupelo, and most significantly, a letter from Bean himself praising Vernon as 'a splendid young man' who had been sufficiently punished, clinched Vernon's early release in February 1939. With Vernon now marked as a jailbird and demoralised, for the next fourteen years the Presleys never seemed to rest. Vernon and Sales took jobs down on the southern coast of Mississippi to work in a shipyard at Pascagoula. But after eight months of hating their makeshift, one room accommodation and the long days in searing heat the two families moved back to home. After one more failed attempt to secure a decent home by yet another bad deal with Bean, (who seemed to have a touch of Mr. Potter from *It's a Wonderful Life* around the edges) the Presleys were forced to rent an old house on Mulberry Alley in Tupelo, right by the city waste dump.

Vernon found a delivery job for a local grocer and Gladys took up her old position at Mid-South Laundry. With her wage coming in they found a better house on North Green Street. These two moves, to Mulberry and North Green Street, put Elvis for the first time physically in and around the African American community that made up 25% of Tupelo's population. Mulberry Alley was on the fringe of Shake Rag - so known (although this is just one of many theories) in the days before train timetables for the fact you could shake a rag to stop a train on the M&O railroad and catch a lift. Shake Rag was burnt to the ground as a perverse part of an 'urban renewal project' in 1968 but before then, it was a historic quarter that overflowed with jazz and blues coming out from its shed houses and honky tonks, and gospel music emanating from its churches. North Green Street was a slightly smarter area that housed the upper working, lower middle class African Americans of servants and nurses who kept the lives of white Tupolians in order. At a distance, Elvis observed the other world of Black Americans, their family gatherings and social clubs, and peeped through the window as he listened to the sounds of the Sanctified Church. On good weather weekends a tent was erected on a patch of land on the east side of North Green Street for a three-day 'revival' where the ladies dressed in their finest and preachers sermonized 'without anything holding them back…chanting, breathing…until their voices soared off into song.' It was a festival of prayer, music and dance, flooding the sensibilities of the onlooker with 'sharp flashes of emotion, the bright

splashes of color, the feelings so boldly on display.' Peter Guralnick summed up the atmosphere of these revivals in *The Last Train to Memphis*, 'You only had to walk up the street and the street was *rocking.*'

The year Elvis first started school at East Tupelo Consolidated, the town achieved its first major radio station. WELO aired all the local country acts including the lively, comedic and slightly corny Mississippi Slim. 'Tall, slender, long-nosed, red-faced, beady eyed' Slim was a great favourite of Elvis' and he religiously listened to Slim's midday Saturday radio show, *Singin' and Pickin' Hillbilly*. His schoolmate James happened to be Slim's little brother and Elvis persuaded him to take him to the WELO studio on Spring Street so he could watch his hero up close. After receiving his first guitar for his 10th birthday, he pestered Slim to show him guitar chords, which, with a jesting reluctance, Slim always did and even threw in a couple of his songs for Elvis to emulate, enjoying the little boy's adoration. Saturday was a happening day in Tupelo, for after the *Singin' and Pickin Hillbilly* programme Elvis routinely took himself off to the weekly *Saturday Jamboree* at the Tupelo Courthouse where, like a civic level *ceilidh*, all comers were welcome to get up and sing if they had a song. Elvis queued up for his turn to sing a Gene Autry song or sometimes a gospel song, but he was mostly remembered for his rendition of 'Old Shep.' It had been a hit for country singer Red Foley but for little Elvis of Tupelo, it was his song. He sang it often and everywhere. He took his guitar into school and charmed his teachers and fellow pupils to the point where it became a standing joke - Elvis and his Old Shep, *again*. But if you listen to the song, I defy you not to weep. It's a classic narrative ballad telling the story of a little boy and his puppy Shep: of the time Shep saved his young master's life after rescuing him from a swimming hole when he got into trouble, and, as the years passed, how Shep grew old and had to be put down. No wonder he kept singing it, it's a pure country heartbreaker.

Through Elvis' early teen years, the time when children start testing out their moral compass and their powers of social judgment, he attended Milam School right in the centre of Tupelo. To his classmates at Milam Elvis was a 'sad, shy, not especially attractive boy, a bit clumsy' and a 'clodhopper… barefoot and in overalls;' the very kind of boy who emanates a heavy masculinity that repels early teenage girls preferring more feminine, pretty boys, perhaps sensing his too powerful sensuality that would later turn him into a sex god. When came the siren call of his form teacher asking her class, 'Do not any of you children have any talent in here?' Elvis raised his hand

and claimed, 'I can play guitar and sing' and the next day he brought in his guitar and showed them that he could. Every day he took his guitar into school and sat in the basement common room and strummed and sang his way through the lunch break, usually the sweet gospel songs of the Presley's church. The form teacher, Mrs. Camp recalled, 'He was so *good*...and the children – they just got so *quiet* and pleased with him.' But to these young Milamites Elvis was still one of the 'undeserving poor.' They saw him as 'white trash' and his hillbilly music worked largely to draw him unwelcome attention. When he was thirteen, the hoodlums of his class cut the strings of his guitar that Gladys had worked hard to pay for and that Elvis devotedly carried into school everyday; that some other classmates clubbed together to buy him some new strings showed that as well as his talent, Elvis' kind and gentle nature was appreciated by the decent kids. From one Milam classmate, Shirley Lumpkin, 'The nicest thing I can say about him was that he was a loner.' Another classmate, Shirley Threldkeld could not recall him from her school days, 'He was that type – forgettable.' But Evelyn Riley sums up the dichotomy of prejudice and insuppressible admiration that Elvis stirred in his contemporaries, 'Then, as now, if you weren't *in* the clique, you were out. We did enjoy listening to him sing. But Elvis was not popular.' He was an *overalls* boy.

He was known and remembered during his school days for singing ballads. He was naturally drawn to the gentler songs that he returned to once the first white light of rock n' roll had burned itself out. In class he sang his favourite 'Old Shep' and the old Scottish song that is a rite of passage for all folk and country singers, the tragic 'Barbara Allen.' Another classmate who recalled the ballad singing Elvis, Maude Dean Christian, confessed she did not recognize the boy she first knew when he exploded from radios with 'Jailhouse Rock' and 'Hound Dog,' but when he 'did the slower tunes' in later years, this set her mind drifting back to classroom memories and she remembered how, in the hot days of summer the doors and windows would have to be closed when Elvis sang 'so that the kids from the other classes would not hear him,' because like the children of the Pied Piper, they were drawn to the sound. When in November 1948 Elvis told his classmates that he and his family were moving to Memphis, they were 'surprised but not shocked. People like the Presleys moved all the time' usually when the rent was due. As Elvis told it, 'We were broke, man, broke...and we left Tupelo overnight. Dad packed all our belongings in boxes and put them in the trunk

and on top of a 1939 Plymouth. We just headed for Memphis. Things had to
be better.'

But their life in Memphis was no more stable than it had been in Tupelo.
After staying temporarily in a boarding house, they spent a year in a grand
shithole on Poplar Avenue in North Memphis. Like the Rachman houses of
Notting Hill in the 1950s and 60s, it was four-floored with high ceilings set in
quite substantial grounds. But internally, it was wretched. Sixteen families
rented a room each, infested with flying cockroaches, with the most basic of
bathroom facilities and no kitchen. The Presleys escaped Poplar Avenue by
moving to Lauderdale Courts, part of the New Deal programme known as a
'housing project,' a system that allots proper accommodation to families
under a certain income bracket. Elvis' night time ritual in Lauderdale Court
was to listen to Dewey Phillips play Louis Jordan, Rosetta Tharpe and Roy
Brown in amongst his freestyle playlist of jazz, r&b and country that typified
his radio show. For live action, the Plantation Inn was where it was happening
in Memphis, across the Mississippi river in West Memphis, to be precise. The
club had originally been a gambling house but since the 1940s it was a
roadhouse that showcased African American musical genius that eventually
migrated east over the bridge to become the Memphis' sound.

The jazz guitar legend Calvin Newborn was a contemporary and friend of
Elvis's during his teenage years of his intense absorption of African American
music. With a complete indifference to the colour line, the fifteen-year-old
Elvis, dressed like no-one else in his second-hand store finds of crazy, bright
patterned shirts and wild outmoded zoot suits, turned up twice a week to
witness the Finas Newborn Orchestra, an eight-piece band led by Calvin's
father. The Newborns eventually came to know Elvis, as did everyone, as 'the
white kid who lived in the projects' and Calvin made it a ritual to spot him in
the audience every night, 'He looked so striking, standing there in whatever
garish costume he had magicked together from his thrift store threads, that the
first thing I would do when I walked out onto the stage was scan the crowd in
search of him.' The Newborn band were a storming act that was already
mixing up musical styles. They could play almost any type of music: pop
standards, r&b, country; any song request they did not know, they would seek
out the sheet music or a recording of the song and know it for next time.

Switching to the Flamingo club downtown on Hernando Street where the
Newborns played a year or so later, the club's owner came up with an idea to
ratchet up the fever in a scene already super charged with the greatest talent

of early 1950s America. It was a weeklong special declared the 'Battle of the Guitars.' Every night Calvin could sense Elvis 'studying my moves, feel his eyes running over my body as I went through my show. He memorized every gyration, every thrust, every twitch.' One particular night during this convulsive week Elvis again showed up, but this time he did something unexpected. Calvin remembers, 'usually, he just hung around the back, as unobtrusive as a white boy could be in a club packed with African Americans. Only later, once everybody's attention had been drawn into the show would he move up towards the front.' But on this night, a barefoot Elvis walked straight up to the stage and asked Calvin if he could play his guitar. After papa Newborn nodded approval for his son to hand the instrument down, Elvis swung back around to face the audience and 'he roared out the opening line to a song, crashed out a spine-breaking guitar chord, and with his hips and legs shaking a mile a minute, he played the hottest guitar the room had ever heard.' Elvis sang 'You Ain't Nothing but a Hound Dog' and Calvin recalled, 'The audience went wild, it felt as though the entire building was shaking along with them.' Calvin knew he'd lost this particular battle, 'By the time he had finished, he had wrecked the house...there was no such thing as rock 'n' roll in 1951, but there were simply no other words that could describe what he did that night at the Flamingo.' When Elvis' became an international sensation his rhythm guitar playing became secondary to his singing; but in those early days, his rockabilly strumming was a riot. We all got to see it in his magnificent comeback show of '68, but in '51 with his hillbilly-gospel voice as rich as the fertile Natchez loam of Mississippi, he was like a newly discovered volcano about to erupt; an apparition of rousing, soulful, electric masculine charisma like they'd never seen - nor have any of us seen since.

With Vernon frequently off work with a bad back and Gladys working sometimes two jobs, they were always either earning too little to pay the rent, or too much and were threatened with eviction. Elvis took work wherever he could get it: mowing lawns, cleaning nightclubs after hours, cinema usher, bar jobs, as a valet. By Christmas of 1952, the Presleys had again gone over the earning limit and were sent another eviction notice. At this point, after three years of being rocked by a pendulum of uncertainty, Elvis implored his parents to move out of the Projects forever. For a couple of months, they stayed with relatives and by early spring they were in a spacious first floor flat on Alabama Avenue. Throughout all these changes, the unexpected, the next move, the eviction letters, the uncertainty, the weary 'what now?' and worry

of survival, the one constant in Elvis' life was the twin devotion to his music and his parents. As Dundy says, 'He knew that he was powerful only when he sang. Moreover, he knew that not only was *he* powerless but – by extension – so were his mother and father when he did not sing.' The formative pain of being cruelly separated from the father who loved him, the sense of injustice that must have silently pervaded the family, the oppression of being labeled 'the undeserving poor' or to put it more coarsely, 'poor, white trash,' and Elvis as an 'overalls boy,' but nevertheless seeing his parents continual attempt to create a dignified life are there in the voice of Elvis, in his deep, elegant release.

Looking back over the lives of the Mansells and Presleys, their eternal hope and optimism never really changed their fortunes. Their families had only briefly advanced since the days of their early ancestors' arrival and they never escaped an existence of instability and poverty; that is, until Elvis expressed their zealous love of melody mixed in with the pain of experience and became a vision of the world's dreams. Dundy sums up the indefinable charisma of Elvis, 'to French Norman blood was added Scots-Irish blood. And when you then add to these the Indian strain supplying the mystery and the Jewish strain supplying the spectacular showmanship…you have the enigma that is Elvis.' These were the ancestors of Elvis's nature; his nurture was in the cultural bosom of the pure poor southerner, born of the culture of the Scots Irish: the close-knit family communities, the moonshining, the constant moving on in the hope of a better home, to rent a better plot of land and find a better job, and most especially 'rousing preaching and a lot of rousing singing.' The weaves and threads of Elvis's values were the generations of farmers, labourers and sharecroppers who, like their distant Scottish and Irish ancestors had a pride in their old traditions. But regardless of all this, with his ancient mix of international bloodlines Elvis was most purely, most physically, *American*.

Playlist:

Young at Heart – The Bluebells
Personal Jesus – Depeche Mode
Lucy in the Sky with Diamonds – The Beatles
King of the Mountain – Kate Bush
Dirty White Boy - Foreigner
Johnny Bye Bye - Bruce Springsteen

14

The Circularity of British Pop

In the spring of 2017, I visited the School of Scottish Studies in Edinburgh and immersed myself in the Burton Manning tapes. As I listened to a 1966 recording of 'Pretty Polly,' sung by Tab Ward accompanying himself on the banjo in Beech Mountain, North Carolina it struck me as being similar to a blues song with the repetition of the opening line, albeit at a snappier pace. Other songs felt truly rooted in Celtic sensibility. There's a hoedown version of 'House of the Risin' Sun' and a tune called 'Cumberland Gap' ('an old fiddle tune') that's so keening and mesmeric it could be a pre-cursor to Teenage Fanclub, with banjo picking that tinkles like a prototype Johnny Marr and plaintive singing that is the ancestor of Morrissey's melodic drone; with another song titled 'I Am a Man of Constant Sorrow,' need I say more. There's another recording called 'Maggie' that if you change the rhythm to a shakedown shuffle rather than a skip, it could be the Stone Roses. There's a radical, mournful, hypnotic and detached feel to this music that feels quite 'indie.' But of course, I'm looking down the wrong end of the telescope; without these mountain songs there would be no Smiths or Stone Roses. Everything is connected. Astounding moments in music all carry an invisible history of collective effort.

A visible, tangible example of the journeying of British ballads to America and back to Britain can be traced by the story of a song mentioned in the previous paragraph. Ted Anthony has exhaustively traced its evolution in *Chasing the Rising Sun* and his careful detective work lays out the genesis, travel and adaptation of a song that went on an oral folk odyssey and culminated in a spectacular finale. Although nothing is ever copper bottomed in the folk tradition, Anthony has provided us with evidence of the song's geographical starting point. By its 'meter and subject' he roots the song in the 'don't-do-what-I-have-done' confessional ballad tradition, if in a grubby, lighter hearted guise. And for this, we have Alan Lomax to thank.

Since 1933 Lomax had been mining for traditional folk song in his home country, but as the communist witch hunt in America heated up, he travelled to Europe and made London his base from 1950-58. His reputation as a leading authority on American folk song had preceded him, opening doors at the BBC and enabling him to fund his research by making radio shows for the Third Programme (he made more than thirty programmes for the BBC in all). His primary reason for travelling to Europe was to carry out field recordings for a project for Columbia Records that was to become the *World Library of Folk Music and Primitive Music*, an astounding eighteen volumes of some of the most strange and beguiling music from Italy, Bulgaria, Spain, Ireland, England, France, Germany, Romania, Yugoslavia, India and Africa. It's a commonly known fact that it took British blues bands to awaken Americans to the gift of their own native blues players, but ten years before, it took an American to draw Britons' attention to the wonder and abundance of their own folk music.

By his considerable energy and enthusiasm between the years of 1950-58 he travelled the length and breadth of the British Isles meeting singers and musicians in quiet dusty corners where popular culture hadn't yet reached, from Aberdeen to Padstow, from Trechory to Sweffling. In 1953, he recorded Harry Cox, a Norfolk farm labourer and ballad singer with a repertoire of songs he'd learned from his father and the locals in the village pub of Catfield. Cox started singing in 1896 when he was eleven years old for in those days 'there weren't no wireless…you used to go to a pub and made your own music – and sing these old songs and everybody join in it.' When Lomax pressed the record button on his tape machine, he encouraged Cox to sing a song he was particularly interested in. It was called 'She Was a Rum One' for which Cox gave two alternate opening verses.

The first:

"If you go to Lowestoft,
And ask for the Hole of the Wall*,
There you'll find Polly Armstrong
She ain't go a hole at all."
*I think that's what he's saying and I've listened to it ten times. I presume it's the name of a pub, The Hole in the Wall which was, is, a common pub name.

And the second:

"If you go to Lowestoft,
And ask for the Rising Sun,
There you'll find two old whores,
And my old woman's one"

The tune to Cox's song is totally different to what we know as 'House of the Rising Sun.' It's more of a hornpipe, and as Anthony says, the song is a 'dirty ditty;' the musical equivalent of a saucy postcard or a sailor's good time drinking song rather than a one of tragedy and despair. Cox's version is all about 'Polly the whore' and the hero's trouble with his cock: he couldn't get it up, he couldn't get it in, he could not get it out, and he finishes off by saying he'll never visit a whore again. I suspect that's all a bit too much graphic sex talk for the ears of America's Bible Belt and possibly explains why it instead became baroque in misery and regret, with the deviant allure of New Orleans as the hero's downfall. Lomax believed the foundation of the song's story was linked to a nineteenth century broadside called 'The Unfortunate Rake' about a young man who catches a nasty STD and dies; for the tune, he believed it bore a resemblance to 'Matty Groves,' a border ballad included in the Childs collections; I gave it a listen and I was inclined to agree with him. But then as I was washing up one evening, I had 'House of the Risin' Sun' dancing in my mind with 'Scarborough Fair,' with the lyric 'It's been the ruin of many a poor boy, and God, I know, I'm one' matching the melody of 'Remember me to one who lives there, she once was a true love of mine.' With rough sketches of lyrics, plot and melody to play with, by the early twentieth century a completely new song surfaced at multiple points simultaneously in the Appalachians, only now it was a litany of deeds of the wicked.

A cultural phenomenon particular to late nineteenth century America was how Jimmie Rodgers first came to dabble in show business - the medicine show. It was a high time when a medicine show came to town, with all the fun and distraction of a travelling fair veiling its true purpose of pushing kitchen gadgets, elixirs and potions with curious names, such as the all-purpose remedy 'Kickapoo Salve – Fever Sores, Cancers, Piles, Indolent Ulcers, CAUSES THEM TO HEAL, KEEP IT IN THE HOUSE.' With its vaudeville, minstrel shows, comedy acts, and dramatic scenes the medicine show was effectively a live, mobile television channel - entertainment adjoined to a sales

push to persuade folks to pull out their hard-earned dollars from their pockets and hand it over in exchange for that bottle of something or other. Another cultural phenomenon of the time was that America, like Britain, was in the grip of a Christian led temperance movement. Bar-room and domestic violence, alcoholism, and poor health had become worryingly common at a time when liquor, beer and cider were cheap, and drinking, most likely, contaminated water was more suspect; a high percentage of those early Americans (and Britons) were pretty much drinking all day from breakfast. As the nineteenth century progressed warning stories with tragic ends wrought by alcoholism were a regular theme at medicine shows; melodramas that looked squarely at debauchery and culpability, ending with the terrible consequences of drink and loose sexual behavior corrupting the sacred family ideal.

Clarence Ashley was born in Bristol, Tennessee in 1895. His maternal grandparents were from the beautiful Ashe County in North Carolina in the heart of the Scots-Irish region Anthony calls 'The Village' - where east Kentucky, east Tennessee, west Virginia and western most North Carolina all border each other. They taught their grandson various old ballads, one of which was 'Rising Sun Blues' which leads Anthony to deduce that the song dates back at least to the mid 1860s. The sixteen-year-old Ashley hopped aboard a touring medicine show in 1911 as it travelled the southern Appalachia region and he stayed on the show circuit for the next thirty years. He played guitar with the Carolina Tar Heels and the Blue Ridge Mountain Entertainers and disseminated 'Rising Sun Blues' around the mining and mountain towns of The Village, singing it in the old Irish style ending the line on a minor third. You can hear his version recorded with the Carolina Tar Heels in 1933; it's a dark merry-go-round put to a tune we associate with the song that lyrically bears a skeletal resemblance to Cox's version: it's told in the first person by a man warning of the lure of wicked women and the destruction of drink, but unlike Cox's version where the hero skips away from the scene without a backward look, Ashley's hero surrenders to sin knowing that his dissolute life is nearly over.

The next singer to record 'Rising Sun' was Homer Callahan, a North Carolinian born in Laurel in 1912. His father had been a postmaster and a grocer but had died when Homer was four and the family experienced great poverty. Like Hattie and Buna Hicks, the Callahan family sang and played music to lift their spirits and feed their souls for free when their stomachs were empty. Callahan's mother was an organist, his brother Walter specialized in

the guitar and Homer played banjo, mandolin, fiddle and ukulele. Keeping the hillbilly tradition, the family had *ceilidh* nights when neighbours from around the mountain came over for a 'sing-in.' It was on one of these nights that a neighbour taught Homer 'Rising Sun Blues.' He and Walter built up their repertoire after absorbing the works of Ernest Stoneman and Jimmie Rodgers until one day in 1933 they were spotted at the annual Rhododendron festival in Asheville, which led to their first recording session. In January 1934 'two little country boys barefoot and in overalls' arrived in Manhattan, discovered the delight of the city's most decadent rituals, that of having breakfast 'out,' and recorded fourteen songs, including their version of 'Rising Sun,' renamed 'Rounder's Luck' by their record company ARC. The Callahans' borderline sinister rendition is set to another minor key waltz and as Anthony says, the Callahans were a 'walking, talking connection between the hills and the highway' with a song that 'evoked old Appalachian balladry and exhibited clear influences of early blues.' 'Rising Sun' now had a foot in both blues and hillbilly folk worlds and was heading for the gathering mainstream of the mass audience.

<center>***</center>

Well, the Cumberland gap ain't nowhere
Fifteen miles from Middlesborough
Cumberland gap ain't nowhere
Fifteen miles from Middlesborough

We now move 130 miles northwest to Noetown, a shanty suburb of Middlesboro in east Kentucky's coal region. It was here the song next appeared completely independently from the Ashley and Callahan sources. Middlesboro, Bell County is a mining town in the heart of the Village. Close to the Cumberland Gap and encircled by Pine Mountain, but it was made all the more remote by its populations' poverty. With the development of the coal and steel industry, the Louisville and Nashville railroad company had connected New Orleans to Knoxville by the 1880s and to Middlesboro in 1889; chances are strangers stopped by every once in a while, but otherwise Noetown was all but cut off from civilisation. People who lived here in the early decades of the twentieth century were too poor to travel, had no electricity and scant access to phonographs or radio.

It was in 1937 that a young Alan Lomax discovered the song that traced a connection between the Kentucky mining town and a Norfolk village. Armed with a grant from the Library of Congress the twenty-two-year-old son of the pioneering folklorist John Lomax was intent on recording for posterity any and all miner and mountaineer blues and ballads yet to be unearthed in the hills of east Kentucky. Hoping for some hidden gems he collected abundant material from 'farmers and housewives' and 'preachers and laborers,' some of which was 'marvelous,' some 'mediocre' but in mid September his diligence and persistence, his travelling dirt tracks from town to town and house to house paid off. The Turners were a mining family with a long history in Bell County. Gillis Turner worked for the coal company, and his wife Mary and their pretty, petite sixteen-year-old daughter Georgia were famous locally for singing folk songs and spirituals. Lomax's discovery of the Turners wasn't entirely happenstance. A tutor at New York University was married to the Middlesboro miner, folk music lover and union pioneer Tillman Cadle, and it was he who had led Lomax to their neighbours. At Cadle's home all the cast gathered – Lomax, his wife, Mary, Georgia and Cadle's nephew Ed Hunter on the harmonica, in a room choc full of large, portable recording equipment. Lomax had clearly yet to come across Ashley or Callahan's version of 'Rising Sun' for on hearing Georgia's rendition he pronounced it to be 'unique.' Many years later when Hunter was interviewed about that September day, he said it was the first time he'd heard the song, too. Perhaps some travelling medicine show musician taught the young Georgia the song; the fact that she shifted her natural 'high pitched and chirpy voice...to a throaty drawl' tells me she might have learned it from a man, although the lyrics she sings are from a female point of view. Perhaps, she had been too embarrassed to sing the song before, it being about wicked things, and only the fancy young man from the city brandishing a microphone whom she might have wanted to impress drew it out of her.

So far, we've seen the typical course of the folk tradition adapting 'Rising Sun' to its audience. Sometimes it's sung from the point of view of a man led to drinking and rambling by a bad woman; in Georgia's version she sang of being a good girl led astray by a hard drinking, wandering, no good'un but added a new reference, '*My mother she's a tailor, she sewed these new blue jeans*' (patented by Jacob W. Davis and Levi Strauss in 1873); but the mystery of how the song got to this point remains. Just under a month later Lomax found another version in Horse Creek, back in Laurel County from a man

named Bert Martin, this time without the jeans reference but still had the hero regretful at not listening to his mother's advice against drinking and hoboing around. Using the folk tradition - mixing tunes, verses and lyric fragments - Lomax assembled a hybrid of everything he'd discovered to date, called it 'The Rising Sun Blues' and presented it to the Greenwich folkies: the South Carolinian Josh White, Louisiana born Lead Belly and Oklahoma's Woody Guthrie. Guthrie cut a sunny version of the song with the Almanacs in July 1941, now called 'The House of Rising Sun' and a year later, Josh White recorded his exquisite, weeping, minor key version that to my ears, perfectly sets up the modern one we know. Josh's sometime singing partner, Libby Holman gave her own magnificent interpretation that is a haunting lament of a woman facing a loss of grace when she becomes a prostitute in New Orleans, with White backing her on guitar. Leadbelly recorded the song several times in the years before his death in 1948.

At the height of the folk revival Lomax's hybrid was dropped into Greenwich coffee house circulation once again in April 1957 when it was printed in the quarterly folk magazine, *Sing Out!* Pete Seegar gave his own cool water rendition in 1958, followed two years later by Joan Baez, performing 'House of the Rising Sun' with the clearest, strongest, most immaculate vibrato known to man. Over in the England Eric Burdon heard it in the local folk clubs of Newcastle, the first time from the Northumbrian folk singer Johnny Handle. But it all came into full focus for Burdon with Bob Dylan's debut album release in 1962; there it was: side 2, track 3, in all its compelling glory, underscored by New York folk singer Dave Van Ronk's deeply effective chord progression. Two years later, with Burdon's broken holler, the gathering storm of Alan Price's keyboards and the reserved, fuck-you-flamboyance so characteristic of British bands, the Animals put the song in their set list on a UK tour with Chuck Berry, released the single and...boom.

That's the circular evolution of 'House of the Rising Sun,' and a singular example of the evolution of British pop. An old folk tune, ballad or an idea for a narrative travelled via the folk tradition, was infused with new local influences and references, then found its way back to the source country; or rather, since 'Scarborough Fair' variants were most commonly found in Yorkshire and Northumbria, perhaps even back to its source county. Then, like an improvisation game, it altered again, recapturing the character of northeast England and with it, a new sense of place.

No-one truly knows where the song took on its recognizable form. England's towns and villages were once littered with 'Rising Sun' pubs where a prostitute might have pulled a punter, perhaps because an image of the sun forms the central feature of The Worshipful Company of Distillers, granted a royal charter in 1638. My instinct tells me the motif of the 'Rising Sun' came from England, from some version of Harry Cox's dirty drinking song, and the name stuck just because it sounded good; the words 'rising sun' evoke fair weather and optimism, and as a setting it nicely contrasts with the doomy lyrics and melody. In late nineteenth century America somewhere in the mining towns and mountains of The Village the English pub became a drunkards' bar-room nemesis; someone, somewhere, in the atmosphere of temperance fever, blended the bitterness borne of bad decisions, addiction, the lure of the railroad and the woe-is-me-a-woman-did-for-me theme of 'The Unfortunate Rake' with that reach in the 'Scarborough Fair' melody. But as 'Rising Sun' travelled from an English port, to The Village, to the café clubs of New York and back to the bare board folk clubs of Newcastle a core element remained immoveable – the clear moral of the story. The reason the song survived, coursing like a river from Cox's laddish, jocular source to Burdon's full cry of pain, is that it drips with the universal feelings of indignity and regret. It's also the ultimate folk song: the same story interpreted, reinterpreted over and over, by each different artist for every different audience. As Eric Burdon says, 'The House of the Rising Sun' 'belongs…to the world.'

Playlist:

Scarborough Fair – Simon and Garfunkel
Girl From the North Country – Bob Dylan
Whiskey In the Jar – Thin Lizzy

15
A Sound from Deep Within

Another universal subject we find in folk song is one of loss. It is a feeling the great songwriters have amplified to express their own internal sorrow and in their doing so, they have connected with the individual sorrows in all of us. Returning to how the 'lonesome' sound came about, the Kentucky born bluegrass singer songwriter, Ricky Skaggs has a theory. He believes it developed over the centuries from an Irish source: 'the Irish tunes had a happy lilt…and those tunes were brought over to America years and years ago and it seems as if those first or second-generation children that grew up playing those tunes started missing their homeland and missing their folks. There was a sadness and a pining and a lonesomeness that just seemed to enter the music, and you know when your heart's broken…your gonna play from your heart, your gonna play much more lonesome feelings and to me that's where that Appalachian Mountain, that High Lonesome Sound, came into being.'

You might wonder how those second-generation children knew what they were missing. How they could be sad for the loss of a place they had never actually experienced as home? Their music was handed down through family lines, with stories to stimulate afresh feelings that seemingly come out of nowhere, but are really part of an invisible ancestral continuity. The Brittonic welsh language, one of the oldest living languages of Europe, has a word for it: *hiraeth*. It refers to a kind of longing mixed with grief for some past one has never had; a deep connection and feeling of loss for a home one has never known that leaves the bearer lonely and restless. I offer it up now to suggest a sonic version of *hiraeth*, together with a high musical intelligence developed by the strength of the *ceilidh* tradition propelled the beginnings of British pop. Through all the changes and advances made to the music of the British Isles over two hundred and fifty years – by unknown travellers along the Wilderness Trail, by enslaved African Americans and free ones - strains of that old Celtic folk spirit could still be heard when it returned to Britain's shores and laid down the gauntlet to a new

generation of Celtic Britons to take up the challenge and innovate it all over again. American music 'took' so quickly and naturally not because Britons were good at copying the American sound, but because its founding elements were native.

The strength of Celtic euphony is widely acknowledged to the point of cliché, but curiously, its contribution to British pop music seems to have mostly gone unrecognised. Yet, if you look back at the artists who are synonymous with its development, or who have contributed to it in glorious and defining ways, you'll find it top heavy with Celtic connections. Genealogists have pegged Paul McCartney's paternal ancestry as a story of Ulster Scots migration taking us from seventeenth century Forfar on the east coast of Scotland to the counties of Antrim and Armagh, switching names from MacIntosh to McCartney and onwards to Lancashire in the eighteenth century; his mother Mary's Catholic family were from County Monaghan. George Harrison's paternal great grandfather was from Wigtown, Ayrshire and his maternal grandfather was born in Ireland in 1870, possibly in County Wexford and migrated to Liverpool in the late 1890s; Ringo's maternal great, great grandparents were from the Shetland Isles and County Mayo. John Lennon's mother Julia's maternal grandparents migrated from Wales to Cheshire in the 1860s or 70s and her paternal grandmother Eliza, born County Tyrone in 1849, was living in Liverpool, pregnant and married to John's great grandfather William by the age of nineteen; John's father Alf, was second generation Irish.

As we explore the heritage of a roster of British pop music icons the Celtic theme continues. Ray and Dave Davies' paternal grandfather Harry was from the Rhondda Valley and their grandmother Amy was of Irish descent. Jimmy Page's maternal grandfather John Gafkin (an Anglicised derivative of Geoghegan) was born in Belfast and settled in Croydon. The Gibb brothers' paternal grandfather Matthew Gibb was a Paisley born weaver who migrated to Lancashire, and their maternal great grandfather James Lynch lived out his years in Manchester but was born in County Galway. David Bowie's mother, Peggy was born in Manchester to Irish Catholic parents. In the early days of Bowie's career, he paid tribute to his mother's side of the family when he appeared at the Albert Hall in March 1970 for a St Patrick's Day charity concert. It was an all-Irish line up, including a turn by Butty Sugrue 'Ireland's Strongest Man,' the close harmony Irish folk band the Johnstons and top of the bill was Ireland's most celebrated tenor, the Derry born Josef Locke. At

the time Bowie was 'a quiet young man…who had yet to make a name for himself' and Richard Hensey, another singer who was there that day, recalled Bowie going up to Locke during the rehearsals and asking for his autograph. Locke asked if the autograph was for Bowie's mother, presuming it would be, but Bowie replied no, it was for him.

Ian Curtis's beloved grandfather Joseph Curtis was from Portarlington in County Laois, Kate Bush's mother was from Waterford, John Lydon's parents were from Cork and Galway. Morrissey, Johnny Marr (Maher) and Shane MacGowan, like Kevin Rowland are second generation Irish, so too is Boy George and of course, as are the Gallagher brothers. Though Ed Sheeran was born in Halifax, the twenty first century prince of British pop describes himself as 'technically half Irish;' his paternal grandmother and grandfather are from Dublin and Belfast respectively, and he remembers 'childhood summers and birthdays and Christmases in Ireland listening to trad music bands.'

Taking a leap back across the Atlantic, the Glasgow born David Byrne of Talking Heads observed the effect his Scottish roots had on his music. His parents' marriage was a typical Glasgow mix - his father was Catholic, his mother Presbyterian - and thinking back to his childhood in preparation for his appearance on *Desert Island Discs*, he decided that his second choice of record should be 'The Rowan Tree' by the Scottish folk singer Jean Redpath. He told Kirsty Young, 'I started thinking about the kind of music that was played around the house…I wouldn't say it was a great favourite of mine but years later now I can look at some of the melodies I've written over the years, and I go, oh, there's a real Celtic influence in some of the melodies I've done, they follow the same kind of melodic arc.' Completely off the geographical track of our story, the music of New Zealand's finest band Crowded House was seeded from Irish folk. The Finn brothers' mother Mary was born in Limerick but moved to New Zealand as a child. Even though she was only three years old when she left Ireland she kept her culture, as Neil told the *Independent* in 2019, 'she had a strong Irish heritage and all the people that we grew up (with) had it too. I carry it deep within.' Like Byrne, Neil knows the impact it's had on his music, 'I have no doubt that there's a deeply ingrained Celtic gene running through me that is attracted to certain melodies…Maybe it was reinforced by the fact that when I was 15 or 16, the only music I could find to play in the small town I grew up in was the folk

clubs... I'd sit around campfires playing old Irish - and English - folk songs and I think it's very valuable.'

Something that is immediately obvious when you look at the list of British artists mentioned above is that none of them have been bit part players in Britain's pop culture. Love them or not, each and every one has had either a major, if not iconoclastic impact on its music, visually on its culture, have been stratospherically successful, made the times or the scenes, or all of the above. All born and raised in England, these artists are recognised as just English. Yet, Kate Bush, Boy George, Noel Gallagher and Ed Sheeran, in particular, have all spoken openly about the influence of their Irish roots; in the main during interviews for the Irish press, perhaps a more willing audience. In the ultimate test of national loyalty, when asked which team he'd support during the England v Republic of Ireland International Friendlies football match in June 2015, Noel Gallagher replied, 'Oh, Republic of Ireland; I don't consider myself to be English at all.'

These declarations have fallen on deaf ears in the British press, which prefer to claim these music legends as simply English without acknowledging that a special ingredient of Celtic musicality might have led to moments of British pop magnificence. But I have a sneaking suspicion that centuries of Irish migration to England have rendered their ethnic contribution invisible, or as the elder Gallagher brother Paul put it 'transparent, a nothing.' The Beatles' Irish and Ulster Scots heritage is generally considered to be a distant irrelevance by the media, but it is no coincidence that it was they who responded most spectacularly to the sounds developed in the hillbilly and African American heartlands. And who put out the call to Paul, John and George, and practically every mega musician of British (and Swedish) pop to pick up a guitar? It was another man of Scots and Irish heritage, one with a fine, vigorous singing voice who reached back to the music of his ancestors and held it aloft to rouse and embolden young Britons, and altered the nation's musical reputation forever.

<p style="text-align:center">***</p>

There must be something of the purist in the British psyche because authenticity seems to be uppermost for its dedicated music lovers. A desire for authenticity that was, perhaps, defined by George Webb and his happy band of amateur players from a munitions factory in Crayford known as the

Dixielanders. Tuning into the stateside New Orleans jazz revival of the late 1930s, the self-taught pianist turned the back bar of The Red Barn pub in the small Kent town of Barnehurst into *the* place to be on Monday nights for bored young folk in the south east of England. Its influence spiraled out to manifest the rebel music of teens and twenty-somethings who wanted something other than the big dance band music of their parents. Trad had long been out of fashion, but in 1941, the slightly built Webb with his 'tiny hands,' his one-time band member Humphrey Lyttleton observed, like 'a pair of kittens, scampering up and down the keyboard' brought it back. The trumpeter Ken Colyer was the ultimate purist. He played only New Orleans Jazz in its original Storyville style; whereas, Chris Barber, he was wide open. The trombone player was the Renaissance man of all twentieth century folk music; he was devoted not only to New Orleans' jazz, but to Delta blues and gospel. His devotion was so potent that Barber can be credited for almost single handedly bringing a host of blues and gospel stars to Britain during the 1950s, cranking up its music vibration yet again and raising the creativity bar to so vauntingly a high level that restless young Britons were suddenly itching to match it.

The Trad jazz of Kenny Ball and his Jazzmen was different again. With their raunchy, swinging arrangements they had the most popular success, with twelve top forty hits, four of which reached the top ten. It's easy to think of Trad jazz as being quaint, slightly stodgy and rigid in its particular way. But when you listen to the chart music of the time it's not hard to hear how it was reasonably predicted that jazz would be the prevailing pop music of the coming decade. In 1960, for example, one of the most exuberant releases came from Somerset clarinetist Acker Bilk and His Paramount Jazz Band with 'Buona Sera,' a glorious Tin Pan Alley tune first recorded ten years earlier by Louis Prima. It reached number 7 in the UK charts that were awash with melodic but plodding, sugar coated American facsimile pop. By comparison, 'Buona Sera' sounds jumping and fabulous. Kenny Ball's version of 'I Love You, Samantha' could be compared with The Stranglers' cover of 'Walk on by.' They each upped the tempo of well-known ballads and utterly transformed them into something fresh, inventive and dynamic. And to any Trad jazz aficionados, please forgive me when I say, 'I Love You, Samantha' is as much two and a half minutes of perfect pop as 'Be My Baby' or 'Teenage Kicks.' All three of them give the same quick, sharp, aching thrill. The 1950s were the boom years of Trad jazz and through the early 1960s, Kenny Ball

and his Jazzmen represented its commercial peak, and it was from this now forgotten scene that Lonnie Donegan took a turning off-road into the hills of Afro-Celtic folk.

Anthony James Donegan was born in Glasgow in 1931. His mother Jo Deighan was Irish Catholic and convent educated in Omagh, a predominantly Protestant area of Northern Ireland; his father, Peter Donegan was Glaswegian and 'a very, very fine violinist.' He once played for the National Scottish Orchestra, but the idea of making a living as a classical musician in Glasgow during the hard economic years of the 1930s was borne of hope rather than reality, as Donegan remembered, 'No one's going to pay a classical violinist to give them a bit of Tchaikovsky when they do not have enough bread to eat.' To lengthen the odds of becoming a jobbing musician Peter Donegan moved his family to London, to Mile End, but the only steady work he could find was as a petrol pump attendant, and barely kept them from poverty. From here he conceded defeat and joined the Merchant Navy, leaving Jo to raise Lonnie effectively as a single parent. Donegan's childhood is another dominated by the theme of illness and loneliness. He caught double pneumonia at the age of four, which brought on rheumatic carditis that permanently affected his heart and as a consequence, he missed a lot of school. With his father was at sea, the war brought even more instability for the young Donegan. The terror of the Blitz pushed he and his mother to make a brief escape back to Glasgow, but again Jo struggled to make ends meet and they were forced to retreat back to London. The summer of 1944 brought a new threat to the people of south east England, this time in the shape of the dreaded 'Doodlebug' and Lonnie was sent to live with slightly better off relatives in the Trafford town of Altrincham in Greater Manchester whilst his mother remained in Mile End until the end of the war.

Through all the instability and isolation, the radio was reliable company. One Scots Irish American singer who was to be a huge influence on not just Donegan, but Bob Dylan, Bruce Springsteen and all singer songwriters with a poetic restlessness in their heart magically came through the speakers, courtesy of the BBC's occasional willingness to play a few folk songs during its wartime transmissions. On Thursday 13th July 1944 Children's Hour aired an interview with Woody Guthrie, advertised in the *Radio Times* as part of a double feature, starting appropriately enough, with 'Ulster Magazine: programme of music, Variety and talk from Northern Ireland followed by From America – 'Songs about Trains' sung to the guitar by Woody Guthrie.'

Guthrie was also in the Merchant Navy on the *Sea Porpoise*, or the *Sea Pussy*, as the boys called it, as one of its eighty-five crew members delivering troops, food and munitions to support Operation Overlord in Normandy. After three thousand marines had disembarked off Omaha Beach on the 5th July the ship struck a mine that had destroyed the engine room, the listing *Sea Pussy* was tugged back to Southampton and its crew ordered home.

Now going by the BBC archives, Guthrie's interview had been recorded in New York on the 11th April that same year, but we're given a different version of events in the sweet, funny and profoundly moving memoir of his life-long friend and fellow merchant marine, Jim Longhi. In *Woody, Cisco and Me* Longhi recounts how he, Woody and the folk singer Cisco Houston were put on a train from Southampton and arrived in at Waterloo station around midday with five hours to kill until the next leg of their journey from Euston to Glasgow. The boys were keen to see as much of London as they could in the few hours they had and they conducted their own walking tour of the bombed-out city centre, gazing up at the still-standing Westminster clock tower, the houses of Parliament, Westminster Abbey and Buckingham Palace, before taking the underground to the East End. They saw the 'inspiring dome of St Paul, but the most inspiring thing we saw,' Longhi remembered, 'was the people's calm.' He marveled at the cheerful fortitude of the crowds at Waterloo station who 'gave off a happy hum, and apart from a few army uniforms, you couldn't tell there was a war going on.' At one point, Woody ducked into a phone booth to telephone a friend and fan of his at the BBC who asked him to come up to Portland Place for a visit. It was then, according to Longhi, that Woody sang his songs for *Children's Hour* whilst he and Cisco waited in a nearby pub. Afterwards, they hurtled to Euston and with minutes to spare they caught the Royal Scot to Glasgow where awaited a ship at Greenock Harbour to take them and hundreds of other able bodied and wounded G.I.s home to New York.

Guthrie had the gift to write about anything that moved him; he was a great narrator of life as he saw it. During his few days absorbing the sights and sounds of the city he became enamoured of the atmosphere, the people and the accent, writing in a letter to his wife, '(they) sound like they are singing even when they are talking.' So taken was Guthrie that he wrote an ode to Glasgow that only surfaced fifty years later when his daughter, Nora discovered over 3,000 unrecorded songs and poems in her father's archive, of which 'Going Up the Clyde' was one, and its chorus is as close to the original

goodbye songs of his ancestors as you can get:

Goodbye to old Glasgow, farewell for a while,
So long to your shores and your Highlands a while,
Goodbye to your lakes and your winds for a while,
My old ship must take me many a sad mile.

About two hours from Glasgow, up on the east coast is Guthrie Castle where Woody's eight times great grandfather Patrick Guthrie, Burgess of Aberdeen was born. His son Captain James Montrose Guthrie migrated to Middlesex County, Virginia with his wife Elizabeth and son John, and the Guthries remained there for the next three generations. John Guthrie's great grandson, William C. Guthrie started the family migration down to Kentucky and his offspring moved to North and South Carolina, Texas, Tennessee and Oklahoma where Woody's father, Charles Guthrie and his wife Nora, settled in Okfuskee County. But the Guthries claimed to be not purely Scots but Presbyterian Scots-Irish, and they maintained an identity of that same Scots-Irish family pride. Nora had 'a tender heart' hard earned 'by suffering a lot of things, and by carrying big loads' that she only relieved herself of when she sang. Stoicism was a family trait; 'Guthries did not complain.' Silently bearing a heavy grief after losing their eldest child Clara at the age of fourteen, Nora 'went deeper' when she sang, and 'tried to tell the 'story' or the 'thought' that is so rich in…old Hill Country songs.' She had learned the old Scots-Irish ballads from her grandpa, Barney Mahoney, 'tales of outlaws, demon lovers, border raids, and seafaring heroes' and she sang them with feeling as she played the piano in the privacy of the Guthrie home. According to Woody's daughter, it was through Nora that her father 'learnt to write songs. There is a strong vein of Scottish influence in his famous ballads.' It's unsurprising Guthrie felt a beguiling connection during his days and nights in Glasgow. Scottish folklore was injected into his soul at an early age by his maternal muse whose mind was destined to drift 'way over yonder in a minor key' as Guthrie put it, after developing Huntington's disease. She died when Guthrie was eighteen; loss pushes hard on the need to creatively connect with the memory of love, and he found some trace of it in the nation of his forbears whose musical traditions defined him and his impact on the world.

And with that, a circle was completed. Just as Donegan, aged fourteen and bursting to buy himself a guitar with his first pay packet having started work as a stockbroker's clerk on Leadenhall Street, was about to mark the

start of a brand-new arc.

My earliest memory of music was jumping up and down to one of my father's Harry Roy records I used to secretly play in the living room when no-one was around. I must have been roughly five years old, but even so, I was aware that I was enjoying my parents' music and I can remember inwardly cringing at how twee and old fashioned it was. Yet, there was something about Roy's arrangements and clarinet playing that made me happy inside. Roy, along with Ambrose and Geraldo, all of them from immigrant Jewish families, were the superstar bandleaders of Britain's dance band craze of the 1920s and 30s, a time when audiences' sensibilities were fixed at sweetness and romance, occasionally edging into 'hot.' But come the 1940s the next generation of Londoners was after something different, something looser, more exuberant and a little more fly.

The Feldman brothers, Robert and Monty, possess the accolade of starting up London's first legitimate jazz club. Both boys were asthmatic and unfit for army service so they spent the war years working as pattern cutters and designers in their father's clothing company on Gerrard Street. But in their own way, they gave the war effort a morale boost. It was 1942, a time when there were just two options for going to anything remotely like a jazz club. There were the rather formal Rhythm Clubs, similar to 'music and meaning' lectures where a record was put on a player and the attendees quietly sat and listened to the music then afterwards, the recitalist led a discussion on aspects of the music they had just heard. The other option was the insalubrious and frankly dangerous, gang infested unlicensed clubs of Mayfair and Soho; fine but dilapidated Georgian houses that had been the after-hours night haunts for shady aristocrats, raffish Guards officers, pimps and prostitutes since the 1930s.

It was on his usual evening journey home in September that Robert Feldman strolled down Oxford Street and paused outside number 100. On instinct he went through the door and down the stairs. In the basement was 'Mack's Restaurant' and as he gazed around, he envisioned another scene, and he thought to himself, 'this would make a nice little club.' He had a chat with the manageress, Old Ma Phyllis, (or The Dragon as club goers were to refer to her for her fierce, watchful presence) and she agreed to rent the space to Robert for £4 a night, three weeks hence.

All of the Feldman brothers were musical and they had a jazz trio going - Robert played the clarinet and saxophone, Monty was on the accordion and their youngest brother, Victor, backed them up on drums; he was then just eight years old and a prodigious talent. Otherwise, to seek out musicians to play in the club, Robert and Monty went where else, but to Soho's Archer Street. Like Seven Dials and later, Denmark Street, Archer Street was a natural congregation point teaming with musicians out on the street or in nearby pubs and cafes, waiting to hear of the possibility of a gig in town or on a cruise liner, but mainly just to hang out. Soho was once a place so organically alive with music and musicians - it was crowded, competitive and bred excellence. The two brothers sought out the best of them, offered them each £3 for the job and put an ad in *Melody Maker*: 'No 1 Swing Club…100 Oxford Street, opening night, for members only…Listen and dance to the following line-up: Kenny Baker; Tommy Bromley; Jimmy Skidmore; Frank Weir. Guest artists: The Feldman Trio. Subscriptions 5s. 0d. per annum to be sent to: The Secretary, Oakleigh Gardens, Edgware.' The Feldmans were inundated with applicants, enough to fill the club three nights over and with an air of confidence and the start of something special 'The Feldman Swing Club' opened its doors at 7.30pm on Saturday 24th October 1942.

One of the key words in the advertisement was *dance*. The dance halls already in operation strictly forbade jiving and jitterbugging, insisting instead on the formal, serene, circular swirl around the dance floor where no-one broke into a sweat. But at the Feldmans' 'jitterbuggers' could relax and have a ball. Renamed the London Jazz Club in 1948, the club went so far as to print in their fanzine-style progammes some 'Dancing to Jazz' tips for the 'many sprightly young sprogs who have the urge to barge around the dance floor, but are deterred by the lack of experience, courage or strength.' They encouraged dancers to allow their 'Facial muscles' to 'easily contort into expressions of hideous imbecility. Without this, you will look strangely sane and wholly divorced from the intensity around you.' Also, 'Be assertive. On this floor only the brave survive.' From the outset, the Feldmans ensured their club was affordable and open to all classes, races and religions. It became known as 'The Mecca of Swing' for the 'Yanks,' otherwise known as US servicemen, and for visiting musicians, including Glen Millar who was refused entry until the Feldman's father, Joseph spotted him and intervened in the nick of time. Other legends who walked through its doors were Sidney Bechet, Benny Goodman, Stephane Grapelli, Django Reinhardt and Art Pepper. For the

British kids just starting out, the teenagers Johnny Dankworth, Ronnie Scott and Donegan, the club was the place to meet like-minded music lovers with whom they might start up something themselves.

The Early Music revival of the 1720s returned classical music to its Renaissance origins.

In contrast, Jazz developed at such a dizzying speed its revival came barely forty years after its birth, simultaneously bumping up against the rise of the new modernists. The negative associations of 'Dixieland' pushed young African Americans towards the development of Bebop but mainstream America finally recognised Louis Armstrong as a national treasure by the late 1940s. Clubs were opening up all over Soho (aided by the fact that even in London property prices were still cheap, as were the rents, a boring but important detail that aided Britain's musical development through the decades until roughly 2000 when prices started to climb vertiginously). The most super cool and influential was Club Eleven on Great Windmill Street. In December 1948 the basement rehearsal room known as Mac's became an ad hoc club for its eleven founder members including Ronnie Scott, Johnny Dankworth and the drummer Tony Crombie, purely in the hope of making a bit of cash. It started out with faces dropping by to listen to the musicians as they rehearsed in the afternoon and then seamlessly, the naked light bulbs and grubby sofas became beautiful as the evening came and more people turned up to listen to the urgency of the new 'fierce' jazz sound the players had picked up in New York whilst working the cruise liners; 'more frantic than Feldman's' Club Eleven took on 'a sense of evil excitement.' It was the place to be, 'shrouded in a marijuana haze,' and the focal point of the London's new jazz sound inspired by Dizzy Gillespie, Miles Davies, Stan Getz and Charlie Parker.

The war was over in Europe but the re-assembly of order and normality had barely begun. Every British male between the ages of 18-30 was required to serve in the army for eighteen months, extended to two years in 1950. For Donegan, this meant being sent to the British sector of Vienna, a city under British, French, Russian and American occupation, as it would remain for ten years after the war. Although it was an unwelcome interruption in his young life, Donegan's period of National Service revealed itself to be a kind of chrysalis stage in the development of his musical imagination. This was mainly thanks to the abundant resources of the American Forces, for 'the Americans' he later commented, 'took America with them;' their soldiers were provided with all kinds of home-from-home extras, and most especially

good for morale was their music.

Divided Vienna was united by the American Air Forces Network radio. The station was closed down in London at the end of 1945 but it was still broadcasting in the Allied Occupied territories. Unlike the mono-range of BBC approved music, AAFN's varied diet nourished and invigorated Donegan Hank Snow, Hank Williams, Woody Guthrie, Nat King Cole, the Carter Family, Lead Belly, Josh White, Big Bill Broonzy and Lonnie Johnson, the latter from whom Donegan took his name. Donegan was posted to a rather cushy job as a storekeeper where the radio was on all day and he recalled, 'I heard things like gospel songs – or as they were called then – spirituals, and quite a bit of jazz. And there was a lot of country music, because contrary to the British perception of the American public, the majority of them are rednecks. Most of them do not live in New York, or Hollywood; they live in Middle America, and listen to country music...so I got a good schooling in country music.' Of course, Donegan was getting a good schooling in how the music of his homeland had altered since its arrival in another country.

The story of the emergence of skiffle, even its very definition, is a bit confusing. I'd always wondered where it came from precisely, what its influences were and why it is considered to be so definitively British when the songs that Donegan sang to launch this new sound were directly from the southern states of America. As Billy Bragg explains in his book, *Roots, Radicals and Rockers*, the word 'skiffle' was spontaneously plucked out of the air to put a label on the music Donegan was making in 1954, but even the name itself has a mix and match connection to its original meaning. We can trace it to the little-known origins of New Orleans' jazz scene, elements of it came from there, at least. The skiffle line up of guitar, mandolin, banjo, harmonica, and the do-it-yourself instruments - the string and washtub upright bass, spoons, kazoo (a comb covered with a piece of paper) and the washboard for percussion - have their links to the late nineteenth century 'spasm' or 'jug' bands of New Orleans, which were themselves a hotchpotch incarnation of the old-time string band. The first record with the word 'skiffle' in the title was 'Home Town Skiffle, parts 1& 2,' released by Paramount in 1929. It's a glorious combination of ragtime, blues and boogie-woogie but here 'skiffle' means a 'parlour social' or just a good old party. Dan Burley and his Skiffle Boys released 'Chicken Shack Shuffle/Skiffle Blues' on the Exclusive label in 1949 but this was another piano led boogie-woogie style jazz record that bears no relation to Donegan tearing up blues and folk six years later. British

skiffle's closest connection in the musical family tree is the string band/bluegrass Memphis Jug Band. Their irresistible, 'Stealin,' Stealin'' released on Victor in 1929 is the near perfect synthesis of African American and Celtic musical sensibilities.

The word 'skiffle' had been in African American parlance for decades but it was Bill Colyer, Ken's older brother, who repositioned it as a type of British music. The Colyers were Londoners to the core. Born in 1922 and 1928, their father was chauffeur to the owner of a gown factory on Poland Street and the two of them grew up running around the streets and publands of Fitzrovia and Soho, living variously in grim flats in Fitzroy Square and Broadwick Street. The family moved to the clean suburbs of Cranford in Middlesex in 1939, but by then Soho was in the blood of the Colyer boys and in adulthood they returned to the beat of the city's musical square mile. Ken was the crusader, but Bill was his guiding light and adviser. In the time-honoured tradition, when Bill was away being a hero taking part in the Normandy landings, Ken had his first musical education by rifling through his brother's out-of-bounds record collection of fifty imported American jazz 78s purchased over many years from Levy's in Whitechapel, all carefully catalogued and stored for safekeeping. After Bill wrote to his mother saying he was due some leave to go home, pre-empting her son's outrage, she wrote by return, 'now don't be angry, but Ken's been playing your records…but he's been treating them with great respect, wiping them clean and using new needles.' When he got home and saw this was true, and he understood Ken was as 'besotted' by the music as he was, this early test cemented the brothers' partnership as roving explorers into the hinterland of New Orleans jazz. When Ken's first band, The Crane River Jazz Band started gigging it was Bill became their manager and it was his idea to add some old country blues to their set 'chiefly for our own amusement,' Ken told *Melody Maker* in the aftermath of skiffle's success. Meanwhile, Barber had done exactly the same after Donegan joined his band via the Soho club network in 1952 and made a commitment/took the gamble on throwing in their day jobs to go 'full time.'

The two bands were ideologically at odds. Source and authenticity were everything and their fundamental disagreement lay in what, or rather who, defined real New Orleans' jazz – was it the clarinetist George Lewis, or Louis Armstrong? But Trad jazz had yet to be accepted as a reputable genre in 1953; to the average person it was 'an assault on the ears,' the distant, 'alien' sounding pre-cursor to the tidier English dance bands and spanking big band

swing. In the spirit of trying to get it established The Crane River Jazz Band and Chris Barber's Jazz Band put their differences to one side to form a united front. Colyer had famously just returned from a visit to New Orleans where he had been thrown in jail for thirty-eight days for outstaying his Merchant Navy visitors permit. It was a price worth paying, Colyer thought, for he had jumped ship with the single aim to hang out in the New Orleans clubs. It's hard to fail with Colyer's kind of determination and he got to sit in and play with real New Orleans jazz bands, including the George Lewis band, and feel their energy and spirit. He was given a hero's return, and having communed with the masters the band was renamed Ken Colyer's Jazzmen – Ken on trumpet, Chris on trombone, Monty Sunshine on clarinet, Lonnie on the banjo, Jim Bray on double bass and Ron Bowden on drums.

As Barber wrote in his biography, the blues and New Orleans jazz 'went hand-in-hand. The only real difference between blues and New Orleans jazz is the instruments it's played on.' There lies the heart of all musical development in the southern states: old-time fiddle swoops were converted to fifes and bugles, the discarded paraphernalia of the Civil War's marching bands, and in time, to clarinets and trumpets; Scott Joplin blended blues syncopation with classical harmony, then ragtime was transposed back to the guitar. It was all conducted in a great magical flow of interpretation and transferal to whatever instruments were at hand by African Americans who need to keep inventing so that they and their families might eat. To provide their audiences with some context of how jazz developed the Colyer Jazzmen added a 'breakdown' of country blues and folk songs to their shows. But the 'breakdown' interlude became so popular the band routinely ended the first half of their set with five or so tunes, with Ken on guitar, Lonnie on guitar and vocals, Chris on double bass, and Bill joining in on the washboard. The boys had been referring to their 'breakdown' set as 'skiffle' for a while, but Bill announced it to the world, quite literally, during a session for the BBC World Service in 1953. The producer asked what precisely was this music the band were playing, and what were they called? For something to say, Bill replied, the 'Ken Colyer Skiffle Group.'

After one year and one album, Ken Colyer's Jazzmen fell out citing 'musical differences,' to put it politely (in truth, there was too much tension between Ken who was 'a strict disciplinarian' and Lonnie the 'dedicated cheeky chappie....always ready with a smart remark.' In Barber's view, the brief flight of the band was a damn shame, 'It had so much going for it: Ken's

excellent lead playing, our rhythm section, in that style, was so good I have not heard a better one yet. Every time I hear one of the records we made, I could cry because it was so quickly thrown away.' I wholeheartedly concur, Mr. Barber, and I direct you now to listen to the Ken Colyer's Jazz Band recording of 'Going Home;' it is sweet as a nut, as my father used to say, and swings with the tight abandon of New Orleans' finest. The break-up of the band was a moment that Ken also looked back on with some regret, when, towards the end of his life, with the more relaxed clarity of hindsight he told George Melly in an interview, 'I think we lost a lot of time arguing, that would have been better spent playing the music.' The band split into two: the Colyers hired the West Country clarinetist Bernard Bilk and a whole new rhythm section, whilst over in the other corner Barber formed Chris Barber's Jazz Band with everyone else, with Pat Halcox replacing Ken on trumpet. Bill hightailed it over to Decca to make sure they gave the follow up contract to their first LP, *New Orleans to London* to the Colyers. But when Decca's A&R manager Hugh Mendl found out they had only one fifth of the band they originally signed, he went straight to his friend Barber to make sure they secured Lonnie, Jim, Pat, Monty, Ron and he for their next album.

Something was in the air in summer of 1954. Or, perhaps it was because the race was on.

The band split in May and by the 13th July, Chris Barber's Jazz Band were recording their debut album for Decca, *New Orleans Joys*, at the company's studio in West Hampstead two weeks after Ken Colyer's Jazz Men had recorded their next album, *Back to the Delta* at the exact same spot. To strike out afresh, Barber was keen to mix it up and record both new and new/old pieces including Duke Ellington's 'Stevedore Stomp,' the Tyneside folk song 'Bobby Shaftoe' and his own composition 'Merrydown Rag' named after the cheap, heady cider that was his interval drink of choice. There are of course, conflicting recollections of what happened next – it was either a day of clear, pre-planned ideas for the new album or a last-minute scramble. By Mendl's account in an interview with Bill Bragg, it was a desperate, clock-ticking suggestion of Donegan's that they throw in some skiffle songs to bump up the track numbers - a 33rpm album needed eight minimum and by the end of the day they only had five. But according to Pat Halcox, the intention to give the listener the experience of a typical night at a Barber band gig, and include some skiffle songs, was there at the outset. 'Everyone suggested things, and we did what everybody liked. Of course, Lonnie liked to sing,' Halcox

remembered, 'and he loved Leadbelly and all the old blues artists.' According to Halcox, the studio engineer, Arthur Lilley told the band the album was to be instrumentals only; at which point Barber insisted Lonnie's skiffle group, the group within the group, 'was an integral part of the repertoire,' to which Lilley allegedly replied, 'Ok, you want to sing something, there's the mike, the tape's running, I'm going for a cup of tea.'

'Rock Island Line' was an old favourite of Donegan's after Leadbelly's superlative folk version had been released on Capitol Records in the UK in 1944. But Donegan embellished the folk story of pig iron smuggling, and made up the explanatory bit 'about New Orleans and the toll gates' that acted like a steady run up to a performance that ends with the energy of a banging Highland fling. The washboard is the iconic percussive sound of the jug and old-time bands and the blues singer Beryl Bryden, one of its few virtuosos, was drafted in for the session and there she is, sounding like the regular rhythm of a chuffing train; Jim Bray had already left for the day, so Barber picked up the double bass. With Donegan on vocals and guitar they recorded 'Rock Island Line' in a similar manner to the way Elvis Presley, Scotty Moore and Bill Black had recorded 'That's Alright' eight days earlier: a tight, three-piece band summoning a genius spirit borne of a combined wealth of musical knowledge and a feverous need to strike out and make a mark. They both caused a vibrational change that had been waiting to happen. All the assembled elements of the music came from the African American-Celtic music makers: the instruments, the songs, the informality, but it was redefined by the way Donegan took it up. Delivering 'Rock Island Line' with a voracious Celtic roar from that wonderfully great mouth of his, he suddenly made country blues and folk feel like a new British sound.

New Orleans Joys was released at the beginning of 1955 and Decca one by one put out almost all its tracks as 78 rpm singles except 'Rock Island Line' which sat quietly on side 1, track 3 not troubling anyone too much. Before rock and roll sprang up out of nowhere like a jack-in-the-box, the charts in both America and Britain were teaming with fulsomely produced, falsetto voiced country ballads. The gentleman country singer Slim Whitman did a Bryan Adams and held the number one spot from the 29th July all the way until the 7th October of 1955 with his yodel reworking of an operetta piece, 'Rose Marie;' Mitch Miller's African American folk song turned Confederate anthem, 'Yellow Rose of Texas' hovered in the UK top ten for several weeks at the end of the year. By then Decca had cottoned on to this country invasion

and adding to its building relevance, Bill Hayley's 'Rock around the Clock' was number one in the British charts; as Bragg suggested, at this point Decca most likely seized on anything that had the word 'rock' in the title. Casting around for a British version of the 'hillbilly' singer, what they began to realise was in Donegan, '"the Irish Hillbilly" from London' as the Washington *Longview Daily News* were to announce him on his first solo tour to America, they had the essence of the real thing. 'Rock Island Line' by the Lonnie Donegan Skiffle Group was released in November, and by February 1956 it had reached number 8 in the UK charts. It was the spark that became a flame that set British music on fire after more than a century of stealthy Irish and Scottish migration had set Celtic roots music running free in the pubs and clubs of England's cities.

Donegan mined the Afro-American folk catalogue recording 'Frankie and Johnny,' 'John Henry,' 'Wabash Cannonball,' 'Worried Man Blues' previously recorded by the Carter Family and Woody Guthrie, 'Midnight Special,' 'When The Sun Goes Down,' 'Bring A Little Water, Sylvie,' 'Dead or Alive,' and 'Lost John.' With his spruced-up rendition of 'Cumberland Gap' he was one of but a handful of British artists to score a number one in the 1950s and stayed there for five weeks at a time when the UK charts were crowded out with super-smooth American crooners and orchestral pieces. But skiffle was to be but a brief kick start to get home grown pop music going. Ken Colyer had formed his own skiffle group but he was not destined to be the figurehead of the new sound. He was right when in 1956 he predicted the craze wouldn't last; by 1960 the idea was largely spent. There's truth in his reasoning too, 'The style has not produced any worth while talent. There is no originality.'

Which is exactly why it worked. As has already been said a zillion times, skiffle was not a music that was intimidating, but nor did it lend itself to virtuosity; it was accessible and uncomplicated and looked within reach of ordinary souls who had never before considered putting themselves out there as professional musicians. What drove the phenomenon, and captured the imagination of Hank Marvin, John Lennon, Paul McCartney, Pete Townsend, Jimmy Page, Van Morrison, Ronnie Wood, Mick Jagger, Rod Stewart, Roger Daltry, Dave Gilmore and the Gibb brothers to name a few, was not just the sense of empowerment but the sheer, unfettered energy Donegan had. It was so infectious it even reached Bjorn Ulvaeus in Sweden and encouraged him to take up the guitar, enfolding the development of ABBA into the story of

British pop once again. It all fell into place simply because, in Donegan's hands, the music had returned home. It sounds banal to say it now as we've become so used to seeing performers go wild and let rip on stage, but back in England in 1955 when 'Rock Island Line' was released Donegan's performance must have been an electric shock to the young onlooker. Even watching him on old footage now all these decades on he's thrilling to watch, and wholly positive. As Lonnie himself emphasised in an interview in the 1980s, the biggest banner he put out back then declared this music was *fun*. He makes you want to jump up and do something. He wasn't just infectious with his rockabilly speed; his live performances were an irresistible call to action.

Playlist:

I Feel Fine – The Beatles
Nobody But Me – The Human Beinz
Come Dancing – The Kinks

16

'Squalid Liverpool'

'The Irish have a notion that any part of the world is better than Ireland, and consequently are fond of change...nine tenths of the Irish settled in England did not come over from necessity, but in a wild spirit of adventure.' These are the words of Michael J. Whitty taken from a report commissioned by the House of Commons in 1833 on the subject of the Irish poor in England. Whitty was a self-made man who lived by his own belief. He was born in 1795 into a farming family in Ducormick, County Wexford but when his father's business faltered in 1821 it was in the spirit of adventure that he ventured to London to become a journalist. Possessed of charm and intelligence he became a great name in the literary world, publishing his *Tales of Irish Life* on the customs and culture of Ireland that was translated into French and German and re-published in America. He moved to Liverpool in 1830 where he become the editor of *The Liverpool Journal*, launched the penny newspaper the *Liverpool Daily Post* and was a much loved and respected Liverpudlian; he spent forty-three years living in the city until the end of his life.

Thousands of Irish men and women were to make the same journey to England during Whitty's lifetime; not in the spirit of adventure but for their survival, and they did so on an epic scale. By ratio of population, Ireland has sent more immigrants out into the world than any other nation. Around eight million people have emigrated from Ireland since the first exodus of the Ulster Scots. Of that enormous figure, five million left between 1800 and 1870. On the eve of the Great Hunger nearly half a million Irish men and women, mainly Ulster Protestants, had already arrived in Scotland and England, having migrated in a steady stream over several decades to find work as agricultural labourers or weavers. But this figure was dwarfed by the mass of people who came over when the Potato Famine hit. Between 1845-49 and the bleak years following, over two million people left Ireland. Even as farming conditions dramatically improved in the 1860s and 1870s, the compulsion to leave remained until 'no Irish family was untouched by it.'

Liverpool was the main point of entry. To get there was 'a trifling expense' after the development of its docks and international shipping links reduced the price of a ticket to little more than a ferry ride. But for Ireland's emigrants, settling in England was the short straw. For those who could afford it, at the price of £4 10s circa 1880, the Atlantic passage granted a shining future in the USA or Canada and they were seen off by the people in their district with an all-night party of drinking, music and dancing at a 'convoy house.' At the break of daylight, the lamentations would begin. The emigrant would be 'drowned with tears and dried with kisses' as the whole company walked with them the first few miles of their 'foot-slog' to the port. These lucky people were the 'emigrants of hope.' England, by contrast, was for the 'emigrants of despair.' It was considered the second-class destination, for there, they imagined not incorrectly, they would forever live in an atmosphere of anti-Catholic and anti-Irish sentiment. Too poor to travel any further, England was both a refuge for the poverty stricken fleeing the famine and a last resort and they made up the bulk of Liverpool's Irish community forever dreaming of leaving for America. Between 1846 and 1852, 600,000 Irish paupers shipped to Liverpool. Just under 300,000 of them either settled in the city or travelled onwards to join family already living in England, Scotland or Wales. By 1861, the number of Irish born people living in Britain was at a historic peak of over 800,000.

In the first decade of this chaotic movement, John Lennon's great grandfather crossed the Irish Sea, found rooms to rent and started a family in an area that became infamously known as 'Squalid Liverpool.' It was found in the westernmost strip of the city that runs from Dingle to Sandhills: parallel to the docks, close to the casual labour market of factories and warehouses (the site of the Cavern Club just over a hundred years later) and was once home to the Irish poor in numbers denser than were to be found in any other city of the western world. The story of James Lennon, and how he and his fellow countrymen developed the character of the Liverpool people was forged in a terrible start. James was born into a farming family in 1829 in the predominantly Protestant County of Down in Ulster. The province had been kept from the worst effects of the Famine but eventually the blight reached the northeast and many died or were forced into the harsh sanctuary of the workhouses. No parts of Ireland were immune to the spread of diseases that followed hard on the heels of poverty and starvation. The lack of hygiene and cramped living conditions incubated typhus fever and dysentery in the poorest

classes but spread indiscriminately. By April 1849 James had escaped to Liverpool and married another arrival from County Down, eighteen-year-old Jane McConville, in St Anthony's church on Scotland Road. The McCartneys were already in England. Having migrated to Lancashire in the 1700s, Paul's great grandfather James McCartney settled in Liverpool around the 1860s, perhaps with a mind to join the new, burgeoning community of fellow Irish immigrants. He married Elizabeth Williams and they took rooms on Scotland Road before moving to the filthy, cramped court housing off Great Homer Street. Scotland Road, like so much of 'Squalid Liverpool,' was a place you could describe as entry-level accommodation for the poor Irish, Protestant and Catholic alike. It was an artery road that's now a dull old dual carriage way called the A59, but during the height of Irish migration of the Victorian age it was every definition of squalid.

In November 1883 Whitty's *Liverpool Daily Post* ran a series of articles over six days, in what must be a first in investigative journalism in Britain. It was an urgent commentary on the city's social conditions that desperately needed to change and coined the area's name, declaring, 'Here resides a population which is a people in itself, ceaselessly ravaged by fever, plagued by the blankest, most appalling poverty, cut off from every grace and comfort in life, born, living and dying amid squalid surroundings, of which those who have seen them can form a very inadequate conception.' The special commission was undertaken by a city councilor, a respected physician and a member of the *Daily Post* staff, all of whom reported anonymously in a series of articles run over six days from the 5th to the 10th November 1883. Their intrepid guide into this 'deep fringe of suffering' was all the more distressing to witness by it being just a few steps away from 'prosperous money-making Liverpool – the Liverpool of clubs, of *cafes*, of banks, of commercial palaces.'

The conditions were so appalling, those forced to exist in them were in a state of denial. In an article entitled, 'Inside The Houses,' a commissioner tells us, 'The house doors are nearly all open. You may go in if you like, no one will object. You will meet with nothing but civility. Your commissioners in all their visits never received a harsh word from young or old, men or women. The people will freely answer any enquiry you may put. Seventy-five per cent of their answers will be lies. That, however is mere incident. You will soon get accustomed to it, and it will not surprise you to hear it pleasantly and emphatically declared that "there is no sickness in this house," when you know absolutely that just up the narrow, rickety stairs, on a bundle of rags in

one corner, the eldest son is "down with the fever," and in another corner, on another bundle of rags, a little girl is fast dying of the same complaint.'

In amongst the 'stench, squalor and sickness,' running parallel to Scotland Road but nearer to the docks is Great Howard Street, described by its 'solid array of public-houses' where 'the brass on the doors is kept bright and the windows scrupulously clean' where a man with 'a copper in his pocket…can purchase forgetfulness for a moment.' Scotland Road, by contrast, was notoriously 'inhabited by the very lowest and worst population in the whole city. Disorder is perpetual, and disease is never absent. Sometimes whole streets are blockaded against the police, and then a pandemonium of violence proceeds unchecked. Every Saturday and Sunday, throughout the whole district, the inhabitants give themselves up to a drunken orgie, and never a week passes but some shocking crime of violence is perpetrated.' The commissioner reasoned this might be because these people had neither 'something pleasant in life to remember' nor 'pleasant to anticipate.' The articles of 'Squalid Liverpool' make hard and heartbreaking reading. Not least because an account of the same terrible conditions had been written up by Dr. Trench, the Medical Health Officer for Liverpool twenty years before and were flatly ignored. With suggestions of anti Catholic prejudice as the cause, the articles are at pains to point out to their readers that the squalor they describe has been left unchecked: 'for years upon years evils have been permitted which a little faithful effort would have removed. The misery is obvious, and its causes are plain, and have been plain for a quarter of a century' and never 'honestly and manfully grappled with.'

In 1851 the Lennons, along with the McConville extended family were all living on Saltney Street, right by Stanley Dock. The road still exists today but the last of the Georgian and early Victorian slums that might have held a morbid fascination for us had they remained, were cleared in the 1960s and have been replaced with the common architecture of a working port, endless warehouses and business units. It's not known how long they lived on Saltney Street, but by 1861 the Lennons, along with their five children and Jane's mother were living in a house on the newly built Paget Street, which also no longer exists, but was once located slightly north of Stanley Dock between Vauxhall Road and Great Howard Street. The *Daily Post* articles on 'Squalid Liverpool' cover neither Saltney Street nor Paget Street in particular, but they do report on Sherwood Street which is almost right opposite Saltney Street and between Vauxhall Road and Great Howard Street, so their descriptive

prose of Sherwood Street can most likely be applied to the conditions on Saltney and Paget Street.

The commissioners took a stroll up Sherwood Street, by their account, one of the 'better' parts of 'Squalid Liverpool.' They were greeted by 'The women' who, 'as usual manifest a good deal of interest in the doings of the strangers. They are of all ages and all sorts, but all are very tattered and nearly all very dirty. At the top of the street is a sewer grid merrily puffing up clouds of steam, which the wind blows through the dilapidated windows of the houses close by. On one side of the street there are a couple of rickety high wooden gates painted a cheerful black. It is not necessary to peep through to discover what is inside. The rustic odour which is wafted across the street proclaims a shippon or stable…In the house No. 40, a talkative lady resides, who gave a great many details concerning the attractions of the street. When the wind is in one direction, she declared that the stench and steam from the sewer grid just outside her door rendered the front part of the house uninhabitable. The walls of the cellar, she further asserted, had a pleasant habit of perspiring, and in the process of time had become coated with accumulations of slimy filth. The good lady's description was so vivid that your commissioners decided to take her word without further investigation.'

Going back forty-four years to a time closer to James Lennon's arrival, the young seaman Herman Melville wrote up an account of his visit to Liverpool which became part of his semi autobiographical novel, *Redburn*. His ship the *Highlander* docked in Princes Dock for more than six weeks during the summer of 1839. At first, he was confounded by how much it had changed from the map in his father's guidebook published fifty years before that was now out of date – a castle positioned near Prince's Dock was no longer there and it its place was 'The Old Fort Tavern.' Indeed, Liverpool had changed. From the 1830s it became an assembly point of all the Celtic nations of the British Isles, with 'more Welsh than any Welsh town except Cardiff, more Irish citizens than any Irish town except Dublin and Belfast, and more Scottish citizens than any but the three or four great towns of Scotland.' The Glasgow shipbuilder William Laird had spearheaded Scottish migration in 1810 when he established an ironworks in the village of Birkenhead and by 1838, the great Cammell Laird Shipbuilding Company. A line of Scots engineers followed on to transform Liverpool's ten miles of docks into the site of England's foremost shipping industry that handled its raw cotton imports, and cotton goods exports. The people of 'the singing nation' had been

the back bone of Liverpool for centuries and made up 10% of the population by the turn of the nineteenth century. For those in North Wales seeking better job prospects it was habitual to relocate not to Cardiff but just a hop across the water to Birkenhead or to take the 30-mile round trip where they settled in Everton, Wavertree and Dingle.

Through that summer Melville came to know the Liverpool people, although the Scouse accent we know now was only just emerging – the flat Lancashire dialect blended with the upward inflected, musical Welsh, and not yet fully infused with the verbal dance of Irish. The narrow streets by the docks were where the town's nightlife could be found, ready to accommodate sailors hungry for a good night ashore. He had the extraordinary experience of witnessing the conception of a murder ballad, from the terrible event itself to a song hollered out on a street corner in less than twenty-four hours. He had come to know one of the many 'sailor ballad-singers, who, after singing their verses, hand you a printed copy and beg you to buy.' This particular ballad singer, 'dressed like a man-of-war's-man' had 'a full, noble voice like a church organ; and his notes rang high above the surrounding din.' On his usual evening stroll to supper through the docks, he noticed a crowd gathered around the Old Fort Tavern. On asking what had occurred he was told 'a woman of the town had just been killed at the bar by a drunken Spanish sailor from Cadiz.' He saw the murderer arrested there and then, 'and the very next morning the ballad-singer…was singing the tragedy in front of the boarding houses, and handing round printed copies of the song which, of course, were eagerly bought up by the seamen.'

All of Liverpool life, and death, seemed to be contained within the docks. Melville observed its lanes 'present a most singular spectacle, the entire population of the vicinity being seemingly turned into them. Hand organs, fiddles, and cymbals, plied by strolling musicians, mix with the songs of the seamen, the babble of women and children, and the groaning and whining of beggars. From the various boarding-houses, each distinguished by gilded emblems outside – an anchor, a crown, a ship, a windlass, or a dolphin – proceeds the noise of revelry and dancing…Every moment strange greetings are exchanged between old sailors who chance to stumble on a ship-mate last seen in Calcutta or Savannah; and the invariable courtesy that takes place upon these occasions, is to go to the next spirit vault, and drink each others health.' Melville encapsulates the Liverpool spirit. A maritime city; its people raised on the semi permanence of a life at sea; ever changing, ever moving,

expansive, and possessed of a latitudinal vision from which evolved a 'laugh-today-for-tomorrow-we-die' outlook that came through in the music. As Paul de Noyer points out in *Liverpool – Wondrous Place: From the Cavern to the Capital of Culture*, 'British people used to sing everywhere: in pubs and public schools, in chip shops and troop ships, in air raid shelters and charabancs in Blackpool. But people in Liverpool went on singing after the rest of the country lost the habit.' It's true, they did. The English lost the habit of singing in groups, music hall style. But Liverpool was born singing; it's in its DNA. To sing was an act that momentarily distracted from the filth and the violence. At home or in the pub it was expected - come on, get up and give us a song, sing out loud! No need to be shy. The city's docklands were where the sailors and the Irish immigrants converged, both for whom singing was fundamental to their existence: sea shanties in carrying out deck duties, and for the Irish, Welsh and Scottish it was natural, customary and was fostered in a feeling of rootlessness where life was better with a song and music itself was 'one of life's necessities.'

To have physically survived the conditions of 'Squalid Liverpool' took luck and strong genes. To spiritually survive, a beautifully constructed piece of music lifted you up into its complete world, temporarily removing you from wherever you happen to be and took you to some other place. Or to put it in the words of the writer Ronnie Hughes, 'Deep in the heart of the place a constant pop song keeps getting written, which lifts its spirits when it seems nothing else can. This is not a place that's given up. It's a proud boastful Celtic city where the lads dream big and talk big and keep writing a big, tuney, hopeful song that could only come from Liverpool.' By the turn of the twentieth century, the slums had been declared illegal and those who had survived them had fought on, worked hard and found decent homes in which they could rejoice on a Saturday night and keep the *ceilidh* tradition with a song and a dance when 'an old Irish man comes in with a fiddle.'

Few could afford record players in Liverpool, but almost everyone had a piano, most especially the McCartney family. Music and performing in the McCartney family was passed on in a continual flow. James's son Joe spent his entire working life at the tobacco importers, Cope Brothers and Co. and like all good companies of the Victorian era, Cope Brothers had a brass band in which Joe played the bass tuba. He and his wife Florrie encouraged musicality in all their seven surviving children, Jack, Jim, Joe, Edie, Mill, Annie and Gin; many were strong on singing but Jim, Paul's father was highly

musical and especially drawn to the piano. In around 1916 a family piano was installed and Jim became a self-taught talent thanks to his good rhythm, and natural ability to catch a melody, and he could hammer out all popular tunes. His first job, aged fourteen, was working as a sample runner for a cotton broker and after three years they gave him the opportunity to make his first public appearance playing all the latest ragtime hits at the company's annual party. From there he went on to form the semi-professional Jim Mac's Band made up of family and friends, and together they had a hoot for a few years playing the new jazz tunes in dance venues around the town until the band wound up in 1924. But Jim never stopped playing at home. Paul's first encounter with music was listening to his father on the piano. He used to 'lie on the carpet and listen to him playing things like 'Stairway to Paradise' by Paul Whiteman;' another one Paul loved to hear his father play was the hauntingly sweet 'Lullaby of the Leaves.' At parties he'd play all the old favourites and Paul remembered 'everyone joining in, getting him drinks, all the old aunties sitting around the room. They knew all the words and melodies. They'd go on for hours, getting progressively more tipsy.' Overridingly, he remembers, 'There was always a musical atmosphere in the house.'

Traditional *ceilidh* nights cropped up all over Liverpool from the 1930s onwards, in clubs organised by the Catholic Church and the Gaelic League. These spilled over into singalong nights in your average pub or after party at someone's home where it was tradition to do a 'turn' and sing a song, if you had one. Otherwise, Liverpudlians adopted American music early and often. After jazz, the next really big craze in 1950s Liverpool was country and western and to such an extent that the city's number of country and western bands almost outdid Nashville. 'Before rock n roll,' recalled the Dingle born Ronald Whycherley, also known as Billy Fury, 'everyone used to play country and western, Hank Williams, or whatever. Anything with some real lyrics about a bit of trouble or a bit of heartbreak.' The Dingle area was a hardened mix of English and Welsh Protestants who were most often 'jobless, penniless and drinking and singing their lives away in its many pubs.' The Starkeys were born and bred Dingle but in contrast, they were productive souls – seamen, tinsmiths and boilermakers – and music makers. Ringo's Starkey grandparents Johnny and Annie, threw everything at him musically. They played the banjo and mandolin and after drunken nights at the local pub, it was a ritual for the extended Starkeys, Ringo's beloved step dad Harry, plus friends and workmates to pile back to his mum Elsie's house on Admiral

Grove for a session. Johnny and Annie tried to jump start Richy's interest in their banjo and mandolin, but they didn't register; they gave him a harmonica which he didn't take to either and there was a family piano, which he didn't attempt to play but he had fun walking on it.

The moment of Richard Starkey's musical awakening was when he went to the cinema to see the cowboy film *South of the Border* staring Gene Autry who sang the film's titular hit song. Autry became, 'the most significant musical force in my life,' he recalled. 'South of the Border' was a song of Irish and Jewish musicality, written by Jimmy Kennedy and Michael Carr (Kennedy wrote the immortal lyrics to 'Teddy Bear's Picnic' and the Leeds born Carr went on to write the glorious theme tune for the television series *White Horses*). But with 'South of the Border,' Autry became the totem of Ringo's dreams, 'America and Americana, of country music, and of maudlin or melodic songs that tell the story of love lost and found' and of one day, actually going to America.

But America was already in Liverpool. The 'Cunard Yanks,' the merchant seamen who came back ladened with all the cowboy hats and boots that couldn't be found in England created a mini-Mississippi within Liverpool, and provided the soundtrack too, with records in their bags of American swag. An early ritual of John Lennon's was to go to a friend's house to listen to the juke joint sound of Hank Williams records, and the first guitar music to reach the ears of George Harrison was Jimmie Rodgers' 'Waiting For A Train' and 'Blue Yodel No 4,' records that his father brought back with him during his years as a steward with the Starline. His mother Louise had copies of Slim Whitman's two British hits of 1955, 'Indian Love Call' and 'Rose Marie,' with their mournful slide guitar and lonesome, otherworldly vocal that floated into the twelve-year-old George's ears and soul; perhaps, playing a part in manifesting the quality of Harrison's guitar playing as Bob Dylan described it: 'every note was a note to be counted.' This little known, early musical education is why Du Noyer calls the country influence an 'over-looked facet of the Beatles' style.' It was the first world of music they entered as independent teens that locked them in, even before skiffle. When Liverpool's first country and western club, the Black Cat Club was founded in 1957, the Beatles played there in homage to the genre that got them started. As Lennon remembered, 'I heard country and western before I heard rock n roll. The people there – the Irish in Ireland are the same – they take their music very seriously.'

From the known and little-known figures in his family we can piece together a picture of what we, as outsiders, know of John Lennon. The most kismet inheritance in Lennon's story is from a man he never met, his grandfather, Jack Lennon. Jack was the middle son of James and Jane, and according to two of the most respected Beatle biographers, Mark Lewisohn and Philip Norman, Jack was somewhere in the range of 'an intelligent, happy-go-lucky soul who sang loud and often in ale-houses' but led a life of 'mysteries, dead-ends and deceptions' to being an adventurous talent who had the courage to leave his job as a freight clerk in the 1880s, head to New York and join the line-up of Andrew Roberton's Colored Operatic Kentucky Minstrels. Of course, the latter story is a more romantic fit for John Lennon's extraordinary life: Grandfather Jack, the advance party in the development of African-Anglo-Celtic music that his grandson fulfilled beyond any of the Lennons' wildest dreams. The one photograph that exists claiming to be of Jack Lennon, of a man smartly dressed in a white top hat, sports jacket and tie with that unmistakable sharp Lennon nose, standing on a stage next to a seated, blacked-up banjo player does add a little evidence to the story. Jack's transatlantic interlude was bookended by the humdrum dry dock existence of a twice married shipping clerk; the second time to his young Dublin born housekeeper Molly Maguire and with Polly, as she was known, he had six surviving children raised in their two up two down terrace on Copperfield Street in Toxteth. All the Lennon children, five boys and a girl, were pretty good singers and the boys tooted well on mouth organs, but his fourth son Alf inherited his 'show-off spirit,' along with an urge to sing music hall songs, 'recite ballads, tell jokes and do impressions' and occasionally serenade the rest of the family by tenderly duetting 'Ave Maria' with his father 'with sentimental tears streaming down their faces.'

John Lennon was destined to have scant contact with this side of his family. Alf grew up to be a wanderer and spent months away at sea as a ship steward on the glamorous transatlantic liners before and after the war and as a merchant sailor during it. His marriage to John's mother Julia was up ended by her affairs in his absence. After the back and forth, heartbreak and tumult of his parents' ill-fated union, and the unwelcome presence of Julia's new man, 'Bobby' Dykins, the six-year-old John was sent to live with Julia's eldest sister, Mimi, in Woolton, a leafy, middle-class village that was, 'the least Irish, and so the most English, suburb of Liverpool.' He settled into the bookish quiet of Mimi's pleasant, semi-detached world. Mimi's husband George

smartened up the boy's reading skills with a daily look at the national and local papers and he had access to a mini library of history books and classic fiction which both he and Mimi absorbed themselves in. Mimi's disciplined, studious living was relieved by her occasional outbursts of playfulness and displays of the sharp Stanley sense of humour, which turned out to be one of John's most famous inherited weapons on the world stage.

Lennon's first contact with a musical instrument was a harmonica owned by one of Mimi's student lodgers. The kindly young man offered to give it to him on the completion of the set task of learning a tune rather than constantly fiddling with the damn thing. He was given until the next morning to do it. Unknowingly, the eight-year-old John harboured a latent Lennon talent for the mouth organ, present in his father and his Lennon uncles, and by the next morning he had not one but two tunes to perform and won his prize (although never one for unnecessary indulgences, Mimi made him wait until Christmas to take possession of it). A conscious musical direction came from his mother. The red-headed Julia had a strong, clear singing voice that bore a resemblance to Vera Lynn's and like Alf, she was witty; she loved to lark about doing impressions, and she had a starstruck 'craving for glamour' and 'an urge to entertain.' During the spurts of time she and her son spent together she played him rock and roll records and revealed to John what a pleasurable, enchanting, boundary free life looked like; the flip side to the one her sister provided, epitomised by how completely relaxed she was about him bunking off school to visit her. She showed him banjo and ukulele tunes she'd been taught by her equally vaudevillian half Irish father George, along with other more sentimental numbers that Paul later helped John convert to the guitar. After her shocking early death, Julia became a painful muse he chased through woods, over hills and mountains, and across oceans of creative brilliance in pursuit of her spirit; she remained with him, so long as he kept playing.

As we get older, we find ourselves being drawn back to our roots. Perhaps, to feel how far we've come, or to gauge how much we have changed, or reckon how true we have been to our original selves. Or it might be because we no longer know where we're going, if we're going anywhere at all. Most likely, it is a return to our essence. It was Lennon's hope that he and Yoko would spend their latter years living quietly in Ireland, specifically off the coast of Mayo on Dorinish Island that he purchased in 1967. But even as young twenty-somethings the Beatles' connection to their roots was close to the surface. On arriving at Dublin airport in November 1963 for what would

be their first and only concert in the capital they were greeted on the tarmac by one of George's Irish cousins. He proceeds to introduce John, Paul and Ringo to an RTE reporter standing by to interview them, finally announcing George as, 'an Irishman here, George Harrison,' to which John responds in a rather shy, please-do-not-leave-the-rest-of-us-out aside, 'hey listen, we're all Irish.'

As they reached their thirties, both Lennon and McCartney released songs in protest against the British occupation in Northern Ireland. In February 1972 McCartney declared his independence with his new band's first single that couldn't have been more direct, 'Give Ireland Back to the Irish' (the BBC never officially bans anything but it was deemed 'unsuitable for broadcasting'). 'The Luck of the Irish' and 'Sunday Bloody Sunday' from Lennon's solo album *Some Time in New York City* released the same year also went un-played by the BBC. It was never going to happen. The lyrics of 'Sunday Bloody Sunday,' a heavy groove response to the Derry massacre of 1972 have all the poetic vitriol of the John Lennon we have come to know and love.

Playlist:

My Bonnie – Tony Sheridan and the Beat Brothers
I Love a Piano – Irving Berlin
Liverpool Drive – Chuck Berry
Wild West Hero – E.L.O.

17

Irish Verve Meets English Restraint

It wasn't just Liverpool's musical DNA that was altered by migration from Ireland over the centuries. The cities that saw the greatest intake of Irish people fleeing poverty and starvation are now the crowned sites of Britain's music scene - London, Liverpool, Manchester, Glasgow. In 1861 the total of Irish born living in England, Wales and Scotland had reached 805,717 and through the first half of the twentieth century Ireland continued to be the main source of migration to England.

An unusual element of Irish migration was the number of single women who came to England alone to seek a better life. Some were middle class women travelling by the steam of ambition in the literary field, the most notable example being Frances Power Cobbe. Born into a comfortable Anglo-Irish Dublin family, Cobbe moved to London around 1860 to become a writer and had many articles and pamphlets published developing ideas on women's rights and anti vivisection. But mostly, unmarried Irish women of working age left for the likelihood of finding a job, usually in service, or as factory girls, washerwomen, weavers and street hawkers selling watercress, matches, apples and oranges. In the more specialised realms of women's employment they worked as nurses, governesses, teaching assistants and cooks. Their numbers increased between the two world wars as technology took over from brute strength in the fields and factories and opened up the job market to women even more; spectacularly so, after the Second World War when female emigration from Ireland was at an all time high for another compelling factor. Job seeking in England offered the chance to escape the ever-watchful presence of the Catholic Church empowered by the governance of the devoutly religious Eamon de Valera who ruled as Taoiseach, then President of Ireland almost consistently from 1932 to 1973.

Scattered among Irish literature and folk song are many references to Ireland's female embodiment. After centuries of injury to its land and people, the female became a national icon again under de Valera, but this time it was

a stereotype of womanhood wrapped up in a Catholic ideal and the constitution was Ireland's new dawn and a line drawn under any previous English influence that had corrupted Irish virtue. But 'the common good' is too often a cloak for tyranny. The Catholic Hierarchy was given nearly free reign over the people of the newly independent country and by a statement signed on behalf of the archbishops and bishops of Ireland in 1925 it decreed 'Purity is strength, and purity and faith go together,' a message local priests were expected to deliver to their congregation at Sunday mass. In real terms, it was a direct order to young women that they must dress modestly, never deviate from the rigid code of morality, nor be influenced by 'pictures and papers and drink.' The Hierarchy considered the most deviant pleasure of all was the 'great evil' of the dance hall, that fomenter of shame and scandal. A good time on a Saturday night was a 'sin and the dangerous occasions of sin. Wherever these exist, amusement is not legitimate. It does not deserve the name of amusement among Christians. It is the sport of the evil spirit for those who have no true self-respect.' The idea of sex, or even physical contact between the sexes, was vigorously suppressed and an appetite developed for retribution to be carried out on young women who made the grievous error of having sex outside marriage.

To escape the Catholic theocracy and the Republic's chronically underdeveloped economy, Irish men and women with any kind of zest for life had no option but 'to go across' in numbers that peaked dramatically in the 1970s to the tune of 957,830, almost a quarter of all of Ireland's total population. Irish men had been migrating since the early 1800s to build the nation's railways, canals, drains and roads; they were given the hardest, heaviest, filthiest work but were treated as a presence to be merely tolerated. With a significant labour shortage after the Second World War, 100,000 men were eagerly recruited in their hometowns to help rebuild Britain and expand its housing stock under the banners of McApline, Wimpey, Tarmac, Balfour Beatty, Taylor Woodrow and Laing. 'It's the Irish way to go into labouring. Building sites. Shit shovelers. John Lydon, son of a shit shoveler.' But like Seamus Heaney, Lydon rejected his father's way of life to instead dig for words. For the young and ambitious, migration to England was a rite of passage. According to the Dublin born novelist Joseph O'Connor, 'you got your plane ticket the day you got your degree. Emigration was so unquestioned that you didn't think about it much, it befell you, like a national puberty.' Yet, in many ways, O'Connor observed, England was a chimera,

'The closer you looked, the more English seemed Ireland, or the more irredeemably Irish seemed England.' Truth lies in the middle, and if we put aside our absolutes, we can find it. No longer the land of 'the old enemy' music bound England and Ireland together forever; as O'Connor goes on, 'Hard to tell kids to hate England when they love Manchester United, Leeds and Chelsea, The Beat, The Specials and The Clash,' confirming what I always judged was my dreamy, overly idealistic view: we are all united by a mutual love of a particular kind of song and it makes the world a better place. I've looked strangers in the eye as we stood in a field or a sweaty hall and as we shout-sung lyrics that are engraved on our souls, in that moment we are one.

With time, education and money the young people of Ireland became affluent and independently minded. They knew that priestly dominance was not a world they had to live in. EU investment in Ireland's economy in the 1990s (and negligible corporation tax for the big tech companies) boosted the national job market and offered graduates a reason to stay. Campaigns for more freedoms, such as the use of contraception and legality of divorce had been won. As a result, although Britain's population had more than doubled since 1900, the 2001 census shows there were just 695,355 Irish born living in Britain, yet 'Irish' was still the largest foreign-born group. Ten years later the figure was pretty much the same at 681,952 but on a shrinking trajectory with just under 400,000 Irish born in Britain in 2019. But include those of Irish descent and the figure is much, much bigger. A pre-census ICM survey in 2001 stated just under a quarter of the British population have an ancestral connection to Ireland, even if it is reaching back into the nineteenth century. It doesn't mean 22% of the British population is entitled to an Irish passport; it goes deeper than that. It can't be quantified by data and admin. I am English born and raised; culturally, I feel very English. But all my life I've been drawn by the call of Celtic music. I can't deny, nor am I indifferent to the stories of my Irish ancestry rooted in the west coast, most likely Connacht where the people of my paternal blood lineage were once known as O'Conbhuidhe; or the fact that my maternal bloodline comes from the family names of Elder and Scot mixed in with the Anglo-Scots name of Walker. We all of us come from somewhere, and those somewheres have stories and intonations that catch in our souls like a distant echo.

We could just leave it there. Scots and Irish musical inheritance kicked off a brand-new period in British music that set the bar high up in the sky and challenged anyone who followed to try harder. But my curiosity to discover how much Celtic musicality had influenced British pop in ways we might not expect post Donegan and the Beatles led me on to look at the lives of pop heroes and heroines that followed. That brings us to the seventies, and who else, but Kate Bush.

In *The Secret History of Kate Bush*, Fred Vermorel goes into detail tracing Bush's Anglo-Saxon ancestry on her father's side of the family, rooted in the small parishes of Pebmarsh and South Ockenden in Essex. In his imagination Vermorel envisions Bush as 'our goddess Frigg. And like the Saxons we both revere *and* fear her. Shroud her in the mystery of her power and the power of her mystery.' The curious thing is Vermorel's account barely mentions Bush's Irish ancestry, in spite of the fact she has spoken many times of her pride in her half Irish roots. Her mother, Hannah Daly was from a farming family in County Waterford who came to England during the Second World War to work as nurse at Long Grove Hospital in Epsom. She met and married the mathematician turned medic Robert Bush in 1943, the same year he graduated from medical school and became a GP in Plumstead. In the early 1950s they and their two sons, John and Patrick moved into an idyllic farmhouse near Welling in Kent, an area that specialises in market gardening. East Wickham Farm is a grade II listed building once owned by a wealthy farming family that supplied London's markets with its fruits and vegetables. It was built around the late eighteenth/early nineteenth century and for the Bush children, John, Patrick, and Cathy who arrived in 1958, it must have felt like a safe arcadia in which to dream and play. It has substantial grounds all enclosed castle-like behind high walls and fences, a duck pond and outbuildings for making dens; including a barn in which was stored an old church harmonium to muck around on and by which Cathy Bush first found her way around a keyboard, hammering out hymns she'd been taught by her father.

As I've mentioned before, the power of Celtic culture has had an engagingly dominant effect wherever it has settled, along the Appalachian Trail and in the Bush home. The Bush home was one of free, openhearted expression and music was everywhere. They had family sing-alongs of traditional Irish tunes, folk songs and 'dirty sea shanties' and their father played classical music on the family piano to unwind; John, older than Cathy by fourteen years, studied law but is a published poet and played in a folk

band, as did middle brother Patrick who is a musician, producer and instrument maker. From the beginning of the seventies through to the mid-eighties John kept a detailed diary of their doings, the songs his sister wrote, his own poetry and the forces that drove them. He remembers an 'Anglo Irish mishmash of influences, religion, music and dance.' 'The Irish aspect always seemed more in focus…My mother filled our house with her Celtic beauty and her singing; her philosophy of life always referenced her childhood and upbringing in the rural south of Ireland.' He goes on to recall, 'Our father embraced the music, the dancing and the humour and he was welcomed into our mother's family with warmth and affection. He also tried to transfer his classical proficiency on the piano to the piano accordion, so that he could play Irish dance music with them; most of our uncles played an instrument, and our mother's family all loved dancing.' For Hannah, home was her memory of Ireland and she recreated Ireland in East Wickham Farm, filling the house with so much love that it spilled over into the songs Cathy had to write from a very young age in order to expel the 'excess of emotion' and get it 'out of her system.' Bush recognized, 'my family are totally integral to everything I do.'

Of their trips back to their grandparents cottage on the Atlantic coast, John paints a scene of undiluted romance; 'there would be pounding of the fiddle and the accordion, starting up like some kind of musical engine against a background rumble of waves crashing on the cliffs at the mouth of the cove…Our aunts and uncles, and our mother, an accomplished step dancer, would be flying around the room, red-cheeked and beautiful, curly haired and with faces like film stars, lit by spluttering oil lamps.' He remembers his grandfather teaching him to notice the beauty of the world around him, 'the sounds of the waves on the cliffs, or how you could hear voices in the bubbling stream that ran past his house and into the sea.' He opened up his grandson's imaginary world with stories of fairies and the blackthorn gateway to their underworld, of ghosts encountered on his night-time gathering of seaweed when the tide was out, in the solitary silence of the full moon. Cathy, the delicate, little dark-haired girl, absorbed all the influences of the adults around her, mixed them in with ideas caught during the quiet intensity of watching sophisticated late Saturday night films on BBC 2 and her imagination. With her family's loving encouragement and by her own determination, she created a world of lyrical precociousness that removed her from her peers. Like all young people who feel older beyond their years, Cathy saw school not as the

best days of her life but as 'a very cruel environment and I was a loner.' She wasn't an 'easy, happy-go-lucky girl' as she used to 'think too much about everything.' Turning inward, she started writing songs at the age of eleven and instead of practicing her violin she spent several hours every daily playing and experimenting on the piano and writing songs about 'anything that moved her' John remembered, 'pets, friends, imaginary loves, elves, the strangeness of ordinary lives.'

In summary, growing up in the Bush household was a musical education Kate looked back on with gratitude, 'I'm very proud of it…I cannot think of a nicer influence. Traditional music says a great deal about the country. English folk music is a lot different from Irish folk music, not only musically, but lyrically. That song 'She Moves Through the Fair' sums up the Irish spirit. It's incredible, so moving.' England once defined itself as a naval and soldiering nation. The timbre of sailor's jigs and shanties, jolly, with major chord certainty and hymn-like conclusions seeped into the feeling of English folk. Irish folk, by contrast, is sensual; wild rather than boisterous, often with minor chords in its resolutions, reflecting the uncertainty of an historically persecuted people. When examining the contrasts of Englishness and Irishness John says, 'For me, as a child, the Irish aspect of our origins manifested in something enchanting, musical and innocently affectionate: our Irish-ness seemed glamorous: our Englishness grey, sedate, and boring. Ireland was summer holidays, and the colour of wild fuchsia and rhododendron, blue skies, golden strands, wild sea and wild music. England was the dullness of smog, school corridors and ice forming on the morning milk bottles.'

John's memories touch upon what I think was once part of the winning formula of British pop: Irish verve and romance meets a very English type of emotional restraint with the resulting psychic tension and release. As Kate said in Rob Jovanovic's 2005 biography, 'I feel that strongly, being torn between the Irish and English blood in me…my mother was always playing Irish music…when you are really young, things get in and get deeper because you haven't got as many walls up…It's really heavy emotionally.' But the two impulses needed to come together in an environment that allowed absolute freedom for a young woman to find out where they might lead, and to dance on the edges of sensual imagination. Looking back over Kate Bush's finest moments they have combined some wildness, fragility and numinosity that have been hard to define and are beyond the capability, it seems, of any other

artist. But once you hear the 'Jig of Life' on *The Hounds of Love*, Bush's third album recorded in tribute to her mother, her Celtic lineage is in full blast. Another example of it came in 1996 when Bush sang in Gaelic with a voice of strength and sweetness beyond words a version of the seventeenth century poem by Peadar O'Doirnin called 'Women of Ireland,' set to an exquisite piece composed by Sean O'Riada. There are traces of the same found in all her work: the mystical, the divine and intimations of immortality. John describes it as 'the pantheistic mystery of Irish folk music' comparing it to the very different influence of the 'catchy tunes of the Methodist hymns' a musical influence from his father's side of the family, and by which Bush first learned the building blocks to her songs. The tunes that were pumped into our ears as children - the primary school hits 'Lord of the Dance' and 'Jesus Bids Us Shine,' the mature heartbreaker, 'Dear Lord and Father of Mankind' and the rousing, 'I Vow to Thee My Country' that would move the heart of the least patriotic Briton, together with all the carols and descants we sang in services and festivals laid down a basic, fundamental understanding of melody and structure, even if we never realised it.

<p style="text-align:center">***</p>

In his autobiography, *Set the Boy Free*, Johnny Marr opens with a memory of Ardwick Green, Manchester in the summer of 1968. He recalls the daily stroll his four-year-old self took with his mother Frances, and their little ritual of standing outside a corner shop called 'Emily's' so that Johnny could gaze up into the window. It was the kind of shop that was once on many street corners in the old days displaying pans, brooms, buckets and firelighters and in 'Emily's' window, a little wooden guitar that was up on the shelf along with the household necessities. So fixated with this guitar was the mini Marr that a glorious day came when, instead of walking on they *went inside*. His mother gave money to Emily, who then took the guitar out of the window display and presented it to him. He carried it with him everywhere, and 'from then on' he recalled, 'I can't remember a time when I didn't have a guitar.'

The Smiths were borne of fruitful obsessions. Morrissey's with the written word of Oscar Wilde, Alan Sillitoe, Alan Bennett and Shelagh Delaney; Marr's with music of his childhood that informed the phrasing of his beloved guitar. They grew up in the cultural mix of big, second-generation Irish families living in the backdrop of Manchester's Victorian grandeur.

'Both those things together' Marr recalls, 'combined to bring out a certain thing that is quite beautiful in all the music that I've made and it's quite intense too.' Marr was born in Manchester not long after his parents had moved there from Athy in County Kildare. His mother was just fifteen when she joined her four sisters and two brothers who had come over to find jobs. It was on a return to Athy to see her family she met the man who became her husband, John Maher, at a local dance. He followed her back to Manchester and they married eight months later. Maher got his first job in a warehouse then joined the early morning gangs who would dig all day 'laying gas pipes in the road,' whilst Frances worked an evening shift as a cleaner at the Royal Infirmary. Soon after, they were joined by John's mother and his siblings; with the presence of aunts and uncles from both sides of the family – his father was a family of five, his mother of fourteen - and the cousins that soon followed, Marr felt the security of existing in 'our own community and a shared sense of background and history that made us feel like a tribe.'

It was an extended family steeped in music and religion. The Marrs were teenage parents of the 1960s 'obsessed about singers and bands' and in amongst the 'statues and crosses and prayers' it was a home that 'always had music going.' His mother listened to the weekly charts, but Marr particularly remembered the moment when his mum and Aunty May came back with a new single, plopped it onto the turntable of their Dansette record player and out came the gentle, opening swinging strut of 'Walk Right Back,' followed by the Everly Brothers' heaven-sent harmonies. Frances and her sister played it over and over, singing along, all the while being watched by her son loving the sight of his mother's joy in the music and carefully noting the guitar hook. Otherwise, like all music-obsessed children you had to take music where you could find it. In the days when the only options were the radio or your own pocket money sponsored record collection, television was another, more haphazard way you got to hear it. ITV's answer to *Top of the Pops* was *Supersonic* (which I never really got a handle on, for some reason. I think they were missing a live audience) but I loved *Razzmatazz*, a kind of entry level *Top of the Pops* that ran from 1981 to 1987; the Bay City Rollers had their own show *Shang-a-Lang* which was terribly exciting, or interesting acts sometimes turned up on the children's afternoon show *Runaround*, or on family shows like *Seaside Special* (the legendary pinnacle of which was ABBA's appearance on the show in 1975 which I never saw but I watched fixatedly every week in the hope the miracle might happen again), and I

always rather liked Barbara Dickson on *The Two Ronnies* (she was grown up, but not dull grown up); *The Old Grey Whistle Test* was a late night mystery. Marr would sit through *Sunday Night at the Palladium* or *Happening for Lulu* in the wild hope of seeing a pop band in the guest slot wielding guitars rather than a solo singer giving their 'soppy ballad with the sound of the BBC orchestra behind them.'

It was at his grandmother's house that he saw actual, real live musical instruments that belonged to his Aunt Betty. She was the family's legitimate musician for Betty was part of Manchester's traditional Irish music scene of bands who were the off-the-radar influence on the city's pop music ascension – bands such as Richard Walsh and his Blarney Boys, The Blanba Blarney Band, The Wild Rovers Band, The Ranchers Showband, The Downbeats, The Sweeneys, Aidan and the Strangers, Paddy and the Wild Country, The Dublin Rogues who all played Manchester's Irish pub and club circuit. The connection to their 'home place,' as Marr describes it, was strong. 'What was great was that when I was growing up, I had the best of both worlds. My parents brought me up to love my roots and appreciate my homeland…It was very, very cool actually but I've always, always regarded myself as Mancunian Irish and there is a particular strain of person who is like that. I've worked with Mani and Noel Gallagher, and Morrissey, all people with exactly the same background as me. They all play music and they all lived in Manchester and they all come from Irish families. So, Ireland is still definitely a huge influence on me.'

The key to The Smiths sound was Marr's childhood exposure to the night-time sounds of his parents' sessions, 'taking in the wildness' of drink and chat and dancing and with pop, rock and roll and country at the heart of it all. Chairs and tables were moved to the side and the seven-year-old Marr watched in delight his gran as she danced 'like a demon' or his parents jiving to Elvis Presley. Hearing the guitar riffs and seeing the feral joy they brought out in the adults around him gave Johnny the urge to make music himself to 'evoke the same kind of feeling.' It was during these nights that his father taught him to play the harmonica and the simple basics of making a tune. All his aunts sang, but the moment he waited for was for his aunt Ann to sing 'The Black Velvet Band;' the way she put the song over 'tinged with sadness.' Sitting watching all the adults, hearing them sing and play took Marr 'somewhere else.' The time would come from him to go to bed and as he lay there in the dark, floating up through the house came the 'other worldly' sounds of music

that became increasingly sad as they played into the night. Marr described this as 'a really magical time for me because the music got really interesting.' He picked up the feelings of 'yearning and a beautiful melancholy that I understood, but that was only expressed in music.' It created what he calls a 'gothic intensity.' Marr recalled, 'in those melodies I discovered a different side to life, and the outside world faded out. It was something I thought that was real and unspoken, and I learned that you could chase that feeling down.' It's a wonderful moment when you understand your greatest treasure lies quietly within. As an adult, the more Marr composed, the more he realised the arcs and chords came from 'that place that I had as a kid that's pretty fucking powerful' and through the music of The Smiths he offered up that that place to all of us (and I've been going there since I was thirteen). Those 'sad Irish tunes,' along with the 'morbid aspects of Irish migrant life' are in the walls of The Smiths songs.

Like the Lennons, the McCartneys, the Starkeys and the Bushes, music making in the Maher home was not just a habit but a priority. It sprang from the *ceilidh*, a free and easy folk social that made singing, storytelling and making music an ordinary occurrence. I am going to stick my neck out and say, without it, British pop music as we know it would not have happened. For the legacy of the *ceilidh* created an atmosphere of natural expression, took away self-consciousness and the fear of singing or performing to the group of people before you, and drenched young minds with the captivating sound of live instruments and pushed melody into their souls which, as they grew up, they translated into songs that reflected their own times and expressed their own feelings, shot through with a watermark of the 'Celtic aspect.' You can pick any Smiths song and find it, but for Marr its emotional force is strongest in what he calls his 'gothic waltzes.' He describes 'Last Night I Dreamt Somebody Loved Me' as 'almost quasi-religious really, dark, quite provincial.' But the crowning waltz of gothic yearning is 'Please, Please, Please Let Me Get What I Want,' a pinnacle of Morrissey's discontent and Marr's gossamer riffs of hope and innocence; a sweetness set in a vale of tears that are a distillation of life itself. Marr was originally going to call it 'The Irish Waltz.' He composed it in 1984 and remembers it 'as a sort of musical letter to my mother,' when he was living in London and missing home. Here is the crux of the Marr genius. The wonder of his guitar playing lies in the depth and wealth of a musical legacy that was his to draw on in perpetuity;

the ancient Celtic expression he heard in his parents' music had been passed down over hundreds of years and he reinterpreted it to create his own.

It was by hearing the guitar playing of Johnny Marr that Noel Gallagher decided he was going to be a professional musician. He collected all their singles, twelve-inches and imports and spent hours playing them in his bedroom, playing along with them and learning Marr's riffs. He believed Johnny Marr to be 'the coolest guitarist in the world,' feeling much more of a connection with the second-generation Manchester-Irish sound than the Irish culture he grew up in; aside from anything else, it was too definitively his father. The County Meath born Tommy Gallagher was in the building trade and he earned good money - very little of which his family saw - and he loved traditional Irish music. He met their mother Peggy at an Irish club the Astoria in January 1964 after Peggy had immigrated from Charlestown, County Mayo to Manchester where her brothers and sisters were already settled. Against the advice of her mother and all her own instincts, she married the seemingly charming man just over a year later and by Peggy's own account, the following twenty years of her life and of her three boys was a kind of hell, wrought by a thousand un-kindnesses. Gallagher had a busy nightlife DJ-ing in Irish pubs and social clubs; his sons Paul, Noel and Liam were routinely made to sit at a table on a school night with a bottle of coke awaiting his instruction to lug boxes of equipment to the van after their father had finished playing cards at two in the morning. He also ran a nice little line supplying bootleg tapes at Longsight Market. They were compilations of all the current best-selling Irish records and Paul would ferry twenty in box on the back of his bike to 'an old Irish bloke' who sold out of them in day at £4 each. His prized possessions were a guitar and an accordion that the boys were forbidden to touch; learning music making was an interest and a pleasure he denied his sons. It was only after an offer came through of a council house that the family could escaped the violent, adulterous, chronically neglectful Gallagher in a midnight flit, and that Noel was at liberty to practice the guitar his mother bought him from a catalogue and paid off weekly. He practiced in his bedroom and all over the house, as much as he needed, which was all the time 'like some junior junkie.'

'The clubs...the familiarity, the music, the comforting routine' - all the elements his elder brother Paul loved about Irish immigrant life, Noel loathed. He rebelled, too, against the expected life pattern for a young man born into the Manchester Irish community: the building trade, an early marriage,

children following soon after and those traditional Irish records that their
father rammed down their ears by playing them *really* loud that to Noel, 'were
the sounds of oppression.' But he reacted to his father's cruel, out of the house
til dawn persona in the typically Celtic way – in song. Through all the years
of living with their father's loveless attention to them, instead of lashing out
Noel quietly absorbed his emotions and kept it all in. Along with his restrained
personality came quiet strength, thoughtfulness and dedication that gave Noel
the focus to retreat into his own world, become a great guitarist and finally
release those contained emotions through his songwriting. As much as he
rejected his father's culture, the Irish priority for making music and creating
poetic storytelling was too strong; it's in his blood. Noel identified the strains
in one of Oasis' biggest hits, 'Live Forever' composed on a Gibson Les Paul
lent to him by Johnny Marr when Oasis were just starting out and he was
scratching around for money, "Live Forever' has the saddest chords but the
most uplifting message and that's being Irish, the Irish can cry while they are
drinking. They cry at funerals and then have the best party. It's the Celt in us.
You find it in the Scottish, the Irish, Scousers and maybe the Welsh if you
look at a band like the Manics. All the Celtic bands have that thing…U2 have
got it – there's a rage in Celtic people, not anger…there's a joy that goes with
it.'

Oasis have often been compared with the Beatles. Musically, I think the
Beatles were a kismet combination that is beyond compare, but at a quick
glance a few similarities stand: yes, they were huge, yes, they caused seismic
impact on the music industry, yes, they were famous for, sometimes
controversially, being themselves. The Gallaghers combined swagger and
vulnerability, anger and tenderness, bombast and larkishness, nihilism and
optimism, nostalgia and modernity. Like the Beatles they were the ultimate
British band that defined a decade and became a legend. Britishness, itself full
of contradictions, dripped from everything the Gallaghers did, said and sang
for good and ill. But again, like the Beatles, at the heart of it all was set a
beautiful, glittering emerald.

In *Bringing it all back home*, Nuala O'Connor describes 'a cyclical
impulse at the heart of Irish artistic expression.' I'd widen that statement to
say that there has been a cyclical impulse at the heart of British artistic
expression. The tunes and songs that left the shores of Britain and Ireland in
the eighteenth and nineteenth centuries formed one part of the pure, raw ethos
from which America's music developed. With the returning ships the music

came back like a gift - changed, sexier, irresistible, and sung with a new feeling that retained the core spirit familiar to those who know it when they hear. But most importantly, it served as a reminder to class constrained Britons of what was possible. Lit with a sense of humour and steered by commercial nous, a new twentieth century generation transformed the music once again, and reshaped it back into regional sounds with that all important sense of place. Once the Beatles fired the starting pistol and created a high atmospheric pressure in song writing - a time when, for creativity *and* commercialism, the sky was the limit - there awoke a dormant lyricism in England that had up until then been suppressed and ignored. England's song making habit was recharged and rose to the surface in a show of rebellion that, for all kinds of cathartic reasons, was about to take Britain's musical reputation to never before seen heights.

Playlist:

Anarchy in the UK – Sex Pistols
The Man with the Child in his Eyes – Kate Bush
Half the World Away - Oasis

18

The Land with Music

The mother of folklore is poverty
A.L. Lloyd, *Folk Song in England*

In his autobiography, *Rotten*, John Lydon tells the story of the time he and Sid
Vicious were walking down the King's Road minding their own business
when a Sloane hollered to them from her car – were they those punk chaps
and would they like to come to her 'coming out' party? In more recent years
the Season has been taken over by the offspring of oligarchs but this was the
1970s, and the tradition for the British upper class to hold parties and 'at
homes' to formally introduce their daughters to Society to find a suitable
husband was still *de rigueur*. The two boys accepted the challenge. On the
appointed evening and accompanied by a grubby, stripper-dressed Nancy
Spungen, they toddled down to a club called 'Wedgies' that once stood
opposite Peter Jones on the King's Road, (and was frequently the venue for
the 'Deb of the Year' competition) where the party was being held in its
ballroom.

They gained entrance after convincing the doorman that they had indeed
been invited, proceeded with purpose to the sumptuous party food, then to the
bar, then had a dance to 'some effete Euro-disco music,' followed by another
feed, then back to the booze. All the while they were horrifying and titillating
in equal measure their fellow guests who included Prince Andrew and David
Frost, whilst being closely followed by the young, giggling hostess,
wondering what they might do next and isn't it all hilarious. The party
photographer tried to take pictures but failed due to an anxious security guard
refusing to allow him to capture images of the punk urchins amongst all these
smart people in their evening dresses and dinner jackets, for it would surely
make the papers. The tragedy of a fabulous image that never was: Johnny
Rotten and Sid Vicious at an upper-class party in a Sloane Ranger night club
in 1977 perfectly summing up the social polarisation that used to pump the

heart of British pop culture. You might think such polarisation still exists today, but the sartorial difference back then was much more pronounced; to give the appearance of dressing expensively is much more affordable in the 21st century with the obscene amount of choice we now have. Plus, believe it or not, 'old money' and its look was trendy, especially after the onset of Diana-mania.

Our Sloane Ranger birthday girl was probably expressing the British upper-class fascination with the ordinary person who was 'making an impact,' a term Jonathan Aitken used in his 1967 *The Young Meteors*, his analysis of the sudden phenomenon of it being super cool to be rich and/or famous and working class; he'd also diagnosed a particular trait that is now full blown, 'that too many of the young generation are ambitious to *be* somebody rather than to *do* something.' Popular culture had been around for hundreds of years, but with its borderline tawdry reputation it was never considered truly desirable by those with real money and power. Never were its key players so admired, nor elevated to high status as they were in the seventh decade of the twentieth century. Around the world, the deification of the 'ordinary man' came at various points in history. In America it was in 1776 when the Boston Tea Party rebelled against George III's tax demands by taking arms, and with a little lawyerly assistance, created their independent rights. In France, the ordinary man (and woman) became heroic in 1789 with the storming of the Bastille and the March on Versailles; in Russia it was 1917 with the bloody ascent of Lenin's Bolshevik party. The idea of the British working-class hero was born with song; warming up in the 1930s by the charisma of George Formby and Gracie Fields, then it was seared into consciousness by the white heat of the Beatles; officially in 1967, when the BBC broadcast 'All You Need Is Love' to millions around the world, transmitting they were at last comfortable with a band of four working class young men from Liverpool representing the nation as Britain's best. The establishment had tried to resist it for as long as they could, but British pop was a cultural rebellion that couldn't be contained. Or perhaps it would be better to call it a cultural coup - a bite to the bottom of the respected tastemakers who held a tight grasp of the arts to ensure they were kept within the bounds of accepted taste. British pop was an overthrow of all that had previously been considered to be worthy of recognition and creatively, when working class song finally rose to the top. But it didn't spring up in the 1960s out of nowhere. As we've seen, it was centuries in the making, and it was built by generation after generation of

unnamed, unknown working people. The subject of the working-class roots of British pop might seem old hat, so repeated and debunked and re-repeated the theory has been over the decades since the 1960s. But the debate about whether John Lennon was working class or middle class, or pointing out that most of Genesis went to Charterhouse, or how the fake barrow boy posturing of certain pop stars reveals the sham of it all is to fixate on the technicolour of modern times to which we are in enthrall.

Why are we so fixed on the decades since 1960? Most likely because Britain's artistic reputation before then presented a picture of a nation that was, certainly from the outsider's point of view, not especially defined by its music. After several trips to England the celebrated German poet, essayist and journalist Heinrich Heine concluded in 1840 with a scathing wit, 'The sons of Albion are themselves the most awful of all dancers, and Strauss assures me there is not a single one among them who could keep time. He too fell sick unto death in the county of Middlesex when he saw Olde England dance. These people have no ear, neither for the beat nor indeed for music in any form, and their unnatural passion for piano-playing and singing is all the more disgusting. There is verily nothing so terrible as English musical composition, except English painting. They have neither an accurate ear nor a sense of colour, and sometimes I am befallen by the suspicion that their sense of smell may be equally dull and rheumy.' Don't hold back, Heinrich.

Celtic folk music is vivid in our imaginations. For centuries it remained a defining part of Scottish, Irish and Welsh identity built into their culture like a reverse Hadrian's Wall: robust and devotedly maintained to repel any incoming Anglicisation. But what of the music of the English people? According to the folklorist Albert Lloyd, England has always been a singing nation. Perhaps, a legacy of the pagan way of life the Church could never fully extinguish. How could it? The joy of singing and dancing is too strong; to suppress it is unnatural. But the ecclesiastical authorities tried to do just that. Fourth century early Christians managed to persuade pagan Britons to worship Christ by building the holy calendar around their ancient festivals: the Celtic fire festival Imbolc in February, signifying the half way point between the winter solstice and the spring equinox became the sacred day of blessing the church candles, otherwise known as Candlemas; the spring equinox at the end of March that marked the beginning of the pagan new year and the start of the astrological calendar instead became Lady Day, celebrating the conception of Christ; pagan Anglo Saxons celebrated the goddess Eostre

of the dawn and the light in April and the Winter Solstice was swapped for Christmas.

Under this arrangement pagan singing and dancing rituals were allowed to continue. But by the sixth century Church councils dryly concluded it was time to stop all this nonsense and announced that singing and dancing were prohibited, both in church and outside of it, a position they tried to maintain for seven hundred years. But resistance was futile. Lloyd claims in the late Middle Age people 'sang a very great deal…all classes of townspeople and country people were making up folk songs and passing them on. They were much in the air.' To illustrate, he recounts a story noted down by the late twelfth/early thirteenth century historian and archdeacon, Gerald of Wales: 'a Worcestershire priest was kept awake all night by villagers dancing in his churchyard – they always danced in the churchyard; it was a pagan hangover – and singing a song with the refrain, ''lemman, thine ore': Sweetheart, have pity. It seems that this priest could not get the song out of his head and the next morning at mass, instead of chanting the Dominus Vobiscum he sang, 'Sweetheart, have pity.' The scandal was considerable.'

We immediately think of Christmas when we hear the word 'carol' but they were once all-year-round dancing songs to celebrate the seasonal high days, which is why the best of them are so sprightly; they were designed for leaping about to. This scandalous episode happened on the cusp of a change in status for the carol. In the thirteenth century, under the cloak of Italian folk song the jolly Christian carol was born. It was a shift in tone ushered in by St Francis of Assisi and his belief that the honouring of the birth of Christ had been overlooked. As a result, happy, pretty, Rome-approved carols that were a blend of Italian folk song and sacred lyrics were dispatched to all corners of Christendom, and encouraged their own kind in Spain, Germany, France and England. For example, the melody of 'Good King Wenceslaus' was taken from the sixteenth century spring carol 'Tempus Adest Floridum' composed by a Finnish clergyman, but many were spontaneous creations by the people. As such they were dimly viewed by the ecclesiastical authorities, no doubt, according to the Australian poet and music critic, Walter J. Turner because they were shaping up a rather 'democratic character of English music.' Compositions Turner thought of a particular 'freshness and directness of expression' were its hundreds of anonymously composed carols that, like the ballads, evolved by the oral tradition using a blend of pagan and Christian themes with their subject matter based in ordinary daily life. One of the first

thought to be composed in England was a drinking song and was originally written in Anglo Norman French which places it around the fourteenth century:

> Lordlings, it is our host's command,
> And Christmas joins him hand in hand,
> To drain the brimming bowl;
> And I'll be foremost to obey,
> Then pledge we, sirs, and drink away,
> For Christmas revels here to day,
> And sways without control.
> Now *wassail* to your all! and merry may you be,
> And foul that wight befall, who drinks not health to me.

Turner called the first Elizabethan era 'music mad;' a time when music making 'was the universal recreation of the people, from the agricultural labourer to the Court and the cultivated classes.' The English people expressed themselves abundantly in song, a musical impulse, he claims, that carried on into the seventeenth century when England became, 'perhaps the most musical country in Europe.' Madrigals, the northern Italian fine part-singing of fourteenth century origin, had a huge late Elizabethan and early Jacobean revival, a madrigal-mad period from which folk musicians borrowed freely and assimilated into 'the whole organism of folk song.' An interrelation between folk music and composers' works went the other way, too; the rhythms of English folk-dance - jigs, hornpipes, morris and maypole dances – invigorated the Elizabethan keyboard. Otherwise, folk songs were composed in midst of day-to-day living, infused with pride and common sense, expressing how 'the common people felt and how they went about their business; what pleased them, what terrified them and what brought them grief; what they had of science and religion, and what they had of hopes.' To Lloyd, the folk songs of England were 'the peak of cultural achievement of the English lower classes; and believe me it is a very high peak, and if you put the songs together, they can take a place alongside those other great collective creations of the unnamed masses' and he cites for comparison the Spanish folk collection the *Romancero* and Finnish oral ballad collection, the *Kalevala*.

For the intervention of a dead hand on creativity, we might look to Oliver Cromwell and his fellow Puritans' desire to pour cold water on sensory

indulgence. Some argue Cromwell has been unjustly portrayed and that contrary to his reputation as the miserable fellow who famously put a ban on fun, he enjoyed the physical pleasures of riding and hunting and kept 'the best of musicians in his "pay and service."' He encouraged his daughters to learn the keyboard, and on the marriage of his fourth daughter Frances, a newsletter was reported '...they had 48 violins and much mirth with frolics, besides mixt dancing...'Although the king's orchestra had been sacked, 'twelve trumpeters' were maintained for State and diplomatic occasions and ambassadors were entertained after dinner with sung Psalms; even in the business of the working day, the tactical singing of a well-composed piece was 'a sure way into the Protector's good graces.' The Interregnum didn't exactly equal eleven years of 'gloomy silence.' Similar to the devastation of the Reformation one hundred years before minster and cathedral organs were destroyed, sheet music burned and choirs dispersed; but in smaller parish churches that could afford the upkeep of an organ, and in the private chapels of the wealthy sacred music from the previous century could still be heard. Yet by their militant attitude towards more elaborate church music, and banning altogether dancing, singing and music making on 'the Lord's Day' the Puritan age muted creative freedom, from which English music never truly fully recovered.

The Commonwealth's prohibition did have one positive outcome. To make a living and to exercise their creativity composers were forced over to secular music and drove music making in the home more than ever before. This may be one reason why at the end of the seventeenth century songwriting in England took a decidedly commercial turn. The music publisher, Henry Playford and the dramatist and satirist, Thomas D'Urfey published several volumes of songbooks entitled, *Wit and Mirth, or Pills to Purge Melancholy* that reads like a *Now That's What I Call Music* of hits from the Restoration period. It was the most popular secular songbook of its time and ran to four reissues with new songs added with every print run. The first edition ran to three volumes and the fourth and final edition had five volumes, with each book containing nearly two hundred 'lewd songs and low ballads' and 'the best Merry Ballads and Songs, Old and New.' They were a snapshot of the development of British popular music to date; a compilation of ancient folk ballads and broadside hits of the streets and taverns, with titles such as 'Oh! My Panting, Panting Heart' and 'Come Jug My Honey, Let's To Bed,' 'Awake my Lute, arise my string,' 'Have you e'er seen the Morning Sun,' 'I

Hate a Fop At His Glass,' 'Do Not Rumple My Top Knot' and an earlier version of the Child ballad, 'Sir Lionel' called 'Sir Eglamore, That Valiant Knight.' Eighteenth century England took the lead in all kinds of developments in the commodification of music. It saw the arrival of concert halls for the middle classes, the concept of the pay for entry gig (invented by the musician John Banister in 1672 as an ingenious way to earn an independent living), saloon entertainment, pleasure gardens, music publishing, advertising, along with John Gay's first middle brow hit musical, 'The Beggar's Opera' that ran for years and years, and balladeers were seen on every street corner.

In spite of the brilliance of Henry Purcell, born on the cusp of the Restoration, England's classical reputation died with him at the end of the seventeenth century. He had no obvious successor. The Kings of Hanover favoured the Italian, Austrian and German composers who had reached fulfilment by the patronage of the wealthiest patron in Europe – the Church of Rome. While England had a multitude of fine composers during the eighteenth century, none quite compared with the big hitters - Vivaldi, Handel, and Haydn. For new music of interest, the Royals and their intelligensia, those tastemakers of England, or rather, of London, looked to the European continent rather than to their own countrymen. That is, until the native body of classical works was uplifted by the Victorians: Parry, Elgar, Smyth and Holst who gave us the Promenades' everlasting suites, operas and symphonies.

Yet, in 1904 another German music critic, Oskar Schmitz, maintained an out of date, but similarly brutal sentiment to Heine, with his most famous and often-repeated quote, 'I have found something which distinguishes English people from all other cultures to quite an astonishing degree, a lack which everybody acknowledges therefore nothing new but has not been emphasised enough. *The English are the only cultured nation without its own music.*' But Schmitz did throw England a bone; even through his anti-English sentiment he could caveat the nation at least had some decent 'street ballads.' It seems it was only by the loud and clear expression of the ordinary man and woman that England, positioned as the converging point for peoples from all parts of the British Isles, was finally understood to be a land *with* music.

So, what happened to England's folk music? If we are to believe Lloyd, England was once as much a singing nation as Wales, Scotland or Ireland. If this was the case, why has folk song never been as deified in England's

cultural history as it is with our Celtic friends? In his 1907 *English Folk-Song: Some Conclusions*, Cecil Sharp wrote how the attrition of rural communities placed England's folk song under threat. Folk musicians were untrained amateurs, they played by instinct and possessed a body of songs that had been passed down through the centuries. Sharp called these people the 'common people;' they had no formal education except what they drew directly from their environment, from their community and by lessons from 'the ups and downs of life.' He goes onto say that the 'common people' were 'no inconsiderable part of the population,' but by the end of the 1800's, after a century of industrialization, they were 'an exceedingly small class – if indeed they can be called a class at all – and are to be found only in those country districts, which, by reason of their remoteness, have escaped the infection of modern ideas.' Sharp makes it clear that the rural singers who perpetuated 'the peasant song' in England were a dying breed, and the folk songs and carols once so in abundance in the early 1800s were disappearing from village life.

On a sunny afternoon in October 2011, I had the pleasure of interviewing the singer-songwriter and 6Music DJ Tom Robinson at the Covent Garden Hotel and, one hundred years later, he could see the impact of what Sharp had identified, 'The history of folk music in England, Scotland and Wales to some extent is a curious one because most countries in the world have a folk tradition that has to do with virtuosity. They have songs handed down from generation to generation that are sung at weddings, funerals, birthday parties that communities sing. It's quite common in India or Morocco or South America for people to burst into song at a social gathering in a way that people in England, at least, don't – in Wales perhaps they do, Scotland, Ireland maybe they do, but in England they absolutely don't. We've lost that communal culture of singing songs that have been handed on, so the folk tradition got side tracked and got shunted off on another branch line and went down a siding.'

'A friend of mine was in Rome for a big football match where England were playing Ireland, one night in one of the bars there were a load of England fans and a load of Ireland fans and they decided to have a singing competition. The England fans could sing 'Rule Britannia,' only the first verse, 'Swing Low, Sweet Chariot,' only the first verse and here we go, here we go, here we go, end of; the Irish fans began with 'Danny Boy,' 'When Irish Eyes Are Smiling,' 'Seven Drunken Nights,' the list went on. They had all these songs that were part of their culture whereas England got divorced from that culture

and that urge amongst us comes out in the form of pop music, in the form of rock 'n' roll, in terms of the music that's generated by youth. Because it's got to come out somewhere, it's a human instinct and it gets fed out through making your own songs, and making records and performing in bands, and get up the noses of the previous generation if you possible can.'

England had lost the culture of singing handed down songs. The sad fact is, England's folk song was eroded over centuries by the land enclosures that took away the livelihoods of small farmers and tenant labourers, driving them into its cities. Songs were left behind in pockets, in villages and artisans' workshops, but the rural voice got smaller and smaller. A seam of urban folk song developed in the collieries of the northeast, but by and large, the industrial noise of machinery drowned out any attempt by the worker to accompany themselves with song, as once he or she used to when weaving, reaping, hammering or spinning. Old style folk song couldn't survive in the atmosphere of city living as sensibilities had to cope with readjusting to an altogether different existence. Besides, they had access to new forms of mass, and more robust, entertainment; the pleasure gardens, saloon theatres and glee clubs of the eighteenth century evolved into song and supper rooms and taverns, and finally, they morphed into music hall where narrative folk mutated into big crowd-pleasing entertainment. Catering to a nascent teen culture, 'Penny Gaffs,' shops on the 'thoroughfares of London' overnight converted into makeshift theatres, where up to six times nightly they staged grubby cabaret shows to a working-class, mostly female audience.

To winkle out a picture of what England's rural folk scene once looked like before it faded away, in 2000 the folklorist Chris Bearman published an article 'Who Were the Folk? The Demography of Sharp's Somerset Singers' for *The Historical Journal*, accompanied with photographs and back-stories of the singers from whom Sharp collected songs all those years ago. Bearman followed up his article with a 'Somerset Folk Map' created with the help of folk singer Yvette Staelens. It's a collection of special dates and traditions according to the seasons, and the map charts Sharp's bicycling travels around the idyllic county from 1905-1918, detailing a selection of the one hundred and twenty-two locations he visited. It also gives the names, photographs and biographies of some of the more three hundred and fifty people he spoke to; ordinary working people from a whole range of trades: brickworkers, farm labourers, the labourers' wives, weavers, blacksmiths, sailors, dressmakers and travellers who offered up their songs for Sharp to put down in his

notebook. His lament for English folk music was timely enough to resuscitate what might have become a lost art. The late Victorians were in the grip of a national effort to protect the natural world and to encourage the urban working classes to reconnect with it, announced by the arrival of the RSPB and the National Trust. In the same spirit and with Sharp as its figurehead, the first folk revival was a conscious attempt by English song gatherers to embark on the restoration of the old songs they believed had been abandoned by the lower classes in favour of the broad, 'vulgar' songs of the music halls.

One of these enthusiasts was Kate Lee, née Spooner, born in Nottinghamshire in 1859 into an upper middle-class Anglo-Irish family. She studied singing and the piano at the Royal Academy of Music and enjoyed an operatic career until she switched her interest to traditional music. She was a founder member of The English Folk Society in 1898, but Mrs. Lee had been independently collecting old songs for a couple of years. In an article she wrote for the first issue of the society's journal, Mrs. Lee included an anecdote that starkly revealed the attitude her upper-class contemporaries held towards working people and their songs. During a Christmas spent in a quiet little village in Buckinghamshire she recalled, 'after breakfast, the singers came into the hall of the house where I was staying, to sing the songs of the village. After listening, I was quite anxious to take some down, but the host did not at all like the idea, because he said, "it would spoil the men very much if they thought they sang anything worth writing down."' Such was her good-hearted enthusiasm she pressed on regardless and made a secret trip into the village to collect the songs when her host was away. When holidaying for a few weeks in an unspecified 'little seaport town in the north of Norfolk' Mrs. Lee made another attempt to gather some tunes, especially as she noticed that in that part of the world many people seemed to live to a hundred years which led her to 'consider it was possible there was some latent music somewhere or other among them, especially as there were stories of witches and a good deal of folk-lore.'

Not at all knowing where to start, Mrs. Lee asked the local doctor and clergyman if they knew of any folk songs but drew a blank. With nothing to lose and 'with a trembling heart' she approached some fisherman who sat daily by the quay and blurted out to one of them, 'do any of you sing?' '"Do any of us sing?" was the startled reply – as they were generally only asked about the weather and the boats and the departed glory of the town since the railway came to spoil the shipping – "Sing? No, none of us sings."' "Oh," I

said, "don't any of you sing when you go out to fish?" "Oh, yes, of course, we sings then." "What sort of songs?" "Oh, all sorts of songs, but none as you would care to hear."' To which Kate replied, perhaps they were just the sort of songs she *would* care to hear and they discussed their favourites: 'The Farmer's Boy' and 'My Johnny Was A Shoemaker,' a striking version of which featured on the debut album of Steeleye Span, *Hark! The Village Wait.* But Mrs. Lee longed to hear the local songs of the area, of ships and wrecks, to which they replied that the man she needed to speak to was 'Tom C-' who's aunt had sung all the old songs and although she was dead, they did not doubt that Tom could sing them for her. Tom was sent for and was instructed to call on Mrs. Lee that evening. He arrived, 'dressed up in his best, and shaking with fright. He said he thought he could sing, but when he began, he was so frightfully nervous, not a note he could utter, and gave way to groans interspersed with whistling when he got anywhere near the air.'

Mrs. Lee ended her article by imploring her fellow society members to do their bit to collect songs on their own travels, for 'If all these lovely tunes are being left to take care of themselves in villages, how soon they will die and be heard no more. I hope very fervently that members will, when they take their holidays, find their way down to the piers and quays before the old fishermen have gone out with the tide.'

Playlist:

Whiter Shade of Pale – Procol Harum
The Poacher – Ronnie Lane and Slim Chance
That's Entertainment – The Jam

19

The Artists of Nowhere

Was Heine's assessment of English creativity unduly harsh? Clearly, he had never beheld a portrait by William Dobson, nor a Turner sunset, nor Joseph Wright of Derby's *An Experiment on a Bird in an Air pump*. But the truth is, the works of William Shakespeare and Agatha Christie aside, Britain's artistic reputation only became world renowned with the ascendency of its irreverent pop music. I know some might snort with horror at such a thought, but if you read that statement again it is hard to disagree.

The artist has never truly been a celebrated figure in British history, and there is no clear answer as to why. Perhaps, it was for want of patronage. Art, like knowledge in Medieval England, was in the almost exclusive custody of the Church. By 1200 there were 9,500 minsters and parish churches across the country and every single person was expected to attend for Sunday worship, moveable feasts, myriad esoteric saints' days and of course, births, deaths and marriages in between. The church was the epicentre of mediaeval life and the art within its walls was used to secure ecclesiastical power by stimulating the senses with mystery and beauty. When readings from the scriptures might leave the congregation unmoved, exquisite paintings of agony and ecstasy were used to elicit a more visceral devotion. Throughout pre-Reformation England working people gazed at wooden panels depicting biblical scenes in vibrant blues, reds, greens and gold and worshiped at sculpted figures believed to be endowed with the power to work miracles; they draped them in garlands on holy days and prayed to them in times of illness and trouble. No different to their Italian counterparts, English artists were little more than anonymous, day-to-day craftsmen employed to produce exquisite altarpieces and frescoes of saints, martyrs and terrifying scenes of Judgment Day; or to assemble an image of royal supremacy with heraldry, coats of arms and decorated barges. What separated the prospects of a gifted artist born in Bury in the 1400s and one born in Florence was investment. Behind the world's most celebrated artists sits a vastly wealthy sponsor, and there was none so vast of wealth as

the head of the Roman Catholic Church. A succession of popes and cardinals cultivated the talents of Giotto, Raphael, Titian and Caravaggio in the flourishing cities of Florence, Venice, Milan and Genoa; so too, did the Medici family who laundered the profits from their banking business by commissioning pieces by Michelangelo and da Vinci. The patron helped to elevate these creative genii and circulated their influence around the heart of Europe to shape the Renaissance and all the onward developments in art history.

Although prosperous regions such as York and Norwich had a healthy ecosystem of fine manuscript illuminators, carvers and glass painters, England's wealthy patrons were in thrall to the desirable works of French and Low Country artisans. Altarpieces, devotional images, gold and silverware, textiles and tapestries were frequently commissioned from abroad, and to confuse the idea of English art even more, Parisian and Flemish artisans were so in demand during the late middle-age many settled in England, namely in Southwark. As for individual artistic talent, there is no remaining evidence of any not otherwise supported by the monarchy. In the introduction to his series of Reith Lectures for the BBC the art historian Niklaus Pevsner presented the first fact that stood out in the history of English painting, 'the total absence of first-rate English-born painters from the fifteenth to the beginning of the eighteenth century.' Although one could counter William Dobson, whom Charles I named 'the English Tinteret' was an artist who might have been described as 'first-rate' and died just as the Puritans came into power. Yet, throughout this period, just as they did for their music, it was the fashion of England's kings and queens to look to the continent for their painters. The most famous of which is Hans Holbein the Younger. In 1535, Henry VIII hired the Bavarian Holbein, a Catholic born artist trained in religious art who had exiled himself in England after the Lutheran Reformation spread through German duchies and principalities. By his deft pivot into portraiture and his gift for crisp delicacy and detail, Holbein rendered the Tudors as a superpower, and their courtiers an arresting cast of characters as a modern-day soap opera. Holbein's only English-born successor came more than a generation later in Nicholas Hilliard, the celebrated miniaturist of the Elizabethan and Jacobean age.

In casting around for a reason for this lack of nurturing of local talent we can look to the events of two years before Holbein first took up his brush to paint the Tudor court, for by then the quantum of English art (97%) had been

trashed and burned. The Reformation declared a spiritual separation from Rome but in reality, it was the vast transferal of wealth from the church to the Crown and a process of cultural vandalism and renewal that ricocheted through the centuries, crystallising the idea of destruction as a creative force and allowing no reverence for what had gone before. With the passing of Act of Supremacy in 1536, eight hundred English monasteries were liquidated along with their artisans' workshops that were the source of English art. Churches themselves were scrubbed of any Catholic reference. In a 'rip it up and start again' fashion, the demolition of church organs and statues, the whitewashing of murals and frescoes, the frenzied defacing of screens and retables, the smashing of stained-glass windows and the burning of tapestries and music manuscripts was the annihilation of the props of the outgoing religious regime and in fits and starts, continued well into the seventeenth century. Not just to obliterate the past, but also to carefully retrieve materials of value – gold, lead, stone, reusable wood. Sculptures were chopped up and repurposed as building blocks, chalices were reduced to wine goblets at the dinner table, painted panels were overturned and reused as table tops or hinged to become cupboard doors.

The idea of 'popish idolatry' seems maniacal to us now, but the net result of what Henry VIII began and Oliver Cromwell finished was the message that in England, local art was disposable. During the Puritan years it became parliamentary policy to purge idolatry and de-beautify sacred places. Under Cromwell's watch, Westminster Abbey had a complete under-haul, as glaziers and joiners were employed to replace the stained glass with clear, to plane away any remaining painted images and to erect scaffold in order to cut out and haul down statues, inside and out, which was no easy task. In Macaulay's *History of England from the Succession of James II* he wondered why 'the nation which was so far before its neighbours in science in art should have been so far behind them all,' although I think he just answered his own question. Macaulay goes on, 'At the close of the reign of Charles the second' he assesses, 'there was not a single English painter or statuary whose name is now remembered.' Horace Walpole agreed, stating this 'low ebb' continued through the reign of George I. The engraver George Vertue blamed 'warrs & parties Revolutions & Religion' for preventing foreign artists from settling in England and re-invigorating the London art scene, for it was in London that every painter of note was either born or moved to, and where succulent commissions were to be had. When the Westphalia court painter Peter Lely,

knighted for capturing the likeness of Charles II and his court of beauties, died
in 1680 his collection of drawings and paintings were auctioned off in the
Banqueting Hall at Whitehall for the astounding sum of £26,000. The Naples
born artist Antonio Verrio grew rich decorating the walls and ceilings of
Burghley House, Chatsworth House, Windsor Castle and Hampton Court with
'Gorgons and Muses, Nymphs and Satyrs, Virtues and Vices, Gods quaffing
nectar and laurelled princes riding in triumph;' so much so that he kept 'one
of the most expensive tables in England.' The Dutch father and son team the
Vanderveldes settled in Greenwich and produced for Charles some of the
world's finest seascapes.

In *The First Bohemians* Vic Gatrell explains how English art was
revitalised not by 'the influx of sunny Italians' but 'of dank Protestant
northerners.' Yet, British art only truly began to flourish with the English
Rococo of Joshua Reynolds and Thomas Gainsborough under Parisian, and
by definition, Catholic influence after the securing of the Hanoverian dynasty.
Although anti-Catholic sentiment was still rife, the Act of Settlement of 1701
had safely set in stone that no future Roman Catholic would be permitted to
take the throne in Britain and as a consequence, ideas absorbed from Catholic
countries were no longer seen as dangerous; or rather, they were now seen as
wild, romantic and stimulating and began Britain's love affair with 'Gothic'
after Walpole's debut novel *The Castle of Otranto* printed in the black letter.
By the end of the eighteenth century the early Romantic painters William
Blake, William Turner and John Constable created a new form of British art
as they searched out ways to express their individualism and to put feeling
before thought. They were looking for a spiritual kind of magic and they
expressed it in the Italianate style that elevated the power and purity of nature.

Britain built its wealth and international status by discoveries in science,
technology and by the Industrial Revolution - all things borne of practicality,
logic and precision. Of all artists, it is Turner who is celebrated as Britain's
finest. Perhaps, because he captured the nation's scientific progress as well as
its seas and sunsets; most spectacularly in what is 'Britain's Favourite
Painting' *The Fighting Temeraire*, depicting the famous Napoleonic battle
ship being tugged into dock by a stout little steamboat through tranquil waters
tinged with bronze and gold, encapsulating the closing of the age of sail and
the onward strength of the age of steam. Turner's luminous way with paint is
bound up with Britain's industrial development with works such as *Rain,
Steam and Speed – The Great Western Railway, Bell Rock Lighthouse*, and

Dudley, Worcestershire, mystically documenting the great changes he witnessed in his lifetime and rendering them beautiful. But then again, the artist who is perhaps dearest to Britons, and the most popular, was shunned by the art world as an amateur outsider. It took thirty-seven years for a major gallery to mount a retrospective celebration of Lowry's works after his death in 1976. But fittingly, the Salford artist was commemorated in a song that made it to number one in the UK charts in 1978; the local singers 'Brian and Michael' paid tribute, even if the art world refused to.

The lack of glorification of Britain's artistic past has counter-intuitively provided a unique strength. In 1983 the novelist Angus Wilson concluded, 'The best contribution we make...is our eccentricity. We have most gloriously in England a country where culture has not been respected, and this has been our salvation. Artists throughout time have been persecuted or neglected, disregarded, laughed at.' He goes on to explain, 'The man of talent in France will be built up by academy honours and prizes until he is rather more than he could ever be in England. But the man of genius can easily be reduced to a kind of academic level. This has happened often in France, where eccentric movements have begun and have been swallowed up in schools of thought...In England, we have many people who belong to no school and to no body, and they are great people.' Not much has changed since. The online magazine *British Art Studies* kicked off its debut issue in 2015 with the click bait statement, 'There's No Such Thing as British Art,' and invited all readers to comment. To get the conversation started they published an opener suggesting that British art itself is 'illusive' and then goes on to pose whether British art even exists at all. The various answers from artists, professors of art history and art critics go down the rabbit hole to question identity and colonialism, the inability to pinpoint 'national characteristics or tastes' and claim that British art is inexactly 'fashioned on the British class system.' They leave you with the feeling that the historic lack of reverence towards Britain's artworks is alive and well; not only that, it is a part of its culture that is permanently open to question, if not downright attack. The Reformation dissolved not just the monasteries and convents but the technicolour, gold leafed heart of English life. Yet, at the same time it struck one of the most idiosyncratic hallmarks of our modern culture. To continue Wilson's comparison, France is famously protectionist of its culture, from paying a stipend to actors in between jobs, to insisting on 40% of radio playlists to be French speaking and providing left-bank accommodation for artists at a

peppercorn rent. As for their art schools the best of them were for the elite. They were expensive, required rigorously high levels of training to gain entrance and were devoted to studying fine art and sculpture. Although in theory anyone could be accepted, in reality they were a world of privilege accessed only by the middle and upper classes. Move to postwar Britain, and it was a very different scene. University education became newly available to the intelligent student from a modest background, and repositioned art school as the option of the 'dropout;' as Keith Richards said, 'It's somewhere they put you if they can't put you anywhere else. If you can't saw wood straight or file metal. It's where they put me to learn graphic design because I happened to be good at drawing apples or something. Fifteen…I was there for three years and meanwhile learned how to play guitar. Lotta guitar players in art school. A lot of terrible artists. It's funny.' Art colleges' reputation altered dramatically once they were recognized as feeder schools for *Top of the Pops* and it was only then they were reframed as the place for unacademic rebel showoffs with artistic leanings. Of course, we all know what Britain's art schools did for British pop culture, from John Lennon onwards. If you don't, have a look at Michael Roberts' *How Art Made Pop and Pop Became Art* – it's as comprehensive a study of Britain's art schools and their impact on British pop music as you will find. But to sum up, the typical British art school was an experimental 'liberty hall,' the place of government sponsored, free-floating experimentation; grants were available for anyone who wanted to attend and after graduating the dole was reliable financial support to drift the day away and dream up ideas that might be parleyed into becoming a rock god.

Iconoclasm and the lack of reverence for the artistic status quo came into full bloom in British pop culture, creating the nation's most democratic and, ironically, its most profitable art form. It's no coincidence its ascension happened in the vacuum left by the devastation of the Luftwaffe. Up until the 1960s the wreckage of hundreds of bombsites in London, Liverpool, Manchester, Glasgow, Birmingham, Sheffield, Hull, Cardiff, Swansea, Coventry, Bristol, Portsmouth, Plymouth and Southampton became children's playgrounds and places for reinvention as they lay in wait for regeneration. With every wave, from the mocking Teddy Boys duking it out with the Mods, onwards to folk rock, prog. rock, punk, post punk, gothic, new romanticism, house, garage, drum and bass trip-hop and grime, the gauntlet was laid down for newcomers to challenge and combat their predecessor's sound and style,

purging their image with a scorched earth spirit and a theatrical flourish. Of all the royal dynasties through the ages - the Plantagenets, the Lancastrians, the Yorks, the Hanoverians, even the Stuarts with their USP of poor old Charles I - we are a nation obsessed with the Tudors. With Holbein's lifelike portraits to gaze at, theirs' is the most famous royal house in British history with stories of lust, sex, celibacy, virtue, and uxoricide all in the pursuit of religious control and the consolidation of power. And it all began with Henry and his break with Rome driven by his fixation to bed Anne Boleyn and to sire a male heir. To achieve this, his decision to embark on a path 'to obliterate England's memory of who and what she had been' set in motion irreverence for what was, and a fearlessness to destroy in order to create.

Playlist:

Seven Seas of Rhye - Queen
Hit Me with Your Rhythm Stick – Ian Dury and the Blockheads
Damaged Goods – Gang of Four
Your Love is King – Sade

20

Robeson Hands on the Torch

When the blues slipped into Britain in 1950 African American creativity had been influencing the nation's mainstream entertainment for more than a hundred years. This time, Britons marvelled at not banjo, but guitar virtuosity. With story songs of real-life events and tragedies, the blues put a rocket up British pop that sang of love and dreamy kisses delivered with a high shine, and brought it back down to earth with a bass heavy thud. It was an influence aided by the singular advantage American blues artists had over their jazz equivalents in Britain. I grew up with the sound of jazz. My father was a lover of all kinds from Jelly Roll Morton and Louis Armstrong, to Benny Goodman, Glenn Miller, Count Basie, Bing Crosby and Ella. As a result, I've always been aware of how big jazz has been in Britain and I found it curious that so few jazz artists came over to Britain during the 1930s, 40s and 50s. Especially since the likes of James Bland, the Bohees and Layton and Turner had no trouble staying indefinitely in England.

It turns out the lack of cordiality between the Musicians Union of Britain and the American Federation of Musicians meant a big fat 'No.' The American union was formed in 1896, their British counterpart in 1921 and relations between the two were beady. The British union used its collective power to prevent American acts playing in Britain, with a particular grievance for 'the importation' of the especially popular 'coloured aliens' on the grounds that thousands of local musicians were struggling to get work. In 1923, Edward the Prince of Wales used his royal hand to broker a deal for Paul Whiteman and His Band to play in England and thereafter it was decided American bands would be permitted to perform for no longer than eight weeks on the understanding that the venue employing them gave work to an equal quantity of British musicians. Sounds fair. But in 1934 the Ministry of Labour and the Musicians Union united to put a complete ban on American bands coming to Britain. It was a tough line but one drawn only in response to the Department of Labor in America drafting the same declaration the year before,

forced by the American Federation's threatened strike action if the Department of Labor looked like they might issue visas to British bandleaders. This deadlock remained for twenty years to a non-sensical degree. In the 1950s, when Chris Barber visited the General Secretary of the Musicians Union to convince him to use his all-powerful hand to permit Louis Armstrong to play in London, the Secretary replied, 'Why do you always want an American trumpeter? Why don't you get a Russian trumpeter?' Well, you can't argue with that.

But for America's blues and folk artists, the deadlock was irrelevant. They weren't classified as 'musicians' and as such, they were not allowed to join the Federation. If they wished to join a union, they were could sign up to the American Guild of Variety Artists that had no tit for tat with its British equivalent. The handy by-product of the Federation's closed door was that for America's blues artists, Britain's doors were wide open. The first bluesman to stroll through was the South Carolinian Josh White. He saw himself not as a blues singer, not even a folk singer, but as a storyteller. Actually, he was known variously as 'the Singing Christian,' 'the Benefit kid,' and 'the Minstrel of the Blues' but, as Langston Hughes wrote in the liner notes of White's album, *Songs by Josh White*, 'Josh is a fine folk-singer of anybody's songs – southern Negro or southern white, plantation work songs or modern union songs, English or Irish ballads – any songs that come from the heart of the people...'

But I need to introduce him to you not through his records, but by the medium of BBC radio drama. In 1944, he narrated a BBC play recorded in New York that aired on the Home Service on the evening of the 6th March 1944 to nine million listeners. It was called 'The Man Who Went to War' and it was a collaboration between Hughes and the BBC producer Geoffrey Bridson. The two happened to have met in a bar in Manhattan in 1943 and they had bonded over a mutual love of jazz, poetry and progressive ideas. Hughes wrote the play, Alan Lomax directed, with musical direction by the composer and arranger Hall Johnson. In the lead roles were the boxer turned actor, Canada Lee and the actress and jazz singer Ethel Walter, with musical accompaniment by White, Brownie McGhee and Sonny Terry. The play tells the story of Johnny after he is called up and the struggles of his wife, Sally who is left behind to look after their family. Its aim was to highlight to the British people the African American contribution to the war against fascism, but really it was the story of solidarity with each and every person who was

fighting on the Allied side. As Paul Robeson explained in the stirring introduction, 'Tonight we are bringing you a new play by one of our leading poets, Mr. Langston Hughes, it is called 'The Man Who Went to War' and it is acted and sung for you by an all-Negro cast; just a few of your 13 million Negro allies in the United States. We, too, are part of this great, global war against fascism... But it is not just a story about our own American Negro troops, it is a play about everyone who is fighting today – the British, the Russians, the Chinese, all who are determined to win freedom for the world. Our story might be set anywhere that the war had been fought, anywhere that the bombs have fallen – London, Moscow, Chongqing. But because we have felt the pathos and the anger of war in our own hearts we are acting and singing our story for you in a way that is natural to us. We are giving you a picture of what you, yourselves, have lived through, Britain. Only the words and the song are our own. For these are the words and the songs that Negroes sing. Like your own, they are the songs of one more freedom loving people.' Next comes a spine-tingling rendition of 'Swing Low, Sweet Chariot' and in the following interludes, White narrates and sings classic blues songs adapted to Johnny and Sally's story including, 'How Long, How Long the Blues' and the old Lead Belly favourite, 'John Henry' with the setting adapted from the railroad to a munitions factory.

When White came to England for the first time in 1950, he was already a celebrated artist of the progressive folk circuit in New York and Washington. He counted Eleanor Roosevelt as a friend and she was godmother to his son, Josh jnr. But White was not especially politically aligned, he was just a born entertainer from a deeply religious family whose formative experience set in his heart an intertwine of a need to perform with an absolute refusal to tolerate racial injustice. He was born in Greenville, South Carolina and grew up during one of the most malignant periods for African Americans since the abolition of slavery. Greenville had been an early adopter of civic segregation in 1912, two years before White was born. But segregation was merely the state decreed subjugation of its citizens. The *un*official subjugation, White recalled, was the 'walking tax' demanded of Greenville's Black residents for simply walking down the street, the beating for perceived 'transgressions,' and, under the cover of night, the grotesque murders that compelled Abel Meeropol to write 'Strange Fruit.' The racial violence that hung in the air had devastating consequences for the White family. An incident involving Josh's father Dennis - a tall, handsome Methodist minister, and his manhandling of a

Caucasian bill collector out of their house for spitting on their living room floor had, as you can probably guess, catastrophic consequences. A couple of days later, the police came for Dennis and they placed him in jail where he was 'beaten to a pulp;' shortly after, he was sent to an insane asylum where he was intermittently to remain for the rest of his life.

Josh was eight years old when he met the blind guitarist John Henry Arnold as he was walking home from school one day. He spotted him trying to cross the street and helped him on his way, striking up a partnership that steered White into a life of making music. With his mother's consent, after school and occasionally bunking off for days on end, White 'led' for Arnold, then for other blind bluesmen. As a 'barefoot boy with a tambourine,' he kept time as 'the men sang gospel in their loud, rough voices' on street corners in towns as far away as Jacksonville, Florida and Chicago. It was a hard existence. White recalled, 'Roaming the roads, never certain where I'd sleep, and almost always hungry. I heard plenty of bad talk, too and at first, I was too young to understand it. But the music – the songs and the guitar, somehow, they made up for everything.' By the time he was fourteen he'd learned to play the guitar and it became so much a part of him through those tough, defining years he and his instrument were inseparable. After being scouted by Mayo Williams he recorded for Paramount and finally escaped the streets to become a versatile, charismatic folk-blues entertainer with a coast-to-coast hit song 'One Meat Ball,' and cameos in Hollywood movies.

Mrs. Roosevelt saw Josh as a true American talent and in the hope of helping his career she invited him on her European tour in 1950 to witness the good works of the Marshall Plan in action, and in Oslo, to unveil a memorial statue of her late husband. He accompanied his illustrious friend to embassy parties in each city they visited and Josh performed to all the dignitaries, including King Gustav of Sweden; in Gothenburg, such was the quick spread of his reputation a crowd of 15,000 people gathered outside the venue he was playing that was rigged with external speakers and were eventually rewarded with Josh making an appearance on the steps. But when White arrived solo in England his reception was akin to a royal visit. His ready audience was made up of dedicated jazz fans and fanatical record collectors who had been primed for his advent by White's appearances on *Children's Hour*, *America Sings*, and *Radio Rhythm Club*, along with multiple articles in *Melody Maker*, *Jazz Music*, *Folk* and *Jazz Journal*. He flew into Manchester in July and debuted at the Hippodrome. Afterwards, the record producer and music critic

Denis Preston declared in *Melody Maker*, 'On Monday night I saw the impossible happen!' The impossible being that one such as White, 'an artist on his first appearance in this country, and not even a name to the average British music-hall patron, held just such an audience spell bound with a twenty-minute selection of unfamiliar folksongs and ballads sung in a most unfamiliar manner.' After the show, Preston interviewed Josh with the respectful enquiry of an awe-struck fan. To help *Melody Maker* readers understand his art White told him, 'I sing songs of the people. Popular songs in the best sense of the word. Not manufactured hits.' 'His approach,' Preston explained, 'is that of the true folk artist; gathering his material from songs he hears about him, no matter the source, and weaving his own fabric of musical embroidery about it.' Above all, 'he is a great one for story telling in song.' For his guitar playing, White believed his secret advantage was that he was self-taught. His untrained interpretation allowed his particular way of playing to capture 'those in-between tones, that sort of strained intonation' upping his appeal even more for British audiences that maintained a curious preference for 'the amateur' over 'the professional.' In between shows, a half-hour demonstration in his dressing room left his 'little cluster of fans' 'wide-eyed' and 'open-mouthed.'

He followed his Manchester gig with a weeklong residency at the Chiswick Empire 'dressed in beautiful blue velvet.' After the show, half of the audience of musicians and jazz fans who'd travelled from all over the country to see him, including Lonnie Donegan, crowded out White's dressing room in the hope of better understanding the magic. His after-show sessions became a Josh White signature. A Liverpool fan described the experience: 'The atmosphere was informal, the recital spontaneous. Someone would mention a song, Josh would strum a few introductory chords, and we were away…we sat at his elbow watching the subtle changes in expression as he sang, listening at close quarters to his beautifully controlled voice and elegant guitar comments. He has a charm of manner and an incredible ease of delivery which cannot be described at second hand. He is a personality not easily to be forgotten.'

For those who couldn't get to see him in person, Josh recorded radio shows for the Home Service (today's Radio 4), the Light Programme (Radio 2), and the Third Programme (Radio 3). He made a quick trip to Paris, then returned to London for a non-stop schedule of two more radio programmes, a private gig with Humphrey Lyttleton's Jazz Band and yet another Home

Service show. This time it was called 'Presenting Josh White,' a half hour
autobiographical programme of Josh strumming songs and recalling his life
on the road with the travelling bluesmen. He signed off to his now vastly
grown and devoted fan base with a handwritten note printed in *Jazz Review*:
'I have met so many wonderful people since my arrival and I'd like to thank
each one, and here it is. I hope I'm able to see you every year, your pal, Josh.'

It was whilst he was in Britain that White learned of his listing in *Red
Channels*. It was a handy guidebook edited by the ex-FBI agent, Theodore
Kirkpatrick and Vincent Hartnett, a right-wing television producer, detailing
names of people in show business - writers, directors, actors and singers, who
by their associations, suggested they might be communist sympathisers.
Anyone who was included in this booklet was essentially blacklisted until they
explained themselves before the House of Un-American Activities. As soon
as White returned home, his career came to a shuddering halt as the HUAC
turned its gaze towards him. White's concerns were first and foremost civic
rights and justice for African Americans, and he mixed in with organisations
of the progressive left who supported the same. But to White his actions were
simply those of a Christian; hence, his nickname 'The Benefit Kid' for his
willingness to play at almost any and all charity fundraisers: 'Folk Song on
the Firing Line' and 'Bundles for Britain' to aid the Second World War effort,
for Catholic organisations, and for Isaac Woodward, the decorated war
veteran who had been blinded after being beaten up by police in South
Carolina. An alliance that caused him particular trouble was with People's
Songs, a group founded in New York in 1945 by Pete Seeger, Alan Lomax
and Lee Hayes to create and promote a body of songs for the American people
and to campaign for civil rights. It was this association that caught the
attention of the FBI and the fact that, along with Billie Holiday, Sarah
Vaughan, and Lead Belly, White had regularly performed at a club called Café
Society in the 1940s, one of the first non-segregated clubs in Greenwich
Village. It happened to have been owned by Barney Josephson whose lawyer
brother Leon worked for the Soviet secret service, and for this, Café Society
was mentioned in newspaper columns as 'the Moscow-line' or 'that
proletarian hangout.' Josephson had already been hounded out of business on
the pretext of breaking liquor licencing laws. Like the 'cancellation' effect of
the 21st century, the process of smearing a person as a 'pink' was done not on
the basis of fact, but amorphously by 'perception.'

The 'red' tag was the death knell of a person's livelihood. In order to have any kind of reputation restored, a person must go through the often covert, indefinable process of 'clearance,' or in other words, surrender their soul. The main thrust of what the HUAC asked of African Americans called to the committee was that they renounce Paul Robeson and his misquoted Paris speech that was now held up as treasonous fact. To head trouble off at the pass, in September 1950 White himself initiated what turned out to be a painful audience with the committee. He was not naturally a talker, he preferred to keep his feelings to himself but caught between two extremes he took the middle ground and spoke in defence of his belief in civil rights but without naming names, nor denouncing Robeson directly, he distanced himself from Paul's politics and that of the People's Songs. He declared he was a 'devoted American who had let himself be used' by 'phony, false faced, political rackets' and that if he had unwittingly aligned himself with the Communist Party by performing at charity concerts he had done so under the 'innocent impression' that he was 'on the side of charity and equality.' Having spoken with passion, honesty and integrity, having shared his formative pain of experience growing up in Greenville yet still insisting on his 'profound love for our America' White was bruised to realise the effect had resulted in the worst of both worlds. He alienated himself from the progressives and still left the HUAC unconvinced. Feeling isolated and betrayed he escaped to Europe until the heat of the 'Red Scare' years were over.

He returned to England in January the following year and *Melody Maker* heralded his triumphant return with a front-page story. His agent had lined up a nationwide twenty-eight date tour, with London concerts every Sunday, all of which was 'a wild success.' Josh was the ideal introducer of the blues to the average British gig-goer. His on-stage persona was relaxed and charming, and while his voice wasn't particularly strong, his performance style was sophisticated and lyrical, and his play list was an eclectic mix of traditional folk of all kinds – blues songs, spirituals, well-loved British ballads such as 'Barbara Allen' and 'Foggy, Foggy Dew,' a naughty reworking of the eighteenth century pleasure garden hit, 'The Lass With The Delicate Air,' the ancient Irish anthem, 'Molly Malone' and the equally ancient English folk song, 'The Riddle Song.'

Knowing Josh was back in town, the head of Light Entertainment at the BBC suggested to the radio producer Charles Chilton that they make the most of him while they could. Chilton had previously recorded Josh in New York

for the 'Radio Rhythm Club,' but to work with White live in the studio was 'a dream come true.' He recalled, 'To us, he was just a singer,' summing up what in fact became the all-in ethos of *Top of the Pops*, 'We couldn't really categorise him. He could do blues and American folk, but he did English folk songs as well, and anything else that came along. And he did them in a way that was so refreshing.' Comparing the same songs sung at school 'with the usual stiff piano accompaniment, and then to hear them sung in this style was absolutely fascinating. It had a great attraction to the English people. His programmes were among the best-liked programmes that we broadcast over the BBC. I couldn't do enough of them.'

White and Chilton put together an African American Anthology that was initially just a one off called 'Walk Together, Chillen,' airing on Good Friday. But it was so successful the BBC asked the producer to compile six more episodes, creating a series that went out every Monday for the month of May. It was renamed 'The Glory Road,' and it was a mix of African American folk music with poetry by Langston Hughes and the civil rights activist James Weldon Johnson. All through Josh's frequent returns to Britain he and Chilton collaborated on many radio projects, but in 1956, they reached a peak. It was with a four-part series on the evolution of African American folk music told through the subjects of 'Slavery, Protest and Freedom,' 'Work songs, Railroad and the Blues,' 'Hard Times, Prisons and the Big City,' and 'Love, Liberty and Hope.' Looking back, Chilton reflected on the work he did with White with pride, 'We went out of our way, and I think we were among the first people, to actively combat racial prejudice with these programmes. And for that reason, we got an awful lot of support from the British people and lots of insults, mainly from the American soldiers stationed in Europe. These programmes were very, very popular – among the best liked programmes that we broadcast over the BBC – and Josh became quite a hero to a lot of people.'

<p style="text-align:center">***</p>

All through the 1950s American blues and gospel artists came to Britain to record radio shows, feature as guest stars of established jazz acts or play its smaller venues. When Big Bill Broonzy visited England in September '51 he was in his late fifties and edging towards old fogeism. In the mid-1940s he had turned the blues electric in Chicago as Muddy Waters remembered, Broonzy 'was the first one I looked at with my eyes playing electric guitar;'

but five years on he had been overtaken by the new sensation of Louis Jordan and his big, fat sax swing. The fact that the 'race' record category was changed to 'rhythm and blues' was evidence of how the music business was changing and evolving. African Americans were naturally forward looking; music that was once a solace now contained painful memories.

For Britons, the old blues Big Bill played held no painful associations, nor had they ever been told to 'Get back.' Having seen the success of Josh White, Big Bill took a punt on cultivating his European fan base. Whilst playing in Germany, the British promoter Bert Wilcox spotted Big Bill and invited him over for what was termed a 'recital.' At the end of August, a discrete advert in *The Stage* announced his appearance at the Methodist Kingsway Hall in Holborn on Saturday 22nd September 1951 to what turned out to be small but discerningly appreciative audience of around forty people. His raw authenticity, his remarkable 'artistry' that was, 'wholly unpretentious' according to Paul Oliver in *Jazz Journal*, 'made Josh White seem slick and effete.' Perhaps a little harsh. Closer to the truth was Josh was no less authentic than Big Bill, just different; the content of their songs was similar but White had acquired a 'high urban veneer' during years of night club appearances in Greenwich Village, whereas Big Bill's country-turned-Chicago blues were more rugged but were delivered with clear diction and sincerity. These turned out to be qualities British blues fans were after and appreciated the most, and Big Bill's Kingsway Hall concert stimulated the bluesification of Britain in earnest.

Big Bill returned in 1952 for a mini tour, playing the Usher Hall in Edinburgh and Hove Town Hall and then again in 1953, when George Melly caught up with him at the Conway Hall in Holborn. Melly recalled in his memoir, *Owning Up* that he went along to his first sighting of Big Bill 'in a state of intense anticipation.' The idea of hearing an African American sing the blues 'was almost unbearably exciting.' Alan Lomax was there to give him a very, very long introduction whilst 'Bill stood patiently at his side.' For Melly, the evening was sublime and Bill's 'whole visit was a splendor.' He reminisces about an after-show party at a little house in Plumstead owned by record shop owner Jimmy Asman 'where Bill would drink a whole bottle of whisky and talk over quiet chords on his guitar, lie outrageously about things he had seen and done and sing the blues until dawn broke over Woolwich.' It must have been like a dream sitting, exhausted and hungover, in the living

room of a house in the southeast London suburbs, listening to the purest
evocation of somewhere so very far, far away.

The torch was passed on again. Big Bill had suggested to Muddy Waters
that he try out in England after his visit in '51, but at the time the idea of taking
his music to such an alien place seemed to him 'so preposterous' that he
immediately disregarded it. Seven years on he changed his mind, or rather,
he'd had it changed for him. Muddy had been discovered by John Wesley
Work on a sharecropping farm near Clarksdale in Mississippi and he became
the king of Chicago blues. But America's music trends shifted at pace and
after a few years at the top, like Big Bill, Muddy found himself relegated by
a younger buck with a new sound. He had been the one to recommend Chuck
Berry to Leonard Chess back in 1955 and the lightening success of rock n roll
shifted him to the sidelines with a shrinking audience. In fact, he was so
lacking in confidence that in 1956 he stopped playing guitar on stage
altogether. A life line came from Chris Barber who offered him a gig to tour
with the Barber band, and now it seemed like not such a mad idea. So, he
boarded a plane with his friend and accompaniment, Otis Spann and flew to
England only to discover 'a big surprise.' His first booking was filming for
Granada Television's *People and Places*; after which, rather bizarrely, Muddy
made his British stage debut at the Leeds Triennial Music Festival at the
Odeon Theatre. It was primarily a celebration of classical music, but the
programme had started to include a few acceptable jazz bands and blues
players; to British promoters, the blues was an acclaimed but still mysterious
type of folk music they were trying to understand. Muddy's first date with
Barber was at Newcastle's City Hall where his electric blues featured in the
second half of the band's set, opening every time with 'Hoochie Coochie
Man.' Folkies turned up hoping to see acoustic blues in the style of Josh White
and Big Bill Broonzy and promptly walked out in protest. Otherwise,
Muddy's dressing room was packed with adoring fans after this and each and
every subsequent performance in Doncaster, London (St Pancras Hall and the
Barrel House and Blues Club), Bournemouth, Birmingham, Bristol,
Manchester, Glasgow and Liverpool; in the words of Barber's business
partner Harold Pendleton, Muddy 'could do no wrong.' The reserved passion
of the fans, their endless questions, curiosity and devotion to the detail of his
performance was quite unlike any attention Muddy received at home and it
revived his confidence and brought him back to life. Even better, unwittingly
he'd planted ideas that marshalled into the British invasion just a few years

later and served to revive his fan base at home and confirm him, not as a has-been of America's music scene, but as one of its rightly celebrated originators.

In the main, the concept of stand-alone concerts for blues players at big venues seemed to be shooting for the moon. The New Orleans' gospel singer Mahalia Jackson made an under-publicised headline appearance at the Albert Hall in November 1952 (as a consequence, the freezing auditorium was only half full) and in February 1957, Big Bill made a similarly under-attended solo appearance at the Free Trade Hall. After which, the *Manchester Guardian* had a point when it complained in its review, 'His ballads of the cotton pickers and their slightly richer colleagues the share croppers, should have found a better audience in the grand temple of the cotton industry.' At first, it was a struggle for the German promoters Horst Lippmann and Fritz Rau to convince their British equivalents that a host of blues artists would sufficiently interest audiences beyond the more select houses they had been playing over the last few years. But Lipmann, especially, had come up against a much more sinister obstacle to enjoying and promoting African American music than parochial apathy.

He was born in 1927 in Eisenach, a mediaeval town in central Germany, and grew up in the shadow of the Third Reich. His parents moved to Frankfurt where his father owned a restaurant and as a teenager, Lipmann played jazz records for the patrons, and formed 'the Hot Club,' the dress code of which was to have 'long hair,' dress 'English style' and wear 'wide pants.' The Nazis banned American jazz for its racial associations and the Hot Club members routinely had gang fights with the Hitler Youth, for which they sometimes landed in jail. When Lipmann invited outlawed jazz musicians to jam in the back room of the restaurant a friend would stand guard out front and telephoned if the Gestapo came in, upon which everyone would scarper through an emergency exit. In 1944, Horst himself was interviewed by the Gestapo for listening to foreign radio stations and 'making propaganda with English and American jazz music.' In adulthood and the freedom of post-war west Germany, Lippmann became an agent and concert promoter and joined forces with Rau with whom he formed Lippmann + Rau. Having finally found a receptive promoter in the Manchester based *Melody Maker* journalist Paddy McKiernan, they negotiated a booking for the city's most famous hall.

McKiernan had been an early champion of turning the Trad jazz revival into a proper business, founding 'The Lancashire Society for the Promotion of Jazz Music' and he approached the promotion of the blues with the same serious intent. Between the three of them, they helped to make Sunday 21st October 1962 one of them most significant dates in the history of British music.

Exactly one hundred years on, at the exact site of the meeting that confirmed the Manchester mill workers' collective solidarity with the enslaved of the southern states, the people of Manchester were rewarded with a show of love from their blues playing descendants. Through their Chicago connections Lipmann and Rau had pulled together some of the most significant artists of the twentieth century for the inaugural 'American Folk-Blues Festival,' including country bluesmen Terry and McGhee, jump blues pioneer 'T-Bone' Walker and electric Delta bluesman John Lee Hooker (sadly, Big Bill had passed away in 1958). This concentration of Black American folk genius magnetized to Manchester the names that were to be the future of British music. Mick Jagger, Keith Richards, Brian Jones and Jimmy Page made the pilgrimage from London on a student shoestring to see them. The backstory as to how these four boys came together that night is told in David Williams' memoir, *The First Time We Met the Blues* in which he recounts his schoolboy friendship with Page, the fellowship found in having an obsession with collecting American blues records, and the five-hour road trip Williams, those nascent rock legends and other devotee friends took in a draughty white transit van.

They landed in the city late on Saturday afternoon and celebrated their arrival by getting 'wasted' at a party at Manchester University's halls of residence and dossing down variously at their friend's rented room in a large Victorian house, the YMCA, and for Mick and Brian (or maybe Mick and Keith, Williams can't quite remember), the back of the van. Having upset the landlady of the house after making a racket coming in the night before, all the boys were banned from taking refuge there to nurse their hangovers. Instead, they splintered into groups and wandered the empty, shuttered Sunday streets of the city centre until Williams, Jagger and couple of others eventually found an inn that was open: a 'huge basement Chinese restaurant' that offered warmth and a cheap set menu over which they guessed and imagined what the evening might hold. Five o'clock came and they made their way to the Hall.

Seated twelve rows from the front on those metal and canvas chairs that

were once the furniture of every school and church hall, they gazed up at the bluesmen, elevated high on the stage. Terry and McGhee were a warm up to the 'tough, dirty' Chicago blues the boys were really there to see. Back home, the duo had learnt to play down their whooping and hollering for white audiences but after their time on the road with Chris Barber four years before, they knew whooping and hollering was exactly what Britons wanted and they gave them a full-throated show. The backing band was made up of Memphis Slim on piano, Willie Dixon on upright bass, Jump Jackson on drums, and 'T-Bone' Walker on guitar who was 'the absolute personification of cool;' his music 'slick and bouncy.' But John Lee Hooker was the one they were waiting for. He was the last to perform, the only artist to play solo, and he came onto the stage 'looking very nervous.' As soon as he started to play, Williams remembers 'all of us were transfixed' as Hooker performed 'I'm In the Mood' and 'Boogie Chillun.' His brief set was soon over, but after an evening of restrained applause between songs, the audience suddenly went crazy and shouted for more. They were rewarded with an everyone-back-on-stage finale of 'Wee Wee Baby' and after the applause died down a second time, like two keen lovers too shy to express their feelings both the audience and the artists froze in a silent 'what now?' moment. The audience then rushed the stage, eager to shake the hands of the blues men and get their autographs. Williams recalled Hooker looking 'shell shocked' as these 'spotty-faced white youths' gathered around him as if he were 'the messiah.'

No amount of carefully thought through prose can sum up the effect the mythic gods from the southern states of America had on Jones, Richards and Jagger quite so well as just one snapshot in Williams' book. It's a photograph taken in September 1962 of a group of friends hanging out in a flat in Bexleyheath. In it, we can spot a pre-cool Brian Jones, dressed in a collar, tie and baggy jumper, looking down with elfin delight at a seated and equally presentable Mick Jagger. Keith Richards is peeping forwards behind Jagger as they each hold up to the camera a picture of their hero, Chuck Berry with the unaffected exuberance of stage door fans. Their friend, Harry Simmonds, is in the foreground twinkling and beaming into the lens as if to confirm, 'yes, the giddiness is real.' Of course, with hindsight it's easy to read into the photo that here are a group of young men who have been given the gift of a spectacular idea and they are going to run with it all the way. But what it also exudes is joy, sheer joy, and in Jagger's eyes, mischievous, unstoppable intention.

The crowning moment of Britain's bluesification was with a 1964 television special, *Blues and Gospel Train*. It was produced by Granada TV in the good old days of regional television, when, in accordance with the licences awarded by the Independent Television Commission, regional channels were obliged to devote several hours weekly to local programming. The Ilford born Bernstein brothers owned the hugely successful Granada cinema chain in the south of England but their next interest was in television and to need to develop an alternative to the BBC. Granada was a key franchise of the north that broadcast to that bank of the industrial heartland, Merseyside, Cheshire, Lancashire, Greater Manchester, Yorkshire, Derbyshire, Cumbria, North Lincolnshire and North Wales but its peak time viewing was shared across the entire independent network. With the launch of *Coronation Street*, the Bernsteins announced their commitment to representing real England, not the high-handed, curated BBC version, living up to their reputation as the 'entrepreneurial socialists.' They wanted to create television programmes that showcased the regions' strong identity, its people and its music, televising everything from Ringo's Cavern Club debut with the Beatles in 1962 to the smoke filled *Wheeltappers and Shunters Social Club*, that cabaret staple of the 1970s; under the guiding hand of the visionary producer Johnny Hamp, Granada provided a television opportunity for blues and gospel artists with a similarly game spirit.

To give the *Blues and Gospel Train* an authentic scenario it was set in an abandoned railway station on Wilbraham Road in the district of Chorlton. The ticket stipulated a dress code of 'Casual gear essential: Denims, sweaters' and the young audience of some two hundred gathered there by word of mouth gazed from one side of the platform at Muddy Waters, Otis Spann, Brownie and McGhee, Cousin Joe Pleasants who appeared on the other; but it was Sister Rosetta Tharpe who stole the show with her impromptu performance of 'Didn't It Rain' as Manchester's skies opened just as she arrived in a horse drawn carriage. *Blues and Gospel Train* was eccentric, and completely unique. It was broadcast on Wednesday the 19th August and drew in audiences of more than ten million, turning the rest of the country on to the blues and r&b that Manchester had been hosting in its clubs with feverish enthusiasm. And round about now, we can pinpoint the beginning of Northern Soul, (although the name wasn't coined until 1970) with the opening of the Twisted Wheel, the drug-fuelled, anti-charts, all night long pre-cursor to the Hacienda with its monster tunes ringing out their summons to fall in on the dance floor

along with hundreds of other sweaty bodies. The Free Trade Hall concert and Granada's television 'first' confirmed England as a second home for the blues players. But spiritual ley lines carried a deeper connection between the people of Britain's industrial north and of America's rural south. The Great Migration transferred the music to Detroit and Chicago, but the bond remained.

Playlist:

Memories of my Trip – Brownie McGhee
Shout to the Top – The Style Council
More, More, More - Carmel

21
The Revolutionary Romantics

There were two key reasons why music evolved and flourished so astoundingly in the southern states of America in early decades of the twentieth century: the mingling of west African and northern European music traditions in rural communities that had remained relatively unchanged since the end of the Civil War, and the emergence of local, independent, commercial radio. The free-styling radio stations showcased the best of regional music of the common people and drove musical adaptation faster than ever before. As Bruce Springsteen remembered of his childhood 'you could turn a dial and hear gospel, turn a dial and hear country, turn a dial and hear blues.'

In Britain, the landscape was quite different. Britain's radio broadcaster meted out music in the spirit of its Director General's Presbyterian dedication to inform, educate and lastly, to entertain. Radio Luxembourg had been doing good work since 1933 as the only accessible commercial radio station available in the UK and by the early 1950s it was transmitting a mix of drama serials, film reviews, quiz shows, religious programmes, plus a countdown of the top twenty. But it was not until Ronan O'Rahilly's off-shore sieging of the airwaves with Radio Caroline in 1964 that Britain's national broadcaster was forced into a complete rethink. Whilst America's folk song thrived, the remnants of England's folk music were picked over, cultivated and brought into the spotlight as a niche, middle class interest. A few genuine folk performers were allowed to represent their own art: in 1908, at the age of 75, the north Lincolnshire singer Joseph Taylor recorded a few songs for Percy Grainger that were released by one of Britain's earliest recording companies, the Gramophone Company; our old friend Harry Cox released 'The Bold Fisherman' on Decca in 1934, and the Welsh folk singer Phil Tanner recorded 'The Gower Wassailing Song' for Columbia in 1936. But these few exceptions proved the rule that whilst English folk was idealised in drawing rooms and civic halls, the cultural vitality of the rural communities that had perpetuated these old songs for hundreds of years was fading away.

There is a hymnal quality to old English folk songs that lent them to a genuinely new English music, albeit in the classical medium. As part of a Europe wide trend to consciously break away from Austrian-Germanic influence, Percy Grainger, Ralph Vaughan Williams and George Butterworth codified what they believed to be the archetypal sound of England's folklore in a new musical movement. The Australian born Grainger made new arrangements of the folk songs 'Shepherd's Hey' and 'Country Gardens;' Butterworth, who died aged 31 in the Battle of the Somme, composed the bright and tender 'The Banks of Green Willow' inspired by an English ballad of the same title and was the score to eleven of A.E. Housman's poems from *A Shropshire Lad*. The most well-known piece from this brief period of expressing an ideal pastoral life is, of course, Vaughan Williams' skyward flitter and swoop, 'The Lark Ascending.' It was first performed in June 1921 and is still Britain's favourite piece, regularly topping Classic FM's annual 'Hall of Fame.' The single movement is enjoyed by those who might not be classical afficionados for the reason I love it so, for its recall of the sweet simplicity of nature.

As the twentieth century progressed, folk dance became even more of a focus for preserving English heritage. One particular dance became a big hit for a few years after the Second World War - the square dance. Whilst researching folk song, Sharp had made the connection that this American dance was, like the songs, part of Britain's own folk tradition (although 'calling out' was an African American addition that spread to the Appalachians) and members of what was to become the English Dance and Folk Song Society toured their barn dances to the places from whence this new/old dance had come: Northumberland, Cumberland, County Durham, Westmoreland and Yorkshire. For those who couldn't be there in person, BBC listeners could tune into the *Village Barn Dance* on the Home Service and the Light Programme at various times of an evening, where they were encouraged to 'Roll back the carpet and join in the fun with Alf Adamson and his Border band' and 'Billy Miller and his Cheviot Ranters.' Princess Margaret was a fan of dancing in the round and the square and the society's director, Peter Kennedy honoured the royal patron of the EFDSS by composing a reel named 'Princess Margaret's Fancy' for her visit to Cecil Sharp House in Regent's Park in the summer of 1949. The first wave of the folk revival in Britain had reached all the way to the top and had been anointed with royal approval.

By then a brand-new wave had been bubbling up in Britain for ten years

or more, sourced from the same desire to preserve the people's art but with a very different vision. It was propelled not by patriotism and sentimentality, but by the political imaginations of two men - Albert Lloyd and Jimmie Miller, otherwise known as Ewan MacColl. They both possessed evocative singing voices - Lloyd's had an unadorned, warm, stridently English simplicity, whilst MacColl's had a beguiling, trembling strength - imbued with a deep sincerity that affirmed their commitment to the ancient spirit of folk song. Armed with these voices they promoted folk music as a form of contemporary and retrospective protest, drawn from what they believed to be the pre-industrial, historic purity of the peoples' song craft, that had, in their view, been swallowed up by that musical by-product of capitalism: popular commercialism. Lloyd and MacColl hoped to stimulate a stirring folk music *renaissance* that would be the soundtrack to a new workers' revolution in Britain. As Lloyd wrote in 1937 in an article for the *Daily Worker* (the precursor to the *Morning Star*) entitled 'The People's Own Poetry' 'Even today the English ballad still goes on developing, no longer, alas, in England, but in primitive communities of English origin and culture, such as in the Appalachian Mountains of the United States...surely the existence of such ballads and the splendid tunes to which they were sung emphatically disproves the theory that the masses are by nature unable to create artistically. And, more than that, the superb quality of English folk-poetry is a foreshadowing of what the masses will be capable of when they are at last free of the stultifying miseries of capitalist industrialisation.'

Both Lloyd and MacColl's worldview had been forged and fixed by living through the First World War and its aftershocks. Lloyd was born in Tooting in 1908, but truly he was a north Londoner. His family moved to Hornsey where he attended the local grammar school, and it was to where he returned after six years in the wilderness of the Australian outback. When Bert was sixteen his father, Ernest had signed him up to a British Legion programme to ship much-needed migrants to the New World in an attempt to spare his son from spectre of death that hung over the Lloyd family. It was an extreme but necessary move, for by the time he was twenty all of Bert's immediate family was dead. A baby brother, Eric had arrived in May 1916 but died in July 1917; tuberculosis killed his older sister Kathie the following winter and six years later his mother died of TB in the winter of 1924. Ernest himself, who's health had been severely weakened after serving in the Great War died in 1925; TB was to take his remaining older sister Trixie in 1927 aged 24 years, while Bert

was still in Australia.

Under a blistering sun the hard graft of fencing, boundary riding, tree cutting, shearing and tail docking a few thousand sheep and lambs, and the primitive existence that can only be found in the oppressive isolation of the Australian bush toned up Lloyd's character in ways that would set the course for the rest of his life. He encountered union power for the first time when he worked at sheep-stations in New South Wales – joining a union was compulsory for those who worked on the big stations - and it was there he first heard a folk song, sheep shearer style, and started to unconsciously become a song collector, memorising lyrics and tunes and jotting down verses in an exercise book for the sake of some desperately needed mental stimulation. Thanks to the Sydney Library postal service, out in one of the most remote places on the planet he intellectually rushed at life, reading, reading, reading, giving himself a personally curated university-level education in literature, music and art, doubly enhanced by his ability to retain facts. He borrowed books by Proust, Tolstoy, Joyce and Twain, the newest novels, classic travelogues, books on Russian literary history, poetry, philosophy, biographies and contemporary literary criticism to fill the mental void. All the while he mixed in with the seasonal shearing gangs and drovers who came and went, leaving behind their folk songs that Lloyd took note of, but was to only fully appreciate, as with all keepsakes one finds on one's travels, when he got back home to Britain.

After six years, Lloyd finally had enough of the life that was so completely remote from who he was and in May 1930 he returned to Britain full of ideas of union power streaked with the fury of how his father had been treated during the war. It was his belief that the filthy and undernourished conditions in the trenches the men who did the dirty job of fighting had to endure had brought the highly contagious tuberculosis into his family. He discovered that the state of mind he had developed thousands of miles away was in tune with his contemporaries back in England who held unresolved grievances by the devastation of the Great War and what they considered to have been the missed opportunity of Britain's almost-revolution of 1919. Bloomsbury, Soho, Fitzrovia and pockets of north London were now hubs of communist activity, with groups of passionately idealistic, left-wing intellectuals who had yet to be disabused of the wonder of Stalin. He moved back to his old neighbourhood in Hornsey, re-adjusted to life in London in the midst of the Depression and became 'the bohemian of bohemians.' He took a

job managing the foreign books department at Foyle's which kept him afloat for a few years and after work, it was his habit to drop into the Admiral Duncan on Old Compton Street or dine in the Formica top cafes of Soho or Meg's Café alongside the legendary Parton Street Bookshop where gathered the young poets and artists who so believed in the cause of anti-fascism that they were prepared to die for it.

Lloyd, described by his old boss Christina Foyle as a gentle man with 'a most charming smile' who seemed to know 'everything about any subject under the sun,' befriended the men and women who were to become the left-leaning cultural vanguard of Britain's art and literary scene. In particular, Leslie Morton, a fellow Hornsey-ite and the soon to be editor of the *Daily Worker*, Lloyd met when he wandered into Morton's Finsbury Park second-hand bookshop in 1932. Through Morton and his wife Bronwen he met his future wife Norma Hutt, and they were all were committed members of the Islington branch of the Communist Party of Great Britain. Lloyd offered to the cause his services as a journalist and cartoonist producing media of all kinds – marching banners, pamphlets, articles and posters, and having had his senses awakened by the drovers' songs he started to tap into the hidden streams of England's folk songs.

It was through Morton that Lloyd had his first rare sighting of England's folk music in its natural habitat. After Morton had finished writing *A People's History of England*, he moved out of London to return home to the Suffolk coast, to a little cottage a couple of miles from Eastbridge. In his book, Morton devotes a passage to an incident that occurred just thirty miles north, to one of the early rebellions against the enclosures of common pasture. In 1549, the Norfolk landowner Robert Kett led some 20,000 men on a march to Norwich in protest against the seizure of land that had been held and worked by the peasantry for generations. The city was taken, and the Earl of Warwick, acting as regent to Edward VI, sent an army of 12,000 to put down rebellion in a battle lasting two long days; Kett was hanged along with hundreds of his followers. The larger cohort of Norfolk landowners were appalled by the rebellion and charged Warwick to give no mercy to the peasant fighters who walked back home to their families. But in the face of their demands for further slaughter the Earl responded, 'Will ye be ploughmen and harrow your own land.' The episode had been so great an upheaval it cemented East Anglia's enduring resistance to the enclosures and, as a result, its 'peasant character,' as Morton called it, survived. It was perhaps why East Anglia was

one of the last bastions of rural folk song, as Alan Lomax was to discover. Lloyd and Norma visited Morton one weekend in 1938 and he took them to the Eel's Foot pub to show them what a Saturday night looked like at his local – it was 'sing, say or pay' night. There tucked in the small bar, presided over by a chairman with a cribbage gavel to keep order and instruct the proceedings, were the South folk: sailors, labourers, tradesmen, gamekeepers, 'young and old, women and men,' giving full blooded renditions of folk songs handed down from generation to generation. There were songs of highwaymen, of adventures of ships at sea, of deserting soldiers or betrayals in love, along with a demonstration of a country step dance called 'Jack's the Boy' and they finished up with 'Auld Lang Syne.' Here were the people Bert had only read about in books, the rural working class keeping their tradition alive for as long as they had air in their lungs.

A year earlier, through an old Parton Street contact, Lloyd had managed to get his first script to the BBC commissioners and the result was a fifteen-minute radio documentary entitled 'Voice of the Seaman.' Ever intrepid, it was based on his research after he spent seven months whaling in the Antarctic. In the squalls, fog and the bone aching cold, working twelve-hour shifts and living a strange, filthy, brutal life of blood and blubber, he had harvested sea shanties and whaling songs from his fellow crew of Norwegians, English and Welsh who 'sang all the time…If two met, they sang in harmony.' The BBC happened to have just produced another radio programme about unemployment in America, called *The Job to be Done* and Lloyd's script, based on the working life of the ordinary British seaman suited a new, borderline revolutionary airing of programmes that had the labouring man's view to the fore. Lloyd managed to persuade the BBC powers to let him make another programme and he returned to the Eel's Foot in the spring of 1939, this time armed with an outside broadcasting unit and some petty cash to keep the beer flowing. The result was 'Saturday Night at the Eel's Foot,' aired on 29th July 1939. It was the first radio programme to give the average Briton listening in from their sitting room an idea of what went on in little pubs hidden in remote corners of England on Saturday nights. The Eel's Foot producer Maurice Brown followed up with a series called 'Thirsty Work' broadcast on the war-time Forces Programme. The half hour programmes were recorded in inns in Westmoreland, at Ebrington in the Cotswolds, Harome in North Riding, Redmire in Wensleydale, North Littleton in Worcestershire, and back at the Eel's Foot. This new series set out to

'reproduce the voice of tap room in song' with samples of the favourite drinking songs of farmers, blacksmiths, quarrymen, shepherds, postmen, policemen, coal sellers and 'jack of all trades'. This was the living tradition of England's song unadorned, and it was captured in the nick of time just as the march of radio, jukeboxes and television did for it.

It was, perhaps, that 'sing, say or pay' night Lloyd used as his muse when he wrote his manifesto of English folk song. After a year's journaling for the *Picture Post* (once Britain's most popular magazine) he enlisted in 1942 and joined the Training Regiment of the Royal Armoured Corps based at the garrison town of Tidworth, Hampshire. In between the 6.15am parade, training in gunner-mechanics, target practice and wireless operations, equipment cleaning, attending lectures, learning morse-code and driving tanks up and down Salisbury Plain he wrote his radical booklet, *The Singing Englishman*. Lloyd had been contemplating his subject for several years, but the trigger of inspiration had been two albums by the American folk group the Almanacs that had been released in the early 1940s. The Almanacs (a precursor to People's Songs) had an ever-changing membership, but at the time the band was made up of Woody Guthrie, Pete Seeger, Lee Hayes and Millard Lampell, and they sang topical songs of anti-war, labour militancy, class consciousness and civil rights set to the sound of traditional harmonized melodies. When Lloyd borrowed two of their albums, *Talking Union* and *Dear Mr. President* from a merchant seaman friend recently returned from New York they were a revelation; they presented him with 'an idea of a new dimension in folk song.' As Bert's friend, the physicist and folk singer John Hasted explained, 'We were all very conscious that 100 per cent of pop music is politics, so if you destroy pop music, it's a political act. Bert understood this earlier than I did. Which is why he was singing English songs while we were still singing skiffle...we were trying to start a movement.'

The folk revival had not yet begun in England and there was yet no sound archive to speak of, but in 1944 Lloyd understood what lay fallow; by the physical records of the Almanacs, he could see what was possible and what the future might hold. Although he found it hard to write in the barracks, ironically, 'due to loud singing of companions!' Lloyd wrote *The Singing Englishman* in his engaging, romantic style formulated around his Marxist belief and infused with the memories of that May night at the Eel's Foot. It had only a small circulation; but being, at the time, a unique re-appraisal it re-ignited interest in England's folk song from a fresh and persuasive point of

view. It was destined to become a mini manifesto for a new folk revival when, at the age of 43, the course of Lloyd's career entirely changed. That moment came in 1951, one balmy summer's night, or a freezing winter one, depending on whose remembrance you read, when Lloyd met MacColl.

Ewan MacColl's childhood was steeped in music. He was born James Henry Miller in Salford on Robert Burns' birthday in 1915 and he was raised in a hothouse of radical politics and song. His parents, William and Betsy Miller were Lowland Scots. They met when Betsy worked in a pawnshop in Falkirk and a rather 'shabby looking' Miller came in to pawn the gold medal he had won in a singing competition. A small, flirtatious spark between them encouraged Miller, who was well liked locally for his warm, slightly roguish character, to smarten up his act. He returned to the shop dressed in his best navy suit and polished shoes, and they married a few months later.

William was a working class intellectual of the old school. He was iron-moulder by trade and a semi-professional pub and music hall singer with the alter-ego name 'Wally Macpherson, a Fellow of Infinite Jest,' and he passed on to his son both a political mindset and a natural inclination to perform. Schooled in socialism during his early days as an apprentice, William was influenced by the oratory of the Glaswegian activist John Maclean and the idea of the return of 'Celtic Communism' – the belief that 'the communism of the clans must be established on a modern basis.' For this, he was widely blacklisted by the management for being a troublemaker, forcing the Millers to reluctantly migrate south of the border to find work. They found themselves in Salford in 1910 after Betsy had been assured by her sister who had already moved down that there that decent wages and accommodation were to be had. Salford was to be their home for the rest of their lives but the Millers' view of it never changed. Betsy recalled how when she first arrived in Salford and she looked around the town that held all their hopes for the future, nausea turned in her stomach; as she took in the 'Little streets' she remembered, 'I hated them and the dirt and squalor and smoke and filth of every kind.' William hated the place, too, but it grew to be irascibly entwined with the familiarity of home; a strange love and loathing they passed on to their son who was born in their rented rooms in a two-up-two-down terrace on Andrew Street; a feeling he was to express in his tender ode to Salford, 'Dirty Ol'Town.'

William took a job at a foundry in Pendleton and the little family - Jimmie was cherished and spoiled as their only surviving child - insulated themselves against their new environment by keeping with their fellow Scots émigrés and absorbing themselves in their own culture. The young Jimmie recalled how his parents spoke in halcyon terms of the picnics, bike rides and sing-a-longs on summer evenings in Falkirk and they ate only Scottish food – mince and chappit tatties, broth, stovies. They kept to a three-day Hogmanay and seeing themselves only as temporary residents in Salford, 'They sang their Scottish songs and talked endlessly of Scotland,' fixing in young Jimmy's mind 'a magical landscape in which my mother and father walked in a cloud of music' and built in their son a feeling of Scottishness he could 'never full claim.' William was handsome, ebullient, with thick dark hair, a cheerful countenance, a 'powerful, tuneful voice' and a 'large repertoire of jokes, tales, ballads and folksongs.' He not only was 'the life and soul' of Hogmanay parties, he had the habit of serenading Salfordians in general, making Jimmy cringe by his singing 'lustily on trams.' In young Jimmy's world, music was everywhere.

William had failed his medical for the army and spent the Great War working in the foundry whilst Betsy, 'thin and bent' and with chronic psoriasis, took in washing and held two cleaning jobs, working 5-9am cleaning offices in central Manchester and the remainder of the day doing the bigger houses of Salford's suburbs. William was a self-confessed militant, and according to his son, 'a revolutionary romantic…who sobbed like a child when Lenin died,' to the point of causing arguments with his wife when she feared his fanaticism might jeopardize the family's stability. But still, for Betsy, it was the three of them against the world or, 'the class enemy' - a term she often used with 'studied venom.' Both she and William were members of the Workers' Arts Club which held film nights of what would now be considered indie cinema of foreign, mostly Russian, films, and Sunday night debates of which Will was a star performer. Their son would watch spellbound by his father's gift of argument and the 'compelling spectacle' of the drama of ideas; improvised, illustrated with literary references and uncertain of outcome, the debate nights were the beginning of his 'fifty-year-love affair with the theatre.' But as the years passed, Miller saw his father suffer from worsening bronchial asthma brought on by Salford's bad air and his upright carriage with a 'brisk, purposeful step' decline into a stoop of despair from frequent unemployment and his weakening health.

A lodger of the Miller's impressed with the well-read Jimmie persuaded the Young Communist League to admit him when he was just 14, perhaps as a rite of passage for he left school that same year, which must have been a relief. Jimmie possessed a fine mind, keen observation and an inventive imagination but his school years had been hard. The shame of being the son of a cleaner in a cast-off uniform and even worse, the humiliating derision of one particular teacher for his being unable to supply an apple for a drawing class developed in him a phobia of school and numbed his mind. The creative child that he was home, 'always singing and writing poems' was paralysed as soon as he walked into the classroom. It was only in the Young Communist League that the private creative Jimmie became public. There, MacColl recalled, he started songwriting 'more or less quite by accident' and through his teenage years class-shame merged with his parent's class-consciousness to brew an anger that distilled into revolutionary zeal he could freely express in the atmosphere of the YCL. Drawing on his parents' repertoires of traditional Scottish ballads and 'the mocking little couplets' of children's street ditties he began to pour that zeal into satirical pieces for factory newspapers and parodying popular songs of the time.

Jimmie Miller's early years ran in parallel to the ascendency of the CPGB. When he first joined, he recalled there were just nine other members of the YCL, but by the time he reached his eighteenth birthday there were, according to MacColl (who had a habit of inflating his figures somewhat) 'probably nearer 900!' Young people had been politicised by the Great Depression of the 1930s, by which the industries of the north were most badly hit. With a group of similar minded teenagers, he formed the Manchester branch of the Workers' Theatre Movement called 'The Red Megaphones,' in honour of a leading communist theatre group in Berlin, with the intent to put on 'a propertyless theatre for a propertyless class' on street corners and in parks all over Lancashire. It was Soviet style, agit-prop theatre – short pieces, a bit of comedy, a couple of songs and a Marxist end message - for which Miller became the scriptwriter re-interpreting the grown-up world of strikes in colonial India and those closer to home in the Lancashire textile mills. He went on the 'Hunger Marches' from Lancashire, Glasgow and Tyneside to London during the years of high unemployment, and he wrote songs for the marchers' 'Forward unemployed, forward unemployed' to sing to keep up their morale.

Through this nascent period of honing his songwriting skill, the young

Miller had various jobs as an office boy, loading cabbages onto trucks and a brief spell as a car mechanic's apprentice. During his many periods of unemployment, he kept warm during the day in the local reference library, tutoring himself in Marxism and the classics of European and Russian literature. Miller had too much thinking energy for a conventional working life; he was a political activist and artist from the get go. He helped organise the Unemployed Youth Movement whilst continuing with the agit-prop theatre and carrying out Communist Party business: early in the morning selling their newspaper outside factories, or handing out leaflets; by evening he was attending meetings or education classes. In better weather, he busked 'singing Hebridean songs to cinema queues' where he had a real-life *Song of Freedom* moment. In the spring of 1934, he was overheard singing outside the Manchester Paramount by a BBC radio scriptwriter, for whom Jimmie's working-class folk hero image suited the ever growing, left-minded BBC regional radio programming. He was invited to audition and his 'vigorously proletarian voice' earned him a radio debut on the 1st May in *May Day in England*, a programme that traced the history of May Day from its pagan roots to being co-opted for a political movement. With money coming him from his new radio career and a growing membership to carry out party business, Jimmie was free to specialise in putting on plays. The Red Megaphones matured into 'Theatre of Action' (this time named after a theatre group in New York) to transmit a broader anti-fascist response to the darkening scene of international politics. His workaday approach to writing songs was intensive training that strengthened his skill, and he familiarised himself with new musical idioms to catch the flavour of the piece, be they of Spanish or Czech influence, or anti-fascist German spiels; being 'a dab hand at a topical lyric' Jimmie wrote songs on demand, on an almost daily basis, swiftly, sleekly and to the point.

He met the woman who became known as 'the mother of modern theatre' at a Theatre of Action rehearsal in Manchester in 1934. Joan Littlewood was a Stockwell born actress who had won a scholarship to take up a place at the epicentre of uppercrust British luvviedom, the Royal Academy of Dramatic Art. To some, it would have been the chance of a lifetime but Littlewood bolted after a few months believing the drama school and its South Kensington outlook 'a waste of time.' After running away to live the bohemian life in Paris, Littlewood returned to England planning to head to the New World via Liverpool. Sleeping rough for several nights she made it to Manchester with

the sole purpose of getting in touch with the only person she knew there, 'an upper-class Bolshie' who had taught her at RADA and who now worked for the BBC. Through a network of 'the BBC crowd, journalists and artists' she found herself one Sunday evening at a Theatre of Action social night where, in the half-dark of a bleak room on the first floor of a forbidding building on Grosvenor Street 'a brown-haired, pale young man with freckles' handed out mugs of tea beside a dying fire.

The marriage of Jimmy and Joan was a union in every sense. Though it was one more of practicality than romance, (they married to be able to go on a theatre study trip to Moscow that never happened) they both had a romantic belief in the genius in every person and they were both deeply committed to modernising British theatre. Joan left her job as assistant stage manager and bit part actress at the Manchester Rep to join Theatre of Action which morphed into the Theatre Union, and under their joint leadership it became an ensemble company that focused on breaking the straightforward entertainment of 'bourgeois' theatre performed under a proscenium arch. Instead, they staged experimental plays that challenged the audience by telling hard hitting stories to working class audiences who had previously only ever seen variety shows and pantomime. A classic example of which was their Marxist reinterpretation of T.S. Eliot's *The Waste Land* entitled *John Bullion: A Ballet with Words*, an eighteen-minute piece on the arms industry with strange stylized dance, disorienting lighting and discordant sound effects. Another anti-war play was part of Manchester's annual 'Peace Week' in 1937 'Miracle at Verdun' which was performed to a full house at the Lesser Free Trade Hall. Their parting shot, for which the police closed them down and hauled Littlewood and Miller into court to explain themselves, was a documentary style revue entitled 'Last Edition' recounting the lead up to the war from 1932 to 1939; not only was it, then, illegal to represent living people in drama, in March 1940 with the Molotov-Ribbentrop pact still intact, their barrister had to convince the judge they were not a group of anti-government, anti-colonial communists but a bunch of harmless, arty cranks. They both got off with a five-guinea fine and bound over for twelve months.

Miller signed up to the King's Regiment in July and was sent to Wathgill training camp in North Yorkshire. In spite of reports from his Lieutenant Colonel describing him as of 'much greater intelligence than the ordinary soldier' and 'cheerful and willing' Jimmie was ill suited to army life for too many reasons. His fellow privates were not much interested in radical politics

nor the theatre but his ability to write a good song or two for the Regimental Concert Party made him popular. As a pacifist he was being drilled to fight a war he didn't believe in, within a system that re-enforced the class hierarchies he detested. The bad food, grubby communal quarters and lack of intellectual stimulation only compounded his dejection. After constantly moving to various posts with the Home Defence and periods of sick leave he slipped away from the Railway Training Centre in Derby in early December and a week before Christmas he was declared a deserter. He was to re-emerge in the summer of 1945 under the cover of a new Scots pen name Ewan MacColl. With their marriage over and putting it behind them, he and Littlewood reformed the defunct Theatre Union that Joan renamed the Theatre Workshop; the workshop that launched a thousand 'workshops.' The company of strolling players picked up new members as they toured the mining villages, textile districts and docklands of England, Scotland and Wales, and of France, Norway, Sweden, Czechoslovakia and West Germany. The plays they performed dealt with every day experiences of war, unemployment, the nasty spates of anti-Semitism in Manchester during the early days of the Palestinian Settlement and the atom bomb, all set to music composed by MacColl who turned out songs and ballad operas as he breathed.

We reach the beginning of the 1950s and Alan Lomax was in-country. In the course of his research he fell in with the tight network of England's folk-art scene and it was only a matter of time before MacColl met the 'substantial Texan with enormous appetites and vitality to match.' It happened at the BBC in Portland Place whilst they were both working on 'Traditional Ballads' for the Third Programme, but the second time they met brought MaColl to an epiphany. It was in the mining village of Tow Law in County Durham where the Theatre Workshop crew were rigging the set and Lomax turned up unannounced with the expectation of recording some songs. But the crew just carried on working as there was too much to be done. To get their attention, Lomax pulled out his guitar and for the next two hours sang songs from 'the coal towns of West Virginia and Kentucky, with chants and hollers learned from the prison camps of Texas and Florida, with blues from Mississippi and Tennessee, with lowdown ballads from Louisiana.' So potently had Lomax captured the energy of the songs he'd heard first hand in the coal camps and prison farms, MacColl remembered, 'It was an education and an entertainment which I doubt any of us, rigging the state that night, will ever forget.'

Lomax added an American perspective to round two of Britain's folk revival. He sharpened its focus and injected it with the can-do attitude of a folk culture that was still very much alive and well in the States. When MacColl heard him sing the old Appalachian ballads for the first time, they struck him as being 'extraordinarily powerful and muscular' to have survived 'three, four, five hundred years of change, who could survive being transplanted, say from here to America, or could survive being changed into a different language.' It occurred to MacColl 'to try and find out whether these songs would mean anything to an industrial audience, to an urban audience.' The same meeting of minds occurred that year when Lomax introduced Lloyd to MacColl at a Theatre Workshop play at Stratford East's Theatre Royal. After being turfed out onto the street by a 'shirty' caretaker they chatted about their interests in politics and theatre and they sang songs to each other for an hour or more until they were 'moved on by a policeman.' At the time, Lloyd was researching his next book, *Come All Ye Bold Miners: Ballads and Songs of the Coalfields* and he stood entranced as MacColl sang the old Robert Burns song, 'The Collier Laddie.' Their shared intention was to persuade working class people to break away from listening to the American mainstream pop music of Frank Sinatra and Bing Crosby and to give them a voice of their own. At the beginning of the twentieth century, the Liberal politician Charles Masterman had articulated the status of the muted working class, 'We are very silent, so silent that no one to this hour knows what we think on any subject, or how we think of it.' The founding of the Labour party in 1900 neatly marked the change that was to take place in Britain's twentieth century story. Thanks to the Representation of the People Act, the party formed its first minority government in 1923 and working people finally had a say in politics. Step-by-step, in the most British of ways, they started to insert themselves into the nation's culture. Literature was gently prized from the hand of the middle and upper classes with Robert Tressell's *Ragged Trouser Philanthropists* and Walter Greenwood's *Love on the Dole*. And slowly, after making a Marxist detour, their musical credibility was, too. By the early 1950s music hall was fading, but its displays of showmanship and commercial energy took care of the business end of British pop. It enshrined the popular song and the star personality, but also developed ideas of word play, transgression, piss-take, fantasy, and cross-dressing and it was rich with spectacle and the bizarre. These ideas hung in the air just as, for the first time in British history, a new political power drove a new cultural one.

In 1958, Alan Lomax departed Britain's shores for the final time having left behind him a love letter, delivered by the medium of radio, in celebration of everything he had discovered. 'A Ballad Hunter Looks at Britain' was a musical map plotted using the co-ordinates of some two thousand examples of native folk music he had recorded since 1950. Having come to the end of his ballad hunt through Ireland, Scotland, England and Wales he concluded, 'I have heard enough myself to be convinced that in the past these islands were the richest garden of melody in the western world. Neglect, snobbery and the harsh years of the industrial revolution wrought serious damage to this rich heritage. But now on every hand there is evidence of a popular resurgence of enthusiasm for the music which lies in the very marrow of the culture of these islands.' From the advantageous view of the outsider, he discerned that there were three major, differing regions of folk music in the British Isles: the old Celtic Atlantic west, taking in Cornwall, Wales, Lancashire, Westmoreland, Yorkshire and the Western Isles whose music was 'characterized by blended chorus singing with big, open voices;' Ireland's music in contrast, was identified by its 'elaborately decorative solo singing style;' over on the east coast, from Aberdeen down to Dorset was "ballad country, par excellence" - lyrically pronounced with melodies 'plain and strong.'

A fourth group were measured by different criteria. These were the new folk singers, 'These skifflers...believe they are playing American style – but to a Texan only their name and some of their tunes seem American – for the rest is as East British as Bow Bells and Piccadilly. They're just a newest bud on the old Bonny Bunch of Roses and if they want to keep on growing, they should, in my mind, try to get closer to their own roots, where the great music is still flowing wild, wonderful and free...'

Play List:

The Wedding of Lili Marlene – Anne Shelton
The Jarrow Song – Alan Price
Labelled with Love – Squeeze

22

The Communist Coddling
of English Folk Song…

If you can laugh at life and at yourselves, you can be tolerant. If you can laugh,
you must hate persecution, you must love decency. Above all, you must love
freedom, for there is no laughter where there is no freedom.
Anatole de Grunwald, *The Demi Paradise* 1943

On the signing of the Anglo-Soviet Treaty in 1942, in a news reel the
ambassador to the USSR, Sir Stafford Cripps reassured the British people that
'the Soviet Union have no idea and no wish to interfere with the internal
affairs of any other country, I know that from the lips of Stalin himself.' But
contrary to Sir Stafford's comforting announcement, London's underground
culture had already been awash with Russian influence for almost twenty
years.

Back in the summer of 1920 at the Cannon Street Hotel in London,
members of the British Socialist Party, the Socialist Labour Party, the
Workers Socialist Federation and smaller revolutionary groups had gathered
for a conference under the banner of the 'Communist Unity Convention.'
They had convened on the urging of Lenin and his imperative that industrial
action should be combined with parliamentary power; on the 1st August, the
Communist Party of Great Britain became the various groups' official united
party, with a hotline to the Comintern for guidance and funding. The CPGB
members understood what was needed to shape hearts and minds of their
fellow Britons. They looked on with admiration at Stalin's state sponsored
'Socialist Realism' that swept in a new aesthetic of persuasion in the 1930s,
boldly depicting an ideal, romanticised image of the new Soviet regime with
great canvases of brightly coloured scenes of strength and vision, and with
music and literature printed in the new Bolshevik orthography to educate the
workers and develop their social consciousness; all other forms of art were
abolished. The CPGB members intended to stimulate something similar in

Britain. With this in mind, they held regular arts and humanities meetings run by various members according to their skill or knowledge, presenting new slants on history, literature, theatre and music to raise the status of communist writers and create a cohesive advance they called 'the Cultural Upsurge.' The musical department of this upsurge was the Workers' Music Association. It was founded by the formidable leading composer, pianist and CPGB member Alan Bush in March 1936 at the Whitechapel Art Gallery in the heart of the east end of London. Bush was fired up by a very specific intention. He intended to counteract what to him and many of his contemporaries had been an insidious musical phenomenon working as an aid to capitalism.

The Newcastle composer Charles Avison had identified it back in 1752. In his *Essay on Musical Expression* Avison wrote of the positive impact a finely constructed concerto or sonata might have on the human spirit. He recognised the potential of how 'the pleasures arising from our internal sense of harmony…pour in upon the mind a silent and serene joy, beyond the power of words.' By 1835, Avison's theory, aided by his own compositions for the amateur musician, had billowed into a national belief system and, politically, a preventative measure. To melt away any ideas of revolt or unrest industry bosses were in the habit of encouraging their employees to form company choral societies and brass bands 'to soften and purify the mind.' As George Hogarth, father-in-law to Charles Dickens, noted, 'The diffusion of a taste for music, and the increasing elevation of its character, maybe regarded as a national blessing…In the densely peopled manufacturing tracts of Yorkshire, Lancashire and Derbyshire, music is cultivated among the working classes to an extent unparalleled in any other part of the kingdom.' The soothing tones of Handel and Haydn, in Hogarth's view, had a truly holistic effect, 'Sentiments are awakened in them which make them love their families and their homes; their wages are not squandered in intemperance, and they become happier as well as better.' Bush's aim was to do the exact opposite. His vision was to guide and coordinate workingmen's musical activities by ushering them towards simplified high art music using modernist techniques and to intensify their emotions with a new lexicon of radical titles such as 'Labour's Song of Challenge,' 'Question and Answer,' 'Make Your Meaning Clear' and 'Unite and Be Free.' Bush saw it quite simply, 'if a musical event is not helping Socialism, it is doing the other thing – that is to say, strengthening Capitalism.'

The WMA was to act as the official body to further the working classes'

musical education. It was to be 'a centre where all amateur musical organisations may exchange information and receive help and guidance. Brass band, dance band, choir, opera, orchestra, fretted instrument, folk song and dance, and individual interest are all catered for in a broad popular approach to music-making.' Talks and lectures were held at the association's headquarters on Great Newport Street and later, Bishop's Bridge Road, along with correspondence courses and an annual summer school at Albrighton Hall in Shropshire, all under the tuition and guidance of some of finest composers of the day – Benjamin Britten, Hanns Eisler, John Ireland, Rutland Boughton, Elizabeth Maconchy and Wladimir Vogel. They published songbooks such as *Popular Soviet Songs* and *Red Army Songs*, and in 1944, the WMA published *The Singing Englishman: An Introduction to Folk Song* as part of a keynote series of booklets that meditated on all kinds of different music guided by socialist thought. On the back cover was a checklist of the association's aims: 'To utilise fully the stimulating power of music to inspire the people. To provide recreation and entertainment for war workers and members of the forces. To stimulate the composition of music appropriate to our time. To foster and further the art of music on the principle that true art can move the people to work for the betterment of society.' It went on to describe its vision for the future: 'At the present time the Association emphasises the need to promote music making of a character which encourages vigorous and decisive action against Fascism. The WMA is pledged to foster the development of music making wherever it can be encouraged – in the factories and in the Forces, in Civil Defence, in Youth Clubs and Schools.' The trouble was, the majority of the people in youth clubs and schools or who worked in the factories, the Forces and in Civil Defence had plenty of anti-fascism in mind, as did the entire country; it was all anyone and everyone ever thought about until the war ended in May 1945. But when it came to their music, most people preferred a little break from thinking about Hitler, Franco and Mussolini and instead, they were dancing and singing along to that confounded American swing that was polluting Britain, and they were having a marvelous time with it, too.

In its pages Lloyd explained how English folk song 'came out of social upheaval' and was the music of a 'class just establishing itself in society with sticks, rusty swords and bows discoloured with smoke and age.' In this pre-industrial England wrote Lloyd, its people 'flourished and the folksong flourished, too, through all the changing circumstances that the lowborn lived

in from the Middle Ages to the Industrial Revolution. And when that class declined, the folk song withered away and died.' Yet, Lloyd unwittingly predicted how English folk music and British pop were to keep continuity when he wrote, 'Generally the English folksinger…did not deny the facts of life nor did he sing about changing them, but he coloured them and wrapped them up in fantasy…and even where they were sordid and stupid and brutal he turned them often into something beautiful and tragic and honourable….But the singer's feeling that this glamorised version of life is not real is nearly always underlined by the astonishing melancholy of the tunes. Even songs with the happiest words commonly have tunes full of sadness and a pathetic longing.' Lloyd admitted that English folk song was devoid of politics, or 'direct political struggle;' instead, 'you get plenty of songs describing bad conditions and plenty satirising the habits of whoever happens to be on top.' He put this down the fact that the 'political fight was not clearly understood by the country workers.' *The Singing Englishman* was, in fact, a good crack at interpretation with hindsight, to drive forward the burning belief of his day – that the latent creativity of the proletariat was about to be fully realised and that Britain's time to embrace communism was now. Well, one out of two isn't bad.

<p style="text-align:center">***</p>

One thing the two folk revivals had in common was an officious approach to the music. Both were rigorously steered by committees, societies, general meetings, rules and regulations, in place of promoting the music and just letting it go free like seeds on the wind to fall where they may. In my little fantasy alternate universe, I imagine how things might have been different. If England's rural folk music hadn't been eroded by the industrial revolution, but had been upheld with weekly 'sessions' in its place of origin, and by annual folk festivals supported by local businesses or the landowning gentry. If it had been confidently passed down through generations with ingenuity and a showier sense of pride, then just maybe, instead of copying minstrel songs from America, young working-class English troubadours (who could all mysteriously afford acoustic guitars in this fantasy world of mine) might have merged their love of banjo music with their own traditional folk song and created a boom of musical invention in England as early as 1860. But it didn't happen that way. In the revivalists' view, and no doubt they were right,

leaving the music to be free would mean leaving it to die. England's folk song was so neglected by a historic lack of attention, the overriding belief was it couldn't survive on its own without a stirring story to support it; in the EDFFS's case, the disappearing life of British peasantry, and in Lloyd and MacColl's case, the working classes' cultural relevance conjoined to a political vision.

Over on the other side of the Atlantic, the Almanacs now reformed as People's Songs and headed up by Alan Lomax, Waldemar Hille, Pete Seeger, Lee Hayes, Earl Robinson and Irwin Silber, published in 1948 their official bible for social change called *The People's Song Book.* It was an all-inclusive mix of union songs, Appalachian folk, spirituals, newer songs like 'Strange Fruit' and Seeger's 'Jim Crow,' along with the 'Star Spangled Banner,' and randomly, 'The Holly and the Ivy.' In the foreword, Lomax wrote, 'Here is a big clean wind of a book that will blow the mists of doubt and discouragement right out of your heart…a folio of freedom folklore, a weapon against war and reaction and a singing testament to the future.'

The very same year the WMA followed up by publishing a similar collection of songs entitled the *Pocket Song Book*, including 'The Lincolnshire Poacher,' 'Pity the Downtrodden Landlord,' 'The Marseillaise,' 'The Man That Waters the Workers' Beer,' 'England Arise,' 'Auld Lang Syne,' 'Campton Races' and 'Jerusalem.' With rather less largesse of spirit, the introduction stated, 'The majority of songs in this volume were chosen by plebiscite among members of the Workers' Music Association to provide for community singing in the larger labour movement in this country.' The simultaneous arrival of these two songbooks sent a clear message: the British folk scene and America's east coast folk hub were now, in essence, political movements. The big difference between them was the New York's was just one of many folk scenes in the States; in Britain the WMA commandeered the only visible folk scene the country possessed. For both camps, their outlook was international rather than national, yet the British strain reserved a special rigidity to guard against what MacColl considered the greatest evil of all - American pop culture infection.

A year or so after he befriended Lomax and Lloyd, MacColl left the Theatre Workshop to join a folk group called the Hootenannys. He had barely scraped a living writing plays, and folk music was slowly edging towards being 'in demand.' He also became a regular at the BBC, making programmes on Scottish poetry and singing folk songs about the trunk roads and transport

cafes of the north. But his series on new and old folk music from both sides of the Atlantic marked the beginning of MacColl as the leading voice of Britain's folk scene. He wrote a six-part series devised and produced by Denis Mitchell called *Ballads and Blues* and through the subjects of the railroad, the sea, soldiering, crime, and work, the series expressed the unchanging common language of the folk. The BBC gave MacColl a decent budget to bring in a rich cast of musicians, including Humphrey Lyttelton and his band, the calypso singer Cy Grant, the Kentucky folk singer Jean Ritchie, Big Bill Broonzy, the uilleann piper Seamus Ennis, the Scottish folk singer, his old Theatre Workshop friend Isla Cameron and Albert Lloyd. Between them, they all represented elements of the free flow of music in America that was now assembling in England.

A year later in July 1954, a live concert of *Ballads and Blues* was held at the Festival Hall with MacColl, Lloyd, Ken Colyer and his Jazzmen, and a host gifted singers and musicians. In an address to the audience, MacColl vocalised what he presumed they might be thinking, that is, 'What possible connections can there be between British folk-music and the Blues of America?' He went on to quote, 'The blues ain't notin' but a good man feelin' down' and he explained how, 'that same definition might be applied to Lancashire songs that represented the downtrodden worker, songs such as 'The Four Loom Weaver' and 'Van Dieman's Land,' or to ballads like 'Lord Randall,' 'The Rocks of Bawn' and 'The Sheffield Apprentice.'' In a *Radio Times* article he elaborated further, 'it is true of all the harsh and bitter melodies which came out of the slums and the sweatshops of early-nineteenth century England. Loneliness, hunger, frustration, despair…these are the common factors which link the ballads of the old world with the blues of the new; the music which is the product of such forces is elemental and violent and this is no less true in England than in America.'

MacColl saw the folk music of Britain and America as equal but separate, and that it should remain that way. In his autobiography, *Journeyman*, written with Seeger's help towards the end of his life MacColl expressed how back then he hoped 'that these songs would help English, Irish, Scots and Welsh workers to assert their national and class identity.' He could see how 'we had become a whole generation who were becoming quasi-Americans, and I felt this was absolutely monstrous! I was convinced that we had a music that was just as vigorous as anything that America had produced, and we should be pursuing some kind of national identity, not just becoming an arm of

American cultural imperialism. That's the way I saw it, as a political thinker of the time, and it's the way I still see it.' To this end, in 1957 MacColl launched The Ballads and Blues Club in a room above The Princess Louise in High Holborn; later it was moved to The Pindar of Wakefield pub on Grays Inn Road and renamed The Singers Club where it survived for an astounding thirty years (now the famous pub/gig venue, The Water Rats). With their persuasive and dominant personalities, Lloyd and MacColl were anointed as the spiritual leaders of Britain's folk scene. MacColl set the rules and they were pretty strict. The repertoire of English, Scots, Welsh, Irish, American and Caribbean folk songs must be categorised in terms of 'tradition,' 'realism' and 'fakeness.' A folk song was vulnerable to corruption by contemporary singing styles, it was decided, and under the charge of 'fakeness' were crimes such as an American inflection, vocal syncopation and adding an instrument to a ballad that had previously been sung unaccompanied. With its rivalry and regulations, new folk clubs opening up around Britain were fraught with cans and cannots, otherwise known as 'club policy.' The Wirral folk singer Bob Buckle remembered the effects of it, 'I look back on it now and I physically cringe. I mean the policy in our club (West Kirby) was that we basically didn't have a policy. 'Come All Ye'! But the very expression 'Policy Club' became rife. "You can't sing this, you can't sing that"..."you must have a policy about floor singers"...even... "you must take the musical initiative from the Singers Club in London." We MUST? We didn't take much notice, and when we had a singer in from that particular clique of folkies it tended to be a pretty dour affair; pretty much unaccompanied "finger in the ear stuff."' When Buckle's band, the Leesiders played in London in a rule-book-out-the-window fashion, MacColl got wind of it. The next time he saw Bob he had a quiet chat with him to remind him how things should be, 'come the revolution...that kind of stuff.' The folk singer, David Waite described the Singers Club as, 'a bit like going in to a church: you couldn't go in while someone was singing and God help you if you scraped a chair during a song. It was very belligerent and people would split hairs about whether something was a miners' song or a steelworkers' song.'

To strengthen the army of properly trained participants in the new revival MacColl and his third wife and fellow folk singer Peggy Seeger established 'The Critics' Group' at their home in Beckenham in 1964. As its name suggests, the purpose of the group was to critique vocal nuances to ensure, for example, an English singer only sang an English folk song and an

authentically English timbre. The group also helped to impart the special skills every performer or musician needed to comply with the MacColl vision of purity of not only the music, but of intellectual thought, too. Every participant of the Critics' Group, over thirty in all, had to make their way through a MacColl-prescribed reading list of books on anthropology, social history, politics, plays, drama theory, folk song and traditional culture. In their defence, Seeger claims in her 'I confess' retrospective of the time that this orthodoxy was meant only for The Ballads and Blues Club, and that the Critics' Group was formed 'at the behest of several singers who also found that they were losing their way in singing traditional songs. We began to attract singers who wanted to study folk singing. You know, there is no set discipline for folk singing - it's an 'anything goes' area even though real dyed-in-the-wool field singers are very specific about how they sing and what they sing. The purpose of the Critics Group was to make it possible for the singers who had not been brought up in the 'folk' tradition to sing the songs in a way that would not abrogate the original intention of the makers… we were not initially telling other singers how to sing - just deciding how WE were going to sing. If we became evangelical and sounded dictatorial, well - that's the way things go. The intentions were honourable.'

On finding a new muse and collaborator in Seeger, MacColl and Lloyd drifted apart; theirs, in truth, had been a partnership of Hobsons' Choice. Lloyd was always more relaxed about the songs being tampered with. He referred to the Critics' Group as 'spiky' and he was well known for giving support to young folk singers and inspiring them to perform in their own way. When Britain's most influential folk-rock band, Fairport Convention were tucked away in a big old house in Farley Chamberlayne in Hampshire recording their 1969 album 'Liege and Lief,' guitarist Richard Thompson recalled 'Bert was on the end of the phone to give us help and encouragement.' But in MacColl's mind, the band only impaired the original music that should remain stringently unaltered. In one of his last interviews, he was unbudgeable from the point of view that Fairport Convention, Steeleye Span and Pentangle who did give folk music a wider audience were doing the traditional songs a disservice 'by giving them a rock treatment or by giving them the kind of instrumentation that they do. The songs suffer on a whole, particularly the ballads.'

In December 2017, Simon Nicols, founder, guitarist, producer and anchor of Fairport Convention for more than fifty years gave me their side of the

story. In a break between shows at King's Place he told me, 'we'd all got copies of the Child ballads,' but the band's early repertoire were what they called 'Sandy's songs.' Sandy Denny, Fairport's lead singer over three albums from 1969-1970 had a collection of songs from her Scottish grandmother and great grandmother who both sang in Scots Gaelic. She also had an intimate knowledge of 'The Oxford Book of English Verse' with border ballad classics such as 'Tam Lin' and 'Matty Groves,' plus her own spine-chilling compositions - rare for women at the time - that found their way onto *What We Did On Our Holidays*, *Unhalfbricking* and *Liege and Lief*. When the band came together Nicols told me, 'rather than oblige her to learn everything we knew, we would find middle ground and we would learn some of her rock solid stuff and that's how it started for Fairport, I think...we'd been to folk clubs, we'd seen some performances which showed us the power and depth of those songs.'

Fairport's bassist Ashley Hutchings, 'the collector' of the band, spent days hunting through the archives in the Vaughan Williams Memorial Library at Cecil Sharp House looking for material, but from Simon's recollection, 'I was listening to all sorts of other stuff, you know like, trad jazz was quite big then and I even used to expose myself to avant-garde jazz pretending I was very cool because it was the 60's after all, you know wild wailing, frantic out of control drummers.' When I asked what drew him to the old folk ballads, 'I just enjoyed them,' he told me, 'I found it exciting. There was a strong sense of purpose and reality to them....I've never got on with the idea of proselyting or preaching politics in music, they don't sit easily with me. I love them both but I think they make unhappy bedfellows. It's great to sing songs about historical politics. But I think it's cool to wait two or three hundred years before you actually come out and make a comment on something musically. Our best historical songs, factually based ones, one's set in the Civil War and one is set in the time of the Peasants' Revolt, 'Red and Gold' for the Civil War and 'Wat Tyler' for 1381. So we're on safe ground.'

Of the folk revivalists Simon reflected, 'They were happy with it under glass and treated as if it were an old document that shouldn't be exposed to the sunlight but in fact, as Martin Carthy has said, the only thing you can do to a folk song to harm it is not sing it. The song remains the same, it's inviolate, you can't harm it, so anything goes.' It's an attitude that was embedded in Fairport's genius for creating a whole new genre. By blending and electrifying ancient English and Scottish folk song with a smattering of

blues and jazz, and writing new ones in a similar vein, Fairport confounded the idea that folk songs were untouchable relics and connected a new British audience to the music of their own country. Of course, the invention of folk rock caused convulsions in the folk revival circles, but it was a natural progression. The point is, the old and new worlds could and still can co-exist, as Fairport's songwriter and guitarist Richard Thompson put it, 'the element of curation of traditional music is still there, I think that's a good thing, I think it should be preserved in its purest form but I also think parallel to that you must have people experimenting.'

MacColl's devotion to his music and politics (by his own admission he was 'to the left of the Communist Party!') were inextricably linked. He tallied that he must have written 'between 150 and 250 political songs' that he and Peggy included in their repertoire. Over the years he wrote songs of struggle in the mining industry, for peace, against Americanisation, for a national identity; he wrote songs for trade unions - the Printer's Union was the first union to form its own folk club in 1963 - and a 'rallying song' for the National Amalgamated Engineering Workers. Upon request he wrote songs for the National Union of Public Employees, for the 'nurses, ambulance drivers, road sweepers, sanitation workers and so on...around a specific struggle,' and most famously, he wrote the jaunty and brutal 'Daddy, What did you do in the Strike?' for the miners in 1984, showing that after nearly fifty years of composing, his gift for lyric and melody was undimmed. He wrote songs to honour the Cuban revolution and in support of the ANC, but ultimately, he believed that 'a political songwriter's main thrust should be inside his own country or inside his own system.'

Around the time MacColl made this statement, one of the most profoundly political acts had been made by not one, but several of the greatest and most popular mainstream British artists. In June 1987, a three-day open-air concert was held on a stage parked right in front of the Reichstag on the west side of the Berlin Wall. It was called 'Concert for Berlin' and was an act of solidarity with the people on the east side of the wall, where popular music was banned for being a dangerous, decadent incitement against the communist regime. All the British and American artists performing, David Bowie, New Model Army, Bruce Hornsby and the Range, Eurythmics, Paul Young and Genesis, agreed that the concert should be aired not just on the RIAS – the Radio in the American Sector, but on RIAS 2 the sister frequency that broadcast to all of Berlin.

The German Democratic Republic had been established in 1949 in the pursuit of an alternative life, but by the 1980s it was clear to all it was a failed experiment. The state was practically bankrupt, houses lay in dereliction, streets were unlit, schools were closing, hospitals were without doctors, shops were few and sparsely stocked and people were desperate to escape a world that was effectively still stuck in 1949. The music of Bowie, Eurythmics et al. floating over the great wall topped with barbed wire and armed guards was the sound of colour, the sound of dreams, opportunity and choice, a life from which they were completely disconnected. The trouble began on the opening night. Bowie's set ran to just under two hours and included 'Absolute Beginners,' 'China Girl,' 'Fashion,' 'Let's Dance,' 'Fame,' 'Modern Love,' and most poignantly of all, 'Heroes,' the song he had written a decade before when he was living in Berlin in almost the very same spot. The lyric was Bowie's imagining of an intimate moment between a couple and their longing to escape the watch of the gun tower. But now, on this day, the song took on a whole new meaning. The audience on the east side trying to hear Bowie 'lobbed stones and bottles at border police' who refused to let them through the barrier erected roughly a quarter of a mile from the wall; dozens of arrests were made.

The crowd got bigger and bigger on the east side as the festival progressed. Three thousand people gathered to hear the Eurythmics' set the following night, opening with 'Sex Crime' and closing with 'The Miracle of Love.' Again, the east Berliners tried to get closer to the music, and chanted 'The wall must come down' and 'Down with the wall' at which point, armed border guards laid into the crowd with truncheons. Genesis were the final headliners on the Monday night, as approximately four thousand people gathered behind the barrier. Those who tried to get through were arrested and dragged along the street. Two hundred people were taken into custody and many were wounded in the outbreak of violence between the police and the unofficial, ghost audience. To east Berliners, like Paul Robeson's telephone broadcast to his friends in Britain, the music they were hearing was the sound of self-determination, only this time it was the artists who were free and the audience incarcerated.

The handling of 'Concert for Berlin' was yet another episode of ideological absolutism. After mass demonstrations and with the tacit permission of Mikhail Gorbachev and his new spirit of *glasnost*, (plus a press conference cock-up that mistakenly sent out the message that people now

could leave the GDR), east Germans peacefully rushed the wall and tore it down brick by brick on that extraordinary night of the 9th November 1989. But of the Berlin concerts, MacColl did not approve. When interviewed that same June, he was asked what were his thoughts on these recent events at the foot of the Berlin Wall? He asked his interviewer in return, 'Why was the concert done at the wall? Why was it done there? Why did they choose that place? Surely that was provocative! You can't have it both ways! If you provoke the government, then you must take the consequences!' It seems MacColl wanted it both ways, too. We shall not be moved? Well, that really depends on who is doing the moving.

MacColl was a man of supreme principle to the end. 'Dirty Old Town' is now in the lexicon of the greatest songs of all time but it was written for a mere scene change for the Theatre Workshop play, *Landscape with Chimneys* that toured the mining towns of Wales in 1951. Along with 'The First Time Ever I Saw Your Face' and 'Sweet Thames, Flow Softly' he proved he could have been a hugely successful commercial songwriter if he had chosen. Instead, he invested his immense gift in writing songs that supported the causes he believed in. One stands in awe at his lyrical imagination, his dedication and his commitment to writing protest and political songs that provided a spiritual binding for union workers and activists over the decades. But the very thing MacColl hoped for, that unleashing of creativity of the proletariat youth, happened in bounding, extraordinary ways with a little help from two forces he perceived as the enemy – creative freedom and the motivation of competition and profit. But through all the political rhetoric, the beauty of the revival was, after skiffle had given permission for young Britons to take hold of a guitar and the folk reverence for 'found' songs had expired, it directed them towards singing a song of their own free will, made up of their own thoughts, and it created intimate public places where they might be seen doing it.

The ancient roots of British pop lay in the social commentary of ordinary and most often, illiterate people and the best of British pop is a continuation of that social commentary. The Jam's 'Eton Rifles' and 'Down in the Tube Station,' The Special's 'Ghost Town' or UB40's 'One in Ten,' or any number of The Style Council's songs seduce the listener not with ideological instruction and musical strictures, but with a mix of musical styles and poetic storytelling that lifts you out of hard-nosed reality and encourages you not to think, but to dream and to feel. As with all types of creativity, music cannot

survive being kept within boundaries from which no-one must deviate; nor can it be siloed, nor can it remain in pigeonholes labeled with its cultural, ethnic purity. It is a living, breathing organism that has travelled, developed and changed over thousands of years and must be allowed to be played freely to express feelings and sensibilities of the current age using whatever instruments or technology that are to hand. Without a mixing and merging of music from different sources and places not only would rock and roll never have happened but popular music altogether would have atrophied.

It turned out the average Briton was generally not interested in digesting political ideology with their music. They wanted to be entertained, or stirred, or transported by a great song with a beautiful lyric or a sharp one; and most especially they wanted to dance. It was Lonnie Donegan who most caught young Britons' imaginations and this is another reason why it was the little side show of skiffle, rather than the hallowed folk community that sparked off British music making in the most spectacular way. By all accounts, both Donegan and MacColl were tricky to work with but at least Donegan looked like he was up for a laugh. In 1950s Britain comedy was king and having a sense of humour was so very rock and roll.

Playlist:

You're a Lady – Peter Skellern
Fotheringay – Fairport Convention
Hollow Point – Chris Wood
Oliver's Army – Elvis Costello
Don't Give Up – Peter Gabriel and Kate Bush
Way Out West – The Gift

23
...and the beginning
of Britain's Indie Labels

The WMA's hope of using music to stimulate a communist uprising in Britain never came to pass. But their efforts nevertheless present us with the startling fact that British pop was not only influenced by American culture, but underpinned by Soviet inspiration, too. Which brings us to kaleidoscope world of the independent labels: Postcard, 4AD, Beggars Banquet, Factory, Rough Trade, Some Bizarre, Bella Union, those little insignias of wonder I used to gaze at as I placed the record onto the turntable, reassuring me I was part of a secret club and certified I was about to hear something wild and extraordinary.

If you, as I do, get a little grumpy that the technological developments of music-playing 'devices' seem to take precedence over the music itself, now rendered as mere 'content,' you can take some kind of comfort from the fact that it really was ever thus. In the early days of the music business major labels grew out of companies that first and foremost sold the record playing hardware. Decca Records, for example, grew out of Barnett Samuel and Sons, a nineteenth century Sheffield based company that made tortoiseshell goods and musical instruments. They relocated to London and after the launch of their 'Dulcephone' (1914) and 'Deccalian' (1922) gramophones the company went public, renamed the Decca Gramophone Company on the syndicate's request that it branched out into record production and in 1929 Decca made its first release. Likewise, Columbia Records was as an offshoot of the Columbia Phonograph Company. Producing actual records was a straightforward business move: maximise sales of record players by releasing records of crowd-pleasing artists.

Independent labels had a very different genesis. These were started up by people who simply loved the music, or wanted to provide an outlet for a type of music that otherwise wouldn't stand a chance with the major labels. The German Jewish émigrés and jazz enthusiasts Alfred Lion and Francis Wolff

founded Blue Note in 1939 as a place for non-commercial Black American artists to make records that kept jazz hot and Harlem fresh rather than formal and formulaic. Back in England, the WMA launched its own record company in that very same year. Well, it wasn't actually a record label as such, it was a record club, and they issued a monthly gramophone pressing of a piece of music which WMA members could purchase by mail order. They first called it the 'Topic Record Club,' and then was renamed Topic Records, which, in spite of financial travails over the decades, remains a testament to adaption, commercial survival and endurance.

Topic's ideals took precedence during the company's first two decades of trading. Their first release was a version of the socialist anthem, 'The Internationale' but their first original recording, labeled TRC.1 was 'The Man That Waters Down The Workers' Beer,' written and sung by Unity Theatre member Paddy Ryan (who in reality was a Dr R.E.W. Fisher). WMA members' subscriptions kept Topic afloat and through the Second World War their small press runs were an assortment of socialist anthems, old English folk songs, songs of African American protest, Russian folk songs, recordings by the Soviet State Choir, and Unity Theatre revue songs, including, 'A New World Will Be Born' by Unity Theatre member, Michael Redgrave. By the late 1940s Topic had attracted quite a stable of folk artists and suddenly the label was more than just a miscellany of folk songs and Soviet anthems. It was shaping up to be Britain's first proper independent record label, and thanks to Lloyd and MacColl, a seam of English music yet to be heard on vinyl in Britain had finally found a home.

MacColl made his record debut in 1950, with TRC39, 'The Asphalter's Song/I'm Champion at Keeping Them Rollin,'' followed by a composition of MacColl's own called 'The Ballad of Stalin' (TRC 54), depicting Stalin not as the murderous tyrant that he was but as some kind of hearty bruiser bestriding the Union fixing myriad problems and leading 'the Soviet People on the road to victory.' Similarly painting an erroneous picture of upward legitimate change, Lloyd published a lengthy article in the *Marxist Quarterly* entitled, 'Folk Song of Our Time?' in which he presented as fact the new folk revival had 'arisen more or less spontaneously among young people in youth clubs, rhythm clubs, trade union branches' which was not strictly true. Thousands of young people, Lloyd claimed, 'have been turning to folk song in search of the satisfaction of some apparently deep artistic want.'

One of those ordinary young people with an artistic want was Bill Leader,

the twenty-six-year-old founder of Bradford's WMA and its Topic Folk club. In 1955, he moved down to London and took the job of managing the Topic label from out of the WMA's office on Bishop's Bridge Road, Bayswater with the idea of expanding its line to slightly more commercial releases that might appeal to the not so overtly politically-minded listener. Armed with a Revox 2 track tape recorder, Leader's Camden flat became a recording studio in which he acted as sound engineer, producer, and patient supporter of all the artists and their music. It marked a dynamic new era for Topic. The label's north star was to provide the soundtrack to Britain's 'proper' folk revival and with Leader's help, Lloyd and MacColl guided Topic ever more towards being their own personally curated label, one ready and willing to put out niche material that no other record company would. They recorded a succession of naval themed albums, *The Singing Sailor* in 1954, an album of whaling songs called *Thar She Blows* in 1957, and evoking the age when 'If the men don't sing right, the ship don't move right' albums of shanties for weighing, hoisting and hauling titled *The Blackball Line* and *Row Bullies Row*. Lloyd made an album of *English Drinking Songs* (although including the songs 'The Foggy Dew' and 'Maggie May' it might technically be called English-Irish Drinking Songs) and MacColl released singles, E.P.s and albums of protest folk song and industrial ballads, including his 1957 album *Shuttle and Cage*. Topic's catalogue included American albums not otherwise available to Britons, such as Woody Guthrie's *Bound for Glory*, The Fisk Jubilee Singers' *Spirituals* for their fan base in Wales and the north of England, Terry and McGhee, and Paul Robeson's transatlantic concert. Lloyd and MacColl teamed up again for two more folk albums, *Bold Sportsmen All* and *English and Scottish Folk Ballads*. In 1958, MacColl released an album of folk love songs with Isla Cameron titled, *Still I Love Him* and in 1959, an album of murder ballads and transportation laments with Peggy Seeger, *Chorus from the Gallows*, including a new ballad on the miscarriage of justice for Derek Bentley.

In the aftermath of the Soviet put down of the Hungarian uprising in 1956, the CPGB's membership fell away dramatically, filtering down to financially weaken the WMA. The knock-on effect was a huge drop in funds for Topic that was already barely breaking even and was now left to its own devices. It needed to adapt if it was going to survive and there was competition from other labels supporting new frontiers of the folk scene that had broken free from the grip of Marxist supervision. The decision was taken by the label's new director Gerry Sharp to release what was to be Topic's most

commercially successful album and one that pointed the way to its long-term survival. It was called *The Iron Muse*, a compilation of Lloyd's beloved industrial folk songs collected from coalminers, weavers, foundry men and shipbuilders from Scotland and the north of England, sung by, among others, the Nottingham folk singer Annie Briggs, County Durham's Bob Davenport, Tynesider Louis Killen and the Scots folk singer, Matt McGinn. It presented a mosaic of provincial distinction and authenticity, but on a wider level it gave recognition to the power of regional music in Britain. It highlighted that a sense of place, a sense of cultural heritage was as important, was far more potent and in fact, more unifying than any political ideology and the combined efforts of Leader, Sharp, Lloyd, MacColl and the Topic stable had primed the British psyche for music with an authentic, northward-Celtic bent. *The Iron Muse* came out in the U.K. in March 1963 and it was so successful it was issued in the US in the spring of 1964. In between time, the Beatles released 'With The Beatles' and proved Lloyd's message of working people's creativity to the power of hundred.

From here-on Topic was content to be the natural, apolitical home for folk singers, including Shirley Collins, the Shropshire farm worker Fred Jordan, Johnny Handle, the High Level Ranters, and the Hull based group The Watersons. With their 1965 album 'Frost and Fire: A Calendar of Ritual and Magic Songs' The Watersons returned England's folk music making to its pagan traditions and our unchanging desire to have our time on the planet marked by days and dates that reconnect us to the earth and to our ancestors. There were now more than a hundred serious folk groups in Britain. The hugely successful Spinners appeared on the scene in 1958 in their own folk club held in a hired room above a Liverpool restaurant. The 'polished group of amateurs' mixed in sea shanties like 'Whip Jamboree' with 'a Bantu freedom song, a Confederate song about the Birkenhead-blockade runner, the *Alabama*,' English folk songs and Jamaican calypso, leaving Lloyd and MacColl to grapple with the reality that their work in the folk field had unintentionally made it 'trendy;' not only that, it had become popular.

Over in America, the cool folk-outposts of Massachusetts, namely Boston and Cambridge offered a music scene less associated with the strife of the Cold War and were beginning their eclipse of the 'old school' folkies. Born of Spanish Mexican-Scots heritage in Southern California, Joan Baez first picked up the ukulele as a young girl to charm her classmates by whom she was shunned for being neither fully white nor fully Mexican. She trained her

voice to deliver the beauty of ancient folk with a dynamic quality far removed from the 'chirpy strum and hearty harmonies' sung under the banner of 'workers of the world unite.' Instead, honouring her Quaker upbringing and her natural disposition to take a stand, she became a figurehead for the pressing issues that dominated 1960s America: civil rights and the Vietnam War. Through her music Baez was an example of female strength in the folk scene, and breathed a fresh, independent feeling into old folk songs of all kinds and told romantic, contemporary stories in the old narrative folk style. It was an approach with astoundingly beautiful consequences that had up until then never been given the room to naturally develop in England's folk fiefdom. Nevertheless, Baez's songs reached Sandy Denny and, along with the influence of the untamable Nottinghamshire born folk singer, Annie Briggs, invited Denny to sing any folk song she chose, whatever way she pleased, dramatically changing the atmosphere in the English folk scene with equally beautiful consequences.

Sandy gave the Singers' Club a look, but, according to her Kingston Art School friend Gina Glaser with whom she went, 'it was not for her. Sandy much preferred the newer folk clubs that were more for her generation where there were no rules about repertoire...she wanted to reach a broader audience and didn't like the staid, collegiate atmosphere of the Singers' Club.' Whilst a cluster of jazz, blues and free and easy folk clubs in Putney, Kingston and Richmond made south-west London a fringe of British pop development, by then, as Denny recalled in 1977, there was 'a folk club on virtually every corner around Soho; there was the Scots Hoose, the John Snow, there was Cousins. God knows how many folk clubs in throwing distance.' All to accommodate a new generation of young folk singers who loved not just folk but all the music that could be experienced in Soho. Now Lloyd's earlier statement was no longer erroneous. His and MacColl's good work and dedication had borne wondrous fruit; England's youth suddenly had caught up on its native folk music, but they were doing things their own way.

With the times changing quickly around them, Topic caught the wind and reached a second commercial milestone. In 1968 they released another compilation series, a great body of work collected by Alan Lomax and Peter Kennedy. First issued on the New York spoken word label Caedmon back in 1961 *The Folk Songs of Britain* ran to ten volumes: *Folk Songs of Courtship*, *Folk Songs of Seduction*, *Jack of All Trades*, *The Child Ballads* (parts 1 & 2), *Sailormen and Servingmaids*, *Fair Game and Foul*, *A Soldier's Life for Me*,

Songs of Ceremony and *Songs of Animals and Other Marvels* and it's probably
the most honest collection of Britain and Ireland's roots music sung by local,
unknown traditional folk singers recorded in the field. Both *The Iron Muse*
and *The Folk Songs of Britain* helped to secure Topic as a profitable business.
When it finally released itself from all associations with the WMA in 1978 it
was free to exist simply as Britain's most comprehensive folk label.

Topic's 'obstinate integrity' helped it to tough out the early years and
prove that non-commercial record production was possible. It was an example
of adaption and survival for all the independent labels that followed, staking
out the freethinking quarter of Britain's music industry. Looking back at the
hopes of the WMA and Topic's key players, their aim to stimulate a flow of
creativity among ordinary Britons was a success beyond all imagination. As
Gerry Sharp understood, politics doesn't sell records on a scale large enough
to survive, but by existing at all Topic laid down the path for Britain's
independent record industry to follow, shaped by the need to deliver the
aspirations of their artists rather than their shareholders. It set up the idea that
there could be a place for regional experimentation in music, detached from
mass-market manipulations that in time, and famously in Britain, became
incubators for new extraordinary talent the major labels would otherwise have
refrained from taking a chance on. A few big labels bucked the trend -
Parlophone and Linn to name a couple, but by and large the independents were
a place for artists to let loose their alternative visions, obscure thoughts and
delicate dreams, and provided a wellspring of invention that, with a lot of help
from John Peel, filtered into and invigorated the mainstream music industry
and kept British pop music so crashingly, mesmerizingly unpredictable. And
it all began with TRC.1, 'The Man That Waters The Workers' Beer;' a song
with the kind of folk-punk spirit that just might have put it in the Festive Fifty.
As Peel said himself in 1999, 'I've been buying and scrounging Topic Records
since 1954. It feels like Topic has always been there, quietly doing good work.
Like a backbone.'

Play List:

Needle of Death – Bert Jansch
River Man – Nick Drake
Isn't This a Lovely Day – Pasadena Roof Orchestra
(We Don't Need This) Fascist Groove Thang – Heaven 17

24
Back to British Balladry

With their new interpretations Williams, Butterworth, Grainger and White were the modernisers of British folk music, as were Fairport Convention, Lindisfarne and Steeleye Span. The folklorist carried out a necessary, loving act of national conservation and they are to whom all music lovers owe a debt of gratitude, for without their work and dedication England's catalogue of folk songs, carols and shanties would most likely have vanished completely by the mid twentieth century. They assembled their finds of a culture that was slowly expiring, but framed them in either their own tidied up, romantic vision or one fenced in by dogma. In their view, the songs were ancient and precious artefacts of a time past and were to be preserved and protected from the violation change. Either way, it was looking back not forward.

It took another American artist to move the old songs of the British Isles forward, revitalising them with contemporary lyrics that suddenly made these ancient tunes feel like a revolution. With his new songs based in British balladry he tilted the 'I am' narrative to 'am I?' and beckoned the Beatles to look a little deeper. MacColl believed Bob Dylan to be 'a dreadful poet' whose songs are 'tenth rate drivel,' but the general view is that he is a songwriter of limitless invention. I have never been a fan of Dylan but it is obvious to anyone who knows his body of work that he possesses a lyrical and musical source that seems to spring eternal.

Dylan believed in the folk tradition and transmitted it in his unique Dylan style. Mining Harry Smith's *Anthology of American Folk Music*, a revised version of James Child's collection released on the Folkways label in 1952, he used fragments of lyrics and traditional melodies, or wrote entirely new lyrics for an old tune that fitted the flow. He updated the context and subject for the audience of his day that by 1960 was being fed on a musical diet of 'milk and sugar.' Assessing the times, Dylan wrote in *Chronicles*, 'All the weirdness and wildness had gone out of country music.' Elvis had 'taken songs to other planets' but was AWOL from the music scene by his

confinement in the army and all that remained was a 'mainstream culture' that was 'as lame as hell and a big trick. It was like the unbroken sea of frost that lay outside the window and you had to have awkward footgear to walk on it. I didn't know what age of history we were in nor what the truth of it was. Nobody bothered with that. If you told the truth, that was all well and good and if you told the un-truth, well, that's still well and good. Folk song taught me that.'

Richie and Orr compiled a list of all Dylan's songs that have their roots in British balladry, of which, perhaps, the most famous is 'The Girl from the North Country.' It borrows from 'Scarborough Fair,' that the folk singer Martin Carthy taught him when they met on the London folk circuit in the freezing December of 1962. Dylan was in town ostensibly as an actor, to take part in filming a Sunday night play for the BBC called *Madhouse on Castle Street*; but truly, it was an enriching research trip for Dylan, the young songwriter. Carthy took him on a folk club tour of all the main spots – the King and Queens pub, Bungies Coffee House, the Troubadour on Old Brompton Road and the newly located Singers' Club where Dylan performed 'Ballad of Hollis Brown,' based on the hypnotic tune and dark narrative of 'Pretty Polly.' Dylan was just twenty-one years old and looking back, Carthy believes those weeks spent in London soaking up the sounds and spirit of its quietly intense folk scene were 'crucial to his development. If you listen to *Freewheelin*,' most of which was made before he came to England, and you listen to the next album after that, there's an enormous difference in the way he's singing, in the sort of tunes he's singing, the way he's putting words together... Bob Dylan's a piece of blotting paper when it comes to listening to tunes.... It had an enormous effect on him.'

Dylan's early work is heavy with the echo of old British ballads. His set list included 'Pretty Peggy-O,' adapted from 'The Bonnie Lass o'Fyvie' with its original story set in the small town in Aberdeenshire; 'Restless Farewell' was adapted from 'The Parting Glass.' Dylan's 'Farewell, Angelina' released in 1965 has very similar cadence to 'Farewell to Tarwathie,' a nineteenth century ballad about a whaler preparing to leave a remote part of Moray up on the very north east of Scotland and sail to the strangeness of Greenland, with the context of the original song magnified to one of an international concern about war and alienation. The nineteenth century Scots ballad 'Tramps and Hawkers' is reflected in Dylan's 1967 release, 'I Pity the Poor Immigrant.' Probably his most iconic song is 'The Times They Are A-

Changin'' and in the liner notes of his 1985 compilation, *Biograph* Dylan explained how his inspiration for it came from, 'the Irish and Scottish ballads…'Come All Ye Bold Highwaymen,' 'Come All Ye Tender Hearted Maidens.' I wanted to write a big song, with short concise verses that piled up on each other in a hypnotic way.'

The truth is Dylan, one of the greatest songwriters of the twentieth century who sold his song catalogue in 2020 in one of the biggest deals in publishing history, started out writing songs by using the thrown clay of British ballads, the intangible heirlooms of our great collective family. They were his route into writing, as he described, 'songs bigger than life…about the strange things that have happened to you, strange things you have seen' – this is all folk songs of centuries passed have ever been about, as then, as now. It's moves me to comprehend the most revered songwriter of our age, an age when popular music reached its global zenith, was simply replicating what our ancestors have been doing for hundreds of years. It's one of the reasons I wanted to write this book, to take our focus out of our own era and find common feeling with the millions of souls who have walked this same earth in the centuries past.

Dylan's methods have led to accusations of piggy backing on others' work. In the particular case of 'With God on Our Side,' the author and poet Dominic Behan criticised him for, in his mind, cheapening the meaning of his original composition 'The Patriot Game' by transposing wholesale the complex, fraught and specific subject of patriotism in Ireland to a global, and ultimately, less meaningful context. But for Dylan, Ritchie and Orr tell us, 'the relationship between his own songs and the authentic originals was never important.' And somehow, through the sheer force of his gruff, uncompromising, mercurially persona Dylan made the majority of the world believe it was never important, either. Most likely, with the exception of Behan, nobody cared from where came the songs Dylan used for inspiration; the new songs he crafted using their foundations were too dazzling, and the often-anonymous compositions belonged to another, pre-copyright century. Woody Guthrie used the same approach by using the melody of 'Pretty Polly' back in 1941 with his song, 'Pastures of Plenty.' Another classic example is The Seekers 1965 million seller, 'The Carnival Is Over;' Tom Springfield (brother of Dusty) wrote new lyrics to an adaptation of the Russian folk song, 'Stenka Razin' to create a paean of majestic heartache that bears a stoicism

we all of us have to find at some point in our lives, and has become Australia's national song.

The British ballad was forged in stories of the folk hero: the charismatic outlaw who delights the audience with tales of their courageous individualism at odds with the dull, dead hand of the state. By folk song's transformation into pop, the folk hero leapt out of the story in a reverse 'Mary Poppins' moment to be physically before us as the hero singing the song. The economic parameters of songwriting have changed beyond all recognition, but the practice has barely altered. We will always be drawn to one who sings out to remind us what, deep down, we are feeling or thinking because the modern pop song's poetry is made of the same common concerns of folk song: work, fear, struggle, joy, love, loss, loneliness and death; the difference now is that the street singers, the *griots* and troubadours are now the heroes. Exactly when folk music transformed into pop is hard to define. Although, in Bert Lloyd's explanation of the folk style lies a clue. One key difference, Lloyd suggested, between folk and pop music is that folk performers tend to refrain from 'impressing their personality' on a song, and from presenting themselves as 'an exceptional figure with a message.' So, working with this observation, take folk music and combine it with the irresistible showmanship of an 'exceptional' figure we now call a lead singer and we have pop music. Which conveniently brings us to Big Bill Broonzy, Lonnie Donegan, Chuck Berry and Elvis Presley. Folk made its transition into the beginnings of pop when Big Bill was filmed in a smoky Brussels basement in *Low Light & Blue Smoke*, when Donegan stormed up 'Rock Island Line,' when Chuck Berry delivered 'Maybelline' with a ton of his naughty charisma, and of course, when Elvis' offered up his supercharged version of 'That's Alright, Mama.'

The crucial mistake made by those who loathed pop music when it emerged, the folkists especially, was to assume it was always doomed to be ephemeral. They underestimated the power of folk music transformed by technology and unfettered invention; they underestimated the strength and skill of songwriting that ran wild and free, and was coloured with the same wonder and beauty as a butterfly resting in the palm of a hand. A letter from a disgruntled folk fan to the editor of *Melody Maker* in August 1965 took aim at Dylan saying, 'Folk was written to last, for people to enjoy for centuries, not to be another 5-minute pop wonder.' Lloyd echoed this sentiment two years later when he wrote in his follow up to *The Singing Englishman*, *Folk Song in England* how Dylan's songs, 'may contain elements of alienation and

protest, as certain folk songs do…but they still remain songs that firmly belong to the insubstantial world of the modern commercial hit.' Bob's songs had been floating around for only five years at that point; 'the modern commercial hit' had yet to prove that the best of them could be commercial and treasured in the long term.

In 1958, Paul Robeson put it simply, 'the songs that have lived through the years have always been the purest expressions of the heart of humanity.' With that statement in mind, perhaps the most unsung tutoring tool to encourage British pop was *The National Songbook*. It was a collection of nearly two hundred ancient Scots, Welsh, Irish and English folk songs, folk-carols and rounds that circulated in Britain's schools from 1905 to the early 1960s. What stood out when reading the preface to the first edition was the editor's need to draw attention to 'the deeply poetical influence that Keltic music will exert upon the young mind.' Traditional folk song gives a budding performer an intuition for melody, for these old songs survived on their melody alone. It's one of the reasons why songwriters raised in the Celtic tradition, a tradition that survives healthily to this day, have an innate ability to write music people want to hear and sing along to. The songs they were suckled on were not held up by production tricks; they were naked, exposed, accompanied by a fiddle or a pipe or piano, if accompanied at all, and they were passed down through generations by the simple, irresistible strength of a captivating tune. They also provide an ancient folkloric connection to a sense of place, and a sense of place was what made British pop; the local soil from which it grows gives a song or a piece of music it's unique depth of flavour, and the listener the feeling of entering another world. Children of today might think them twee or irrelevant, but that's when you tell them without folk song there would be no pop music at all. You may ask, what is the benefit of old folk compared with the modern stuff taught in primary schools now? Let me tell you that many traditional folk songs, those 'sweet fading ghosts' as Lloyd described them, have a depth and gentleness, a beguiling strangeness and some kind of magic contained in their reflection of another time and they connect the singer to ancient melody, rhythm and harmony from which everything since has been drawn.

'Some say things have changed and we will not have folk songs any more. They are the pessimists. And some try to revive traditional music that has nothing to do with social life any longer; and all that happens is they give you a recital of the popular songs of the past; and they try and make a living thing of it. They are the optimists. But that is not the whole story. Things do change, and they change again; and just because at this moment we have no great body of fine folk song that is bound close to our social life and the times we live in and the way we go about our work, that is not to say there will never be any more. We may have to wait till...cultured music and popular music have become one and the same...where men can be what they are, and think and feel and sing as they do, without reference to class or colour or creed.' Writing this in 1944, Lloyd foreshadowed what British pop of the second, equally 'music mad' Elizabethan era would become. Although the body of fine folk song appeared in quite a different way to what he might have expected - mass culture, yes, but a common British culture of a kind. Times changed, they changed a whole lot, and a body of new songs using the old ways were just a generation away. In an interview Lloyd gave to *Recorded Folk Music* in 1958, it's almost as if he can sense it coming, when he observed there was 'a considerable resurgence of music-making, and not only on the primitive level of skiffle. That is to the good. And if the signs are read aright, it may be leading to the active exploration of our own native traditions. That would be better still. And if that gets under way on a truly broad scale, severe shocks and delightful surprises may be in store.'

Well, weren't they just, Bert. Severe, delightful shocks and surprises on the broadest scale imaginable that showed just how much, with a bit of Celtic encouragement, England's own native tradition for song making was far, far from dead. In fewer than ten years after he made this prediction, British music that reflected the ordinary, everyday working person's life and loves - those dominant subjects of folk song throughout all time, were dangling and jangling in the ether. Not just in Britain, but all over the world. Like Aesop's fable of 'The Wind and the Sun,' Britain's working-class culture won out in the end. Not with force. Not with revolution. But with the warmth of a cracking song.

Notes

1 – Written on the Wind

7 'Domino himself was at…' Coleman, R. *Blue Monday: Fats Domino and the Lost Dawn of Rock 'n' Roll*. Da Capo Press, 2006, p11

7 BBC News, Skye cave find western Europe's 'earliest string instrument,' 28 March 2012

8 'Who the hell can study music we do not know ever existed?' Moore, AF, and Vacca, G (eds). *Legacies of Ewan MacColl: The Last Interview*. Ashgate, 2014, p77

8 Cunliffe, *The Celts*, Oxford University Press, 2003, p143, Cunliff lecture and Oxford DNA study 2015

9 'Sword and shield songs,' Professor Kuno Meyer, Ph.D. Ancient Gaelic Poetry'

9 Stavanger, Doug Orr, Douglas Milton Orr and Fiona Ritchie, *Wayfaring Strangers: The musical voyage from Scotland and Ulster to Appalachia*, University of North Carolina Press, 2014, p27

9 Trade routes between Scotland and Scandinavia, Victoria E. Clark, M.A., *The Port of Aberdeen: A History of its Trade and Shipping Since the Twelfth Century to the Present Day*, D. Wyllie and Sons, 1921, p1

9 'Where fairy-folk, ghostly creatures of the sea,' J.E. Housman, *British Popular Ballads*, Harrap, 1952, p17

9 'Celtic melancholy,' Annie Lennox: No more marriage for me, *Telegraph*, 7th March 2008

9-10 Stewart, D. *Sweet Dreams Are Made of This: A Life in Music*. London: Penguin, 2016, p150-151

10 'Cradle of Scottish balladry,' Doug Orr, Douglas Milton Orr and Fiona Ritchie, *Wayfaring Strangers: The musical voyage from Scotland and Ulster to Appalachia*, University of North Carolina Press, 2014, p25

10 'undeniably the British tradition's nearest sibling,' David Buchan, *Ballad and the Folk*, Routledge and Kegan Paul, 1972, p7

10 'Abba in Great Britain,' https://abbasite.com/articles/abba-in-great-britain/

11 Two-thirds, David Buchan, *The Ballad and the Folk*, Routledge and Kegan Paul, 1972, p6-7

11 'Sequestered, pastoral,' ibid, p63.

11 'Where the nurses and old women sing,' *The Ballad Repertoire of Anna Gordon, Mrs Brown of Falkland*, Scottish Text Society, 2011, p27

11 'Ghosts and superstition,' ibid, p26

11 'The Elfin Knight,' Donna Heddle, 'Stormy Crossings: Scots-Scandinavian Balladic Energies,' *Journal of the North Atlantic*, Vol. 4, 2013, p163

11 'Sir Stig and the King of the Scots' daughter,' ibid, p163

12 'Lady Isobel and the Elf Knight,' ibid, p163

12 'Willie's Lady,' Francis Childs, edited by George Lyman Kittredge, *The English and Scottish Popular Ballads Vol. 1*, Houghton, Mifflin and Company, 1882, p81-83

12 Twenty-seven versions of Twa Sisters, David Buchan, *The Ballad and the Folk*, Routledge and Kegan Paul, 1972, p8

12 'the bare rolling stretch of country...' A.L. Lloyd, *Folk Song in England*, Panther Arts, 1969, p163

12 Political Tensions, Housman, *British Popular Ballads*, Harrap, 1952, p49
Chansons, 'Scottish Song, 1500-1700,' Kenneth Elliott, 7 November 1957
"In the first half of the sixteenth century-especially during the regency of Marie de Guise, widow of James V, and later during the reign of her daughter Mary, Queen of Scots - music at Holyrood was strongly influenced by that of the French court. We find three types of song from this period based on French models: three-part 'medleys,' four-part dance-songs and polyphonic chansons." P4

13 'David le Chantre,' David Tweedie, *David Rizzio and Mary Queen of Scots: Murder at Holyrood*, The History Press, 2006, p19

13 'merry fellow' ibid 59

13 Rizzio sent to Edinburgh, ibid, p12-13

13 'deep, attractive voice' ibid, p18.

13 'a charming, soft singing voice,' Antonia Fraser, *Mary, Queen of Scots*, Weidenfeld & Nicolson, 1969, p182

14 Song fragment, David Tweedie, *David Rizzio and Mary Queen of Scots: Murder at Holyrood*, The History Press, 2006, p64

14 'The style of Scotch music was fixed before his time' James Beattie, Essays: on poetry and music, as they affect the mind; on laughter and ludicrous composition; on the utility of classical learning, p187

15 'came to know the great clan chiefs,' David Tweedie, *David Rizzio and Mary Queen of Scots: Murder at Holyrood*, The History Press, 2006, p48

15 unified national consciousness, Claire Nelson 'The Creation of a British Musical Identity: The Importance of Scotland's Music in Eighteenth Century Aesthetic and Philosophical Debates,' *Context* 22, 2011, p120

15 Gallic infection, ibid, p113-114

15 'private homes, pleasure gardens, and even concert halls' ibid, p111

15 stirring purity of its pretty airs, ibid, p115

15 no music of its own, ibid, p120

16 Eriskay footage, Scotland on Screen, https://scotlandonscreen.org.uk/browse-films/007-000-002-215-c

2 – The Unstoppable Spirit

17 Gaelic psalm singing,' YouTube, 1 Aug 2010,
 https://www.youtube.com/watch?v=w62TN2iCP1g
18 'hard-faced, thick-palmed,' James Webb, *Born Fighting: How the Scots-Irish Shaped America*, Random House, 2004, p86
18 'swearing, breaking the Sabbath' 'fornication, drunkeness' 'uncomely gestures,' James G. Leyburn, *The Scotch-Irish*, North Carolina University Press, 1962, p57
18 'Galloway is more civil of late,' William MacKenzie, *The History of Galloway: From the Earliest Period to the Present Time*, John Nicholson, 1841, p4
18 'bleak and bare solitude,' Henry Grey Graham, *The Social Life of Scotland in the Eighteenth Century*, A & C Black, 1899, p2
 Hallowe'en has particular meaning in the Celtic world, originating in the ancient winter fire festival, *Samhain* that marked the beginning of the dark half of the year.
18-19 'at a christening there was much, at a funeral there was more...,' Henry Grey Graham, *The Social Life of Scotland in the Eighteenth Century*, A & C Black, 1899, p186–7

3 – Sing Me a Story

22 'a full fourth of the undertaken lands' 'on condition of living in villages...' Richard Bagwell, *Ireland Under the Stuarts and During the Interregnum Vol 1*, Longmans, Green, and Co., 1909, p86
22 'you pull the strings on some kind of instrument – a fiddle or a banjo, or something or other like that...' Ted Anthony, *Chasing the Rising Sun*, Simon and Schuster, 2007, p93
23 The harp in Scotland and Ireland since the eighth century, Doug Orr, Douglas Milton Orr and Fiona Ritchie, *Wayfaring Strangers: The musical voyage from Scotland and Ulster to Appalachia*, University of North Carolina Press, 2014, p84
24 Johnny Doyle, Journal of the Folk Song Society Vol 5 no 19 (June 1915) pp122-148 (The Gaelic name was converted to Johnny Doyle for versions found in England)
25 Dozier Interview with Dale Kawashima
 https://www.songwriteruniverse.com/hdh.htm
25 The Gallowa' Hills, Doug Orr, Douglas Milton Orr and Fiona Ritchie, *Wayfaring Strangers: The musical voyage from Scotland and Ulster to Appalachia*, 2014, p90
 also http://www.rampantscotland.com/songs/blsongs_gallowa.htm by William Nicolson, The Braes of Galloway, 1793-1849

Note: The Counter Reformation was a powerful Catholic response that found plenty of support in Ireland. The Irish Church was reinvigorated by incoming Jesuits from France preaching to the Irish people in Gaelic, offering pastoral encouragement and bolstering the patriotic pride of the Irish people to strengthen the Catholic base and the political power of Rome.

26 616,000, James Graham Leyburn, *The Scotch-Irish: A Social History*, University of North Carolina Press, 1962, p126

26 'Sword, famine and plague,' Jeremiah 24:10

26 Derry Siege, James Webb, *Born Fighting: How the Scots-Irish Shaped America*, Random House, 2004, p101

26-27 Test acts, James Graham Leyburn, *The Scotch-Irish: A Social History*, University of North Carolina Press, 1962, p64-66

4 – The Emigrant's Farewell

29 Quarter of a million, David Hackett Fischer, *Albion's Seed: Four British Folkways in America*, Oxford University Press, 1990, p606
*although Bernard Bailyn estimated 155-200,000, ibid, p609

29 150,000 from Ulster, ibid, p608

29 The majority Ulster Scots, ibid, p609

29 Early seekers, Leyburn, 'Presbyterian Immigrants and the American Revolution,' Journal of Presbyterian History, 1976, p13

29 'the colour of a summer sky' Polly Devlin, *The Far Side of the Lough*, V. Gollancz, 1983, p66

29-30 Linen history, Crommelin met William, then the Prince of Orange, 'The History of Irish Linen' Spectator, 15th March 1930

30 Ball held on the frozen Boyne, 'Dancing on Ice: recalling the Great Frost of 1740,' Independent.ie, 4th March 2018

31 Droughts and sheep disease, ibid, p164

31 Goodbye songs, Doug Orr, Douglas Milton Orr and Fiona Ritchie, *Wayfaring Strangers: The musical voyage from Scotland and Ulster to Appalachia*, University of North Carolina Press, 2014, p117

31 Hackett Fischer calls the later years that saw the height of the migrations 'The Flight.' By his conservative estimate Fischer states that between 1717-1775 the numbers of immigrants leaving Ireland, Scotland and the north of England were on average around 5,000 a year, *Albion's Seed: Four British Folkways in America*, Oxford University Press, 1990, p608

31 Down the Mersey estuary, ibid, p609
Truly the folk music of, (although he also quotes as high as 90%), ibid, p p634-635

32 Rent racking, James Graham Leyburn, *The Scotch-Irish: A Social History*, University of North Carolina Press, 1962, p163-164

32 'a mania...an undulant fever,' James Graham Leyburn, *The Scotch-Irish: A Social History*, University of North Carolina Press, 1962, p169

33 'Swarms...undershift,' David Hackett Fischer, *Albion's Seed: Four British Folkways in America*, Oxford University Press, 1990, p605

33 Quaker Philadelphia, ibid, p605

33 Stubbornly proud, ibid, p606

33 'Audacious and disorderly habits,' James Graham Leyburn, *The Scotch-Irish: A Social History*, University of North Carolina Press, 1962, p192

33 'High rents and Oppression,' A. R. Newsome, 'Records of Emigrants from England and Scotland to North Carolina,' 1774-1775, *The North Carolina Historical Review*, Vol. 11, No. 1, 1934, p52

34 'We had again a good dinner,' Samuel Johnson, A journey to the Western Islands of Scotland (1775) and Journal of a Tour to the Hebrides with Samuel Johnson, L.L.D. (1785, New York 1936) 242 (2 Oct 1773). Also in cited in David Hackett Fischer, *Albion's Seed: Four British Folkways in America*, Oxford University Press, p608, footnotes

34-35 Magazine quotes, Bernard Bailyn, *Voyagers to the West: A Passage in the Peopling of America on the Eve of the Revolution*, Random House USA, p41-42

35 'America will, in less than half a century,' ibid, p42

35 'for a nation scattered in the boundless regions...have no effect,' ibid, p40

35 'time sanctioned ways of life,' ibid, p40

35 'whole neighbourhoods...,' David Hackett Fischer, *Albion's Seed: Four British Folkways in America*, Oxford University Press, 1990, p605

35 'Hard neighbours,' James Graham Leyburn, *The Scotch-Irish: A Social History*, University of North Carolina Press, 1962, p192

35 Fertility 40% higher, David Hackett Fischer, *Albion's Seed: Four British Folkways in America*, Oxford University Press, 1990, p666

35 'The number of white people in Virginia...,' H. Tyler Blethen and Curtis W. Wood, *From Ulster to Carolina: The Migration of the Scotch Irish to Southwestern North Carolina*, University of North Carolina Press, 1998, p37

36 Border counties: people from Cumberland, Westmoreland and Lancashire to Ulster, David Hackett Fischer, *Albion's Seed: Four British Folkways in America*, Oxford University Press, 1990, p621-622

36 90% of Settlers in Appalachia, ibid, p795

36 Very essence of southern living, James Webb, *Born Fighting: How the Scots Irish Shaped America*, 2004, Random House, p129

36 Everyone's survival, David Hackett Fischer, *Albion's Seed: Four British Folkways in America*, Oxford University Press, 1990, p639

5 – The Folk Elite of Appalachia

37 'Should auld acquaintance be forgot?,' Grady McWhiney, *Cracker Culture*, University of Alabama Press, 1988, p37

37 'The country of the mind,' 'The Sense of Place' is the subject and the title of a lecture Seamus Heaney gave at the Ulster Museum in January 1977 and which is reprinted in Preoccupations1.

37-38 Jim Brock & Arlin Moon, Grady McWhiney, *Cracker Culture*, University of Alabama Press, 1988, p120

38 Arlin Moon – Portrait of an artisan
https://www.youtube.com/watch?v=4evfNi7mop8

38 18% of Appalachian households, Wilma A. Dunaway, *Slavery in the American Mountain South*, Cambridge University Press, 2010, p25

38 Free African Americans in Upper South, Ira Berlin, *Slaves without Masters: The Free Negro in the Antebellum South*, New Press, 1992, p136

39 Polymath and musicologist, Piero Scaruffi the most important source of innovation for music in the western world after the rhythmic notation innovations of Ars Nova. http://www.scaruffi.com/history/blues.html

39 John Knox hatred of dancing, Antonia Fraser, *Mary, Queen of Scots*, Weidenfeld & Nicolson, 1969, p182

39 'gracefully and becomingly,' ibid, p183

39 Dancing forbidden in both cultures, Alan Lomax, *Land Where the Blues Began*, Pantheon, 1993, p365

39 *Griots*, https://teachersinstitute.yale.edu/curriculum/units/files/93.03.09.pdf p5

40 'There is, without a doubt…' Laurent Dubois, *The Banjo: America's African Instrument*, Harvard University Press, 2016, p35-36: Richard Jobson traveled up the Gambia River in 1620 and 1621 (ngoni is in bambera language, a Mande sub group; xalam is serer language, khalam is wolof; akonting is mandinka, the largest of Mande group)

40 'blues fiddler, banjo picker…,' Alan Lomax, *The Land Where the Blues Began*, Delta, 1995, p365

41 Ruff's story: https://www.willieruff.com/line-singing.html

42 Similarities between white and black spirituals, John W. Work, *American Negro Songs*, Dover Publications, 1998, p6-7

42 Focuses on the beat, ibid, p9-10

43 'so concentrated as to be epigrammatic' Jeffrey Green, 'Roland Hayes in London, 1921,' The Black Perspective in Music, Vol. 10, No 1, 1982, p33

43 'Back to my roots' Yoruba lyric "Awa oma ranti se ranti ye o, isedale baba wa."

43 Different languages and customs, Laurent Dubois, *The Banjo: America's African Instrument*, Harvard University Press, 2016, p51

43 1750-1775, half were Senegambians, Michael T Coolen, 'Senegambian Influences on Afro American Musical Culture,' Black Music Research Journal, Vol. 11, No. 1, 1991, p2

43 Senegambians, 53% in Georgia, ibid, p4

44 The fodet, ibid, p12

44 'Bangelo,' Dana J. Epstein, Dana J. Epstein, *Sinful Tunes and Spirituals: Black Folk Music to the Civil War*, University of Illinois Press p5

44 'Bangeon,' Anna Maria Falconbridge, 'Narrative of Two Voyages to the River Sierra Leone 1791-1792-1793,' 1794, p80

44 Akan pitch tone, *Deep Blues: A Musical and Cultural History of the Mississippi Delta*, Penguin, 1982, p29

44 'there are local traditions of exceptionally refined vocal polyphony,' ibid, p28

45 'Marriage or other feasts,' A report of the Kingdom of Congo: and of the surrounding countries; drawn out of the writings and discourses of the Portuguese, Duarte Lopez: Filippo Pigafetta, 1533-1604: Hutchinson, Margarite, p110
https://archive.org/details/reportofkingdomo00lope_0/page/110/mode/2up?q=lute

45 'The players touch the strings in good time Signify their thoughts,' ibid, p111

45 Animal horns, drums, flutes, xylophones, *Deep Blues: A Musical and Cultural History of the Mississippi Delta*, Penguin, 1982, p29,

46 'In the adjoining house...' George Tucker, *The Valley of Shenandoah, or Memoirs of the Graysons, Vol III*, C. Wiley, 1825, p4

46 'bright-hued, long-tailed coats, accented with gilt buttons and fancy shirts,' Paul A Cimbala, 'Black Musicians From Slavery to Freedom: An Exploration of African American Folk Elite and Cultural Continuity in the Nineteenth Century Rural South,' The Journal of Negro History, Vol. 8, No. 1, 1995, p17

46 'Africa, dat good ol land,' ibid, p18

46 African American preservation of Scots and English folk song, *On the Trail of Negro Folk Song*, Dorothy Scarborough, Harvard University Press, 1925, p33

46 Work songs, Dana J. Epstein, *Sinful Tunes and Spirituals: Black Folk Music to the Civil War*, University of Illinois Press, p161

46 'A silent slave...,' Frederick Douglass, *The Life and Times of Frederick Douglass*, first published 1881, Dover Publications, 2003, p32

46 'As an aching heart is relieved by its tears,' *Sinful Tunes and Spirituals: Black Folk Music to the Civil War*, University of Illinois Press, p179

6 – A Brethren of Oddities

49 John Lee Hooker story, Joe Boyd, *White Bicycles: Making Music in the 1960s*, Serpent's Tail, 2006, p67

50 'What in heaven's name for?' Paul Robeson, *Here I Stand*, Othello Associates, 1958, p32-33

51 'Whom I came to know and love,' ibid, p48

51 'gave him access to sources...,' Jonathan Gould, *Can't Buy Me Love*, Harmony Books, 2006, p63

53 By-laws and old vagrancy laws, ibid, p16

53 'The prisons are full of them,' Voltaire, *Letters on England*, Penguin, 1980, p30

53 'cannibals and satanists,' James Walvin, *The Quakers: Money and Morals*, John Murray Publishers Ltd., 1997, p19

53 Roundly abused, ibid, p21

55 On it were 10,639 names, Adam Hochschild, *Bury the Chains: The British Struggle to Abolish Slavery*, Macmillan, 2005 p121
into a national movement, ibid, p130

56 'the sense of the nation has pressed abolition on our rulers,' James Walvin, *England, Slaves and Freedom 1776-1838*, University Press of Mississippi, 1987, p122

56 'a good fleet at sea,' The Press Gang Afloat and Ashore, JR Hutchinson
https://www.gutenberg.org/files/6766/6766-h/6766-h.htm#link2HCH0006

56 north of England prime area of recruiting, Nicholas Rogers, The Naval Impressment and its Opponents in Georgian Britain, Hambledon Continuum, 2007, p53

56 Press gang statistics, ibid, p6

56 'Whom The Gang Might Take, The Press Gang Afloat and Ashore,' Chapter IV https://www.gutenberg.org/files/6766/6766-h/6766-h.htm

57 Barbary Pirates, Robert C. Davis, *Christian slaves, Muslim Masters: White Slavery in the Mediterranean, The Barbary Coast, and Italy*, 2003, p5

58 Debut was a sensation, Bernth Lindfors, *Ira Aldridge: The Early Years, 1807-1833*, University of Rochester Press, 2011, p63-66

58 'The House was very full...,' ibid, p67

59 'an intelligent lady...' 'rascals in the box office,' ibid, p93,

59 Marriage to Margaret, Herbert Marshall and Mildred Stock, *Ira Aldridge: The Negro Tragedian*, Rockliff, 1958, p309

60 The Padlock, Bernth Lindfors, *Ira Aldridge: The Early Years, 1807-1833*, University of Rochester Press, 2011, p113-116

60 'better conducted than by the last manager,' ibid, p135

60 Aldridge tours, ibid, p179-181, p201

60 Edmund Kean description, ibid, p166

61 'Positively the last appearance...,' Herbert Marshall and Mildred Stock, *Ira Aldridge: The Negro Tragedian*, Rockliff, 1958, p115

61 Greatest test for any actor, Bernth Lindfors, *Ira Aldridge: The Early Years, 1807-1833*, University of Rochester Press, 2011, p261

61 'demolishing everybody,' ibid, p229

62 'Nature has been good to Mr. Aldridge...,' Herbert Marshall and Mildred Stock, *Ira Aldridge: The Negro Tragedian*, Rockliff, 1958, p123

62 five years running, Bernth Lindfors, *Ira Aldridge: The Early Years, 1807-1833*, University of Rochester Press, 2011, p287

62 'Grand Classical and Dramatic Entertainment,' Bernth Lindfors, *Ira Aldridge: The Vagabond Years, 1833-1852*, University of Rochester Press, 2011, p58

62 carriage etc & taking care of ticket sales, Bernth Lindfors, *Ira Aldridge: The Vagabond Years, 1833-1852*, University of Rochester Press, 2011, p50

62 medley of scenes and songs, ibid, p43

62 new young talent, ibid, p50

62 'he is, as to cash, in full feather,' ibid, p44

63 nobility and gentry, ibid, p50 & 90

63 'crowded to excess,' Herbert Marshall and Mildred Stock, *Ira Aldridge: The Negro Tragedian*, Rockliff, 1958, p159

63 'blaze of triumph,' ibid, p158

63 He returned to the London stage, ibid, p158-159

63 'The Surrey side,' ibid, p160

63 'grandeur and sublimity,' Bernth Lindfors, *Ira Aldridge: The Vagabond Years, 1833-1852*, University of Rochester Press, 2011, p143

63 'A treat of high order,' ibid, p142

63 'We could not perceive any fitness...' Herbert Marshall and Mildred Stock, *Ira Aldridge: The Negro Tragedian*, Rockliff, 1958, p121

63 'His delineation of the proud, revengeful Moor...' , ibid, p163

63 'The twenty years struggle...,' Bernth Lindfors, *Ira Aldridge: The Vagabond Years, 1833-1852*, University of Rochester Press, 2011, p143

64 Hungarian National Theatre, Bernth Lindfors, *Ira Aldridge: The Last Years, 1855-1867*, University of Rochester Press, 2013, p86

64 'Index to the Gotha almanac,' Herbert Marshall and Mildred Stock, *Ira Aldridge: The Negro Tragedian*, Rockliff, 1958, p216

64 'A simple recital of all my successes abroad...,' Bernth Lindfors, *Ira Aldridge: The Last Years, 1855-1867*, University of Rochester Press, 2011, p190

65 'The toast having been most cordially received...,' Bernth Lindfors, *Ira Aldridge: The Last Years, 1855-1867*, University of Rochester Press, 2015, p203

65 Society of polish artists of film and theatre, Herbert Marshall and Mildred Stock, *Ira Aldridge: The Negro Tragedian*, Rockliff, 1958, p334

7 – A Hand Across an Ocean

68 'Sincere effort of earnest people,' Carol Faulkner, 'The Root of Evil: Free Produce and Radical Anti-Slavery,' *The Journal of the Early Republic*, Vol. 27, No. 3, 2007, p379

68 Cotton economy production levels, Eugene A. Brady, 'A Reconsideration of the Lancashire "Cotton Famine,"' Agricultural History, Vol. 37, No. 3, 1963; R. C. O. Matthews, *A Study in Trade-Cycle History: Economic Fluctuations in Great Britain 1833-1842*, Cambridge University Press, 2011 (1954), p138

68 77% of cotton imports, Sven Beckert, *Empire of Cotton: A Global History*, Vintage, 2014, p243

68 Lancashire produced 90% of Britain's cotton, Dave Haslam, *Manchester: The Story of the Pop Cult City*, Fourth Estate, 1999, p7

69 Save for some efforts of the cotton smugglers, Sven Beckert, *Empire of Cotton: A Global History*, Vintage, 2014, p246

69 Agitation for British government to come out for the southern states, ibid, p260-61,

69 'The working class is accordingly fully conscious...'
https://wikirouge.net/texts/en/A_London_Workers'_Meeting_(1862)

70 unemployment statistics, 'The Distress in Lancashire,' *New York Times*, November 26, 1862

70 'little murmuring,' Joseph H. Park, The English Workingmen and the American Civil War. *Political Science Quarterly*, Vol. 39, No. 3, 1924, p432

70 'tall chimneys were smokeless...,' Edwin Waugh, *Home-Life of the Lancashire Factory Folk During the Cotton Famine: Reprinted as Reported in the Manchester Examiner and the Times of 1862*, CreateSpace Independent Publishing Platform, 2017, p5

70 'Any one well acquainted with Lancashire..., ibid, p140-41

71 'that this meeting, recognising the common...,' 'Condemnation of the American Rebellion,' *Daily News* (London), 2nd January 1863

The American International Relief Committee, W.O. Henderson, M.A. Ph.D, *The Cotton Famine in Lancashire, 1861-1865*, Manchester University Press, 1934, p53

71 '11,236 barrels of flour...,' Report of the American International Relief Committee, for the Suffering Operatives of Great Britain, 1862-63, Cornell University Library, 1864, p30

71 'only in London, Liverpool and Glasgow...' Joseph M. Hernon, jnr., British Sympathies in the American Civil War: A Reconsideration, *The Journal of Southern History*, Vol. 33, No. 3, 1967, p361

71 'all but spurned at Edinburgh, all but cursed at Glasgow...,' ibid, p361

71 'a black vessel destined to be burned on the moor...,' ibid, p363-364

72 'their friends and brethren across the Atlantic,' Joseph H. Park, The English Workingmen and the American Civil War. *Political Science Quarterly*, Vol. 39, No. 3, 1924, p446

72 'thoroughly permeated every class in this country...,' ibid, p436

72 'This public meeting desires to express...,' *Manchester Guardian*, 25th February 1863

8 – The Idols of the Halls

73 Morris and Irish tunes, Bernth Lindfors, *Ira Aldridge: The Vagabond Years, 1833-1852*, University of Rochester Press, 2011, p67
Chimney sweeps, ibid, p70

73 'Quaint capers of a cleave-boy,' W.T. Lhamon Jnr, *Jump Jim Crow*, Introduction, Harvard University Press, 2008, p40-41

74 'smeared in lampblack...giving rather feeble imitations' of African Americans 'in their gayest moods.' Black Stephen Foster, *Pittsburgh Courier*, 5 August 1939

74 Cocknefied minstrels, J.S.Bratton, English Ethiopians: British Audiences and Blackface Acts, p141

74 after the civil war, J.S. Bratton, 'English Ethiopians: British Audiences and Blackface Acts 1835-1865,' The Year Book of English Studies, Vol. 11, 1981, p131

74 'line upon line,' Michael Pickering, *Black Face Minstrelsy in Britain*, Routledge, 2008, p27

74 Haverly's Ethiopian Minstrels to England, ibid, p64

74 James A. Bland, James R. Hullfish, James A. Bland Black Pioneer Songwriter

75 John Jay Daly, *A Song in His Heart*, p62-70

75 'a vast assemblage of persons...' 'Haverly's Minstrels,' *Daily Telegraph*, 1st August 1881

76 'drawing crowded houses nightly...' *Meath Herald and Cavan Advertiser*, 29th April 1882

76 'annual return of Hague's Minstrels..., *Manchester Times*, 4th August 1883

77 'Tickle the banjo strings a l'americaine,' 'The Prince and the Banjo,' *World's News*, 6th June 1925 (Trove news archive)

77 'silk costumes of gay colors,' 'Has Only Memory,' *Crab Orchard Herald*, 9th January 1920

77 'An elegant night haunt in Leicester Square,' Eoghan O'Tuairisc, Eugene Watters and Matthew Murtagh, *Infinite Variety: Dan Lowrey's Music Hall 1879-1897*, Gill and Macmillan, 1975, p84

77 'effervescent top,' 'Has Only Memory,' *San Angelo Evening Standard*, 4th January 1920

77-78 'James Bohee has opened a first-class Academy,' Evanion catalogue British Library

78 'Three hundred consecutive performances,' *Essex Standard* 25th July 1891

78 'hundreds of thousands of dollars,' 'Has Only Memory,' *San Angelo Evening Standard*, 4th January 1920

78 'Audience wept with them,' Eoghan O'Tuairisc, Eugene Watters and Matthew Murtagh, *Infinite Variety: Dan Lowrey's Music Hall 1879-1897*, Gill and Macmillan, 1975, p85

78 'the enthusiasm of their reception was instantaneous' *East and South Devon Advertiser*, 29th June 1895

78 James Bohee death, *South Wales Daily News* – Thursday 7th December 1897

79 'moving picture theater on Broadway,' 'Has Only Memory,' *San Angelo Evening Standard*, 4th January 1920

9 – The People's Artist

81 'status of beneficiary and ward,' Alain Locke, *The New Negro*, Albert and Charles Boni, 1925, p15

82 'It is through art we are going to come into our own,' Martin Duberman, *Paul Robeson: A Biography*, The New Press, 1989, p72

82 Family history, Paul Robeson, *Here I Stand*, Othello Associates, 1958, p6-8

83 'There will be no prejudice,' ibid, p87

83 Emperor Jones reviews, ibid, p89-90

83 'warm and friendly and unprejudiced,' ibid, p87-88

83 Amanda Aldridge, ibid, p91

84 Lawrence Brown, Paul Robeson Jnr, *The Undiscovered Paul Robeson: An Artist's Journey, 1898-1939*, John Wiley & Sons, 2001, p65

84 Roland Hayes in London, 1921, The Black Perspective Jeffery P. Green, p33

84 The spirituals of his father, Paul Robeson, *Here I Stand*, Othello Associates, 1958, p49

84 'the great poetic song-sermons,' Paul Robeson, *Here I Stand*, Othello Associates, 1958, p49

85 'the greatest all-star coloured show,' Frank C. Taylor with Gerald Cook, *Alberta Hunter: A Celebration in Blues*, McGraw Hill, 1987, p97

85 £1,000, 'Candid Communications,' *John Bull*, 11th February 1928

85 'at the height of her fame,' 'Candid Communications,' *John Bull*, 11th February 1928

85 'tore up the place,' Frank C. Taylor with Gerald Cook, *Alberta Hunter: A Celebration in Blues*, McGraw Hill, 1987, p97

85 London life, Martin Duberman, *Paul Robeson: A Biography*, The New Press, 1989, p115-116

86 "There was a great deal of food and much champagne," ibid, p118

86 Details of the party made the front page of the Chicago *Defender*, ibid, p118

86 *Sanders of the River*, ibid, p179-182

87 *Song of Freedom*, ibid, p204

87 Specifically Welsh song, Paul Robeson, *Here I Stand*, Othello Associates, 1958, p49

87 Welsh miners' march, Paul Robeson Jnr, *The Undiscovered Paul Robeson: An Artist's Journey, 1898-1939*, John Wiley & Sons, 2001, p156

87 Visit to Russia, Martin Duberman, *Paul Robeson: A Biography*, The New Press, 1989, p186

88 Civilian territory that had now become a war zone, 'World Shocked by Massed Murder' *Western Times*, 30th April 1937

88 The armed escort of two trawlers, Belfast *Telegraph*, Sat 22nd May 1937

89 'has soured us, we despise them openly,' Martin Duberman, *Paul Robeson: A Biography*, The New Press, 1989, p221

89 France and America can stand by inactive, ibid, p216

89 Play a piano introduction through twice, ibid, p222

89 Something inside had turned, ibid, p223

89 Unity Theatre, ibid, p223-224

90 *The Proud Valley*, ibid, p231-34, 234

90 'found the hand of brotherhood,' Paul Robeson, *Here I Stand*, Othello Associates, 1958, p54

90 'a closer bond between us,' ibid, p54

90 'a big, black Pollyanna,' 'The Cinema,' Spectator, 15th March 1949

91 To have dinner with visiting friends, Martin Duberman, *Paul Robeson: A Biography*, The New Press, 1989, p236-7

91 'wide in human terms is our civilization,' ibid, p238

92 Brattle sold out within hours, ibid, p264

92 *Othello* reception at Brattle, ibid, p265

92 Othello on Broadway stage, ibid, p276-277

92 many American writers and journalists, ibid, p277

92 Longest run for Shakespeare on Broadway, ibid, p286

92 'Shakespeare, the genius that he was...,' Paul Robeson discusses Othello https://www.youtube.com/watch?v=-DF7YQrC7HM

93 'the English public seem as fond if not fonder of Paul than ever,' Martin Duberman, *Paul Robeson: A Biography*, The New Press, 1989, p338

93 'It is common enough...,' 'Mr. Robeson's Tour,' *Manchester Guardian*, 18th February 1949

93 'Just a shilling or two,' 'Mr Robeson's Free Concerts,' *Manchester Guardian*, 7th May 1949,

93 'generous welcome,' 'Paul Robeson' 13 April 1949

94 'some members of the audience whistled,' 'Cat Calls For Robeson,' Bradford Observer, 22nd April 1949

94 'champion of human rights,' 'The Six Condemned Negroes,' *Guardian*, 11th May 1949

94 Paris speech, Martin Duberman, *Paul Robeson: A Biography*, The New Press, 1989, p342

94 Peekskill concert, *Paul Robeson Jnr, Paul Robeson: Quest for Freedom, 1939-1976*, John Wiley & Sons, 2010, p167-8

95 Passport confiscation, ibid, p211-212

95 'stop notice,' Paul Robeson Jnr, Paul Robeson: Quest for Freedom, 1939-1976, John Wiley & Sons, 2010, p212

95 'A propagandist,' ibid, p126

95 Paul Robeson – The Lost Shepherd, Paul Robeson Jnr, Paul Robeson: Quest for Freedom, 1939-1976, John Wiley & Sons, 2010, p215

95 Robeson blacklisted, ibid, p214

95 black churches, peace rallies, progressive cultural events, ibid, p214

95 annual earnings, Paul Robeson, *Here I Stand*, Othello Associates, 1958, xviii

95 Suffered a mental decline, Paul Robeson Jnr, *Paul Robeson: Quest for Freedom, 1939-1976*, John Wiley & Sons, 2010, p248-9

96 '...we are assembled in 1956...,' Paul Robeson, *Here I Stand*, Othello Associates, 1958, p57

96 'I recall how a friend in Manchester deepened my understanding,' ibid, p54

96 'It is deeply moving to me...,' ibid, p57

96-97 Free Paul Robeson concert, Martin Duberman, *Paul Robeson: A Biography*, The New Press, 1989, p449-450

97 'United States Department of State look rather silly,' ibid, p450

97 'As we were engulfed by the wave of affection...,' Paul Robeson Jnr, *Paul Robeson: Quest for Freedom, 1939-1976*, John Wiley & Sons, 2010, p266-7

10 – Coal Town Crossroads

99 The Overnight City: The Life and Times of Van Lear, Kentucky, 1908-1947,

Clyde Roy Pack, Storyatom, 2016

100 Company towns, Cindy Campbell Krause and Darrell Campbell, *A Hillbilly Grows Up: Boyhood Adventures in Rural Kentucky*, CreateSpace Independent Publishing Platform, 2015, p1

100 'preternaturally talented,' Barbara Allen and Thomas J. Schlereth, *Sense of Place: American Regional Cultures*, University Press of Kentucky, 1990, p136

100 'about every Saturday night,' ibid, p129

100 'Everyone in the family played,' ibid, p128

101 Amos Johnson, ragtime piano to guitar, Charles K. Wolfe, *Kentucky Country: Folk and Country Music of Kentucky*, Charles K. Wolfe, University Press of Kentucky, 1982, p110

101 Open tuning, fretting with a knife or bottle, Barbara Allen and Thomas J. Schlereth, *Sense of Place: American Regional Cultures*, University Press of Kentucky, 1990, p131

101 Levi Foster, ibid, p131 ibid; Charles K. Wolfe, *Kentucky Country: Folk and Country Music of Kentucky*, Charles K. Wolfe, University Press of Kentucky, 1982, p110

101 As early as 1918, Barbara Allen and Thomas J. Schlereth, *Sense of Place: American Regional Cultures*, University Press of Kentucky, 1990, p123

101 'That A chord,' ibid, p131-132 ibid, (a fourth chord variation instantly makes the sound more melodic)

101 'you got a colored fiddler, we don't want that...,' Charles K. Wolfe, *Kentucky Country: Folk and Country Music of Kentucky*, Charles K. Wolfe, University Press of Kentucky, 1982, p113

101 'Always got along...,' p110, ibid

101 'The mines, back then...,' Barbara Allen and Thomas J. Schlereth, *Sense of Place: American Regional Cultures*, University Press of Kentucky, 1990, p129

102 Rosine and Horton, Richard D Smith, *Can't You Hear Me Calling*, Da Capo Press, 2001, p23

102 Shultz-Travis region, ibid, p125 ibid

102 Not seen again for years, p134, ibid

102 'the sound of his guitar slowly fading,' ibid , p23

102 'Floating dance-halls,' Iain Lang, *Background of the Blues*, Workers' Music Association, p15

102 Up and down Green River, Barbara Allen and Thomas J. Schlereth, *Sense of Place: American Regional Cultures*, University Press of Kentucky, 1990, p133 (steamboats ceased around late 20s, p129, presumably because rail took over)

102 'Big, black hat,' Charles K. Wolfe, *Kentucky Country: Folk and Country Music of Kentucky*, Charles K. Wolfe, University Press of Kentucky, 1982, p113

102 Louisville and St Louis, Charles K. Wolfe, *Kentucky Country: Folk and Country Music of Kentucky*, Charles K. Wolfe, University Press of Kentucky, 1982, p113

102 Wintering in New Orleans, Richard D Smith, *Can't You Hear Me Calling: The Life of Bill Monroe Father of Bluegrass*, Da Capo Press, 2001, p23

102 'bouncy, cut time rhythm' for square dancers, Barbara Allen and Thomas J. Schlereth, *Sense of Place: American Regional Cultures*, University Press of Kentucky, 1990, p136

102 make a guitar sound like a ragtime piano, ibid, p131

102 'spread like wildfire,' ibid, p135-136

102 Cannonball rag is said to be composed by Shultz, although some claim it was written by fellow Muhlenberger, Kennedy Jones.

102 Shultz teaching the Everly family, ibid, p131

102 'Magnificent...follow him around,' *Songs of Innocence and Experience*, Arena, BBC, 1984

103 'lyrics to hundreds and hundreds of songs, and he knew them all...,' Nuala O'Connor, *Bringing it All Back Home*, Merlin, 2000, p30

103 'tried very hard to be Irish.' ibid, p30

103 In his biography of Monroe, *Can't You Hear Me Callin,*' Richard D. Smith's mentions the story of how Berry and rockabilly pioneer Carl Perkins killed hours on the road touring from venue to venue harmonizing and singing songs such as

103 'Blue Moon of Kentucky' and the ancient English murder ballad, 'Knoxville Girl,' p134

103 'the riches of English, Welsh and Gaelic folk..,' Paul Robeson, *Here I Stand*, Othello Associates, 1958, p50

103-104 'merry and sad,' 'the grand old woods for miles around reverberate with their wild and plaintive noises,' Frederick Douglass, *The Life and Times of Frederick Douglass*, first published 1881, Dover Publications, 2003, p61

104 'Child as I was, these wild songs...so mournful,' ibid, p61

104 http://www.mikescottwaterboys.com/waterboys-discs.php?releaseid=5& releasepageid=14

11- Messages from the Mountains

105 Lackey's story, James Webb, *Born Fighting: How the Scots-Irish Shaped America*, Random House, 2004, p119

105 'Near biblical story telling,' ibid, p121

105 Grandmother's archive, ibid, p121

106 Basque culture, Grady McWhiney, *Cracker Culture*, University of Alabama Press, 1988, p xlii-xliii

106 Women were the keepers of the songs, Wayne Erbsen, *Rural Roots of Bluegrass*, Native Ground Books and Music, 2003, p14

106 'whether in the garden,' ibid, p14

106-107 Buna Hicks quotes, Burton Manning Collection, School of Scottish Studies, Edinburgh University

107 'Muddy Waters was raised on a musical cusp...' Robert Gordon, *Can't Be*

Satisfied: The Life and Times of Muddy Waters, Back Bay Books, 2003, p14

108 'pop roots music performer," Barry Mazor, *Meeting Jimmie Rodgers*, Oxford University Press, 2009, p17

108 'powerful black monsters belching fire and smoke...' Carrie Rodgers, *My Husband Jimmie Rodgers*, Country Music Foundation Press, 1975, p10

109 'A railroad man,' Nolan Porterfield, *Jimmie Rodgers: The Life and Times of America's Blue Yodler*, The University Press of Mississipi, 2007, p171

109 'strange and poignant,' Robert Palmer, *Deep Blues: A Musical and Cultural History of the Mississippi Delta*, Penguin, 1982, p44

109 'the weirdest music I had ever heard,' ibid, p45

109 Miles of track, https://www.lib.uiowa.edu/exhibits/previous/railroad/

109 Largest job market after the cotton fields...only as trackside labourers, Max Haynes, *Railroadin' Some: Railroads in the Early Blues*, Music Mentor Books, 2006, p26

110 From 130,000 to 4 million, https://www.npr.org/sections/parallels/2017/04/06/521793810/at-a-hefty-cost-world-war-i-made-the-u-s-a-major-military-power

110 'those factory whistles cried freedom,' Alan Lomax, *Mister Jelly Roll*, University of California Press, 2001, p180 (*flapper* was first used in the *Chicago Tribune* in 1913)

110 500,000, one tenth in Chicago South Side, ibid. p180

110 Lula White and Gypsy Schaeffer, ibid, p50

110 'dressed in their fine evening gowns," ibid, p50

110 'New Orleans was the stomping ground,' ibid, p42

111 'breaks...clean breaks...,' p63-64, ibid

111 played all night and practiced all day, p108 ibid

111 'domestic torpedo,' ibid, p179

111 'the money town,' ibid, p180

111 Chicago *Defender*, Saumuel B. Charters, *The Country Blues*, Da Capo Press, 1975, p47

111 'dealers and private persons,' Max Haynes, *Railroadin' Some: Railroads in the Early Blues*, Music Mentor Books, 2006, p32

112 disease ridden rail camps, Nolan Porterfield, *Jimmie Rodgers: The Life and Times of America's Blue Yodler*, The University Press of Mississipi, 2007, p12

112 Family musicians, ibid, p21

112 Life in Meridian, ibid, p20-21

113 'wistful Irish charm and a cocky grin,' ibid, p18

113 'noon dinner rests...crooning lullabies,' Carrie Rodgers, *My Husband Jimmie Rodgers*, Country Music Foundation Press, 1975, p7

113 'hoboes of all races slept, ate, talked - and traded blues verses,' Barry Mazor, *Meeting Jimmie Rodgers*, Oxford University Press, 2009, p14

113 'happy-go-lucky youngster...,' Carrie Rodgers, *My Husband Jimmie Rodgers*, Country Music Foundation Press, 1975, p23

113 'He'd jump up from the table...,' ibid, p23

113 Wartime railroad boom, Nolan Porterfield, *Jimmie Rodgers: The Life and Times of America's Blue Yodler*, The University Press of Mississipi, 2007, p39

114 washing dishes, ibid, p44

114 'call board to call board,' ibid, p52

114 Brutal cough, ibid, p52

114 'Wherever the night caught us...,' Carrie Rodgers, *My Husband Jimmie Rodgers*, Country Music Foundation Press, 1975, p72

114 Scots Irish in origin Mike Parris and Chris Comber, *Jimmie the Kid: The Life of Jimmie Rodgers*, Da Capo Press, 1977, p10

114 'restlessness, displacement...,' Nolan Porterfield, *Jimmie Rodgers: The Life and Times of America's Blue Yodler*, The University Press of Mississipi, 2007, p7

115 'about all he had was the clothes on his back...,' Carrie Rodgers, *My Husband Jimmie Rodgers*, Country Music Foundation Press, 1975, p63

115 Sallee Gooden, Nolan Porterfield, *Jimmie Rodgers: The Life and Times of America's Blue Yodler*, The University Press of Mississipi, 2007, p88

115 Okeh, Columbia and Vocalion, ibid, p89

115 'upstart new variety of musical entertainment,' ibid, p89

116 Control of the copyrights, ibid, p100

116 Finest classics of American song, ibid, p100-101

116 'In no section of the South have the pre-war melodies...,' ibid, p105

116 Bristol details, ibid, p105

116 'if you knew how to play C on the piano...,' ibid, p106

117 Jimmie falling out with Jack Grant, ibid, p107

117 'Oil and water... they do not mix' ibid, p108

117 'his own personal and peculiar style.' ibid, 109

117 'Where The River Shannon Flows' ibid, p110

117 'shabby, lanky youngster with the pitiful cough,' Carrie Rodgers, *My Husband Jimmie Rodgers*, Country Music Foundation Press, 1975, p121

117 convinced reception desk, Nolan Porterfield, *Jimmie Rodgers: The Life and Times of America's Blue Yodler*, The University Press of Mississipi, 2007, p117

117 'underneath that painfully...,' Carrie Rodgers, *My Husband Jimmie Rodgers*, Country Music Foundation Press, 1975, p121

117 'Why yes, I think we can use it now,' ibid, p121

117 Over 10,000,000, Nolan Porterfield, *Jimmie Rodgers: The Life and Times of America's Blue Yodler*, The University Press of Mississipi, 2007, p383

118 'could not keep time, read a note, play the "right" chords...,' ibid, p5

118 'No genius...,' Carrie Rodgers, *My Husband Jimmie Rodgers*, Country Music Foundation Press, 1975, p75

118 'touching the hearts of ...lifting them up,' ibid, introduction, p xix

118 'indelicate,' ibid, p144

119 'lungers,' Barry Mazor, *Meeting Jimmie Rodgers*, Oxford University Press, 2009, p112

119 'here in America there have been many who appreciated...,' Paul Robeson, *Here I Stand*, Othello Associates, 1958, p50

119 Leadbelly's favourite inappropriate material, Barry Mazor, *Meeting Jimmie Rodgers*, Oxford University Press, 2009, p53

119 'The country singer Jimmie Rodgers – me and Robert...,' ibid, p51

119 '*My* man that I dug, that I really *dug*...,' Barry Mazor, *Meeting Jimmie Rodgers*, Oxford University Press, 2009, p48

119 'Mississippians, black and white...,' ibid, p47

12 – The Murder Ballad

122 'Horrible,' 'Dreadful,' 'Full Particulars,' Charles Hindley, *The History of the Catnach Press, at Berwick on Tweed, Alnwick and Newcastle-Upon-Tyne in Northumberland, and Seven Dials, London*, 1886, px

122 'practical tolerance,' Charles Knight, *London Vol III*, 1842, p265-266

123 'Seven Dials! the region of song and poetry – first effusions, and last dying speeches.' Charles Dickens, *Seven Dials, Sketches by Boz*, 1837, Chapter 5

123 'Worn its dirt with a difference,' Charles Knight, *London Vol III*, p264

123 'Leo X of street publishers,' Charles Hindley, *The History of the Catnach Press, at Berwick on Tweed, Alnwick and Newcastle-Upon-Tyne in Northumberland, and Seven Dials, London*, 1886, p221

123 lampooning false reports, p76, ibid

123 'execrable tea-paper, blotched' Charles Knight, *London Vol III*, p264

123 'Catnach, King of the Picts...,' Charles Hindley, *The History of the Catnach Press, at Berwick on Tweed, Alnwick and Newcastle-Upon-Tyne in Northumberland, and Seven Dials, London*, 1886, p296

124 singers in country pubs, G. Malcolm Laws, Jr, *American Balladry from British Broadsides*, The American Folklore Society, 1957, p43

124 'Seven Bards of Seven Dials,' Charles Hindley, *The History of the Catnach Press, at Berwick on Tweed, Alnwick and Newcastle-Upon-Tyne in Northumberland, and Seven Dials, London*, 1886, pxii,

124 'three yards a penny,' ibid, p221

124 'who sings the songs through every city, town, village or hamlet,' Charles Hindley, *The life and times of James Catnach, Late of Seven Dials*, Cambridge University Press, 1878, p390

124 'Time was when this was a thriving trade...,' ibid, p390

125 'The Scarborough Tragedy,' Charles Hindley, *The History of the Catnach Press, at Berwick on Tweed, Alnwick and Newcastle-Upon-Tyne in Northumberland, and Seven Dials, London*, 1886, p265

125 'Execution of James Ward,' ibid, p273

126 jobbing hacks, G. Malcolm Laws, Jr, *American Balladry from British Broadsides*, The American Folklore Society, 1957, p33

126 The basic ballad formula, ibid, p32

126 Pepys collection of broadsides: https://magdlibs.com/2015/01/14/pepys-broadside-ballads/

126 British broadsides distributed throughout America, G. Malcolm Laws, Jr,

American Balladry from British Broadsides, The American Folklore Society, 1957, p66

127 'move into the heart of the action immediately,' Moore, AF, and Vacca, G (eds). *Legacies of Ewan MacColl: The Last Interview*. Ashgate, 2014, p47

128 'The Murder Ballad,' Jelly Roll Morton
https://www.youtube.com/watch?v=N8uBGte6eIM

13 – The Hillbilly Cat

131 'a melancholy country. Long, tracts of mountainous desert …' *Beauties of Beattie: Selected from the Writings of James Beattie*, Longman Hurst, Rees and Orme, 1809, p181

131 'horrors would often haunt their solitude, and a deeper gloom overshadow the imagination of even the hardiest native.' ibid, p183

131 'smooth and lofty hills covered with verdure,' ibid, p183

131 'terrible,' ibid, p183

132 'the patriarch of the Ohio County Monroes, Richard D Smith, *Can't You Hear Me Calling: The Life of Bill Monroe Father of Bluegrass*, Da Capo Press, 200, p5

132 'proud, hardworking, honest, and law-abiding,' ibid, p7

132 'in a high, clear voice,' ibid, p10

132 small home town of Rosine, ibid, p9-10

132 360-acre farm, ibid, p11 ibid

132 Bill's status in the family, ibid, p13

133 'he got a wonderful Scotch-Irish sound out of it':
https://www.youtube.com/watch?v=uYlwVL3RHfo

133 Mandolin cobbling around the house, Richard D Smith, *Can't You Hear Me Calling: The Life of Bill Monroe Father of Bluegrass*, Da Capo Press, 2001, p19-20

133 Shultz, ibid, p23-24

133 only be described as hot, "Above all there was fire, speed and sheer drive," ibid, p55-56

133 "I wanted to have a music of my own..." 1 min 10 sec Interview
https://www.youtube.com/watch?v=W_loxtCMnEw

134 'knock the shit out of the color line,'
https://www.nashvillescene.com/music/article/13063664/peter-guralnick-discusses-sam-phillips-views-on-race-and-music

134 'picking four rows at a time, at 110 degrees,' Peter Guralnick, *Sam Phillips: The Man Who Invented Rock 'n' Roll*, Weidenfeld and Nicholson, 2015, p6

134 'invincible determination,' ibid, p12

134 'Battercake trees and a molasses river,' ibid, p12

135 'Samuel, you're going to grow up and be a great man someday,' ibid, p13

135 'a belief in things that are unknown to you.' ibid, p13

135 'became the lodestar for his life…,' ibid, p xiv

135 Lovelaces, ibid, p7-8

135 Love me tender, ibid, p5

135 Jimmie Rodgers, ibid, p8-9

136 William Presley, 'Elvis Presley's Irish roots proven by legal document,' Michael Parsons, *The Irish Times*, 22nd April 2016

136 'She was a sharecropper...' Elaine Dundy, *Elvis and Gladys*, University Press of Mississippi, 2004, p60

137 Norman Mansells, ibid, p13

137 Kelso around 1180, George F. Black, *Surnames of Scotland; Their Origin, Meaning and History*, The New York Public Library, 1946, p580

137 William Mansell and Morning Dove, Elaine Dundy, *Elvis and Gladys*, University Press of Mississippi, 2004, p13-16

138 'Alabama fever,' ibid, p17

138 'twelve thousand travellers within a single day.' ibid, p17

138 the Mansells settled down in Marion County, ibid, p19

138 elder son John, Elvis' great, great grandfather, ibid, p20

138 John's third son White Mansell moved away to Saltillo, ibid, p21-24

138 Third daughter of White Mansell, Lucy, ibid, p24

138 Reduced to sharecropping, ibid, p24 ibid

138 The Husseys, ibid, p24

139 'Do-Si-Do' or 'Weaving the Basket,' ibid, p24

139 'Doll' and Robert p25, ibid

140 four hundred illegal operations, Charles Maclean *Scotch Whisky: A Liquid History*, Cassell, 2005, p54

140 fever cure, Michael McGowan, *The Hard Road to Klondike*, The Collins Press, 2014, p9

140 'there wasn't a rivulet or a stream in place that hadn't a still-house beside it,' ibid, p6

140 Grandpa Bob was particularly good at brewing it. Elaine Dundy, *Elvis and Gladys*, University Press of Mississippi, 2004, p33

140 Billie, An Etymological Dictionary of the Scottish Language: Illustrating ..., Volume 1, By John Jamieson

140 'In short, a Hill-Billie is a free...,' *New York Journal*, April 23, 1900 taken from *Billboard*, 'Billboard Backstage,' 5th December 1953

141 'that same "Hill Billie" will divide...,' 'In the Mountain Oil Lands' *Buffalo Courier*, 5th May 1901

141 'The worst crime in the code, 'The Code of the Hill Billie,' *Kansas City Star*, 2nd November 1913

141 'they were like a mule train...,' Elaine Dundy, *Elvis and Gladys*, University Press of Mississippi, 2004, p37

141 'each time with the hope...,' ibid, p34

141 Habitually the entire extended family would up sticks, ibid, p35,

141 First home, ibid, p61-62

142 'That's about all there was to do...,' ibid, p62

142 The story of Vernon's cheque debacle:

https://www.youtube.com/watch?v=rjTrpjw9-dQ

142 Three years in Parchment, ibid, p78

142 Prison conditions ibid, p82

142 First Assembly of God Church, ibid, p81

142 'every time the door was open," ibid, p81

143 'puts your mind to rest. At least it does mine, since I was two,' ibid, p82

143 'splendid young man' https://www.youtube.com/watch?v=rjTrpjw9-dQ

143 Pascagoula, Elaine Dundy, *Elvis and Gladys*, University Press of Mississippi, 2004, p86

143 Another bad deal with Bean, ibid, p108

143 Mulberry Alley, ibid, p119

143 Gladys Mid South Laundry, ibid, p127

143 25% black population, ibid, p130

143 on good weather weekends a tent, Peter Guralnick, *Last Train to Memphis: The Rise of Elvis Presley*, Abacus, 1995, p27

143 'the sharp flashes of emotion,' ibid, p27

143 'without anything holding them back,' ibid, p27-28

144 'You only had to walk up the street and the street was *rocking*.' ibid, p28

144 WELO, Elaine Dundy, *Elvis and Gladys*, University Press of Mississippi, 2004, p94

144 'tall, slender, long-nosed, red-faced, beady eyed,' ibid, p94

144 Old Shep, ibid, p95

144 'sad, shy, not especially attractive...,' ibid, p120

144 singing gospel at school, Peter Guralnick, *Last Train to Memphis: The Rise of Elvis Presley*, Abacus, 1995, p26

145 'He was so *good*...,' Elaine Dundy, *Elvis and Gladys*, University Press of Mississippi, 2004, p122

145 cut guitar strings, ibid, p124

145 Trashy and hillbilly, Peter Guralnick, *Last Train to Memphis: The Rise of Elvis Presley*, Abacus, 1995, p26

145 'The nicest thing I can say about him was that he was a loner,' Elaine Dundy, *Elvis and Gladys*, University Press of Mississippi, 2004, p123

145 'He was that type – forgettable.' ibid, p123

145 'Then, as now, if you weren't *in* the clique, you were out...' ibid, p123-124

145 'did the slower tunes...,' Elaine Dundy, *Elvis and Gladys*, University Press of Mississippi, 2004, p124

145 'so that the kids from the other classes would not hear him,' ibid, p124

145 'surprised but not shocked...,' Peter Guralnick, *Last Train to Memphis: The Rise of Elvis Presley*, Abacus, 1995, p28

145 'We were broke, man, broke...,' ibid, p28

146 Poplar Avenue, Elaine Dundy, *Elvis and Gladys*, University Press of Mississippi, 2004, p134

146 Humes High, ibid, p135

146 Elvis' night time ritual in Lauderdale court, Stanley Booth, *Rhythm Oil: A Journey Through the Music of the American South*, Da Capo Press, 2000, p 49

146 Plantation Inn, interview with Jim Dickinson
https://www.youtube.com/watch?v=S3EOffeZ9s8&t=113s

146 'the white kid who lived in the projects,' Dave Thompson, *Bayou Underground*, ECW Press, 2010, p22

146 'He looked so striking, standing there in whatever…,' ibid, p24

146 Versatility of the Newborn band, ibid, p23

147 'Battle of the Guitars,' ibid, p24

147 'studying my moves…,' ibid, p24

147 'usually, he just hung around the back, as unobtrusive as a white boy…,' p25, ibid

147 barefoot Elvis, Stanley Booth, *Rhythm Oil: A Journey Through the Music of the American South*, Da Capo Press, 2000, p202

147 'he roared out the opening line to a song,' Dave Thompson, *Bayou Underground*, ECW Press, 2010, p25 (There seems to be a discrepancy in dates for when this happened. When talking to Stanley Booth in Rhythm Oil, Calvin recalls it happening late in 1952)

147 'the audience went wild…,' Stanley Booth, *Rhythm Oil: A Journey Through the Music of the American South*, Da Capo Press, 2000, p202

147 Various jobs of the Presleys, Elaine Dundy, *Elvis and Gladys*, University Press of Mississippi, 2004, p137

148 'He knew that he was powerful only…,' ibid, p125

148 'to French Norman blood was added Scots-Irish blood…,' ibid, p26

148 'rousing preaching and a lot of rousing singing,' ibid, p24

148 pride in their old traditions, ibid, p121

14 – The Circle of British Pop

149 'meter and subject' 'don't-do-what-I-have-done,' Ted Anthony, *Chasing the Rising Sun*, Simon and Schuster, 2007, p25

150 Lomax in Britain, E. David Gregory, 'Lomax in London: Alan Lomax, the BBC and the Folk Song Revival in England, 1950-1958,' Folk Song Journal, Vol. 8, No. 2, p137-139

150 'there weren't no wireless…,' Ted Anthony, *Chasing the Rising Sun*, Simon and Schuster, 2007, p25

151 Dirty ditty, ibid, p25 ibid

151 Matty Groves, ibid, p25

151 Medicine shows and temperance movement, Ann Anderson, *Snake Oil, Hustlers and Hambones*, MacFarland, 2015, p91-94

152 Clarence Ashley, Ted Anthony, *Chasing the Rising Sun*, Simon and Schuster, 2007, p27

152 The Village, ibid, p27

152 Carolina Tar Heels and Blue Ridge Mountain Entertainers, ibid, p28

153 'two little country boys barefoot and in overalls,' 'sing-in,' ibid, p44-46

153 'walking, talking connection between the hills and the highway,' ibid, p46

154 hunting the hidden songs of the miner and mountaineer, ibid, p51
154 'farmers and housewives,' ibid, p51-52
154 Noetown and the Turners, ibid, p53-54
154 'unique,' ibid, p54
154 'high pitched and chirpy voice,' ibid, p54
155 Bert Martin, ibid, p57-58
155 hybrid version, ibid, p68-69
155 'The Rising Sun Blues,' ibid, p70
155 Sing Out! ibid, p89
155 Josh White, ibid, p82
155 Hearing Dylan's version, ibid, p145
155 Eric Burdon on discovering House of the Risin' Sun
 https://www.youtube.com/watch?v=N8bKL4nO9xE
156 It belongs to the world, Ted Anthony, *Chasing the Rising Sun*, Simon and
 Schuster, 2007, p155

15 – A Sound from Deep Within

157 Ricky Skaggs, Michael C. Scoggins *The Scotch Irish Influence on Country
 Music in the Carolinas*, The History Press, 2003, p118
157 'the Irish tunes had a happy lilt…' Nuala O'Connor, *Bringing It All Back
 Home: The Influence of Irish Music*, BBC Books, 1991, p20
157 hiraeth, Val Bethell, March 2003, BBC Wales Arts
157 https://innerwoven.me/tag/hiraeth/
158 Paul McCartney's paternal family tree:
 https://gw.geneanet.org/tdowling?lang=en&pz=timothy+michael&nz=dowli
 ng&p=robert&n=macintosh
158 Paul, third generation by his grandfather Owen Mohin born in Monoghan
 around 1879
158 George Harrison heritage, Mark Lewishon, *Tune in: The Beatles: All These
 Years*, Little, Brown, 2013, (possibly in County Wexford, as grandfather John
 French's sister, Elizabeth is down as born in County Wexford), p22
158 Ringo heritage, ibid, p25
158 Davies brothers' heritage, Johnny Rogan *Ray Davies, A Complicated Life*,
 Random House, 2015, p9
158 Jimmy Page, Martin Power, *No Quarter: The Three Lives of Jimmy Page*,
 Omnibus Press, 2016. Note: Old school friend, David Williams describes
 Jim's mother Patricia in the *Time We Met the Blues*, 'a petite, dark haired
 women with a strong personality, a glint in her eye and a wicked sense of
 humour' and 'the driving force behind his musical progression.'
158 'a quiet young man…,' Nuala McAllister Hart, *Josef Locke, The People's
 Tenor*, p118
159 'technically half Irish,' 'Arthur's Day: Ed Sheeran Interview,' W.J. London,
 21st September 2011

159 'childhood summers and birthdays and Christmases listening to trad music bands.' 'Is Ed Sheeran Irish? Singer's roots revealed as he prepares for Dublin concerts,' David Coleman, 5th May 2018

159 'I started thinking about the kind of music…,' 7 mins 35, *Desert Island Discs*, Friday, 23rd March 2018

159 'she had a strong Irish heritage and all the people that we grew up…' Father and son Neil and Liam talk family jamming, *Independent* 5th January 2019,

160 'I don't consider myself to be English at all,' 'The Unstoppable Noel Gallagher,' Richard Purden, 3rd March 2015

160 'transparent, a nothing,' Paul Gallagher & Terry Christian, *Brothers from Childhood to Oasis: The Real Story*, Virgin Books, 1996, p208

161 'tiny hands,' George Webb Obituary, *Telegraph*, 14th March 2010

162 'a very, very fine violinist…,' Patrick Humphries, *Lonnie Donegan: And the Birth of British Rock & Roll*, The Robson Press, 2012, p14

162 'No one's going to pay a classical violinist…,' ibid, p13

162 Caught double pneumonia, ibid, p16

162 unstable childhood, ibid, ibid, p17-21

163 *Sea Porpoise*, Ed Cray, *Ramblin' Man: The Life and Times of Woody Guthrie*, W.W. Norton, 2004, p281

163 'inspiring dome of St Paul…' Jim Longhi, *Woody, Cisco and Me*, University of Illinois Press, 1997, p266

163 'gave off a happy hum…' ibid, p264
According to BBC Archives: A recording made in New York on 11th April 1944 'Evelyn GIBBS interviews Singer Woody GUTHRIE, on leave from the US Merchant Navy, recorded by the BBC in New York for Children's Hour. Guthrie talks briefly about his itinerant lifestyle and performs his own and traditional American ballads, accompanying himself on the guitar.'

163 London tour and BBC visit, Jim Longhi, *Woody, Cisco and Me*, University of Illinois Press, 1997, p265-266

163 'sound like they are singing even when they are talking,' Patrick Humphries, *Lonnie Donegan: And the Birth of British Rock & Roll*, The Robson Press, 2012, p18

163 Sailed from Greenock, Jim Longhi, *Woody, Cisco and Me*, University of Illinois Press, 1997, p268

164 Tennessee, Texas, Ed Cray, *Ramblin' Man: The Life and Times of Woody Guthrie*, W.W. Norton, 2004, p5

164 Nora Guthrie, ibid, p5

164 'a tender heart,' ibid, p12

164 'Guthries did not complain,' ibid, p46

164 'she went deeper…,' ibid, p12

164 'tales of outlaws, demon lovers, border raids, and seafaring heroes,' ibid, p12

164 Nora Guthrie's comments on her father's Scots influences and song lyrics: 'Folk icons Scottish lyrics are tuned up,' *The Sunday Times*, 5th December 2004

164 'way over yonder in a minor key,' Ed Cray, *Ramblin' Man: The Life and*

Times of Woody Guthrie, W.W. Norton, 2004, p31

164 celebrated his first job as a clerk, Patrick Humphries, *Lonnie Donegan: And the Birth of British Rock & Roll*, The Robson Press, 2012, p27

165 'Pimps and prostitutes,' *Mirror* Perth 10th Jan 1953, book review of Jack Glicco's *Madness after Midnight*
*although a month later, the Grafton Rooms in Liverpool revived the jitterbug with an 'American Dancing' night, in order to welcome the recently arrived G.I.s, and the Paramount Dance Hall on Tottenham Court Road followed suit in 1943

165-166 The Feldman story, 'The Feldman Swing Club,' *Jazz World*, April 1996

167 Club Eleven, http://henrybebop.co.uk/clubs.htm

167 'the Americans...took American with them,' Patrick Humphries, *Lonnie Donegan: And the Birth of British Rock & Roll*, The Robson Press, 2012, p46

168 a rather cushy job as a storekeeper, ibid, p47-48

168 'I heard things like gospel songs...I got a good schooling in country music,' ibid, p47

168 parlour social or just a good old party, Billy Bragg, *Roots, Radicals and Rockers: How Skiffle Changed the World*, Faber & Faber, 2017, p92

169 The Colyers were Londoners to the core, Pete Frame, *The Restless Generation: How Rock Music Changed the Face of 1950s Britain*, Rogan House, 2007, p2

169 Fifty imported American 78s purchased over many years from Levy's in Whitechapel, Pete Frame, *The Restless Generation: How Rock Music Changed the Face of 1950s Britain*, p3

169 'now don't be angry, but Ken's been playing your records...' ibid, p6

169 'chiefly for our own amusement,' ibid, p2

169 'an assault on the ears,' 'Jazz Echoes of the Past' by Benny Green, *Observer*, 18th Jan 1959

170 'getting jazz established,' Chris Barber and Alyn Shipton, *Jazz Me Blues*, Equinox Publishing, 2014, p19
Review of George Lewis's New Orleans Band, Odeon Tottenham Court Road, 18 Jan 1959, 'experience stretches back into the semi-mythology of street parades, band contests and the Storyville red-light district,' 'Jazz Echoes of the Past' by Benny Green, *Observer*, 18th Jan 1959

170 ideological differences, Chris Barber and Alyn Shipton, *Jazz Me Blues*, Equinox Publishing, 2014, p19

170 thrown in jail for thirty-eight days, p25, ibid

170 'went hand in hand. The only real difference between blues and New Orleans jazz...,' ibid, p27

170 the boys had been referring to their 'breakdown' set as 'skiffle' for a while, ibid, p27,

170 BBC World Service session, Billy Bragg, *Roots, Radicals and Rockers: How Skiffle Changed the World*, Faber & Faber, 2017, p92

170 'a strict disciplinarian,' Patrick Humphries, *Lonnie Donegan: And the Birth of British Rock & Roll*, The Robson Press, 2012, p85

170 'a dedicated cheeky chappie....,' Chris Barber and Alyn Shipton, *Jazz Me Blues*, Equinox Publishing, 2014, p30

170 'It was a tragedy that the band was so short lived...' ibid, p29-30

171 'I think we lost a lot of time arguing....,' Patrick Humphries, *Lonnie Donegan: And the Birth of British Rock & Roll*, The Robson Press, 2012, p86

171 West Country clarinetist Bernard Bilk, Patrick Humphries, *Lonnie Donegan: And the Birth of British Rock & Roll*, The Robson Press, 2012, p85

171 Hugh Mendl, Billy Bragg, *Roots, Radicals and Rockers: How Skiffle Changed the World*, Faber & Faber, 2017, p106

171 Decca's recording studio in West Hampstead, (Broadhurst Gardens), ibid, p106

171 'Everyone suggested things, and we did what everybody liked...,' Patrick Humphries, *Lonnie Donegan: And the Birth of British Rock & Roll*, The Robson Press, 2012, p99

171 'Stevedore Stomp' to the Tyneside folk song 'Bobby Shaftoe,' p108 *Roots, Radicals and Rockers*, Billy Bragg

172 'was an integral part of the repertoire,' Patrick Humphries, *Lonnie Donegan: And the Birth of British Rock & Roll*, The Robson Press, 2012, p102-103

172 Beryl drafted in, trio recording Rock Island Line, Patrick Humphries, *Lonnie Donegan: And the Birth of British Rock & Roll*, The Robson Press, 2012, p100

172 Bray had already taken off, Mendl (Decca Boss) ibid, p104

172 *New Orleans Joys* was released at the beginning of 1955, Patrick Humphries, *Lonnie Donegan: And the Birth of British Rock & Roll*, The Robson Press, 2012, p126

172 Charts filled with country ballads and folk songs, Billy Bragg, *Roots, Radicals and Rockers: How Skiffle Changed the World*, Faber & Faber, 2017, p150

173 ''rock' suddenly had currency with teenagers,' ibid, p155

173 Decca needing hillbilly artists (released Friday 11th November 1955) ibid, p151-153

173 Donegan's American folk recordings, Billy Bragg, *Roots, Radicals and Rockers: How Skiffle Changed the World*, Faber & Faber, 2017, p136

173 'The style has not produced any worthwhile talent. There is no originality.' Pete Frame, *The Restless Generation: How Rock Music Changed the Face of 1950s Britain*, p2

174 Fun, https://www.youtube.com/watch?v=A9Qbf-WqyHc

16 – Squalid Liverpool

175 'The Irish have a notion that any part of the world...,' Donald M. MacRaild, *The Irish Diaspora in Britain, 1750-1939*, Palgrave MacMillan, 2011, p193 (originally from State of the Irish Poor p.v)

175 Whitty biography, 'Michael James Whitty, (1798-1873),' *The Past: The*

Organ of the Ui Cinsealaigh Historical Society, No. 10 (1973-74), p45

175 By ratio of population, Ireland has sent more immigrants; eight million since start of 1700s; five million between 1800-1870, Donald M. MacRaild, *The Irish Diaspora in Britain, 1750-1939*, Palgrave MacMillan, 2011, p6

175 between 1845-49 and the bleak years immediately after over two million people left Ireland, ibid, p7

176 'no Irish family was untouched by it,' ibid, p7

176 'a trifling expense,' John Belcham, *Irish, Catholic and Scouse: The History of the Liverpool Irish, 1800-1939*, Liverpool University Press, 2007, p57

176 'drowned with tears and dried with kisses,' 'foot-slog,' Michael McGowan, *The Hard Road to Klondike*, The Collins Press, 2014, p49

176 'Emigrants of hope,' 'emigrants of despair,' Donald M. MacRaild, *The Irish Diaspora in Britain, 1750-1939*, Palgrave MacMillan, 2011, p192

176 1861, historic peak, https://www.ourmigrationstory.org.uk/oms/the-irish-in-early-industrial-britain-diversity-and-differing-opinions

176 Denser numbers, any other city in the western world, *Squalid Liverpool*, reprinted from the *Liverpool Daily Post*, p3

176 James Lennon, Mark Lewisohn, *Tune in: The Beatles: All These Years*, Crown Publishing Group, 2017, p15

177 James MacCartney, ibid, p19

177 'Here resides a population...' 'Squalid Liverpool,' reprinted from the *Liverpool Daily Post*,

177 'deep fringe of suffering,' ibid, p22

177 'prosperous, money-making Liverpool...,' ibid, p22

177 'Inside The Houses,' ibid, p5

178 'stench, squalor and sickness,' ibid, p40

178 'solid array of public-houses...,' ibid, p12

178 'It is inhabited by the very lowest and worst population in the whole city. Disorder is perpetual...' ibid, p9

178 'something pleasant in life to remember...,' ibid, p12

178 'for years upon years evils have been permitted which a little faithful effort would have removed. The misery is obvious, and its causes are plain, and have been plain for a quarter of a century' ibid, p21

179 'The women...,' ibid, p13-14

179 The Old Fort Tavern, Herman Melville, *Redburn*, (1849) Penguin Classics, 1976, p217-219

179 'more Welsh than any Welsh town except Cardiff...,' J. Belchem and D. M. MacRaild, 'Cosmopolitan Liverpool,' in J. Belchem (ed.), *Liverpool 800: Culture, Character and History* (Liverpool, Liverpool University Press, 2006), p. 315.
https://www.electricscotland.com/History/england/england01.pdf

179 The Glasgow shipbuilder William Laird had spearheaded, ibid, p 105

179 A line of Scots engineers, ibid, p105 (Alexander Elder and John Dempster from Glasgow and Dumfriesshire respectively, established the Elder Dempster Line; William MacAndrew from Elgin set up the MacAndrew

Line; and Charles MacIver from the Hebrides helped establish Cunard's "ten miles of docks," ibid, p106

180 10% of population, http://news.bbc.co.uk/1/hi/wales/3482625.stm

180 Welsh settled in Dingle, Everton and Wavertree, https://ymliverpool.com/welsh-connection-liverpool/31513
Looking back to ancient Britain, where Liverpool now sits was once part of the kingdoms of Hen Ogledd (the Old North), and its inhabitants were seen as kinsmen to the northern Welsh.

180 'sailor ballad-singers, who, after singing their verses…,' Herman Melville, *Redburn*, (1849) Penguin Classics, 1976, p264-265

180 'present a most singular spectacle…,' ibid, p263

181 laugh-today-for-tomorrow-we-die, Paul du Noyer, *Wondrous Place: From the Cavern to the Capital of Culture*, Virgin Books, 2004, p2

181 'British people used to sing everywhere…,' ibid, p3

181 'one of life's necessities,' ibid, p55

181 'Deep in the heart of the place a…,' ibid, p4

181 'an old man comes in with a fiddle,' John Burrowes, *Irish: The Remarkable Saga of a Nation and a City*, Mainstream Publishing, 2003, p275

181-182 McCartney musical background, Mark Lewisohn *Tune in: The Beatles: All These Years*, Crown Publishing Group, 2017, p19-20

182 'lie on the carpet and listen to him playing things like 'Stairway to Paradise'…,' Paul du Noyer, *Wondrous Place: From the Cavern to the Capital of Culture*, Virgin Books, 2004, pix

182 Number of country and western bands almost outdid Nashville, ibid, p58

182 'Before rock n roll…everyone used to play country and western…,' ibid, p58

182 'jobless, penniless and drinking and singing their lives away…,' Mark Lewisohn *Tune in: The Beatles: All These Years*, Crown Publishing Group, 2017, p23

182 Dingle background, tinsmiths and boilermakers, ibid, p23-24

182 Ringo's Starkey grandparents Johnny and Annie, ibid, p44

183 'the most significant musical force in my life,' ibid, p44

183 'America and Americana, of country music, and of maudlin or melodic songs that tell the story of love lost and found,' ibid, p44

183 Of one day, going to America, P44 ibid

183 the cowboy gear, the hats and boots, p44 ibid

183 Steward with the Starline, p44 ibid

183 Every note was a not to be counted, Dylan, https://www.youtube.com/watch?v=4z5fNg7nQ3s

183 'over-looked facet of the Beatles' style…,' Paul du Noyer, *Wondrous Place: From the Cavern to the Capital of Culture*, Virgin Books, 2004, p59 (the first Country and Western band was in 1953, Dusty Road Ramblers, p58)

183 An early ritual for John was going to a friend's house to listen to the juke joint sound of Hank Williams' records, Mark Lewisohn *Tune in: The Beatles: All These Years*, Crown Publishing Group, 2017, p 78

183 'I heard country and western before I heard rock n roll…,' Paul du Noyer,

Wondrous Place: From the Cavern to the Capital of Culture, Virgin Books, 2004, p59

184 'an intelligent, happy-go-lucky soul who sang loud and often in ale-houses,' 'mysteries, dead-ends and deceptions,' Mark Lewisohn *Tune in: The Beatles: All These Years*, Crown Publishing Group, 2017, p15-16

184 'Jack' Lennon, Philip Norman, *John Lennon: the Life*, Harper, 2009, p4-5

184 'show off spirit,' 'recite ballads, tell jokes and do impressions,' ibid, p5

184 'with sentimental tears streaming down their faces,' ibid, p5

184 'the least Irish, and so the most English, suburb of Liverpool,' Mark Lewisohn *Tune in: The Beatles: All These Years*, Crown Publishing Group, 2017, p37

185 inherited weapons on the world's stage, ibid, p38

185 Earning a harmonica, ibid, p43

185 voice like Vera Lynn, doing impressions, Philip Norman, *John Lennon: the Life*, Harper, 2009, p42

185 'craving for glamour' 'an urge to entertain,' ibid, p8

185 bunking off school, Mark Lewisohn *Tune in: The Beatles: All These Years*, Crown Publishing Group, 2017, p79

185 Julia as a muse, Ian MacDonald, *Revolution in the Head: The Beatles' Records and the Sixties*, Vintage, 2008, p327; Mark Lewisohn *Tune in: The Beatles: All These Years*, Crown Publishing Group, 2017, p43 & p79

17 – Celtic Verve meets English Particularity

187 the number of single women, Donald M. MacRaild, *The Irish Diaspora in Britain, 1750-1939*, Palgrave MacMillan, 2011, p8-9

187 Teaching assistants and cooks, ibid, p145

187 The job market opened up further, ibid, p6-7
Examples of the female embodiment of Ireland: the name Kathleen Ni Houlihan is a character used in narratives to represent Ireland's nationalism; *The Sean-Bhean bhocht*, is a folk song from the time of the 1798 rebellion, an ode to Ireland, the Poor Old Woman; and one of Ireland's oldest political songs, *Roisin Dubh*, which translates into *The Black Rose*, is the emblem for the chieftains bitter battles with the English in the late 16th century.

188 Ireland's virtue corrupted by Englishness, Louise Ryan Gender, *Identity and the Irish Press, 1922-37: Embodying the Nation*, 2002, Edwin Mellen Press, p4

188 'Purity is strength, and purity and faith go together,' the statement issued by the Hierarchy in 1925 at their October meeting in St. Patrick's College, Maynooth. Statement:
https://lxoa.wordpress.com/2012/02/16/irish-hierarchys-statement-on-dancing-1925/

188 'to go across' – Donall MacAmhlaigh, *An Irish Navvy, The Diary of an Exile*, The Collins Press, 2013, p1

188 'It's the Irish way to go into labouring.' John Lydon, *Rotten: No Irish, No Blacks, No Dogs*, 2003, Plexus, p10-11

188 'you got your plane ticket...' 'Older Legacy Fades by Popular Demand,' Joseph O'Connor, *The Irish Times*, 4th April 2014

189 Irish born migration statistics from https://thewildgeese.irish/profiles/blogs/irish-in-britain-census-statistics

2019 figures, 'Britain's shrinking, ageing Irish population' Ciara Kenny, *The Irish Times*, 9th March 2019

189 A quarter of the British population have an ancestral connection to Ireland: http://news.bbc.co.uk/1/hi/uk/1224611.stm although the London statistic is incorrect. For a more nuanced picture of Irish ancestry in Britain: https://blogs.ancestry.co.uk/ancestry/2015/03/16/what-does-our-dna-tell-us-about-being-irish/

190 'our goddess Frigg...,' Fred Vermorel, *The Secret History of Kate Bush*, Music Sales Ltd., 1983, p63

190 mathematician turned medic, ibid, John Carder Bush, *Kate: Inside the Rainbow*, Sphere, 2015, p12

190 East Wickham Farm: https://historicengland.org.uk/listing/the-list-list-entry/1359400

190 grounds all enclosed, castle-like, Rob Jovanovic, *Kate Bush, The Biography*, Portrait, 2005, p12-13

190 an old church harmonium, ibid, p11

190 'dirty sea shanties,' ibid, p16

191 'Anglo Irish mishmash of influences...,' John Carder Bush, *Kate: Inside the Rainbow*, Sphere, 2015, p13

191 'excess of emotion,' Rob Jovanovic, *Kate Bush, The Biography*, Portrait, 2005, p20

191 'my family are totally integral to everything I do,' ibid, p21

191 'there would be pounding of the fiddle and the accordion...,' John Carder Bush, *Kate: Inside the Rainbow*, Sphere, 2015, p12

192 'a very cruel environment and I was a loner,' 'easy, happy-go-lucky girl,' 'think too much about everything,' Rob Jovanovic, *Kate Bush, The Biography*, Portrait, 2005 p15

192 'anything that moved her,' 'pets, friends, imaginary loves, elves, the strangeness of ordinary lives' John Carder Bush, *Kate: Inside the Rainbow*, Sphere, 2015, p13

192 I'm very proud of it...,' Rob Jovanovic, *Kate Bush, The Biography*, Portrait, 2005, p16

192 'For me, as a child, the Irish aspect...,' John Carder Bush, *Kate: Inside the Rainbow*, Sphere, 2015, p11

192 'I feel that strongly, being torn between...' Rob Jovanovic, *Kate Bush, The Biography*, Portrait, 2005, p13-14

193 'the pantheistic mystery of Irish folk music,' John Carder Bush, *Kate: Inside the Rainbow*, Sphere, 2015, p12

193 'catchy tunes of the Methodist hymns' ibid, p12

193 'Emily's,' Johnny Marr, *Set The Boy Free: The Autobiography*, Penguin Random House, 2016, p1-2

194 'From then on,' 'I can't remember a time when I didn't have a guitar,' ibid, p2

194 'Both those things together combined to bring out a certain thing...' 'Johnny Marr pays homage to his Irish roots,' RTE interview, 20th Feb, 2013

194 Marr family history, Johnny Marr, *Set The Boy Free: The Autobiography*, Penguin Random House, 2016, p4

194 'gas pipes in the road,' ibid, p6

194 'our own community and a shared...,' ibid, p8

194 'obsessed about singers and bands,' ibid, p9

194 'statues and crosses and prayers,' ibid, p5

194 'always had music going,' ibid, p9

194 'Walk Right Back,' ibid, p8-9

195 'soppy ballad with the sound of the BBC orchestra behind them,' ibid, p10

195 Aunt Betty, ibid, p13

195 'home place,' 'Johnny Marr pays homage to his Irish roots,' RTE Wed 20th Feb 2013

195 'What was great was that when I was growing up I had the best of both worlds...,' ibid

195 'It was very, very cool actually but I've always...,' ibid

195 'taking in the wildness,' Johnny Marr, *Set The Boy Free: The Autobiography*, Penguin Random House, 2016, p14

195 'like a demon,'

195 'evoke the same kind of feeling,' 'her way of singing tinged with sadness,' 'somewhere else,' ibid, p14-15

196 'other worldly' Sean Campbell, *Irish Blood, English Heart: Second Generation Irish Musicians in England*, Cork University Press, 2011, p129

196 'a really magical time for me because the music got really interesting,' ibid, p129

196 'yearning and a beautiful melancholy....' Johnny Marr, *Set The Boy Free: The Autobiography*, Penguin Random House, 2016, p14-15

196 'gothic intensity,' Sean Campbell, *Irish Blood, English Heart: Second Generation Irish Musicians in England*, Cork University Press, 2011, p129

196 'in those melodies I discovered a different side to life...,' Johnny Marr, *Set The Boy Free: The Autobiography*, Penguin Random House, 2016, p15 Marr

196 'that place that I had as a kid that's pretty fucking powerful...' Sean Campbell, *Irish Blood, English Heart: Second Generation Irish Musicians in England*, Cork University Press, 2011, p130

196 'sad Irish tunes,' 'morbid aspects of Irish migrant life,' ibid, p129

196 'Celtic aspect,' ibid, p130

196 'gothic waltzes,' ibid, p130

196 'almost quasi-religious really, dark, quite provincial,' ibid, p130

197 'as a sort of musical letter to my mother,' ibid, p130

197 The Smiths influence, Paul Gallagher & Terry Christian, *Brothers from*

Childhood to Oasis: The Real Story, Virgin Books, 1996, p106

197 against her own instincts, Paul Gallagher & Terry Christian, *Brothers from Childhood to Oasis: The Real Story*, Virgin Books, 1996, p5

197 in the building trade, ibid, p6 & p8

197 DJ-ing, ibid, p66, p70

197 'an old Irish bloke,' ibid, p67

197 His prized possessions were a guitar and an accordion…, ibid, p44

197 family escaped, ibid, p14

198 'like some junior junkie,' ibid, p45

198 'the familiarity, the music, the comforting routine,' ibid, p68

198 the life already mapped out for a young man…, ibid, p68

198 'were the sounds of oppression,' ibid, p68

"Live Forever' has the saddest chords…,' 'The Unstoppable Noel Gallagher,' Richard Purden, 3ʳᵈ March 2015

18 – The Land with Music

201 'some effete Euro-disco music,' John Lydon, *Rotten: No Irish, No Blacks, No Dogs*, 2003, Plexus, p10-11, p144

202 'making an impact,' Jonathan Aitken, *The Young Meteors*, The Murray Printing Company, 1967, p9

202 'that too many of the young generation are ambitious to *be* somebody…,' ibid, inside flap

203 Heine & Schmitz http://www.musicweb-international.com/dasland.htm

204 'sang a very great deal…' Albert Lloyd, *The Singing Englishman*, W.M.A., 1944, p21

204 'a Worcestershire priest was kept awake…,' ibid, p21

204 'democratic character of English music.' W.J. Turner, *English Music*, William Collins of London, 1947, p20

204 'freshness and directness of expression,' ibid, p20

205 'Lordlings, it is our host's command…,' Charles Hindley, *The History of the Catnach Press, at Berwick on Tweed, Alnwick and Newcastle-Upon-Tyne in Northumberland, and Seven Dials, London*, 1886, p249-250

205 'music mad,' W.J. Turner, *English Music*, William Collins of London, 1947, p18

205 'was the universal recreation of the people…,' ibid, p18

205 'the whole organism of folk song,' edited by Allan F. Moore and Giovanni Vacca, *Legacies of Ewan MacColl: The Last Interview* Ashgate, 2014, p15

205 'the common people felt…,' A.L.Lloyd, *The Singing Englishman*, WMA, 1944, p3-4

206 'the best of musicians in his "pay and service",' Jeffrey Pulver, 'Music in England during the Commonwealth,' Acta Musicologica, Vol. 6, Fasc. 4, 1934, p171

206 'they had 48 violins and much mirth with frolics…' ibid, p171

206 'a sure way into the Protector's good graces,' ibid, p 171 (Thomas Ford, a Stuart composer of romantic songs, 'Music of Sundry Kinds' 1607 includes, 'Since First I Saw Your Face')

206 'gloomy silence,' ibid, p180

206 its militant effect noticeably discouraged excellence, ibid, p180

206 elaborate choral and instrumental music in churches, ibid, p170

206 banning singing dancing and music making, ibid, p170

206 It never truly fully recovered, ibid, p180

206 A secular development, ibid, p181

207 Rather than to their own countrymen, W.J. Turner, *English Music*, William Collins of London, 1947, p30

208 'common people,' Cecil Sharp, *English Folk Song: Some Conclusions*, Simkin & Co. London, 1907, p3-4

209 'thoroughfares of London,' Henry Mayhew, *Of Street Piemen*, Penguin Classics, 2015, p17

209 Penny gaffes, ibid, p17-19

209 Who were the folk: http://eprints.bournemouth.ac.uk/18361/1/Somerset_Folkenabled_pdf_of_map.pdf

210 Founder member of the Folk Song Society in 1898, Journal of the English Folk Dance and Song Society, Vol 5, no. 3, Dec 1948, p114

210 'after breakfast, the singers came into the hall...' Kate Lee, 'Some Experiences of a Folk-Song Collector,' *Journal of Folk Song Society*, Vol 1, No. 1, 1899, p7

211 'If all these lovely tunes are being left...,' ibid, p12

19 – The Artists of Nowhere

213 By 1200 there were 7,500 cathedral status..., Nicholas Orme, Going to Church in Mediaeval England, Yale University Press, 2021, p1

213 exquisite paintings of agony and ecstasy were used to elicit a more visceral devotion, Lady Morgan, *The Life and Times of Salvador Rosa*, 1824, p2-3

214 York and Norwich had a healthy ecosystem, edited by Richard Marks and Paul Williamson, *Gothic*, V&A Publications, 2003, p97

214 'the total absence of first-rate English-born painters from the fifteenth...,' Nikolaus Pevsner, *The Englishness of English Art*, British Broadcasting Corporation, 1955, p3

214 'the English Tinteret,' Horace Walpole, *Anecdotes of Painting in England*, 1849, Thomas Kirgate, p351 https://archive.org/details/anecdotespainti02walpgoog/page/n14/mode/2up

215 eight hundred sacred buildings and artisans' workshops, Nick Groom, *Gothic: A Very Short Introduction*, Oxford University Press, 2012, p27

215 chalices were reduced to wine goblets, edited by Tabatha Barber and Stacy Boldrick, *Art Under Attack: Histories of British Iconoclasm*, Tate Publishing, 2013, p59

215 painted panels were overturned, ibid, p62

215 Westminster Abbey, ibid, p77

215 'the nation which was so far before its neighbours in science...,' Thomas Babington Macaulay, *History of England from the Succession of James II Vol 1*, J.M. Dent and Sons, 1848, p309

215 'At the close of the reign of Charles the second...,' ibid, p310

215 'low ebb,' Vic Gatrell, *The First Bohemians: Life and Art in London's Golden Age*, Penguin, 2013, p243

215 'warrs & parties Revolutions & Religion,' ibid, p242

216 'Gorgons and Muses, Nymphs and Satyrs,' Thomas Babington Macaulay, *History of England from the Succession of James II Vol 1*, J.M. Dent and Sons, 1848, p311

216 'one of the most expensive tables in England,' ibid, p311

216 'the influx of sunny Italians,' Vic Gatrell, *The First Bohemians: Life and Art in London's Golden Age*, Penguin, 2013, p99

217 'The best contribution we make....' Edited by Kerry McSweeny, *Depth and Diversity in Fiction: Selected Critical Writings of Angus Wilson*, Viking, 1984, p248

217 'The man of talent in France will be built up...,' ibid, p248

217 'There's No Such Thing as British Art,' Conversation piece coordinated by Richard Johns, British Art Studies

217 40% French playlist, 'Quotas killed the radio star: French DJs rebel against prescribed playlists,' Jon Henley, 30th September 2015

218 'It's somewhere they put you if they can't put you...,' Robert Greenfield, Rolling Stone Interview: Keith Richards, 19 August 1971

219 'to obliterate England's memory of who...' Eamon Duffy, *Saints, Sacrilege and Sedition*, Bloomsbury, 2012, p11

20 – Robeson Hands on the Torch

221 'coloured aliens,' https://www.muhistory.com/contact-us/1921-1930/

222 Russian trumpeter, Chris Barber and Alyn Shipton, *Jazz Me Blues*, Equinox Publishing, 2014, p51

222 Britain's doors were wide-open, ibid, p51; footnote: the legislation hailed back to the 1920s and was why so many American jazz musicians migrated to Paris rather London.

222 as a storyteller, Elijah Wald *Josh White: Society Blues*, Routledge, 2002, p136

222 'the Singing Christian,' ibid, p54; 'the Benefit kid,' ibid, p106; 'the Minstrel of the Blues,' ibid, p117

222 'Josh is a fine folk-singer of anybody's songs...,' ibid, p117

223 'walking tax,' ibid, p5

224 'beaten to a pulp,' ibid, p7

224 'barefoot boy with a tambourine,' ibid, p11

224 'the men sang gospel in their loud, rough voices,' ibid, p11

224 'Roaming the roads, never certain…,' ibid, p17

224 Roosevelt tour, ibid, p171-172

225 'On Monday night I saw the impossible happen!,' Dennis Preston Interviews Josh White, *Melody Maker*, 15th July 1950

225 'dressed in beautiful blue velvet,' Patrick Humphries, *Lonnie Donegan: And the Birth of British Rock & Roll*, The Robson Press, 2012, p53

225 'The atmosphere was informal, the recital spontaneous…,' Elijah Wald *Josh White: Society Blues*, Routledge, 2002, p176

226 'I have met so many wonderful people…,' ibid, p175

226 'the Moscow-line' or 'that proletarian hangout,' ibid, p147

226 Josephson broke liquor laws, ibid, p168

227 'clearance,' ibid, p184

227 'devoted American who had let himself be used,' 'phony, false faced, political rackets,' 'innocent impression,' 'profound love for our America,' ibid, p191

228 'a dream come true,' 'To us, he was just a singer,' ibid, p210

228 'We went out of our way…,' ibid, p213

228 'the first one I looked at with my eyes playing electric guitar,' Bob Riesman, Peter Guralnick, *I Feel So Good: The Life and Times of Big Bill*, University of Chicago Press, 2012, p 283

229 'artistry,' 'wholly unpretentious,' 'made Josh White seem slick and effete,' Roberta Freund Schwartz, *How Britain Got the Blues: The Transmission and Reception of American Blues Style in the United Kingdom*, Taylor & Francis, 2016, p40

229 'high urban veneer,' 'Spontaneity of the Small Group,' *Manchester Guardian*, 8th Oct 1958

229 'in a state of intense anticipation…,' George Melly, *Owning Up*, Penguin, 1965, p491-492

230 Stopped playing guitar on stage altogether, Robert Gordon, *Can't Be Satisfied: The Life and Times of Muddy Waters*, Back Bay Books, 2003, p147

230 'a big surprise,' ibid, p158

230 Eighteenth century estate in west Yorkshire, Chris Barber and Alyn Shipton, *Jazz Me Blues*, Equinox Publishing, 2014, p55

230 Brought him back to life, Robert Gordon, *Can't Be Satisfied: The Life and Times of Muddy Waters*, Back Bay Books, 2003, p157-163

Mahalia Jackson Albert Hall concert, *I Feel So Good: The Life and Times of Big Bill*, University of Chicago Press, 2012, p184

231 'His ballads of the cotton pickers…,' 'Big Bill Broonzy Arrives' *Manchester Guardian*, 23rd February 1957

231 Lipmann's father owned a restaurant, Mike Zwerin, *Swing Under the Nazis: Jazz as a Metaphor for Freedom*, Cooper Square Press, 2000, p22

231 'long hair,' 'dressed English style,' 'wide pants,' ibid, p56

231 Lipmann invited jazz musicians to jam in the back room, ibid, p55

231 'making propaganda with English and American jazz music' ibid, p87
231 Paddy McKiernan, George Melly, *Owning Up*, Penguin, 1965, p407,
232 The Manchester pilgrimage, David Williams, *The First Time We Met The Blues*, Music Mentor Books, 2009, p69-92
234 The Bernstein Brothers,
https://www.ianpercy.me.uk/docs/docbrocken/DRB4%20Blues%20Gospel%20Train%20(09-10).pdf
Ian Inglis, *Popular Music and Television in Britain*, Ashgate, 2010, p201
Blues and Gospel Train ticket, http://earlyblues.org/british-blues-articles-and-essays-blues-and-gospel-train/

21 – The Revolutionary Romantics

237 'You turn a dial and hear gospel….,' Elvis Presley: The Searcher, HBO 2018
238 The African roots of 'calling out,' Philip A. Jamison, 'Square Dance Calling: The African American Connection,' Journal of Appalachian Studies, Vol. 9, No. 2, 2003
238 Princess Margaret visit to Cecil Sharp House, Michael Brocken, *The British Folk Revival, 1944-2002*, Ashgate, 2003, p46
239 'Even today the English ballad still goes on developing…,' Dave Arthur, *Bert: The Life and Times of A.L. Lloyd*, Pluto Books, 2012, p60
239 Lloyd's family story, ibid, p6-8
240 Lloyd in the Outback, ibid, p13-17 (some of the sheepshearer songs he gathered ended up on his 1971 album *The Great Australian Legend*)
240 Lloyd's return to England, ibid, p37-39
240 'the bohemian of bohemians' ibid, p41
241 Foyles and life in Soho, ibid, p40-43
241 As did one of the frequenters of the Parton Street scene, the Cambridge poet John Cornford, who was just twenty-one when he joined the Republicans in the Spanish Civil War and was shot on the front-line near Lopera in Spain on the 27th December 1936.
241 'a most charming smile,' 'everything about any subject under the sun,' ibid, p41
241 Kett's Rebellion, A.L. Morton, *A Peoples History of England*, Lawrence and Wishart, 1938, p172-174
242 Eel's Foot, Dave Arthur, *Bert: The Life and Times of A.L. Lloyd*, Pluto Books, 2012, p103-105
242 'Voice of the Seaman,' ibid, p79
242 Life as a whaler, ibid, p81-89
242 'sang all the time…,' ibid, p89
243 Army life and *The Singing Englishman*, ibid, p126-134
243 'an idea of a new dimension in folk song,' ibid, p198
243 'we were all very conscious that 100 per cent of pop music is politics…,' ibid, p199

243 'due to loud singing of companions!,' ibid, p130

244 one balmy summer's night, or a freezing winter one…, Ben Harker, *Class Act: The Cultural and Political Life of Ewan MacColl*, Pluto Press, 2007, p207

244 Miller family story, Ben Harker, *Class Act: The Cultural and Political Life of Ewan MacColl*, Pluto Press, 2007, p5-6

244 'The communism of the clans must be established on a modern basis,' Peter Berresford Ellis, *A History of the Irish Working Class*, Pluto Press, 1985, p11

244 'little streets…,' Ben Harker, *Class Act: The Cultural and Political Life of Ewan MacColl*, Pluto Press, 2007, p6

245 'They sang their Scottish songs and talked endlessly of Scotland,' ibid, p7

245 'a powerful, tuneful voice,' ibid, p9

245 'thin and bent,' Joan Littlewood, *Joan's Book: The Autobiography of Joan Littlewood*, Methuen, 1994, p98

245 'a revolutionary romantic…who sobbed like a child when Lenin died,' Ben Harker, *Class Act: The Cultural and Political Life of Ewan MacColl*, Pluto Press, 2007

245 'the class enemy,' 'studied venom,' Joan Littlewood, *Joan's Book: The Autobiography of Joan Littlewood*, Methuen, 1994, p99

245 Workers' Arts Club, Ben Harker, *Class Act: The Cultural and Political Life of Ewan MacColl*, Pluto Press, 2007, p16-17

245 brisk, purposeful step, ibid, p10

246 'always singing and writing poems,' ibid, p12

246 Left school and joined the Young Communist League, ibid, p13-14

246 'more or less quite by accident,' edited by Allan F. Moore and Giovanni Vacca, *Legacies of Ewan MacColl: The Last Interview* Ashgate, 2014, p17

246 'the mocking little couplets,' ibid, p18

246 Red Megaphones, ibid, p18; https://wcml.org.uk/maccoll/maccoll/theatre/the-red-megaphones/

246 'A propertyless theatre for a propertyless class,' Joan Littlewood, *Joan's Book: The Autobiography of Joan Littlewood*, Methuen, 1994, p89

246 'Forward unemployed…,' Ben Harker, *Class Act: The Cultural and Political Life of Ewan MacColl*, Pluto Press, 2007, p28

247 'singing Hebridean songs to cinema queues,' Joan Littlewood, *Joan's Book: The Autobiography of Joan Littlewood*, Methuen, 1994, p98

247 'vigorously proletarian voice,' Ben Harker, *Class Act: The Cultural and Political Life of Ewan MacColl*, Pluto Press, 2007, p38

247 be they of Spanish or Czech influence, edited by Allan F. Moore and Giovanni Vacca, *Legacies of Ewan MacColl: The Last Interview* Ashgate, 2014, p22

247 'a dab hand at a topical lyric,' Joan Littlewood, *Joan's Book: The Autobiography of Joan Littlewood*, Methuen, 1994, p105

247 'waste of time,' ibid, p68

248 'an upper-class Bolshie,' ibid, p70

248 'the BBC crowd, journalists and artists,' ibid, p76

248 'a brown-haired, pale young man with freckles,' ibid, p87

248 Marriage for Moscow, Joan Littlewood, *Joan's Book: The Autobiography of Joan Littlewood*, Methuen, 1994, p102

248 to audiences who had previously only ever seen variety shows and pantomime, Joan Littlewood, *Joan's Book: The Autobiography of Joan Littlewood*, Methuen, 1994, p108

248 'Miracle at Verdun,' ibid, p104

248 They got off with a five guinea fine each and bound over for twelve months, Joan Littlewood, *Joan's Book: The Autobiography of Joan Littlewood*, Methuen, 1994, p114

248 'much greater intelligence than the ordinary solider,' 'cheerful and willing,' Ben Harker, *Class Act: The Cultural and Political Life of Ewan MacColl*, Pluto Press, 2007, p62

249 Army career, ibid, p103

249 Theatre Workshop, Joan Littlewood, *Joan's Book: The Autobiography of Joan Littlewood*, Methuen, 1994, p158

249 'substantial Texan with enormous appetites and vitality to match,' E. David Gregory, Lomax in London: Alan Lomax, the BBC and the Folk-Song Revival in England, 1950-1958, 2002, p136

249 'the coal towns of West Virginia...,' ibid, p142

249 'It was an education and an entertainment...,' ibid, p142

250 'extraordinarily powerful and muscular,' edited by Allan F. Moore and Giovanni Vacca, *Legacies of Ewan MacColl: The Last Interview* Ashgate, 2014, p27

250 Alan Lomax introduced Lloyd to MacColl, Ben Harker, *Class Act: The Cultural and Political Life of Ewan MacColl*, Pluto Press, 2007, p95

250 'moved on by a policeman,' Dave Arthur, *Bert: The Life and Times of A.L. Lloyd*, Pluto Books, 2012, p207

250 'We very are silent, so silent...,' Charles Masterman, *From the Abyss: of its inhabitants, by one of them*, R. Brimley Johnson, 1902, p24

251 'I have heard enough myself to be convinced...,' E. David Gregory, Lomax in London: Alan Lomax, the BBC and the Folk-Song Revival in England, 1950-1958, 2002, p158

251 'characterized by blended chorus singing with big, open voices,' ibid, p157

251 'These skifflers...believe they are playing American style...,' ibid, p158

22 – The Communist Coddling of Folksong...

253 reassurance from Sir Stafford, 'Allied Greetings to Russia,' British Pathe, 1942

253 Comintern funding, https://core.ac.uk/download/pdf/12825503.pdf p799

254 Cultural upsurge, Dave Arthur, *Bert: The Life and Times of A.L. Lloyd*, Pluto Books, 2012, p164

254 'the pleasures arising from our internal sense of harmony...,' Charles Avison, *An Essay on Musical Expression*, Royal Society, 1775, p2

254 'the diffusion of a taste for music...,' R. Nettel, 'What Happened to Folk Song,' *Music and Letters*, Vol. 26 No. 1, p28

254 'if a musical event is not helping Socialism...,' Emer Bailey, *The London Labour Choral Union, 1924-1940: A Musical Institution of the Left*, pxiv

255 WMA headquarters, Andy Croft, *The Years of Anger: The Life of Randall Swingler*, Routledge, 2020, , p64

255 'a centre where all amateur musical organisations...' A.L. Lloyd, *The Singing Englishman: An Introduction to English Folk Song*, W.M.A., 1951, p70

255 'To utilise fully the stimulating power of music...,' Michael Brocken, *The British Folk Revival*, Ashgate, 2003, p50
Popular Soviet Songs and Red Army songs, ibid, p52

255 'came out of social upheaval...,' A.L. Lloyd, *The Singing Englishman: An Introduction to English Folk Song*, W.M.A., 1951, p4

256 'Generally the English folksinger...,' ibid, p30-31

256 'direct political struggle,' ibid, p30

257 'Here is a big clean wind of a book...,' Waldemar Hille, *The People's Song Book*, Oak Publications, 1961, p3

257 'The majority of songs in this volume were chosen by plebiscite...,' Michael Brocken, *en*, Ashgate, 2003, p49

257 MacColl joins the Hootenannys; 'in demand,' Joan Littlewood, *Joan's Book: The Autobiography of Joan Littlewood*, Methuen, 1994, p434

258 'The blues ain't notin' but a good man feelin' down...,' E. David Gregory, *Lomax in London: Alan Lomax, the BBC and the Folk-Song Revival in England, 1950-1958*, 2002, p145

258 'that these songs would help English...,' Ewan MacColl, *Journeyman: An Autobiography*, Sidgwick and Jackson, 1990, p338

258 'we had become a whole generation who...,' Michael Brocken, *The British Folk Revival*, Ashgate, 2003, p34

259 Ballads and Blues Club repertoire, edited by Allan F. Moore and Giovanni Vacca, *Legacies of Ewan MacColl: The Last Interview* Ashgate, 2014, p158

259 'tradition,' 'realism' and 'fakeness,' Michael Brocken, *The British Folk Revival*, Ashgate, 2003, p35
American inflection, vocal syncopation and adding an instrument, ibid, p35

259 '"Come All Ye'!...,' Michael Brocken, *The British Folk Revival*, Ashgate, 2003, p36

259 'a bit like going in to a church...,' Mick Houghton, *I've Always Kept a Unicorn: The Biography of Sandy Denny*, Faber & Faber, 2015, p41

260 'at the behest of several singers...'
https://www.folkmusic.net/htmfiles/edtxt39.htm

260 'spiky,' Dave Arthur, *Bert: The Life and Times of A.L. Lloyd*, Pluto Books, 2012, p337

260 'Bert was on the end of the phone...,' ibid, ix

260 'by giving them a rock treatment or...' edited by Allan F. Moore and Giovanni Vacca, *Legacies of Ewan MacColl: The Last Interview* Ashgate, 2014, p120

262 'to the left of the Communist Party!' ibid, p43

262 'between 150 and 250 political songs,' ibid, p30

262 'nurses, ambulance drivers, road sweepers...,' ibid, p32

262 'a political songwriter's main thrust...,' p41

262 the time of MacColl making this statement: 23/6/87

263 dozens of arrests were made, 'Berlin Clash' *Aberdeen Evening Express*, Monday 8th June 1987

263 'The wall must come down...,' 'Off the Wall: Eurythmics start a riot' *Daily Mirror*, Tuesday 9th June 1987

264 'Why was the concert done at the wall?...' edited by Allan F. Moore and Giovanni Vacca, *Legacies of Ewan MacColl: The Last Interview* Ashgate, 2014, p42

23 - ...and the Beginning of Britain's Indie Labels

268 Topic early years, Michael Brocken, *The British Folk Revival*, Ashgate, 2003, p55-57

268 'arisen more or less spontaneously...,' Dave Arthur, *Bert: The Life and Times of A.L. Lloyd*, Pluto Books, 2012, p239

268 Bill Leader, ibid, p257

269 'If the men don't sing right, the ship don't move right,' Cover notes, 'The Blackball Line,' Topic Records, 1957

269 Barely breaking even, Michael Brocken, *The British Folk Revival*, Ashgate, 2003, p59

269 Competition from other labels, ibid, p62

270 The Iron Muse, ibid, p64-65

270 Bert and The Watersons, Dave Arthur, *Bert: The Life and Times of A.L. Lloyd*, Pluto Books, 2012, p239

270 The Spinners 'a hundred serious folk bands,' 'Folk-Song' Victor Anant, *Guardian*, 19th Feb 1963

270 'polished group of amateurs,' 'Folk-song Without Folk,' Peter Eckersley, *Guardian*, 13th November 1961

270 'a Bantu freedom song, a Confederate song...,' ibid.

270 'trendy,' Michael Brocken, *The British Folk Revival*, Ashgate, 2003, p63

271 'chirpy strum and hearty harmonies' Joe Boyd, *White Bicycles: Making Music in the 1960s*, Serpent's Tail, 2006, p30

271 Baez influence, Mick Houghton, *I've Always Kept a Unicorn: The Biography of Sandy Denny*, Faber & Faber, 2015, p60

271 'it was not for her. Sandy much preferred....,' ibid, p27

271 'a folk club on virtually every corner...,' ibid, p27

272 Formally parted company with WMA, ibid, p65

272 'obstinate integrity' Michael Brocken, *The British Folk Revival*, Ashgate, 2003, p55

272 'I've been buying and scrounging Topic Records since 1954...' *Billboard Magazine*, 3rd October 1998

24 – Back to British Balladry

273 'a dreadful poet' edited by Allan F. Moore and Giovanni Vacca, *Legacies of Ewan MacColl: The Last Interview* Ashgate, 2014, p37; 273 'tenth-rate drivel,' Dave Arthur, *Bert: The Life and Times of A.L. Lloyd*, Pluto Books, 2012, p171

273 'milk and sugar,' Bob Dylan, *Chronicles, Volume 1*, Simon and Schuster UK Ltd, 2004, p34

273 'All the weirdness and wildness had gone out of country music.' ibid, p34

274 'mainstream culture' 'as lame as hell and a big trick...,' ibid, p35

274 Newly located Singers' Club, Dave Arthur, *Bert: The Life and Times of A.L. Lloyd*, Pluto Books, 2012, p332

274 'crucial to his development...,' 'Flash-back: Bob Dylan,' Casper Lewellyn-Smith, *Guardian*, 18th September 2005

275 'the Irish and Scottish ballads...' Doug Orr, Douglas Milton Orr and Fiona Ritchie, *Wayfaring Strangers: The musical voyage from Scotland and Ulster to Appalachia*, University of North Carolina Press, 2014, p57

275 'songs bigger than life...,' Bob Dylan, *Chronicles, Volume 1*, p51

275 The Patriot Game, https://comeheretome.com/2016/11/07/the-life-and-work-of-dominic-behan/

275 'the relationship between his own songs...' Doug Orr, Douglas Milton Orr and Fiona Ritchie, *Wayfaring Strangers: The musical voyage from Scotland and Ulster to Appalachia*, University of North Carolina Press, 2014, p56

276 The outlaw hero, J.E. Housman, *British Popular Ballads*, Harrap, 1952, p20

276 work, fear, struggle, joy, love and death, edited by Allan F. Moore and Giovanni Vacca, *Legacies of Ewan MacColl: The Last Interview* Ashgate, p63

276 'impressing their personality' 'an exceptional figure with a message,' A.L. Lloyd, *The Singing Englishman*, W.M.A., 1944, p12

276 'Folk was written to last,' David Simonelli, *Working Class Heroes: Rock Music and British Society in the 1960s and 1970s*, Lexington Books, 2013, p51

276 'may contain elements of alienation...' A.L. Lloyd, *Folk Song in England*, Panther Art, 1969, p410

277 'the songs that have lived through the years...,' Paul Robeson, *Here I Stand*, Othello Associates, 1958, p49

277 'the deeply poetical influence that Keltic music...,' Charles Villiers Stanford, *The National Songbook*, Boosey and co., 1905, preface

277 'sweet fading ghosts,' Albert Lloyd, *Folk Song in England*, Lawrence & Wishart, 1967, p411

278 'Some say things have changed...,' Albert Lloyd, *The Singing Englishman*,
 W.M.A., 1944, p68
278 'a considerable resurgence of music making...,' Dave Arthur, *Bert: The Life
 and Times of A.L. Lloyd*, Pluto Books, p171

Bibliography

Albion's Seed, Four British Folkways in America, Hackett Fischer, David
Alias, David Bowie, Gillman, Peter and Leni
American Balladry from British Broadsides, Laws
American Negro Songs, Work, John M.

Ballad and the Folk, The, Buchan, David
Ballad Repertoire of Anna Gordorn, The, Rieuwerts, Sigrid
Banjo, The, Dubois, Laurent
Bayou Underground, Thompson, Dave
Beatles, Tune In, The, Lewisohn, Mark
Bert, The Life and Times of A.L. Lloyd, Arthur, Dave
Bob Dylan, Chronicles, Vol 1, Dylan, Bob
Born Fighting, Webb, James
British Folk Revival, Brocken, Michael
Bringing it all back home, O'Connor, Nuala
British Popular Ballads, Housman, J.E.
Brothers, From childhood to Oasis, the real story, Gallagher, Paul, Christian, Terry
Bury The Chains, Hochschild, Adam

Can't be satisfied, The Life and Times of Muddy Waters, Gordon, Robert
Can't Buy Me Love: The Beatles, Britain and American, Gould, Jonathan
Can't you hear me callin,' The life of Bill Monroe, Smith, Richard D.
Captives, Britain, Empire and the World 1600-1850, Colley, Linda
Celts, The, A very short introduction, Cunliffe, Barry
Celts, The, Roberts, Alice
Chasing the Rising Sun, Anthony, Ted
Christian Slaves, Muslim Masters, Davis, Robert C.

Country Blues, The, Charters, Samuel B.
Cracker Culture, McWhiney, Grady

David Rizzio and Mary Queen of Scots: Murder at Holyrood, Tweedie, David
Deep Blues, Palmer, Robert

Elvis and Gladys, Dundy, Elaine
English Music, Turner, W.J.
Ewan MacColl, The Last Interview, Moore, Vacca

Folksong of England, Lloyd, A.L.
From Ulster to Carolina, Blethen, H. Taylor, Wood Jr., Curtis W.

Great Abolition Scam, The, Jordan, Michael
Gothic, The, A Very Short Introduction, Groom, Nick

Here I Stand, Robeson, Paul
Hillbilly Elegy, Vance, J.D.
History of the Catnach Press, Hindley Charles
History of the Rise, Progress and Accomplishment of the Abolition of the African
 Slave Trade by the British Parliament (1808), Vol 1 Clarkson, Thomas
History of the Scottish People, A, Smout, T.C.
Home Life of the Lancashire Factory Folk During the Cotton Famine, Waugh,
 Edwin

Ira Aldridge, The Early Years, Lindfors, Bernth
Ira Aldridge, The Final Years, Lindfors, Bernth
Ira Aldridge, The Negro Tragedian, Marshall, Herbert, and Stock, Mildred
Ira Aldridge, The Vagabond Years, Lindfors, Bernth
Irish Blood, English Heart, Second Generation Irish Musicians in England,
 Campbell Sean
Irish Diaspora in Britain, 1750-1939, MacRaild, Donald M.
Irish, Catholic and Scouse, Belchem, John
Irish, The Remarkable Saga of a Nation and a City, Burrowes, John

James Logan and the Culture of Provincial America, Tolles

Jazz Me Blues, The Autobiography of Chris Barber, Barber, Chris with Alyn Shipton

Jimmie Rodgers, My Husband, Rodgers, Carrie

Jimmie Rodgers, The life and times of America's Blue Yodeler, Porterfield, Nolan

Jimmie the kid, the life of Jimmie Rodgers, Paris, Mike, Comber, Chris

Joseph Locke, The People's Tenor, McAllister Hart, Nuala

Journeys to England and Ireland, de Tocqueville, Alexis

Kate Bush, the biography, Jovanovic, Rob

Kate Bush, the Secret History of, Vermorel, Fred

Kith and Kin, McReynolds, Alister

Last Train to Memphis, The Rise of Elvis Presley, Guralnick, Peter

Liverpool, Wondrous Place, Du Noyer, Paul

McApline's Men: Irish Stories from the Sites, Ultan Cowley

Meeting Jimmie Rodgers, Mazor, Barry

Mind of the South, Cash, W.J.

Mister Jelly Roll, Lomax, Alan

Morrissey, Autobiography

Mysteries of Udolpho, Radcliffe, Ann

Owning Up, the trilogy, Melly, George

Paul Robeson, a biography, Duberman, Martin

Picts, Gaels and Scots, Early Historic Scotland, Foster, Sally M.

Plain Folk of the Old South, Owsley, Frank Lawrence

Quakers and Abolition, Carey, Brycchan & Plank, Geoffrey

Quakers, The, Money and Morals, Walvin, James

Railroadin' Some, Haymes, Max

Ramblin' Man, The Life and Times of Woody Guthrie, Cray, Ed

Redburn, Melville, Herman

Rediscovering the South's Celtic Heritage, Vann, Barry

Roots, Radicals & Rockers, Bragg, Billy

Rotten, Lydon, John

Rural Roots of Bluegrass, Erbsen, Wayne

Rhythm Oil, Booth, Stanley

Sam Phillips, the Man Who Invented Rock n Roll, Guralnick, Peter

Scotch-Irish Influence on Country Music in the Carolinas, Scoggins, Michael C.

Scotch-Irish, The, Leyburn

Set The Boy Free, Marr, Johnny,

Singing Englishman, The, Lloyd, Albert

Slaves Without Masters, Berlin, Ira

Snake Oil, Hustlers and Hambones, The American Medicine Show, Anderson, Ann

Squalid Liverpool, reprinted from Liverpool Daily Post

Sweet Dreams Are Made of This, A life in music, Stewart, Dave

Three British Revolutions: 1641, 1688, 1776, Pocock, J.G.A.

The Undiscovered Paul Robeson, An Artist's Journey, 1898-1939, Robeson Jr, Paul

The Undiscovered Paul Robeson, Quest for Freedom 1939-1976, Robeson Jr, Paul

Voyagers to the West, Bailyn, Bernard

Wayfaring Strangers, Ritchie and Orr

White Gold, Milton, Giles

Women Against Slavery, The British Campaigns 1780-1870, Midgley, Clare

Woody, Cisco and Me, Longhi, Jim

Working Class Heroes, Simonelli, David

Index